Graphis Inc. is committed to presenting exceptional work in international Design, Advertising, Illustration & Photography.

Published by **Graphis** | CEO & Creative Director: B. Martin Pedersen | Publishers: B. Martin Pedersen, Danielle B. Baker | Editor: Anna N. Carnick
Graphic Designer: Yon Joo Choi | Production Manager: Eno Park | Design / Editorial Interns: Malia Ferguson, Joanna Guy, Mi Young Kim, Ji Young Lee, Melanie Madden, Nikeisha Nelson, Ryan Quigley, Corey Sharp, Meaghan Tirondola | Support Staff: Rita Jones, Carla Miller

Remarks: We extend our heartfelt thanks to contributors throughout the world who have made it possible to publish a wide and international spectrum of the best work in this field. Entry instructions for all Graphis Books may be requested from: Graphis Inc., 307 Fifth Avenue, Tenth Floor, New York, New York 10016, or visit our web site at www.graphis.com.

Anmerkungen: Unser Dank gilt den Einsendern aus aller Welt, die es uns ermöglicht haben, ein breites, internationales. Spektrum der besten Arbeiten zu veröffentlichen. Teilnahmebedingungen für die Graphis-Bücher sind erhältlich bei: Graphis, Inc., 307 Fifth Avenue, Tenth Floor, New York, New York 10016. Besuchen Sie uns im World Wide Web, www.graphis.com.

Remerciements: Nous remercions les participants du monde entier qui ont rendu possible la publication de cet ouvrage offrant un panorama complet des meilleurs travaux. Les modalités d'inscription peuvent être obtenues auprès de: Graphis, Inc., 307 Fifth Avenue, Tenth Floor, New York, New York 10016. Rendez-nous visite sur notre site web: www.graphis.com.

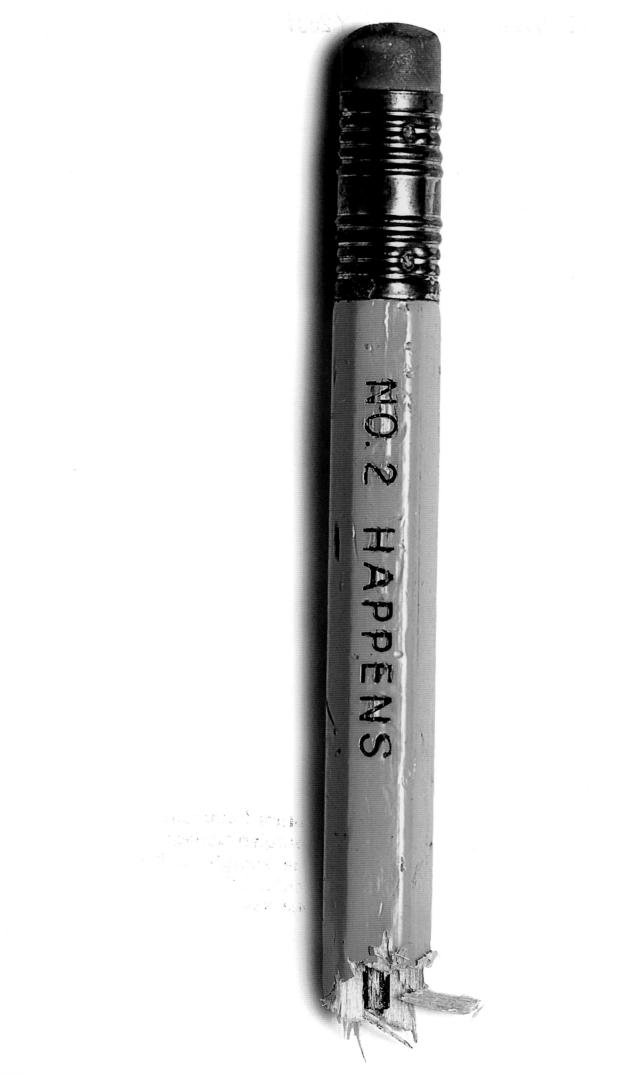

Contents

Previous Spread: Photo by Shaun T. Fenn

Opposite Page: Photo by John Schulz

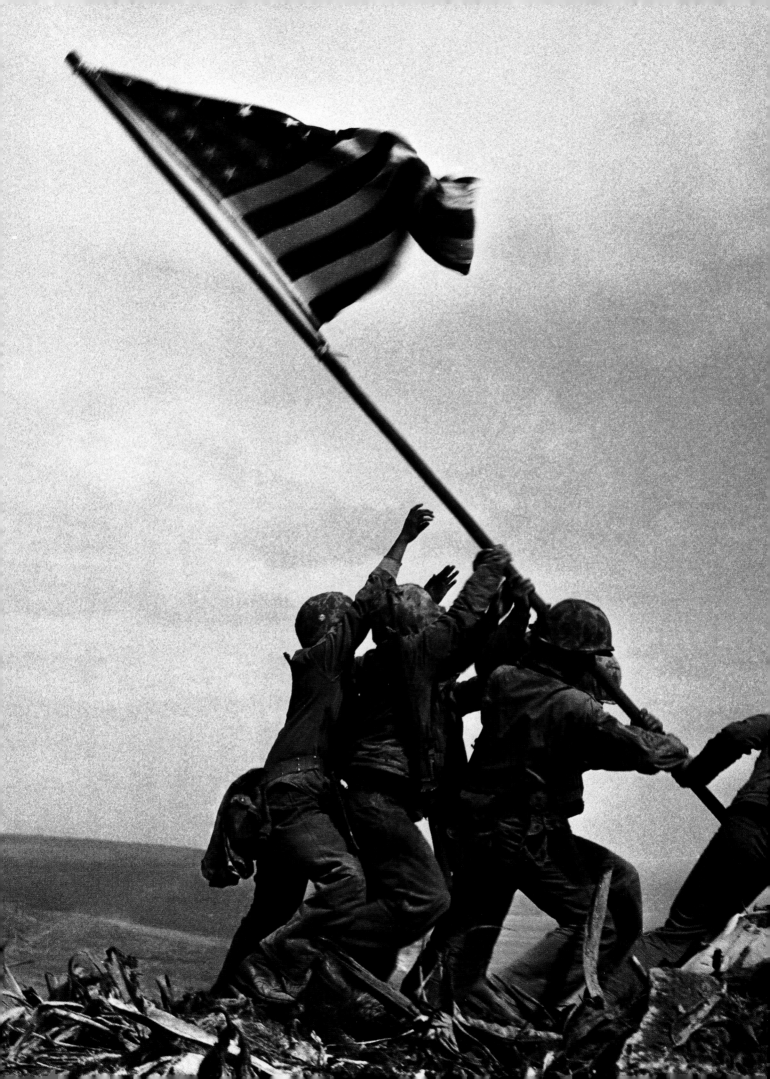

Thomas J. Abercrombie 1930–2006

Abercrombie began his career in newspapers — *The Fargo Forum* and *The Milwaukee Journal* — where he was named national news Photographer of the year. Abercrombie was recognized most notably for his outstanding work as a freelance Photographer for *National Geographic*, and in 1959 he was named Magazine Photographer of the year. He worked extensively in the Middle East, covering the region for nearly three decades. Abercrombie died at the age of 75 due to complications following open heart surgery.

Chance Brockway 1919–2007

Brockway covered the Ohio State Buckeyes as a sports Photographer for several years, until his death at age 88. He was a regular on the sidelines of Buckeye sporting events and devoted a majority of his life to documenting and capturing the Ohio State athletic tradition. In addition to his work at the school, he shot for *Sports Illustrated* and *The Sporting News*. An expert on his home state, he also published two books on local Ohio history as part of the Images of America series, which included photographs from his own collection. Chance Brockway demonstrated the value of the Photojournalist by recording and enriching the state and the university he loved.

Douglas Chevalier 1919–2007

Chevalier worked at the *Washington Post* where, during his 30 year tenure, he covered the terms of seven presidents and took photographs for thousands of news stories. He covered the inauguration of Dwight D. Eisenhower, the funeral of John F. Kennedy, the 1968 downtown riots in Washington and the Watergate hearings that eventually led to the resignation of Richard Nixon in 1974. He has won awards from the White House News Photographers Association for his photographs of Eisenhower and also for his photo of a crying Amy Carter boarding Air Force One following her father's loss to Reagan in the presidential election.

Leonard Freed 1929–2006

While he studied under Alexey Brodovich and pursued a career in painting, Freed was attracted to the storytelling abilities inherent in Photography. Freed worked as a Photojournalist and followed Martin Luther King, Jr. on his march from Alabama to Washington, and also took compelling photographs of Harlem during the fifties and sixties. In 1968, he published his influential book, *Black and White in America*. Several of his photos have been accepted into the permanent collection at the Smithsonian Institution. He was a member of the Magnum Photo Agency.

Master Cpl. Darrell Priede 1977–2006

Canadian Darrell Priede entered the military in 1996 as a gunner, and later served as a peacekeeper in Bosnia before applying to become a military Photographer during his second tour in the Balkans. He died along with five Americans and a Briton when the CH-47 Chinook helicopter they were flying in was shot down in Afghanistan's volatile Helmand province. Prior to the crash, Priede was photographing coalition forces attempting to capture a valley from insurgents. Priede was highly regarded for his contributions to various in-house publications, including *Army News*. He was just 30.

Ben Pritchard 1982–2007

A documentary Filmmaker and Photographer, Ben Pritchard died from a heart attack while mountain biking at the age of 25. He was an integral member of the 14 Days Project, which seeks to "provide a greater awareness of the global community through the unique marriage of extraordinary Film and Photography, allowing everybody to develop their own ideas for creating lasting and meaningful change. Building a bridge to the world around us by listening to others tell their own story." Pritchard's photographs of individuals from around the globe helped foster awareness and cultural tolerance.

Joe Rosenthal 1911–2006

Unable to pass an eye exam, Rosenthal was rejected as an army Photographer during World War II, but pushed to follow the war anyway as a Photographer for the Associated Press. Rosenthal is most famous for his Pulitzer Prize-winning photograph of soldiers struggling to hold up the American Flag atop Mount Siribachi following the attack on Iwo Jima. To capture his award winning photo, Rosenthal had to carry his bulky speed graphic camera up the mountain. His photo became the model for the United States Marine Corps Monument in Washington, D.C., and captured one of the most powerful moments in WWII and US history.

Photograph by Joe Rosenthal | Courtesy of AP Photo

John Jobe Abbass 1923–2007

Born in Australia, John was educated in Sydney schools and a graduate of Sydney Academy. He served his country during the Second World War in the Canadian Army in England, Belgium, Holland and France. John was a co-founder and president of Abbass Studios Limited, Sydney, established in 1946. He also owned and operated the Econo Color Camera Stores throughout the Maritimes. He established portrait studios in Glace Bay, New Waterford and Antigonish. John served as past president and vice-president of the Maritime Provinces Professional Photographers Association and vice-president of Professional Photographers Association of Canada. He was the first local provider of fast photo finishing in the Maritimes. John had a keen interest in politics, and was president of the Nova Scotia Progressive Conservative Association in 1985, 1986 and 1987. In 2004, John was inducted into the Cape Breton Business Hall of Fame.

Bernd Becher 1931–2007

Bernd Becher is best known for photographing relics of industry in the evolving urban landscapes of late-20th-century Europe and the US with his wife, Hilla. The Hasselblad Foundation celebrated "their systematic Photography of functionalist architecture, often organizing their pictures in grids, [which] brought them recognition as conceptual artists as well as Photographers." The Bechers were honored with a Hasselblad Award in 2004. Mr. Becher taught Photography at Düsseldorf Academy for 20 years, and his students include Andreas Gursky, Candida Hofer, and Thomas Ruff.

Roger Berg 1935–2007

At age 15, Roger Berg built his own telescope, and thereafter pursued his interest in taking pictures through the telescope, learning to process film and take photographs. He owned Roger Berg's Creative Photography Studio, where he specialized in portraits and digital imaging. Mr. Berg and Mr. Tom Atkins started Columbia Photo Supply, a local camera shop, in 1968. Berg held exhibits displaying works of artists like Ansel Adams and Edward Weston at the store until 1992, when he committed himself to the pursuit of commercial Photography. In 2000, Mr. Berg built his own studio.

Ruth Bernhard 1905–2006

Born in Berlin, Ruth Bernhard attended the Berlin Academy of Art, and moved to New York in 1927 to pursue her photographic career. Motivated by an encounter with Edward Weston, Ms. Bernhard moved to the west coast in 1935, where she became a colleague of Ansel Adams, Imogen Cunningham, Minor White and Wynn Bullock. She was widely respected for both her commercial work and for her more personal, fine art photos, particularly her female nudes and still lifes. Ms. Bernhard lectured and conducted master classes throughout the US through her 95th birthday.

Warren Bolster 1947–2006

Shooting from helicopters and mounted cameras on surfboards, Warren Bolster was considered one of the world's top surf Photographers. Mr. Bolster's work was featured in major surfing magazines across the globe, from the United States to Australia, Europe, South America and Japan, and included in publications such as *Sports Illustrated* and *The Honolulu Advertiser. Surfing Magazine* called Bolster "one of the most prolific and gifted surf/skate Photographers."

Joel Brodsky 1939–2007

Brodsky, most famous for his photos of Jim Morrison and The Doors, shot musicians for hundreds of album covers and promotional materials. Growing up in Brooklyn, NY, Brodsky developed an interest in Photography during his teenage years, and after graduation from Syracuse University and service in the Army, he began his career in 1966. Brodsky shot photographs for Vanguard recording artists Country Joe and the Fish, Otis Spann, Junior Wells, and Buddy Guy. Later, working with Elektra, Brodsky had the opportunity to work with The Doors, establishing a professional relationship that lasted 40 years and defined the careers of both Brodsky and The Doors. Brodsky finished his career in advertising, doing work for Bloomingdale's, Avon and Revlon.

John "Kozy" Kozieja 1926–2007

A veteran and self-employed home-improvement salesman, John Kozieja loved Photography and racing. For over fifty years and throughout the midwest, Kozieja photographed racing events for multiple motor sports media outlets like Racingwisconsin.com and *Hawkeye Racing News*. His specialty became photographing open wheel racing events, featuring some of the fastest racing vehicles in the world. In 2000, Kozieja was awarded the revered Badger Midget Auto Racing Association Media Award.

Malise Cooper Dick 1935–2007

Educated at England's Carlisle Technical College, Cambridge University, and Rhode Island's Brown University, Malise Cooper Dick was an accomplished economist who worked for the World Bank Group, where he developed infrastructure in West and East Africa, Latin America, and the Caribbean.

As member, chairman and executive committee member of the World Bank-International Monetary Fund's International Photographic Society (IPS), Dick fostered the development of amateur and intermediate Photographers. As chairman of the nominating committee, he reviewed and awarded the top Photographers of the IPS. His own Photography also received awards from the Society, and his photos were exhibited at annual IPS meetings. Dick was executive committee member and treasurer of the Chesapeake Education, Arts and Research Society (CHEARS), a nonprofit organization dedicated to the health of all who share the Chesapeake watershed environment.

Jose M. Duarte 1967–2007

Jose M. Duarte was a well-respected and inspirational faculty member at the University of Texas at Brownsville and Texas Southmost College (UTB-TSC). He started at UTB-TSC as the school's Photographer, but later accepted a position as administrative assistant. With his friend and colleague Dr. Tony Zavaleta, he photographed various areas of Mexico. In addition to his award-winning photographs, he covered fiestas and was Webmaster for the Border Curanderismo research project webpage. He was a member of the National Press Photographers Association, the International Freelance Photographers Association and a sponsor of the UTB/TSC Photography Association.

James Fee 1949–2006

Fee is remembered for his Photography of the American Landscape, but it was the Peleliu and Angaur Islands of Micronesia where his career blossomed. His father fought on the islands during one of the most gruesome battles of WWII. Subsequently, his father returned from the war a troubled man who eventually committed suicide in 1972. This experience brought Fee to the islands to photograph the landscape that had changed his father's life. His father's battle with mental illness, and the landscape that precipitated that illness, were central themes to the majority of his work thereafter. He truly captured the darkness and the pain of the American psyche.

Martha Holmes 1923–2006

Martha Holmes made her career at *Life Magazine*. She worked 40 years at the magazine, taking photographs of such popular figures as Judy Garland, Joan Crawford, Rocky Marciano, and Eleanor Roosevelt. Former editor of *Life*, Bobbi Burrows, believed: "She had a talent for extracting the best from people." Her most famous picture is a photograph of Jackson Pollock crouching over his canvas with a lit cigarette dangling from his mouth, a picture that later went on the face of a 33 cent US postage stamp. Holmes broke barriers when she worked as one of the first female Photographers of sports, a role once held primarly by men.

Tom Needham 1929–2007

Needham was a Photographer for *The News Herald* of Panama City, Florida for 50 years. His photographs focused on nature and wildlife. He loved to go to the local St. Andrews Park and take photographs of the birds there. He was patient with the camera, sometimes waiting an hour to take the right photo. He was also a community advocate for the environment and received the first Bay Point Invitational Award for Outstanding Public Service in 2005. In addition to taking photographs for *The News Herald*, Needham showed his work at local art galleries.

Wallace Seawell 1916–2007

Seawell spent his life taking photos of the famous. Born in Georgia and raised in Florida by his mother, he received scholarships to his hometown Ringling School of Design, and went on to receive a degree from the Rochester Institute of Technology, where he graduated with honors. After serving in the military and spells at the Eastman-Kodak Fashion Studio of New York and Howard Hugh's RKO pictures, he began working with Paul Hesse and fostered a professional relationship that shaped the rest of his career. Seawell took over Hesse's studio in 1963, where he began working with celebrities. He shot portraits of famed actors and actresses such as Elizabeth Taylor, Audrey Hepburn, Sophia Loren, Paul Newman, Gregory Peck, Tony Curtis and Rock Hudson. He also photographed prominent political figures, including Ronald and Nancy Reagan, with whom he remained lifelong friends.

Henry Bradford Washburn, Jr. 1910–2007

A staggeringly accomplished man, Washburn was an explorer, mountaineer, Photographer, and cartographer. Completing both undergraduate and graduate degrees at Harvard, he was also the recipient of nine honorable doctorates later in his life. Washburn's pioneering aerial mountain Photography changed the way mountain climbing routes were seen and prepared, a feat he accomplished from his early 70s to late 80s. Washburn's mountain Photography developed into his celebrated maps of Mount Everest and Mount McKinley. He was director of the Boston Museum of Science and central to its development as one of the top museums in the country. Washburn received the King Albert Medal of Merit, and the Centennial Award from the National Geographic Society, an award he shared with his wife, Barbara, the first woman to summit Mount McKinley.

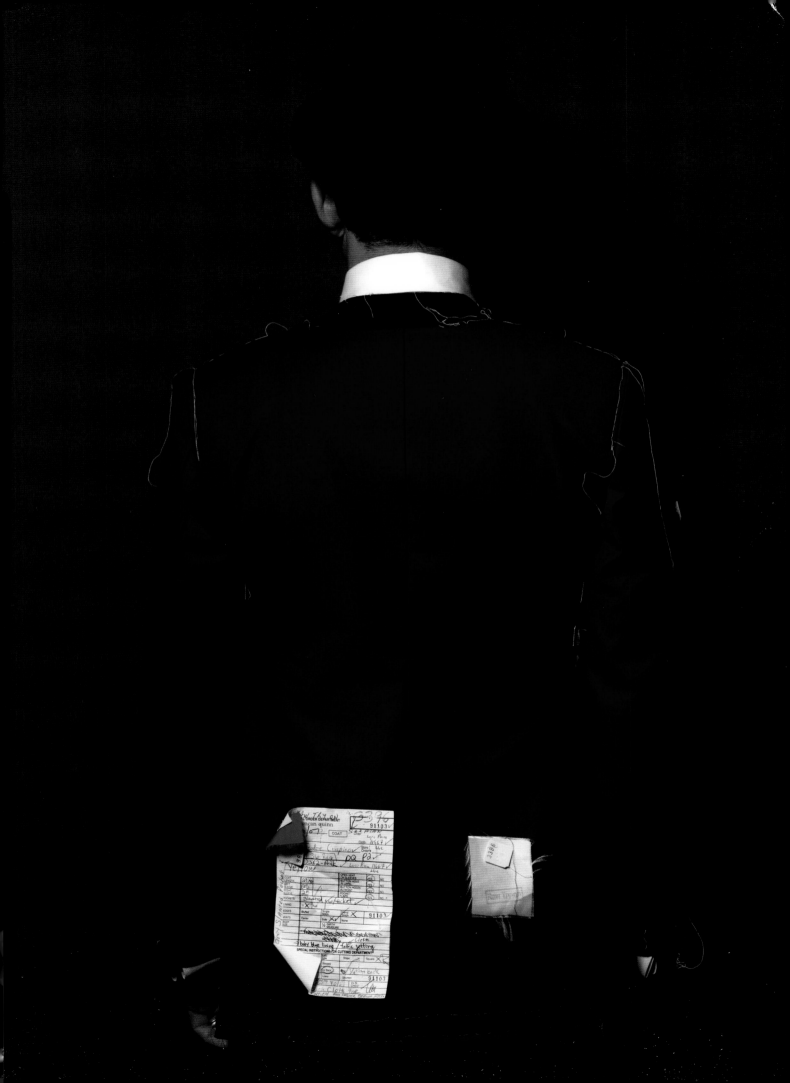

A Conversation with **Henry Leutwyler**

Swiss born Photographer Henry Leutwyler's excitement and passion for his craft are contagious. An internationally respected artist, Leutwyler still conveys a sense of awe — even a guilty pleasure — when describing his career. Over the years, he has been a consistent contributor to Graphis. We sat down with him to discuss his remarkable career, the beauty of objects, his interests outside of Photography, and, of course, Elvis.

Who gave you your first camera?
My father gave me a Kodak 224 Instamatic (I still have it!) when I was about six years old. My father was an avid Photographer. He actually took some really beautiful pictures, but in his time, I guess, Photography was not really considered a career in Switzerland, more of a hobby. In some parts of the world I have visited that is still the case. I remember a few years ago, while traveling in Jordan, I was asked what I did for a living, and when I responded that I was a Photographer, the guy squinted at me and said, 'No, really, what do you do to make a living?'

As a student, you were told you might not have what it takes to be a professional Photographer. Your response was to open your own studio, despite a lack of formal training, and teach yourself. What was this time in your life like? And do you think that streak of independence and determination is still present today?
When I was told that I would never be a Photographer because I failed the chemistry part of the entrance exam, I knew that Photography was the only option for me. I was determined, and I opened the studio out of spite. All my friends at that time were starting to settle down with fiancés and comfortable jobs, and I knew that that was not the life I was looking for. I see now that I had no qualifications to own or operate a studio, but I had the mind of a 23 year old. It was not a huge success, and I quickly came to the conclusion that I had a lot to learn (and I'm still learning today). At that point I decided to move to Paris….

After a decade in Paris, why the move to New York? What drew you to the city as an artist, and what has kept you here?
New York is the center of the universe. I have been here almost 12 years and I still feel like I just arrived. This is an ever-changing city. Anytime I am feeling uninspired, all I need to do is go stand on the corner of Prince and Broadway and watch all the crazies walking past, and I know I made the right decision to live here. I also like bringing up children here. I hope that they will grow up with open, creative minds.
Also, New York is where the Photography industry is based — the industry as far as what I am interested in doing anyway. I have always considered myself an editorial Photographer, and all the magazines that I love are here, so it made perfect sense for me to be in this city. I was in Paris for 10 years before coming here. I felt, after that many years, that I had done all that was available to me and I did not want to stagnate as a Photographer, so it was time to move on. To sum up New York: I am always excited to leave and even more excited to come back.

One of the wonderful aspects of your work is that you are not limited to one particular subject matter or style. You shoot portraits, still life, editorial…How do you think the different styles and subjects complement one another? Are you a better Photographer as a result?
My curiosity is fed by everything that goes on around me, the city I live in and the places I visit. I am constantly on the lookout for people and objects that could make a great picture.
I feel that my Photography evolves because I allow myself to experiment all the time. I am never really satisfied; I try to always do better and I love to discover new techniques. I like the idea that I am able to be in the studio one day shooting a portrait and the next working on a series of still lifes. It keeps me on my toes. Complacency is never an option.

How do you balance commercial and fine art/personal work?
I never quite differentiate between the two. It still comes as a shock to me that people who commission me for more commercial work sometimes direct me to shoot something that bears no resemblance to my style. I wonder what the point is of hiring someone and then asking them to do something that is not appropriate to their style.
I have been fighting since I came to New York with the concept of Photographers are Photographers; not just fashion Photographers or cosmetics Photographers. New York today wants specialized Photographers — you pick up the phone and ask the guy to shoot a banana, but you will not ask him to shoot an apple, and I think this is a huge mistake. I love to do flowers on Monday, guitars on Tuesday. I'm happy because I'm doing Broadway, I'm doing celebrities, I'm doing the fun stuff. I'm trying to keep my creative mind alert with different projects and mixing it up. And I believe if you look at the images, you still know they're mine.
And I always think, if we wait for the ideal client, like *Vogue*, to call you to shoot the cover, you may die waiting. You have to go ahead and do

whatever makes you happy. Hopefully one day — and it worked with Graphis, I mean we're talking now — hopefully one day people will understand, enjoy, and call for the fun project.

What excites you?
What excites me about my job is that when I wake up in the morning, I have no idea what assignment might come my way. I can literally be in my office doing paperwork in the morning and on a flight to Fiji that very same evening. That is what I love about the editorial world — it always takes you by surprise. It's never boring. I love the thrill of the shoot, the setting up, the subject arriving on set, the hair, the makeup. I love to see the transformation that occurs on a shoot. I usually shoot very quickly, and when I know that I have the image — a new image — then I get excited. People are often shocked that I can take a picture in ten minutes, but that's not really the case — it's ten minutes on set that day, but it's actually 20 years of experience.
Non work-related: my kids — never a dull moment; my books — I have been collecting for 30 years; travel — there is so much to learn, so much still to see. I have been lucky enough to travel extensively as a Photographer, and I can honestly say that seeing the world is the absolute best education anyone can have. I have a far more tolerant view of the world after having walked through the streets of Damascus, the oldest continuously inhabited city in the world.

What do you love most about Photography?
It's not a job as far as I am concerned. I love what I do, and I am lucky enough that other people think that what I do is worthwhile, and sometimes I even get paid to take pictures!

I have read you like to get to know your subjects a bit, if possible, before shooting, by going out to dinner, doing background research, etc. How often are you actually able to prep like this? And how do you think this preparation is reflected in your photographs?
I do some preparation, but it really depends on the subjects themselves. Sometimes I feel that you can know too much, and that can impair your judgment when it comes to the shoot. Sometimes you cannot help but know a lot about that person simply because they are in the news at the time. When I was commissioned to shoot Karl Rove, I had already formed my opinion on him, and knew exactly how I wished to portray him. I also knew that I was not going to get a lot of time with him and that I would certainly not be working in ideal circumstances — when you shoot in the White House, you basically take whatever location they allow you to shoot in. I always try not to get too emotional in these situations and I don't want to give too much away, but the very brief conversations that do occur during these moments are always interesting. Karl thanked me for making him look like Robert Redford. I'm glad he felt that way; I did not have a lot to work with!

How do you make subjects comfortable and establish rapport on set?
I don't always need or want my subject to be comfortable. In some circumstances, a certain degree of discomfort is not a bad thing. I find that when subjects get too comfortable, they become far more self-aware and self-conscious, so I prefer to shoot fast. I don't always give away too much information, and people are generally surprised when I tell them that I have finished. I recently photographed Matthew Broderick. He was really surprised when I told him after about 5 minutes that we were done. He said to me, 'Either you're very good or you don't give a fuck.' I have a feeling that some Photographers feel like they need to give a lot of attention to celebrities and create a show for themselves, but all I am really interested in is the final image. When I know I have the picture, I have it; there is no need to waste any more time after that.

Your wife, Ruba Abu-Nimah, is a respected Art Director and Designer. What is it like working together? Do you collaborate consistently?
My wife and I have been collaborating since we met almost 20 years ago. We have an innate understanding of what each other is looking for in a project and how we should go about achieving that. Whereas most jobs require briefs, meetings, and conference calls, once we know what the project requires, we don't discuss much.
She has a tremendous love of Photography, and a very good eye. We've worked on a variety of different projects over the years, from books to beauty campaigns, and the results are always compelling. On the other hand, I have total respect for Design and Typography, and over the years I have even developed immunity to type on my images. When it's done

right, it can even elevate the image and make it more beautiful.

Not too long ago, you did all the still life Photography for Elvis By The Presleys, *a companion book to the CBS television special and Sony BMG documentary featuring stories from the Presley family. The book was a huge success — translated into 8 languages, #1 best seller in the UK and #8 on* The New York Times *best seller list.*

How did you become involved? What struck you most about this project? What was most challenging, and what did you learn?

My wife, Ruba, conceived the project. She was approached by Elvis Presley Enterprises through their book agent, David Vigliano. The Presleys wanted to do something personal — something that had never been published before. It was to be an oral biography by the Presley family — Lisa Marie and Priscilla mainly. My wife had the idea that she wanted this book to be a portrait of Elvis; clearly there were challenges there, so she decided to ask for access to some of Elvis's most personal objects in order to create a visual portrait of him through his belongings. She approached me with the idea, and I decided to channel my inner Weegee. I thought that the best way to shoot these objects was almost like crime scene pictures. The result was a really strong visual story, getting as close to Elvis as possible.

I loved that project! It was so exciting for a Swiss guy from a small town to have access to so many objects that had never been photographed before and that had belonged to a true pop icon. The challenge was deciding what to shoot and what not to shoot, and sometimes to convince the people working with me that even the most mundane of objects (a plastic comb, for example) can take on a new meaning when photographed in a certain way and placed in the right context. People tend to be drawn to the more flashy objects, but I really was looking for the ordinary. Because when they belong to Elvis Presley, they are not so ordinary anymore. And Elvis reopened my mind to the beauty of objects. Objects talk. And I always think it is incredibly relaxing to shoot objects after you shoot fashion or celebrities. You are responsible, you're in a little corner, and you do your own stuff.

You said reopened — was there a particular, earlier project that really changed your perception of objects?

Flavor was the first cookbook I did with Rocco DiSpirito, and *Flavor* led me to look at foods in a different way. We go to a restaurant, spend a lot of money, eat in 20 minutes and leave. We don't realize the effort in the kitchen and the beauty of the raw materials as they are; the beauty of nature, the beauty of what God created. We are Photographers, but our eyes are becoming lazier, and we don't have time to look at objects' face value. We just look at cute girls and we like dudes and we like fashion and that's where the money is, but the real beauty is in what God created. Again, objects speak. A flower speaks, a guitar speaks, a still life of great food speaks.

Would you please describe your ongoing portrait series of Piper Perabo — your working relationship, what the process is like, her reincarnations, and why she is such a fantastic subject?

Piper is a chameleon! She is able to transform herself into any character and any mood. She is an amazing subject because she is a real actress with incredible talent, an old fashioned actress in the real sense of the word. She reminds me of old Hollywood or what I imagine that to be — a real character actress, with a lot of style, and she's also very beautiful. When we work together we use no makeup, no stylists. It's very low key — a total collaboration. It's been going on for two or three years. We get together in the studio and we do basically Cindy Sherman, but it's not really Cindy Sherman. It's Piper Perabo. She thinks of characters that she wants to be, and we bring them to life in the studio. Often she does not even tell me what she's bringing with her. It's always a surprise. We plan little, produce a lot. It's as improvised as can possibly be in a studio, which tends to be a very controlled environment. We have total freedom to work as we see fit.

The idea is to find people who are in the beginning of their careers, and invest, and become friends, work together, and with a bit of luck, it will turn into a fabulous, fabulous project. I have maybe 150 images of Piper, and at some point I'll do a book: *Piper By Henry.* Most Photographers don't have time to do this anymore. I believe in time, I believe in nurturing relationships, thinking, organizing, and improving and doing it again and again and again until it hopefully becomes interesting, and more than commercial. Piper is one of those projects.

Tell us a bit more about the dichotomy of the Candy and Guns shots.

Sometimes, while on a shoot, clients don't realize that I am referencing a previously shot image. I like to play with juxtapositions all the

time. I try to contextualize everything I do. Sometimes it's about just experimenting, seeing if the same technique and style can work in two different worlds and what meaning can be given to that image by using a style used for a previous image. I shot the candy first, and really just wanted the picture to be a celebration of color — a pop art image, or even an homage to Matisse from a color perspective — but I also loved all the graphic shapes that the candies come in, so I treated the different elements almost the same way a Designer would treat type on a page. When it came to shooting the guns, I opted for the same technique to see how two seemingly different subjects would look in the same context. I am always interested in seeing how two images side-by-side feed off each other (that is my editorial side talking, always thinking in spreads). In the end these two images can have the same meaning — guns kill, but then so does sugar. It's pleasure and death.

How much of your shooting is planned? How much is spontaneous?

This depends so much on the circumstances of the shoot. Recently, I was shooting a beauty campaign, particularly demanding in light of the fact that I was expected to shoot 8 different visuals in one day, including hair, wardrobe and makeup changes. The client also wanted one shot, at the end of the day, of a nude. They were looking for a more evocative picture, an inspirational shot. I was not quite sure how I was to achieve this all on time! I knew that I could not use the same light as the beauty shots and that I had to do all this before 5pm (models leave at 5pm on the dot!). All day I was wondering how the hell I was going to pull this off, when about 30 minutes before the end of the shoot, I remembered a lighting technique that I have not used in 15 years. My assistants and I took down the set and put up a new one in 10 minutes, and we got the shots in about half an hour. The end result was quite a surprise, but these are some of the best images I produced this year.

What is your state of mind while shooting?

Quietly apprehensive.

From the long list of portrait shoots you've done, do any one or two stand out more than others to you? Who was the most fun to work with? Most challenging? Any memories of being particularly star-struck?

I was definitely star-struck when I photographed Julia Roberts for *Three Days of Rain.* She walked into Industria Superstudio (my second home), and when I greeted her I told her that I was so glad not to be 21 anymore, because I would be pretty terrified at the prospect of having her in front of my camera. We worked for about 15 minutes, no hair people, no makeup people; she came with no entourage. She was gracious and a true professional.

At the premiere of the play, Julia introduces me to her husband, who says that he loves the picture I took of his wife, to which I reply that it's not hard since she is so beautiful. He begs to differ, saying that he has taken thousands of pictures of her and not any of them are as good as mine. That was a good moment in the life of a Photographer.

Is there anyone specific out there whose portrait you would still really like to shoot?

So many! I am waiting for my next surprise. Actually, I would be thrilled to have the opportunity to photograph Sylvie Guillem, and I regret never having had the opportunity to photograph Rudolf Nureyev, Miles Davis and Jimi Hendrix.

Which photograph or photo series is your proudest achievement?

I will never forget shooting the dancer Jorge Donn in the late eighties. The shoot was pure magic. I also remember when Helmut Newton told me after 16 frames that I was done (and that if I didn't have it now, I never would). There was the time Mikhail Gorbachev didn't want me to photograph him from my camera angle because it showed the birth mark on his forehead. I did manage to do it anyway.

What elements are necessary for a successful photograph?

I am still trying to figure this out as we speak.

What is in your camera bag? What equipment do you use? Anything you could not do without?

I do believe that you should be able to photograph anything, anytime with the simplest of equipment; usually the sun will do or even a candle. But if pressed, I still love all things Swiss and have a particular penchant for equipment manufactured in Switzerland. I especially love my 8x10 Sinar, my 4x5 Master Technika and my Broncolor strobe equipment. I still love film; I'm having a hard time accepting that all that has almost disappeared, and everytime I hear of one more paper or film that has been discontinued, it's like a small death. I did, however, make the inevitable switch to digital in early 2006, and there are clearly advantages to this new way of working. And I must admit that I have really been

"Henry is the most talented, hardest working, sweetest portrait Photographer
I have ever worked with."

Stefan Sagmeister, *Designer*

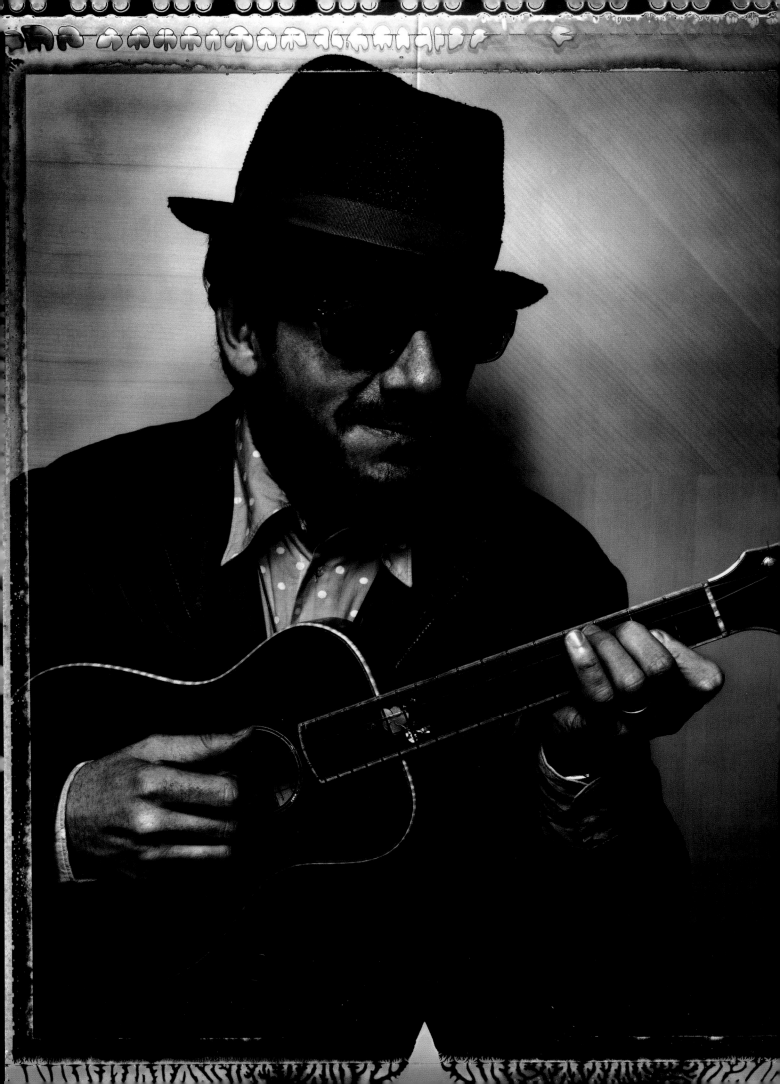

"I called Henry the day before we had planned to shoot together for the first time and said,
'I'm not sure I want to be photographed,' and he said,
'That's fine. Why don't you come as someone else?' We have been working together ever since."

Piper Perabo, *Actress*

"I've worked with Henry on both commercial and editorial work. He is a dream to work with.
He has uber-talent, uber-passion and a fabulous sense of humor and joy.
I trust him explicably with both beauty campaigns and portraits. His set is calm, happy, and a ton of fun."

Bobbi Brown, *Makeup Artist & CEO, Bobbi Brown Cosmetics*

enjoying shooting pictures with my new iPhone!

Who are your favorite Photographers?
Richard Avedon, Frantisek Drtikol, Paul Outerbridge, Edward Weston, Jr., Martin Munkacsi, Manuel Alvarez Bravo, Bill Brandt, Raymond Meier, Josef Sudek, Julius Schulman, Robert Polidori, Andre Kertesz, William Klein, Robert Frank, Paul Strand, Albert Watson and so many more…and, of course, Mr. Penn, Mr. Penn and more Mr. Penn…

Do you have a favorite photograph?
Bewegungsstudie (Movement Study) by Rudolf Koppitz, 1926.

What other passions do you pursue besides Photography?
I love dance. Whenever I can escape and go to a ballet rehearsal I feel rejuvenated. This is where I charge my batteries. Nothing is more beautiful than a dancer in motion.

How do you define beauty?
Beauty is subjective. I know that sounds like a cliché, but it's the truth. Irving Penn managed to find beauty in street garbage. That was a big lesson and an eye-opener for me — never to discount anything without looking very carefully first.

What's the greatest difference in your perception of Photography now versus when you were just starting out?
I take it far less seriously. I am aware that I am not performing open-heart surgery on newborns. Even though things can seem hard at times, ultimately I am doing what I love. Most importantly, I surround myself with the best people I can find. My assistants are the most important link in the chain; I have a tremendous respect for them and I always try

to help them achieve their own dreams. It is a great feeling to see an assistant become a Photographer.

Finally, do you have any advice for Photographers just starting out?
Just go for it. Work hard, and if you have it inside you, it will all work out somehow. Don't expect immediate success, and beware — shooting stars only look good in the sky.

Interview by Anna Carnick

Biography: Henry Leutwyler is an internationally acclaimed, award-winning Photographer. Swiss born, Leutwyler was a creative force in Paris until 1996, when he moved to New York City with his wife and two children. His work has appeared in Vogue, Vanity Fair, The New Yorker, Portfolio, Esquire, *and* Fortune, *among many other publications. His subjects include 50 Cent, Elvis Costello, Nathan Lane, Liv Ullmann, Roberto Benigni, Win Wenders, Queen Noor of Jordan, Mikhail Gorbachev, His Majesty King Abdullah II, Oprah Winfrey, Tom Wolfe and Dizzy Gillespie. He is the recipient of awards from the Art Directors Club of New York, Society of Publication Designers, RX-Awards, Donside Awards, How Awards, PDN Awards, James Beard Awards, and Graphis. For more information on Mr. Leutwyler, please visit www.henryleutwyler.com.*

Images: page10, Dunkan Quinn, page11, Henry Leutwyler Self Portrait, page13, Elvis Glasses with name, page14, Elvis Costello, page15, Candy (left), Guns (right), page16, Gibson, Hendrix, Strauss Guitars and The Edge, page17, Gibson.

"The guitar is like the body of a woman. It's very sensual.
They're all different, they all speak a different language,
they all have a different color, and they all have a different religion."

Henry Leutwyler

"I love Henry. He's someone consistently great to work with.
He always produces amazing, personal portraits of people. The entire process is great each time.
The thing about Henry is that he treats everyone the same — interns, assistants and celebrities.
That sort of empathy and respect comes out in the work that he does.
I think that's because of the kind of person that he is."

Michael Norseng, *Photo Director, Esquire Magazine*

The Parish Kohanim Interview

There is a graceful element to everything Parish Kohanim shoots. According to his friends, that same grace permeates every aspect of his life. The Shiraz born, Atlanta-based artist's commitment to celebrating beauty translates into an impressive oeuvre, spanning over thirty years in both commercial and fine art work. We spoke with Parish while on location in Santa Fe, shooting his latest project with Cirque du Soleil.

Parish, tell us a bit about the Cirque du Soleil project. How did you initially become involved?

It was kind of an accident. I met one of the Cirque de Soleil performers at the gallery opening of my friend, Sculptor Richard MacDonald. The performer was seated next to me. We started chatting, and he said let's do some Photography. That was the catalyst for the whole thing.

We've done three sessions so far in the studio. To see his dedication and focus has been remarkable. I am just so inspired.

What is your approach to the series?

Simplicity. Focusing on the magnificent human form and its extraordinary capabilities. I don't do drugs. I don't drink. Photography is my drug. I got into the session and I was in a cloud! It was the ultimate experience, working with their talent and dedication. It was beyond passion. They have such an incredible and intense degree of commitment to their art. That was common ground for us: creating and capturing a frozen moment with a shared sense not only of collaboration, but an intense degree of commitment to our art. I decided to keep the backgrounds simple — black, blue. It brought their shape out more and added drama.

It must be challenging, given the show's simultaneously physical and artistic nature. Please describe what it's like working with performers as physical subjects?

The initial impact was powerful. I have always enjoyed photographing people. This was different. Their dedication fascinated me.

What amazed me was the serenity of their faces. They know how to fall, yet some of the things they did had to be painful. They kept going, with grace and elegance. And despite extraordinary effort, they were serene. I was photographing moments I could never get twice. I don't plan too much; I like letting the shot develop. It's a process of enjoyment, developing ideas seemingly from nowhere that emerge from the neurotransmitters in your brain. I agonize, but it gets better. The idea comes and I develop it into a visual reality that I can capture and share with others. That's where the joy in Photography is for me, in the process and the sharing.

One of the dancers, Stephan, had a lot of ideas. We were shooting on a 30" Apple monitor so we could see what we had and let it evolve. He would do a sketch of a new pose then work on that position for an hour or so to get it the way we wanted to shoot it. Sometimes, we were actually jumping with enthusiasm. 'Yeah! This is it!' His dedication and desire for perfection were inspiring. It reminded me of an interview I read once with Tiger Woods. Woods was winning all these golf tournaments, all these awards, but at one point he decided to stop competing and work on his swing. For two years he didn't win trophies, but that was ok, because he was determined, and he wanted to get better. And Stephan was the same way. If he had a terrific pose that was 99.9% there, but even 0.1% was missing, he just kept going until it was better.

We shot for a long time; these guys have unbelievable endurance. We had long days photographing. I think it was the wonderful high and energy we had between us that kept us going. I was having such a great time with them. It was such a special moment in my life and I was sorry when the shoot was over.

What inspires you?

What inspires me the most is nature. When I was growing up in Shiraz, we lived in a town quite like Santa Fe, surrounded by mountains and crystal clear skies. In the evenings, my father would take us out by a stream that flowed from a spring. We would take some tea and sit in the moonlight under the stars, sometimes shooting stars, and listen to the sound of the water. We didn't say a lot; it was a sort of meditation. My parents inspired me to see beauty in simple things, and that is what I want to share. I don't do work that is trendy or edgy. I just do what comes naturally for me, from my heart. I do work that is inspired by nature. I look at the work of a lot of sculptors: Bernini, Michelangelo, my friend Richard MacDonald — in fact, work by artists in different genres. Most are inspired by nature.

How did your painterly style develop?

It's a mixed media concept of Painting and Photography. At one point, I worked with makeup artists who really helped and inspired me. We would shoot portraits again and again. And though we did some planning, we had no idea where it would end. Images evolved. I really loved the surprise at the end. I am doing something similar with landscapes now. It's the same concept — Photography, then mixed media. It is different, and that's the reason I do it. I'm a commercial artist by trade, and I do my fine art Photography as an escape. I do it for myself, and I like to share it with friends. A lot of people appreciate it now, which is satisfying, but not why I do it. And it's not about money — I'm not wealthy or well off. I just feel this is the right thing to do.

How would you define beauty?

Beauty is the divinity inside all of us. We have to tap into it and connect with each other. The Hollywood and media distortion of beauty is an aberration. It's my duty as a fine art Photographer to stay focused on beauty, to find and share simple beauty in simple objects.

When songwriters write, they never think in terms of how much money they are going to make, how many copies of the CD they are going to make, what kind of awards they are going to win. They just write because they have to. That is the way I feel about Photography. Poets do it with Poetry, Painters with Painting, Musicians with Music. I do it with Photography.

What elements are necessary for a successful photograph?

A photograph has to have impact. It has to stop the viewer. This is a difficult task because people are impatient these days. A photograph that is successful has a storytelling aspect. It requires attention to detail and spontaneity. I pay a lot of attention to design and lighting. If I stop the viewer for even five seconds, the photograph is working. I often consider what it is about a particular photograph or painting that stopped me. The answer is in the art I'm connecting to. That's what's so important.

What drew you to the USA at 17?

I was always drawn to the US If there was a past life, I must have lived it here. When I arrived, I went to California and I felt right at home immediately. It wasn't about money or glamour. It was something I can't define. I am grateful to be here.

Was there a particular moment when you realized you had to be a Photographer?

When I came to the United States I wanted to be a geologist. I was fascinated with landscapes, but didn't know how to channel that interest. I took a geology course and it bored me. So I started taking art courses. The teachers coached and encouraged me. Without them my life would not be the same. My last elective in college was a Photography course, and it was love at first sight. It was a perfect fit, and I feel very fortunate because I didn't have to search for that for years. I was fascinated with my father's photographs growing up, and I was always a visual person. But I did not know I'd be a Photographer. I'm so glad I am.

What was your first big break as a professional Photographer?

I don't think I had one. I bought a camera and learned all I could about it. When I started out, I was shooting a lot a products. We do a lot of things we don't really love to do in the beginning. It was paying my bills and it was a difficult position to leave. It also taught me discipline and patience. And lighting. I had to make the subject look three dimensional and more interesting. It was an important lesson. That was the positive part — the learning process — taking my time and doing it right.

You consistently speak to students and artists at educational events. Is there anything in particular you wish you'd been told when you were just starting out? Anything you like to share with students?

Some of the Photographers I really admired were unapproachable; they had lists of assistants. Most of them didn't teach. I wasn't really told anything. You don't have to be told. I just stayed true to my commitment. When I was at San Francisco State, I took a Photography course with a bunch of students who hated my work. I dreaded the critiques. My photographs were colorful and crisp. They were of beautiful things. That was not fashionable. I didn't let their comments derail me. My conviction and commitment were much stronger.

I tell students to enjoy the process; it's leading to something good. It just gets better and better if you pay attention. Don't get influenced or discouraged. And don't listen too much to the negative talk in your brain — we have our own prejudices. Listen to where the truth is within; that's where the source of creativity is. Everything emits from that point. As a good friend of mine puts it, 'Leap and a net will appear.' And passion is, of course, the essential ingredient.

Why do you give back?

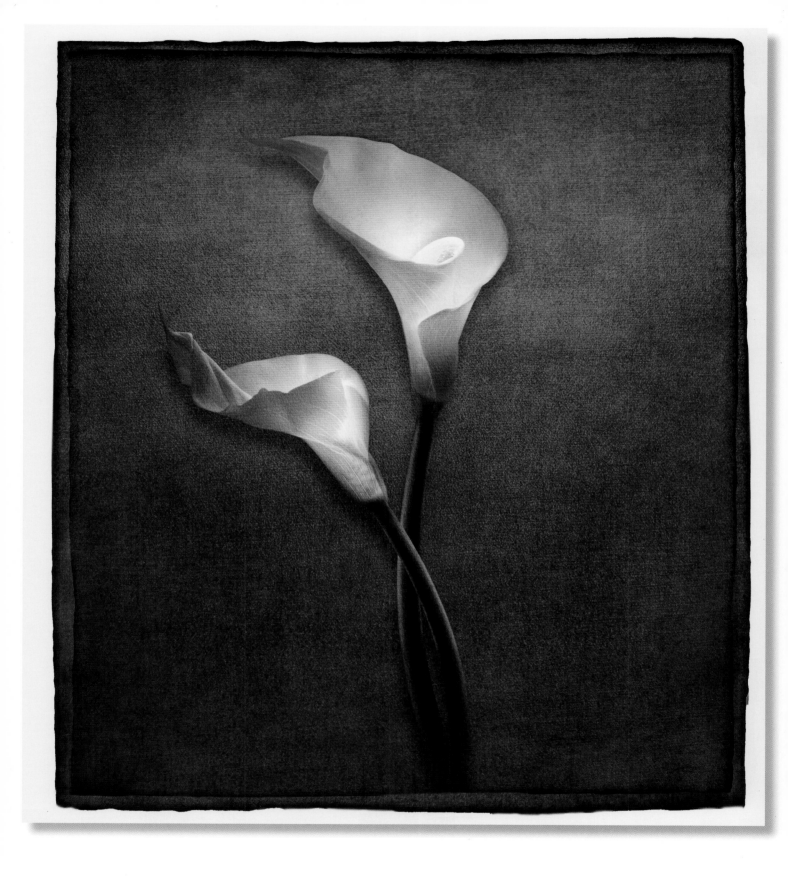

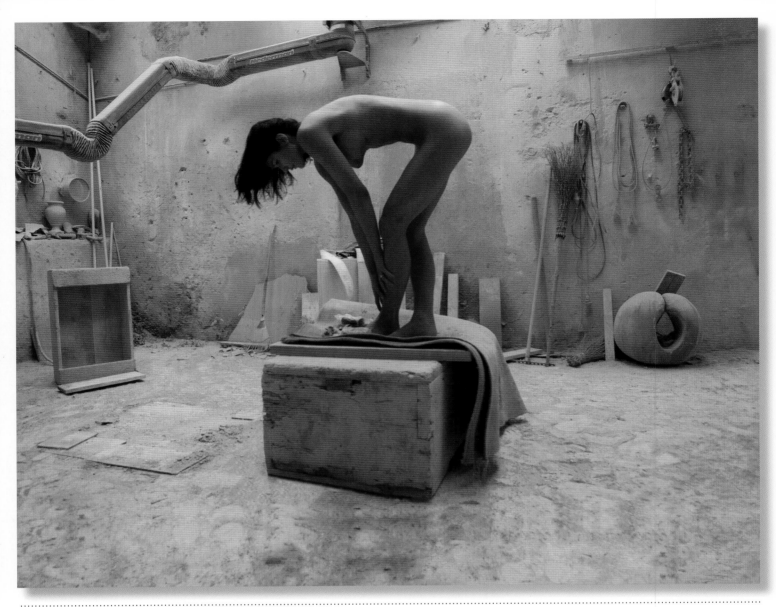

"Parish is one of the most genuine, unassuming and talented people I have ever met. His loving, fun personality and simpatico are only surpassed by his artistry."

Joanne Truffelman, *Chairman, TG Madison*

"I really work with Parish because of his cappuccino. He's meticulous about how he prepares it, serves it and appreciates it. And although the process to make the drink is standard, somehow his outcome is always leaps and bounds beyond anybody else's. The same applies to his work. It's perfect, beautiful, and timeless, and can only be made by him. He's an absolute joy to work with and I'm proud to call Parish my friend."

Brett Player, *President/Creative Director, Play, a VTA Company*

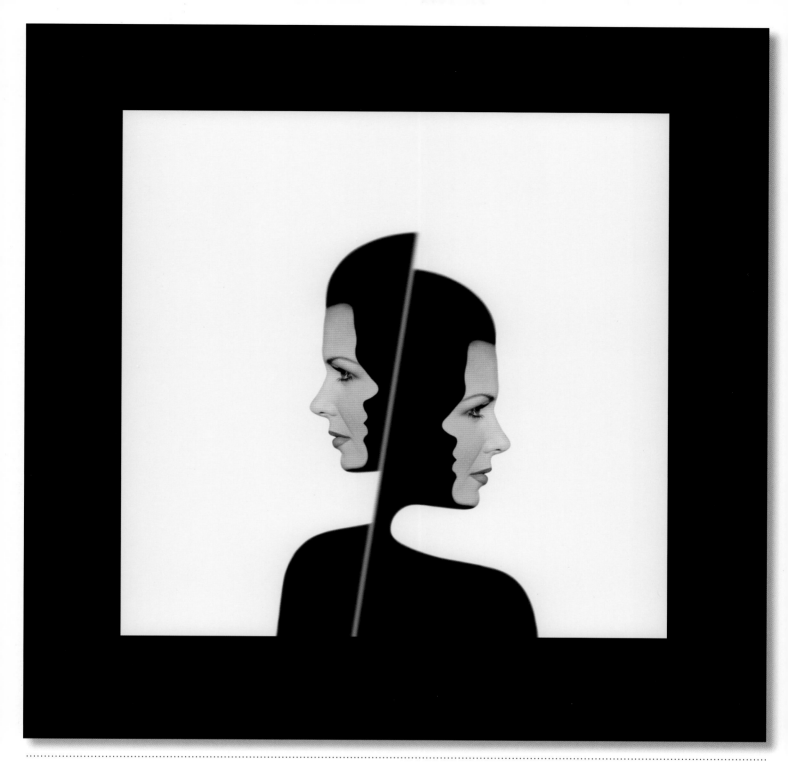

I feel obligated; we all have a responsibility to nourish the upcoming artists. And I enjoy the energy of committed students. An intern recently walked into my studio. He was interested in taking one of my seminars. My studio manager said he had a special personality and I should see him. He adopted us and we've adopted him — it's been wonderful. He brings in vitality and inspiration, and he's like a sponge. He's a mature, dedicated person, and he loves Photography. I love sharing my knowledge. I think everybody should.

Is it true you visited the Avedon studio and were told to stick to tv?
One of my greatest desires was to go to New York and work for Richard Avedon. When I went to his studio, his studio manager looked at my portfolio (which had taken me two or three years to put together) for a few split seconds, critiqued it in a very negative way, and told me that this was not the way fashion Photography was shot. He told me, 'There's not much of a future for you in Photography.' In retrospect, I know rules are to be broken, but back then I was devastated. Ultimately, I realized, this is only one person's opinion. Focus and go after what you love. My work was mostly self-taught; I waited tables to put myself through San Francisco State, and I didn't have the money for Photography school. I never waivered in my love for Photography, though. I had a second bedroom in my house in San Francisco, and I taught myself a lot — studied the work of several Photographers, trying to figure out how they did it all. I would never really copy them; I would just want to see, okay, why is this photograph so impactful? I would analyze their work and try to do it myself and put a twist on it — do it my way. And that's what I like to tell a lot of the young students, because people can tell you a lot of different ways to do what you really love, but the only way you can really do it is your own. It's the right way for you.

Are there passions you pursue besides Photography?
I have no life [laughs].

I hear you're a cook. Is that correct?
I love to cook. There's a common denominator between cooking and Photography: starting with ingredients and making something you can really enjoy. I also like nature, being outdoors. I have non-stop admiration for the glory that is all around us. I'm in Santa Monica, where there are beautiful, flowering trees. I stop and pay attention. I grasp the energy from that beautiful tree, or that flower — whatever it is that stops me. I enjoy this quote: 'There are two Zen masters in my life, and they are my cats.' There is so much in this world to appreciate, so much that is so simple, so pure.

If you were to retire tomorrow, what would you do with your time?
I tell my wife, when I die, make sure I have a camera around my neck before you cremate me [laughs]. If I reach 90, I'll still be compelled to photograph because that's the way I document beauty and feel the moments that are special to me.

Who are your favorite Photographers?
I have favorites in many art forms. Van Gogh, Vermeer, Rembrandt, the list goes on — Frank Gehry, Santiago Calatrava. Photographers? Diego Uchitel, Irving Penn. They have stayed true to their message, and though the imagery is changing and their messages are changing, the essence is still there — it's their signature, their voice, their style. Their energy is essential. You have to stop and pay attention, because the energy is living within; it is connecting with your spirit. That's the connection that makes art work.

As a result of your success, you've been approached by and are now affiliated with some very well-respected companies, including Canon. Recently, you also joined the advisory board for Apple's new software, Aperture. Please tell us about your involvement.
I have been one of 53 Photographers worldwide formally involved with Canon for over fourteen years. Honorably and thankfully! They got me

involved in their Print Master program, focusing my experience in fine art printing on their wide format printers. As a result, at one point, there was a large show of my photographs, and a guy there from Apple asked if I'd like to join them in developing new software. I said I'd love to, and that software has simplified my life. It was the first of its kind to help me organize my files with ease. The less time I spend at my computer, the more active I am. Both of these relationships have been interesting and satisfying. And I'm proud to say I believe in the products. If I don't believe in something, I don't get involved.

Apple put together a terrific piece about you on their website (www. apple.com) a couple of months ago.

I was honored. I got so many responses from people wanting to see more of my work. It allowed my work to connect with so many people who had in some sense stopped and paid attention. Once again, it's all about connection. It is essential to me. It goes without saying that I am delighted to have my work in *Graphis*. I admire your publications. And this has been a pleasure.

Interview by Anna Carnick / Contributing Editor Caroline Hightower

Biography: Parish Kohanim's passion for and commitment to Photography have been the fundamental focus of his career for the last three decades. Winner of many national and international awards, he has built a reputation on stunning color and black and white imagery. Since 1994, he has been honored to be a member of the Canon "Explorers of Light," an internationally respected mentoring program, which includes only about 60 of the world's top Photographers. He was also recently invited to join an elite group of artists as a Canon Print Master, and is on the advisory board of Apple Computers for their new software, Aperture. The Parish Kohanim Fine Art Gallery made its debut in Atlanta in 2003, fulfilling a lifelong dream for the artist. Here, he continues to challenge and reinvent himself through his art, imagination and love of beauty. For more information on Parish Kohanim, please visit www.parishkohanim.com.

Images: page18, Swirl, page19, Parish Portrait photographed by Vered Koshland, page20, Cala Lily, page21, Nude Study in Artistic Space, page22, Single Split, page23, Introspection Study 1, page24, Coleen Queen, page25, Stephan Gula.

**"His person and his view of life are as beautiful as his Photography.
He is a great friend."**

Richard MacDonald, *Sculptor*

Q&A with Hugh Kretschmer

At 13, Hugh Kretschmer was given a Pentax SLR, and a lifelong passion was born. Describing himself as a Photo-Illustrator, this L.A.-based artist's work is at times surreal, occasionally shocking, and always clever, often bridging the gap between fine art and commercial work. Kretschmer says that pursuing his passion was not always easy, and there were times he struggled even to find enough change for food. Below, Kretschmer reveals what sustained him, the moment when he first felt like a whole artist, and what he loves most about Photography.

I understand your father introduced you to Photography. He was an engineer for McDonnel-Douglas, photographing and filming rocket launches for NASA. Can you describe what it was like growing up with this access? When did you take your first photograph? What was the first camera you ever used?

When I was thirteen my father gave me a Pentax SLR and a few lenses and invited me into his darkroom, which was a converted, cinder block bomb shelter outside our house. There he took one of my negatives and showed me how to make a black and white print from it. The magic started the very moment that image began to appear in the developer and has not waned since.

As far as Dad's work is concerned, I thought it pretty geeky until about my late teens, when I realized how important his contribution to space travel really was. At that point I couldn't get enough, and we would get together in his office to rehash the glory days of the Apollo missions, chasing solar eclipses in air force jets or slowing movement in rocket engines with ultra high-speed cameras. I mean, this guy supervised work on the very first retrievable capsule that was sent into space and safely brought its payload back to Earth — a motion picture camera. It photographed a weather balloon reaching the outer Earth's atmosphere and bursting. The next day, *The New York Times* published a three-image sequence of the event on the cover with his name underneath it. The accompanying article heralded the event as a success and the crucial first step in sending a man into space. Eleven years later he sat us all down in the living room to watch Neil Armstrong take his first step on the moon. My dad did his best to hide his tears, but I knew what they were about.

Who were your other creative influences growing up?

I had one book by Jerry Uelsmann that my dad gave me as a gift. I remember being mesmerized by the Photography and wondered how he assembled his montages so seamlessly. His work proved to me there was no limit to realizing my imagination, and set the bar as far as I was concerned. I still have that book, and while living in New York I had the opportunity to hear him speak at a convention. He was quite a bit grayer than his picture on the back cover, but he was still holding true to his technique, despite the advances of digital imaging. Afterward, I sent him some prints of my work and a letter telling him what an impression his work had made on my career. I included his book, which I asked him to sign. He not only replied with kind words and a signature, but with a copy of his most recent book. I store that first book in archival plastic.

After graduating from Art Center College of Design, you did commercial and reportage work and became a finalist for an elite National Geographic *internship. How did you make the transition to your current photographic style? Did the earlier work benefit your current projects?*

When I graduated from Art Center I wanted to do illustrative still-life, but found myself only landing very straight-forward assignments. It seemed there wasn't really a market for what I wanted to do. The way I was shooting things wasn't creatively satisfying. I quickly realized I was shooting what I thought everyone else wanted me to shoot, and that wasn't working personally or professionally. This was the first juncture of my career, requiring me to re-evaluate what I really wanted to do. Having some success in school with Photojournalism, I decided to give it a try by traveling to Asia for three months. It was a very fulfilling experience on many different levels, and I liked what I did there. I put a boundary on my decision when trying for the internship — if I didn't make it, I would go back to what I was really trained to do, commercial still-life — this time, however, with a different philosophy: shoot what you love.

I did a little soul searching, realized I had a passion for early 20th century art and began experimenting with assemblage and collage coupled with graphite and airbrush on a large light table. The technique evolved into a portfolio of images like no one had ever seen before. The pictures were derivatives of the Cubist, Dadaist, Constructivist, and Bauhaus movements, but with modern themes and related iconography. This was the launching point of my career and the first time I felt like a *whole artist*.

But you continued to face challenges?

On the flip side, I had a lot of questions and fears about the work and its applicability in the marketplace. Yes, it was freeing creatively, but could I earn a living shooting this way? I was taking a huge gamble, spending a lot of money and time with no guarantees. Although there was a lot of positive interest from Art Directors from the outset, no one quite knew how to apply the work to a project, and for quite a while there were no jobs, eventually forcing me to use the spare change I had stored in a novelty liquor bottle just to eat.

Around that time, three jobs came in from Designers who wanted to work with me. They had no idea how to art direct me, so instead, they gave me a few descriptive words and a lot of faith. The resulting images were very successful and are some of my favorites. Those projects led to others and things took off for me professionally, eventually getting to the point where I could not keep up with the demand, and I found myself being asked to repeat things I'd done before, simply because of the nature of the market and types of clients who could use conceptual, cubistic still life. That led to another re-invention, as I transitioned from solely shooting objects to incorporating people and environments into my images. This required a pretty drastic shift from the cubistic influences of my past. I created a large personal series called *Gastronopolis*, about a beautiful alien woman who, after trying various ways of assimilating upon her arrival to Manhattan, realizes what she really wants is to eat the city to sate her needs. This series formed the new basis for my portfolio direction and allowed me to start working with a much more diverse range of clients than I had before. Even though I moved away from cubistic-styled work, I think my photographs still carry an undercurrent of my early influences.

Where do you think your best ideas come from? And how long do you generally mull an idea over before execution? Days, weeks, months?

I cannot possibly pinpoint a particular event or sighting that stemmed a successful idea, but when I am feeling stuck, the best place for me to go to is a museum. I experience a recharging there and am often very quiet afterward and in my head. I don't usually carry a sketch book when I go, but do have one close at hand at any given time, generally. It is filled with ideas for future photographs, and the best ones eventually get on film, time and money permitting. At this point there is a backlog, and many have only been in the sketch phase for years now.

How would you describe your style as a Photographer?

I think Photo-Illustrator better describes the genre of Photography I do. I have a hard time describing my style because I am perhaps too close to it and cannot see it for what it is. So, I will talk about what I do, if you don't mind. I love my job because for the most part my clients come to me to solve their visual problems. It is challenging and satisfying at the same time because the onus is on me to find the right solution, but so rewarding when it is successful. My work is concept driven, and the finished photo *has* to say something beyond its surface of composition and light and tell a story. I like to describe it as an additional layer that invites participation from my audience.

Your photographs are not limited to any one look or feel. They're sometimes playful, sometimes dark, and very often dreamlike. How do you maintain this range?

I was fortunate enough to learn early in my career that sticking to one particular style or look was a slow death, creatively as well as financially. It was not how I envisioned my career path, and of all the things I changed, the most profound was my philosophy — not to be married to a particular style, but to find the appropriate solution to the visual problem. It felt like I was treating my subject with more respect instead of forcing it into a place where it doesn't necessarily fit.

My sensibilities connect the images together. I like humor, I appreciate surrealism and I'm attracted to ugly. It's also all the little subtleties — lighting, color choices, and mood — that seem to be consistent and are the common threads. I also see my work going through phases or periods. Right now I am experiencing a desire to shoot images with human body parts in them. It sounds a little Jeffrey Dahmer, but I think I have been treating the images lightly, and as a result, they are more palpable than gross. It feels like I just have to get it out of my head, into my sketch book and on to film. The sooner the better.

What drives your work — the joy of experimentation or creation, the story you're trying to tell, etc.? What is your creative philosophy?

What drives me is the next project. I notice I get very excited — a little gleam in my eye — when the call comes in. I think it is because the project offers hope for new possibilities.

Please describe how you create images. What's your process?
Most of my work is editorial based, and I illustrate fiction and nonfiction stories. The way the assignment unfolds is I am first presented with a manuscript of the article and asked to come up with an opening image. Sometimes the Art Directors have an idea or two of what they want, but mostly they are looking for my take on it. I will present a written or verbal description of my idea first and see how they respond to it. This gives the Art Director an opportunity to add his comments or suggestions before I go to a drawing. The sketch is the most important element of my process because it becomes my blueprint for executing the photograph. I labor over the sketch phase because I'm doing much more than just conceptualizing. Most importantly, I am planning the elements and their relationship to each other, but also designing the set and plotting my lighting.
I especially like building the props and sets and creating the mood and feeling. If I am in the midst of building a prop, let's say, I can't rest until that last detail is addressed and what I envisioned is complete. There is a lot of satisfaction seeing the outcome when the photograph works well.

What elements determine a successful photograph?
I like to put it this way: if I am looking at a particular illustration and find myself staring, it is successful to me. That said, there is no one element that determines a successful photograph, but a combination of elements. Beyond the choice of light, balanced composition, enhancing set and propping is the idea itself. It is best for me to tell a story with a photograph and add something more. It becomes that much more engaging for my audience. At least that is what I strive for.

What part of your work do you find most demanding?
Keeping up with the ever-changing technology. I started my career at a very different time and still employ very tactile techniques that someone else can most likely pump out in a few hours using digital means. I am grateful to have developed my career when I did because I now have more options at my disposal than others who only know Photoshop.

What technology do you use to capture your images?
I am still going between film and digital capture, but would really like to finalize the jump. I think it has finally arrived, and I do see the advantages of shooting digitally. I told myself that when a captured file is as good as one of my scanned 4x5s, then I would embrace it. Well, now it's here and it is going to stay.

Photography has always been a hands-on medium of expression. How does digital technology change the relationship of the Photographer to the act of image-making?
That is a tough question because it really depends on the Photographer. I was recently shown some images done by a young, up-and-coming Photographer who basically constructed his images digitally. Very little shutter pushing was used in his work. It was hard to see where the Photography existed in his pictures, but this is how he thinks. He obviously uses the tools he knows and uses them quite well. That, to him, *is* hands-on. For me, however, hands-on is just that in my work. I strive for it and try to come up with a more analogue approach, even knowing a digital solution exists. There is something inherently tactile and hand-crafted to my work that still is unobtainable by digital means.

Who is the best Art Director you've worked for and why?
That is hard to say because there have been many with their own style and approach that match my sensibilities. A successful collaboration is based on mutual respect for each other and the assignment. I work best and the results turn out best when I have asked enough of the right questions to get the information I need to proceed, and the Art Director feels comfortable enough to let me go and do my thing. I cannot pick one Art Director, but there are some notables from very early on:

Designer Larry Vigon, Lou DiLorenzo from *Travel Holiday* who I worked with in 1997, Fred Woodward from *GQ* and John Korpics when he was at *Esquire*. I also owe a great debt of gratitude to Laura Zavets from *Bloomberg Wealth Manager Magazine.* We worked on many great assignments together, most of which I still love to show off.

Please describe your Boxing Gloves *photo (see left and on page 217). What was the inspiration? How was it executed?*
I have a love/hate relationship with boxing. I think it is a primal and brutal sport, yet I've done multiple series around it. On some level I am attracted to it, and this shot is my latest contribution. It began as a 'what if' question: What if hands were the gloves? After sketching it out and plotting an approach, I felt it could work. I wanted a rundown locker room setting, and built the set using antique fixtures, lots of spackle, paint and grime. I reconfigured shoe eyelets so that they could be applied to my skin. Yes, they are my hands. My make-up artist, Jane Choi, shaved my hands and forearms and applied the eyelets with spirit gum. She used 'dirty' make-up to give them an aged appearance, and my assistant photographed them in the set with a 4x5 camera and low contrast, color negative film. The light at this stage had to have a closer ratio due to increasing contrast throughout the process. I made enlarged prints on low contrast, type C paper and sized the hands to match the approximate dimensions of real boxing gloves. An extra set of prints were made of a skin texture that I used later. Back in the studio, I mounted the hand prints to poster board and carefully cut the outer edges of the hand and the center of the eyelets out. Cutting into the print to make the glove opening was tricky because I had to cut along a two dimensional plane and make it look 3D. I had to do the same with the skin texture print, as it was going to be the interior of the glove and the upper edge of the opening. I glued this piece on the outer edge on the backside of the glove print with the skin texture facing the camera, and carefully matched the edges of the two prints together. Then I attached the other end, letting the paper's natural tendency to lie flat help shape the cavity of the inside of the glove. It took a few tries to get the edges to flow together and look believable. I finished the illusion by actually lacing each print with glove laces. I mounted the assemblages to the back wall of the set, then positioned and styled the lace ends. I followed the same lighting direction and quality as used when we originally shot my hands and finished dressing the set. Again, I shot it with low contrast, 4x5 color negative film, then had high res scans made. The final file required very little retouching.

Please tell us about the Botox series. Where did the series come from? Who was the client and what was the message? How did you achieve the Stepford Wives aesthetic so seamlessly?
This was a story for *Health Magazine,* and it was just about when Botox was making it big here in the States. People were throwing these parties where they would invite a doctor friend or someone who knew how to administer a dose by injection, and a bunch of their friends. The Art Director wanted to play on the Tupperware Party phenomenon of the '50s and '60s by dressing up the characters and sets in period costumes and furnishings. We worked out a four-image sequence that started with the women at the party being presented the night's treats as the opener and ended with the central character looking into a hand mirror as she turns into a mannequin.
I worked closely with my wife, Christina, who styled for me. We collaborated on every detail, from the broaches to the ashtray. I wanted to make the central character stand out from the rest of the girls, so we found a pink dress for her while the others were dressed in greens and teals. I also wanted the set to be of the same overall color, and was able to find enough furniture and a wallpaper in that palate. The last prop to find was a mannequin that looked like the central character, and Christina just happened to find it. It was the only mannequin that was in good shape at this particular prop house, and it couldn't have been a better fit. I took one look at it and knew it was going to be a successful shoot.

"So much of Hugh's strength is in his ability to go beyond. You give him a starting point and he keeps going, coming up with solutions beyond our own imaginations. I know a Hugh picture immediately on sight. He's got a signature style, and he's just a great thinker."

Dora Somosi, *Director of Photography, GQ*

"What I love about Hugh's work is its conceptual edge.
He doesn't rely on a look or style; he uses Photography to tell a story or provoke a thought.
It doesn't hurt that his execution is flawless."

Nancy Mazzei, *Creative Director, VH1*

My greatest challenge, however, was to have the five girls' make-up and hair done in four hours with one hair stylist, Mili Simon, and one make-up artist, Robert Moulton. Not easy! That morning, you could smell the hairspray down the hall, there was so much of it. The last detail was the wig that the main character wore that would eventually be transferred to the mannequin in the last shot. With everyone finally ready, I gathered them round and directed them on how they were to act — stoic, expressionless, affected. Since most of them were actors, it wasn't much of a reach, and they clearly got into their characters.

I think my favorites are A Walk in the Park *and* Curious Sight. *Would you please describe these photographs as well?*

A Walk in the Park was one in a series of images for *Bloomberg Wealth Management Magazine* illustrating a story on current hedge funds. The Art Director, Laura Zavets, asked me to come up with five scenarios relating to fashion that involved actual hedges. My take was to create a feeling of 1940s film throughout the series by shooting it in black and white, using artificial lighting to accent, and dressing the characters in vintage clothing. A friend recommended the Ladew Topiary Gardens near Baltimore as the location, and I drove down from New York to scout it. This is one of the few times I had to depend on the location to come up with my concepts, but it was easy. There was a lot to work with there, and I was able to address several aspects of fashion and clothing in general. Back in New York, I went to work finding and creating the props. It was summer, and my wife and I spent a couple of weekends on the sun deck of our health club applying fake boxwood to a pair of trousers and a wire dress form. I had a prop maker make an oversized sewing needle, and I found a very large pair of sheers. The day of the shoot I was nervous because I had never done this type of location work before, nor shot five set-ups in one day. It was, however, one of my all-time favorite shoots. I remember it was really hot that day, and all of us were either assisting or posing in God-awful wool clothing. Models were on short supply, so

I even posed as a paparazzi.

Walk in the Park was the second shot of the day, and was derived from a group of topiary dogs that were part of a larger hunting scene. To camera right, out of frame, were two topiary riders on horseback jumping a fence, complete with top hat. On camera left was the fox running away from the mayhem. The clothing on my model was key because I wanted her to be primary and the dogs secondary. Christina found this amazing ensemble, complete with white fur collar and matching hat. I told the model I wanted confidence on the verge of aloofness, and to keep her face turned away from camera so we would not see her eyes. She nailed it and the results read perfectly, leading your eye to her first, then to the dogs, revealing only then that they are shrubs. I am very proud of this series and that it garnered top honors in its category at the Society of Publication Designers Awards that year.

Curious Sight was, again, part of a five-image series, and was my first fashion spread. Shot for *Los Angeles Magazine*'s 2007 Spring fashion issue, it is a visual story of two mannequins that are in search of something unknown to them, that is only realized when they finally meet. The series depicts certain events in real life where two people might stand or sit next to each other, but without any idea the other exists. It is only once something clicks inside that their desire for one another rises to the surface. In this scene, the characters are walking their toy dogs and are awestruck by the racy display in the window. They may be unaware of each other, but their dogs are not.

What are you working on now?

I am redirecting my efforts towards doing more Advertising work by shooting personal work geared for that market and promoting it. I don't think it is too far of a stretch to say I am going through a third transit in my career right now. I am also developing another fashion story and am in the midst of selling a book idea to a few publishers.

What do you love most about Photography?

That everyday it is something new — a new assignment, a new idea, a new challenge.

What is your greatest professional achievement?
Without a doubt, it was the *Gastronopolis* series I mentioned earlier. It was one of the most creatively satisfying and personally involved projects I have ever done. It was a total creation from start to finish, from the design of the costume to just about every prop I used. It took a year and just about every ounce of will and dollar I had to finish, but it was completely freeing.

Through the series, I was able to combine my love of sci-fi, art deco, and the incredible architecture of New York that enamored me upon my arrival there, and launch my career into a totally new direction.

What is your greatest personal achievement?
Being married to the same person for the last eleven years and fathering two gorgeous girls.

Besides Photography, what are you passionate about?
Well, my kids for one — that's a no brainer — but I also have a love for skiing. I'm learning guitar at the moment, but haven't gotten beyond the pain in my fingers to say I am passionate about it. And I just took my first surfing lesson last week and bruised a rib. I loved it, though, so maybe that qualifies. The deco design period is precious to me, and I get a chance to have it around me wherever I go through a deco watch collection I have. I love travel but don't do enough of it. I love being home but also like foreign countries. And art! I like seeing a painting in person that I have seen in history books forever. That's a turn on!

Do you collect photographs? What do you have on your walls?
No, actually I don't collect photographs. Christina and I have a few vintage posters and a small collection of Victorian book plates. Other than that, our daughters' artwork or portraits fill our walls. I have a few of my sister's sculptures here at home and in my studio.

Who are your favorite Photographers of all time?
Irving Penn has always been my most favorite, all-time, wanna-be-like-him Photographer. The breadth of his work reveals the talent he is.

Lately I have been looking at Gregory Crewdson's work and find it fascinating. He is able to describe so much in one shot. He reaches way below the surface of his characters, their interaction together and the scene around them, and forces his audience to ask the question, 'What is really going on here?'

Where do you think the best work is coming from today?
I don't know if Advertising is where the best work is coming from or more where I'm looking these days, but I have a new appreciation for it. There's some really clever stuff out there — especially from other countries.

Any final words on Photography?
I can't say enough about it. I love it, but am challenged by it at the same time. I love the process and I really love the outcome, especially when the shot works. On the other hand, it's difficult to constantly face new competitors for commercial work and daunting to keep up with the new technology I need to embrace. My word for myself lately is 'evolve,' and if I can keep that in mind, this next juncture in my career will be as rewarding as the last one.

Interview by Anna Carnick

Biography: Born in Santa Monica and currently living in L.A. with his wife and two daughters, Photographer Hugh Kretschmer earned a BFA from Art Center College of Design in Pasadena, California. His varied clients include Esquire, Health Magazine, Los Angeles Magazine, The New York Times Magazine, *FX Networks, VH1, Kohler, Sony and Teknion. He is the recipient of awards from* Communication Arts, HOW, Print, I.D., Photo District News *and* Graphis, *among many others. For more information, please visit www.sharpeonline.com and www.bransch.net. Images: page26, Carnage Begins, page27, Kretschmer and his daughter photographed by Nico Pevy, page28, Placebo, page29, Boxer, page30, Injection, page31, Boxing Gloves, page32, Curious Sight, page33, A Walk In The Park.*

Since 1944, Graphis has been a beacon for outstanding work in the international visual arts community. With the introduction of the Annuals, each piece selected for inclusion was always considered an award winner. This year, we further recognize any piece that is included in the Annuals as a Gold Award winner, with accompanying certificates and trophies. We congratulate and thank each and every one of our talented contributors for the amazing work we continue to see every year, and proudly present you with this year's Graphis Photography Annual winners.

Award photograph by Phil Marco

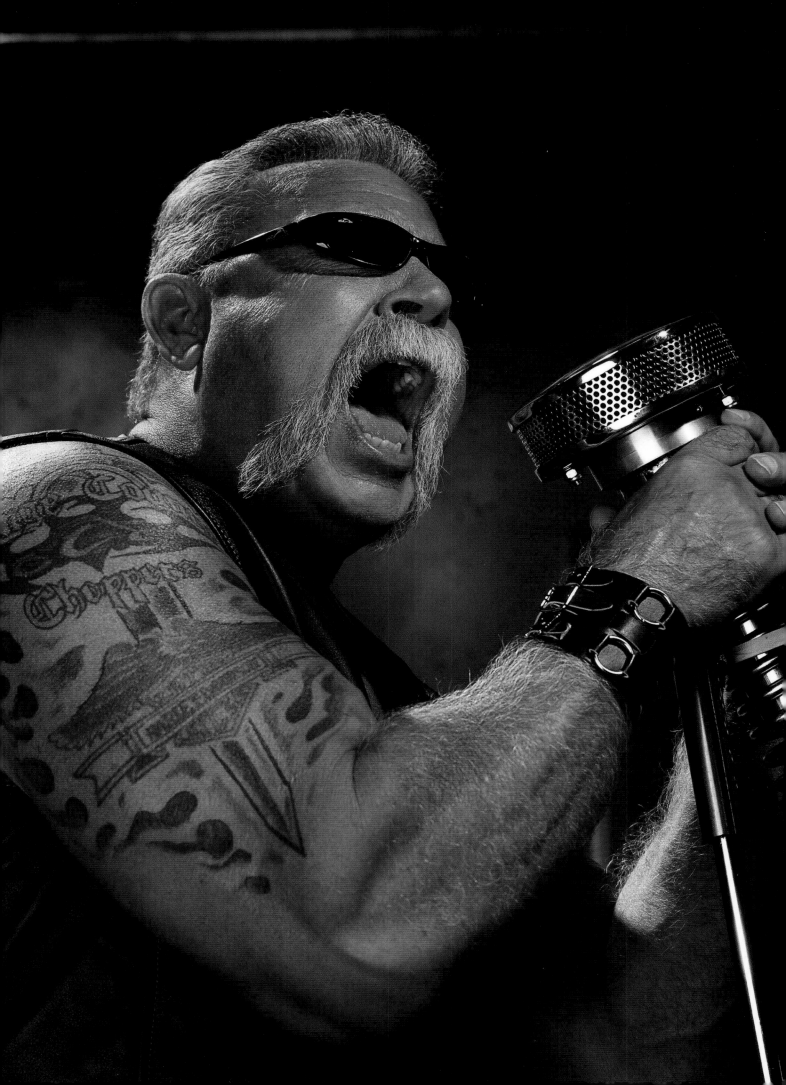

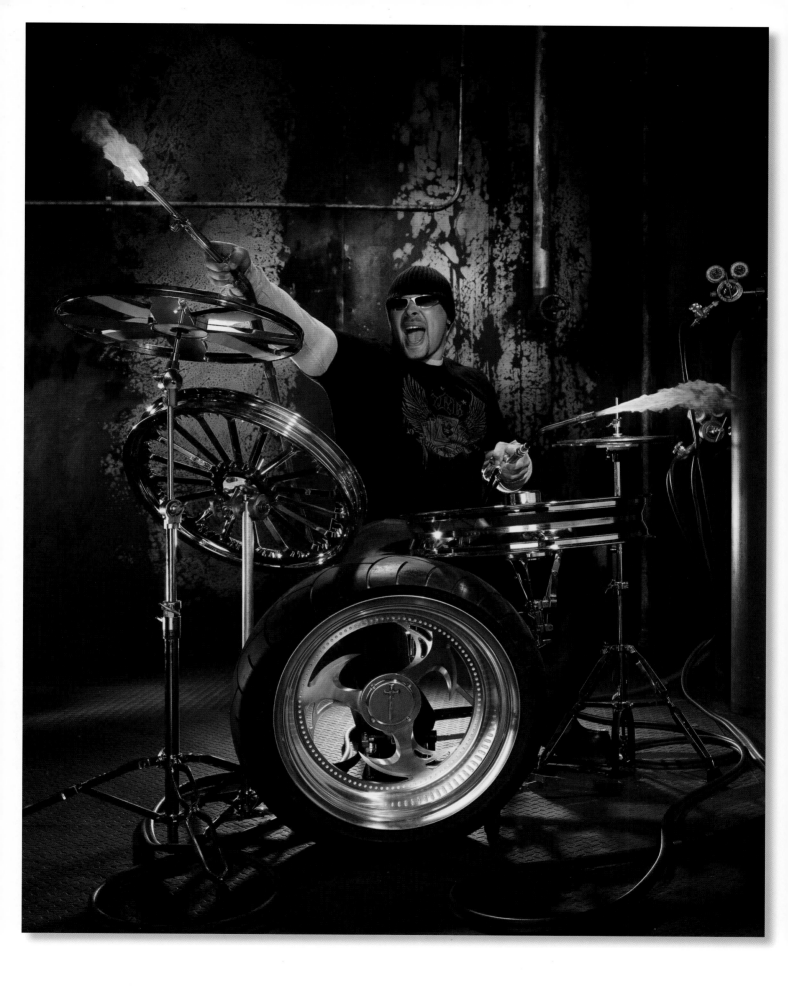

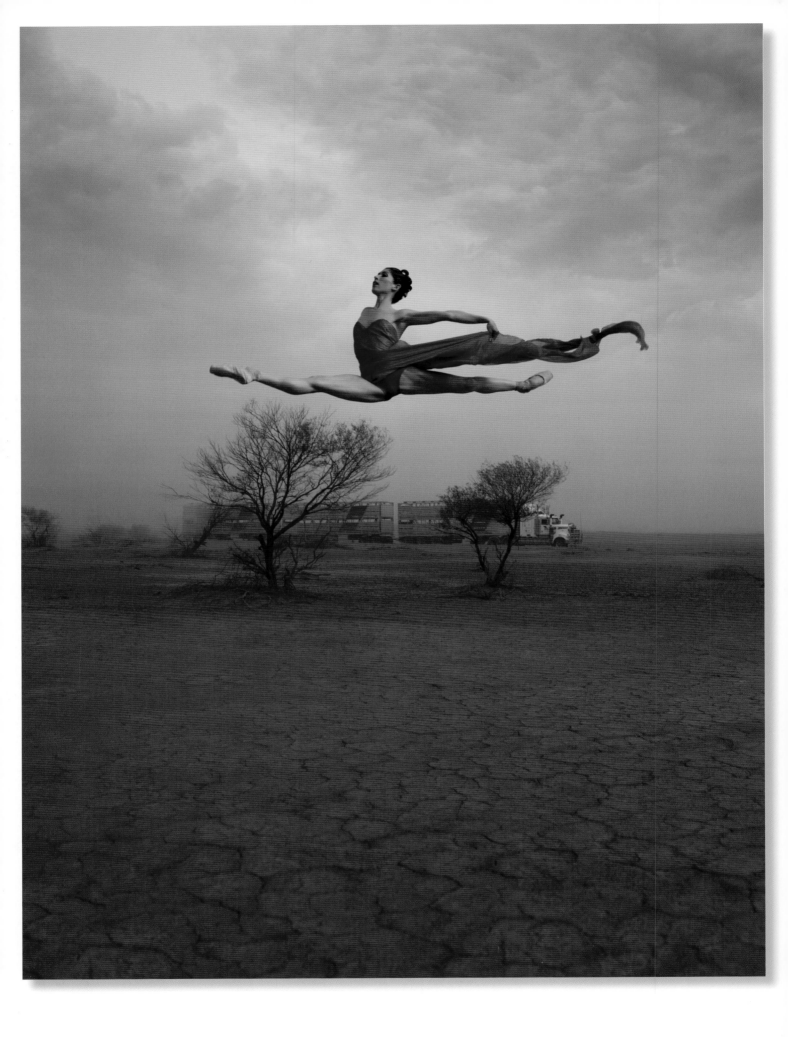

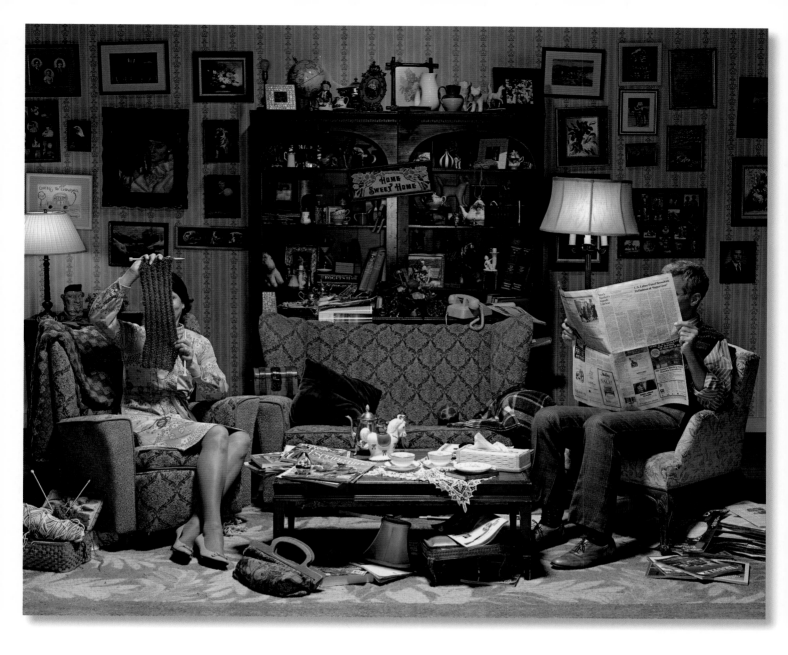

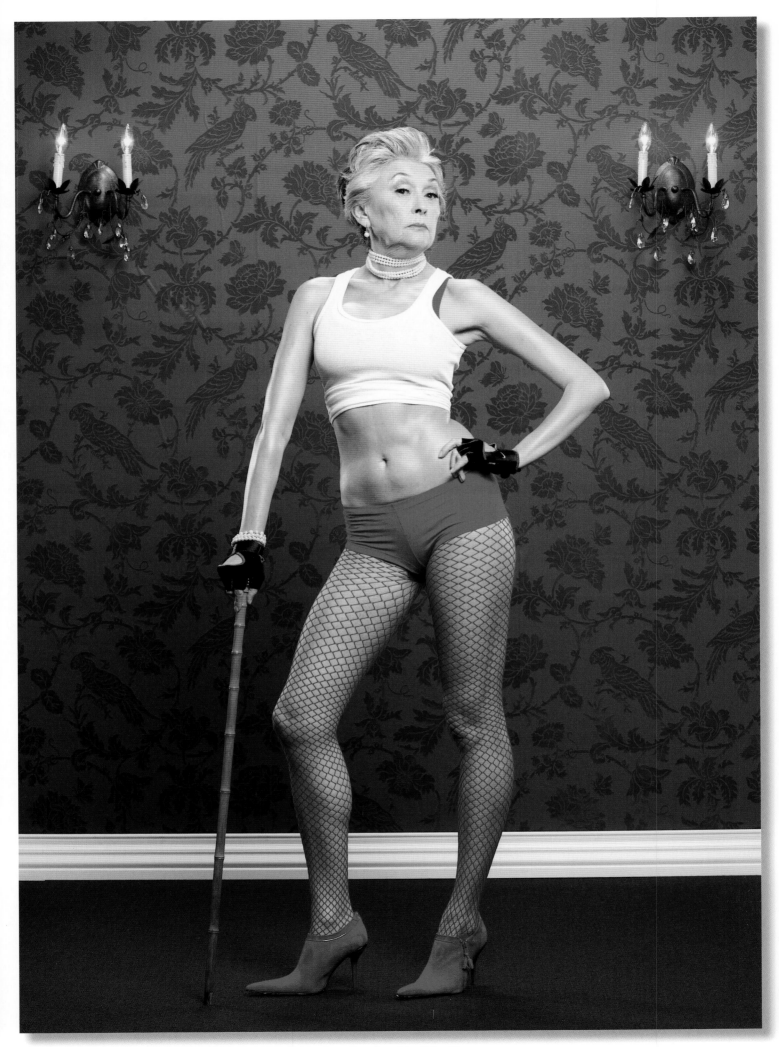

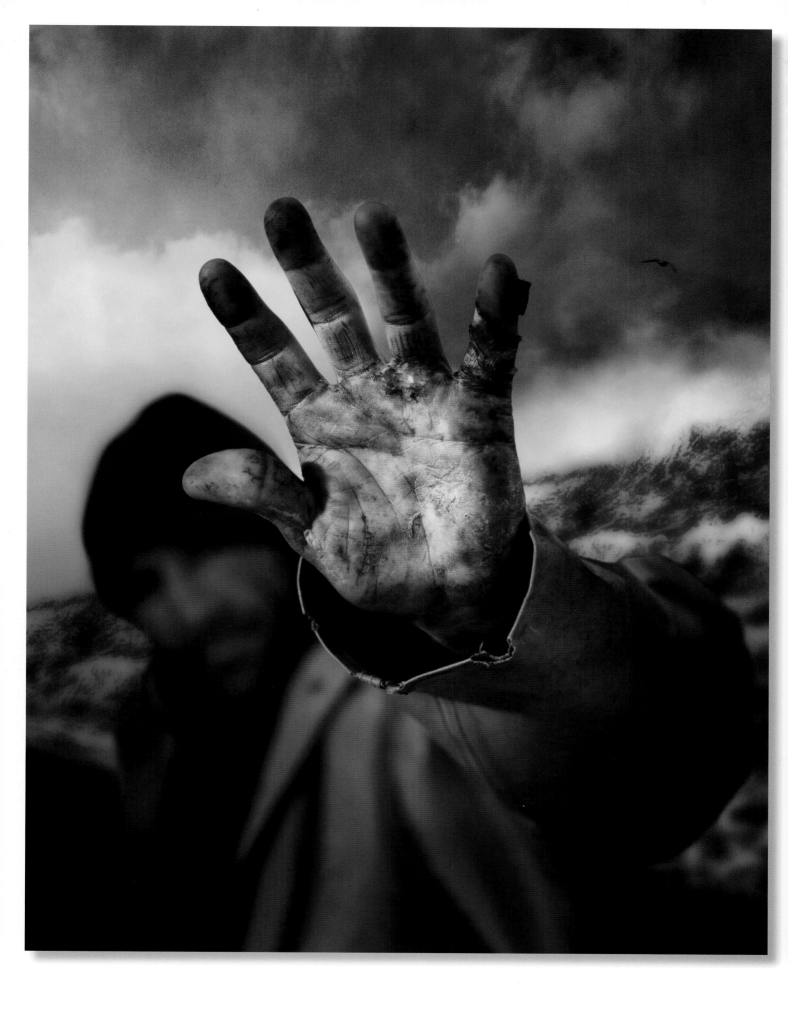

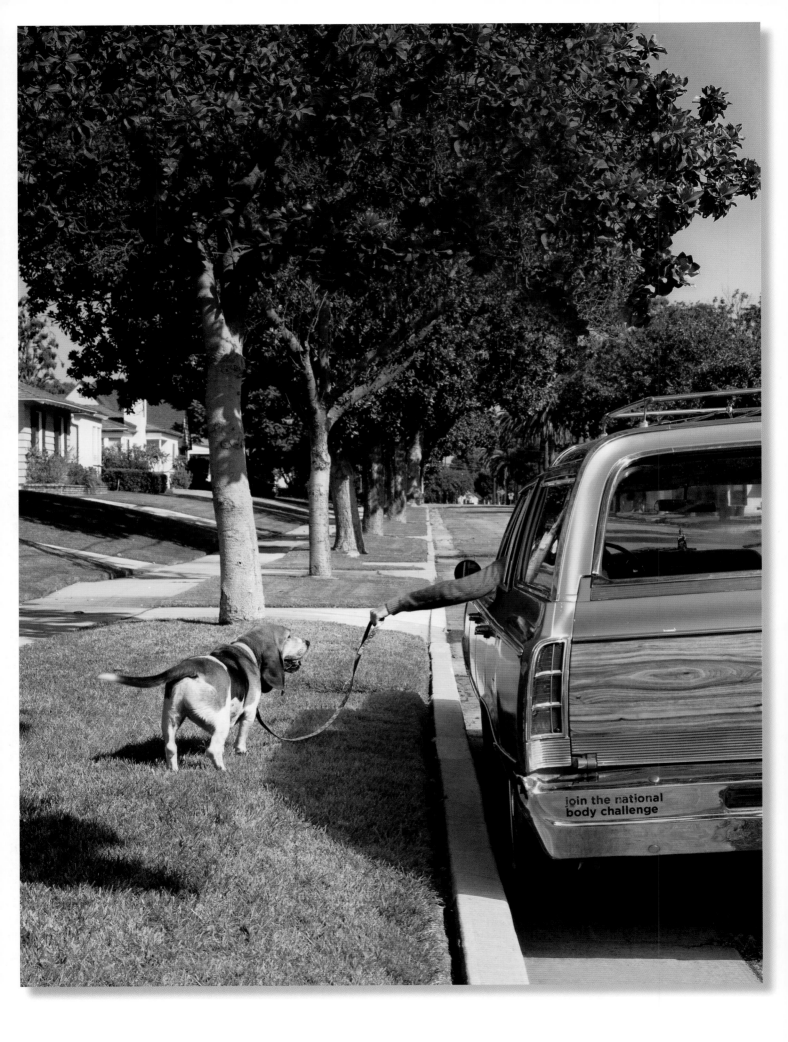

join the national
body challenge

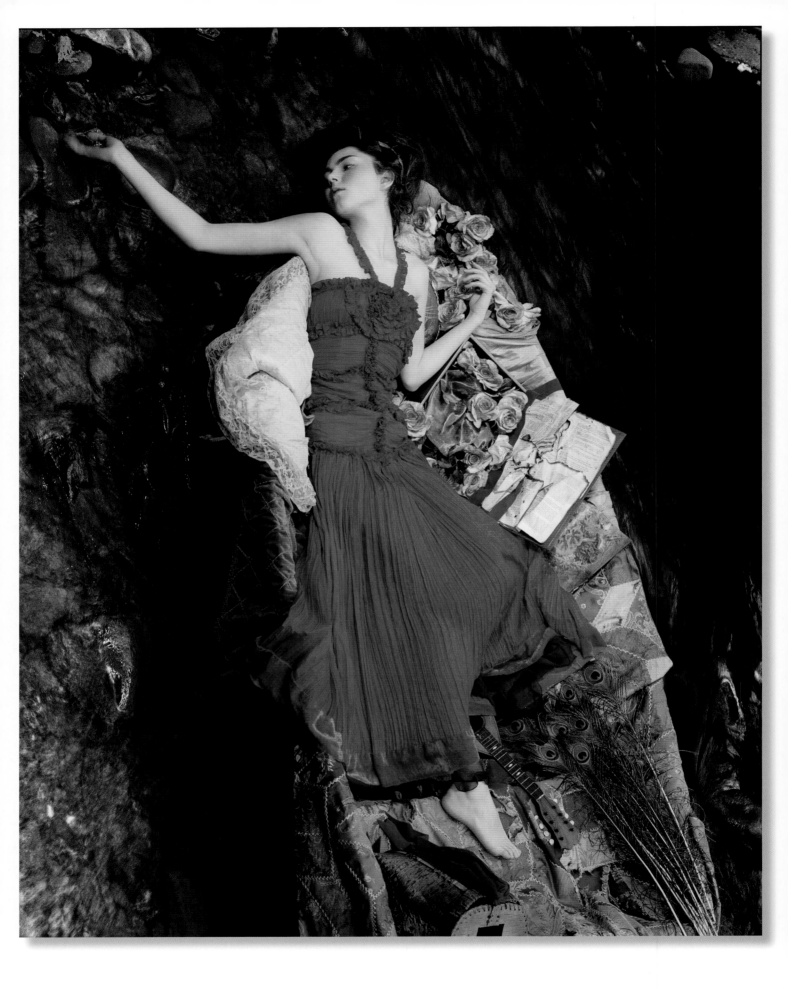

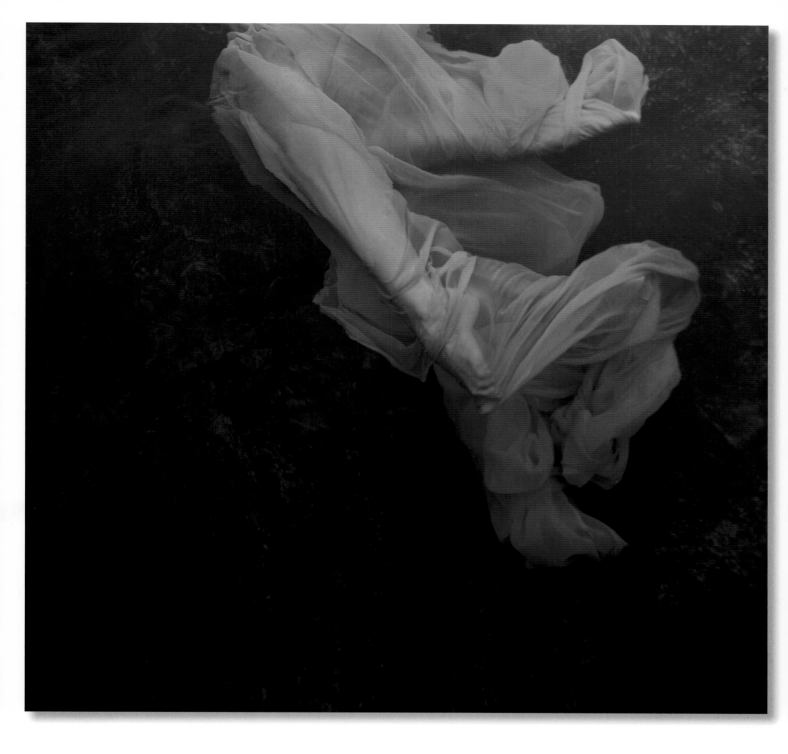

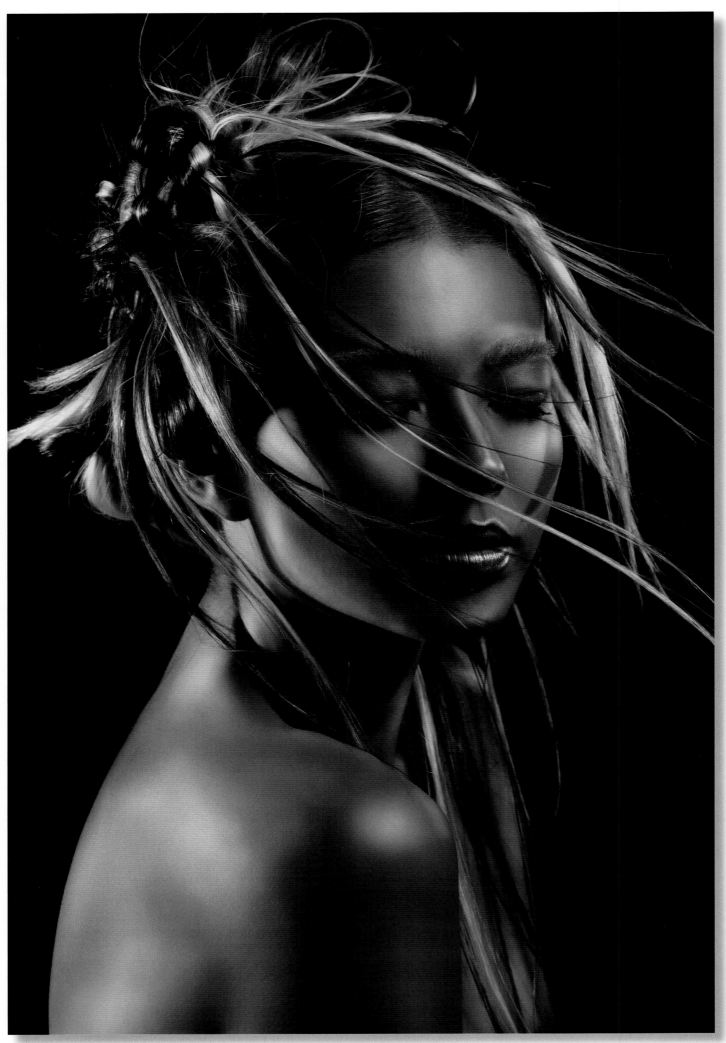

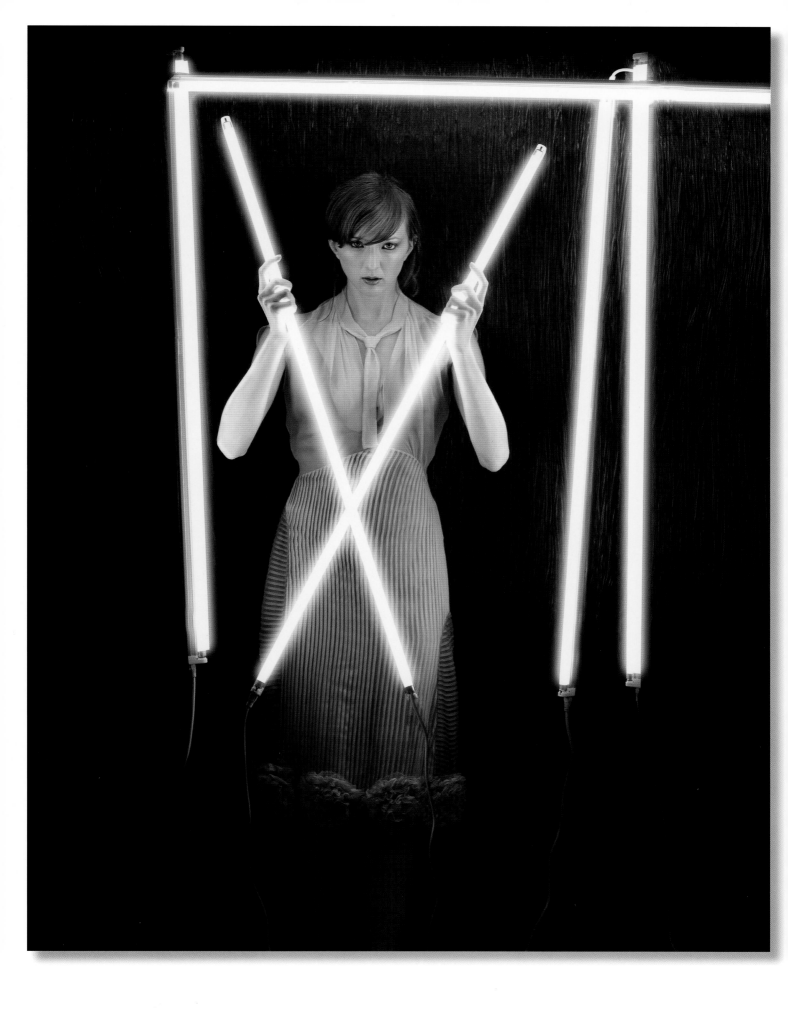

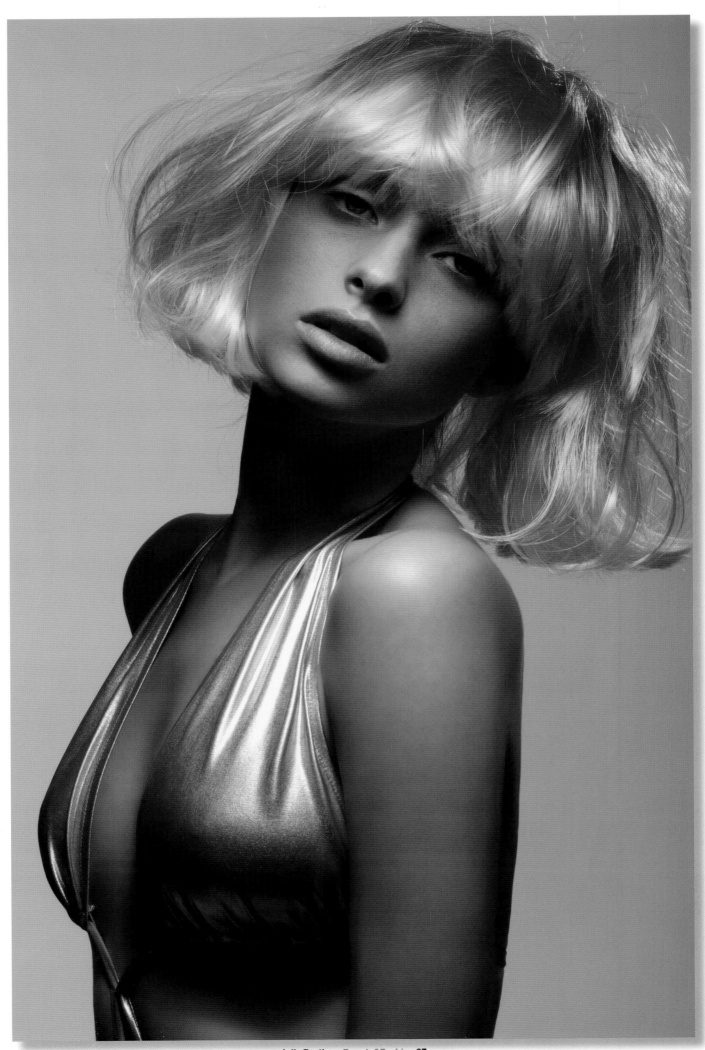

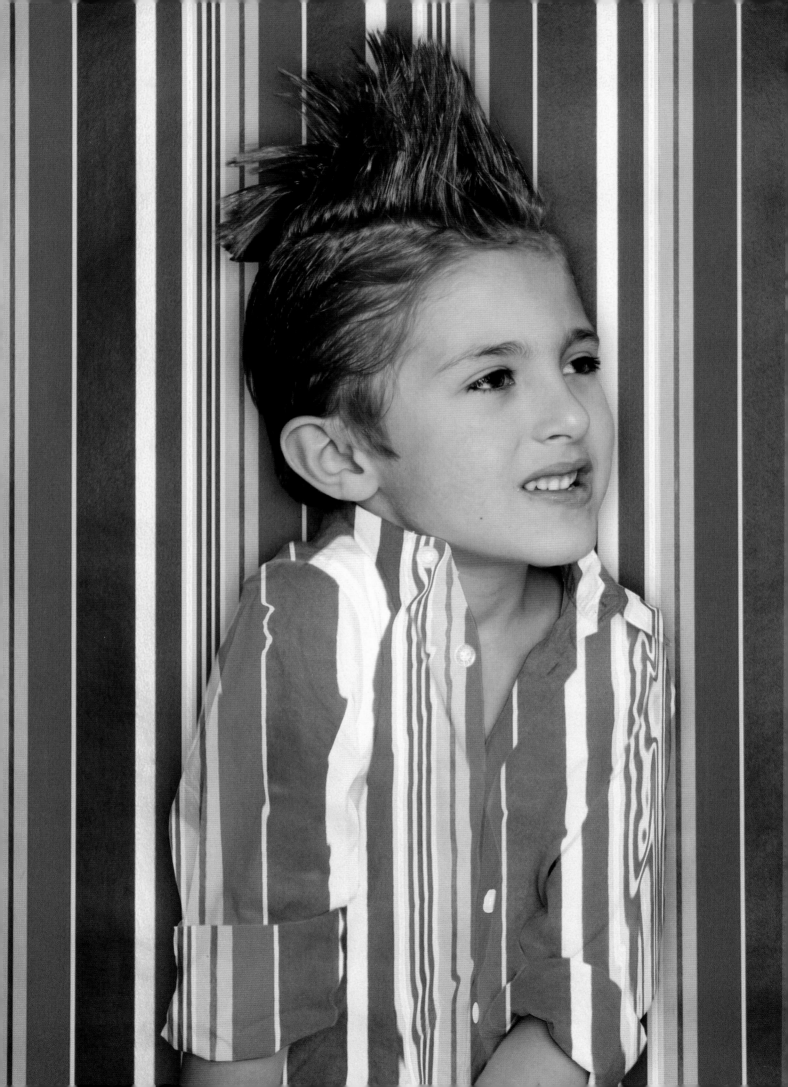

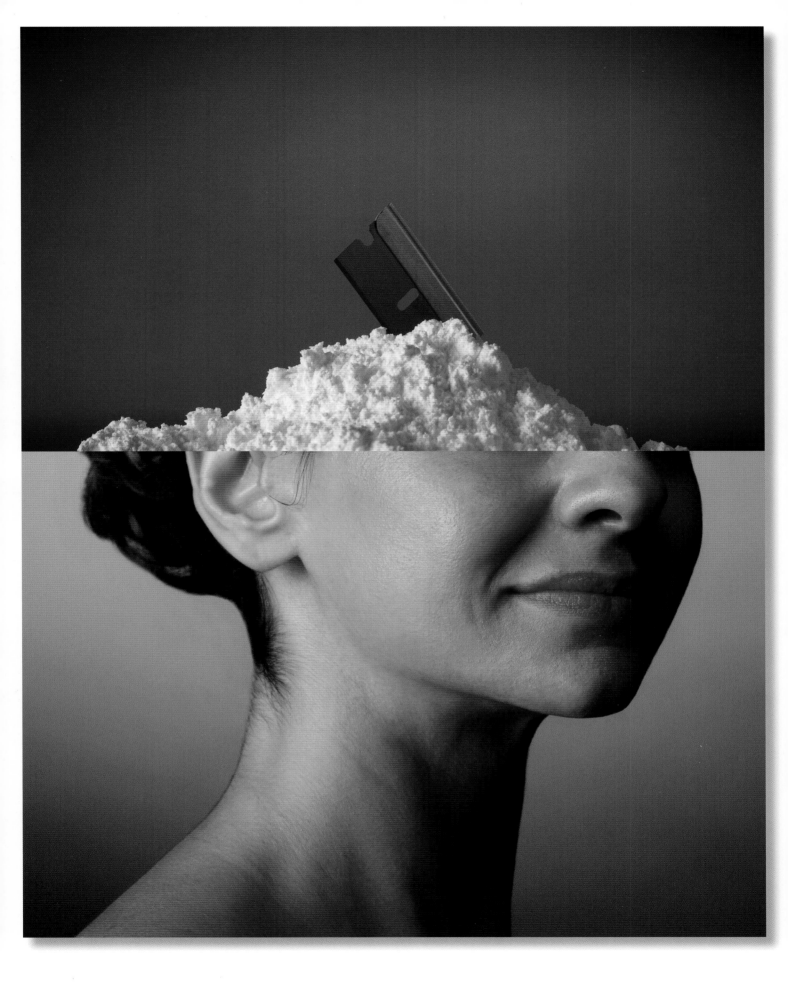

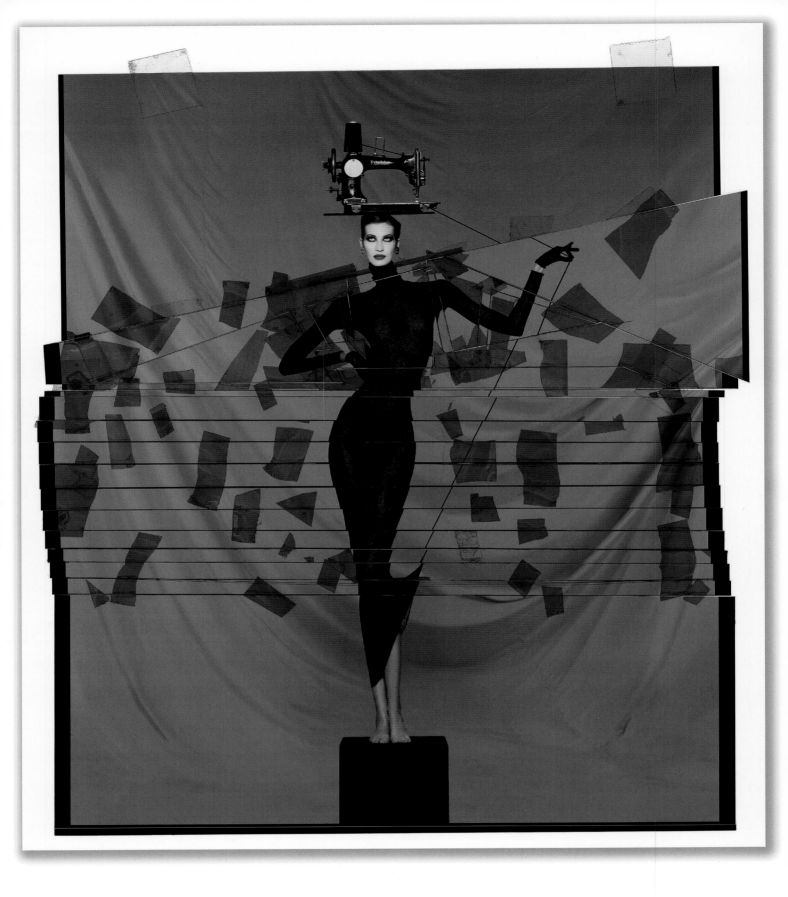

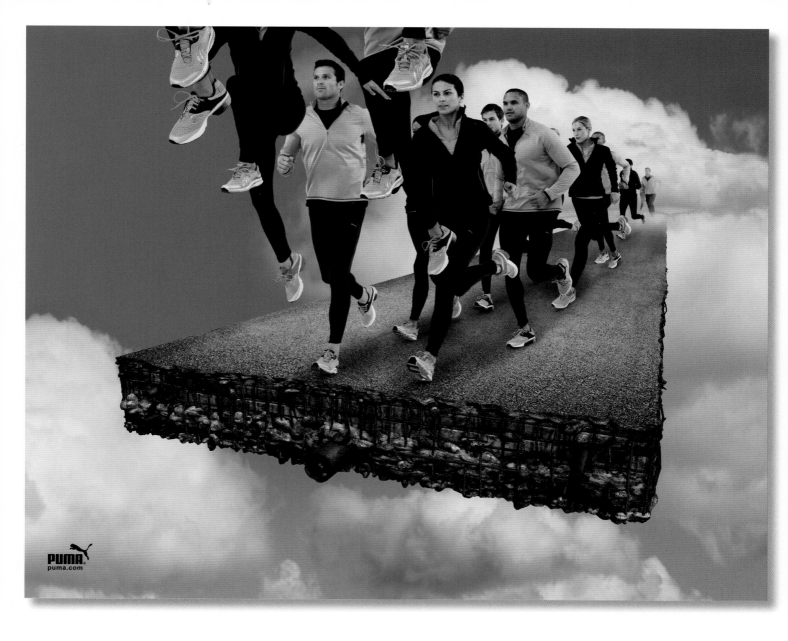

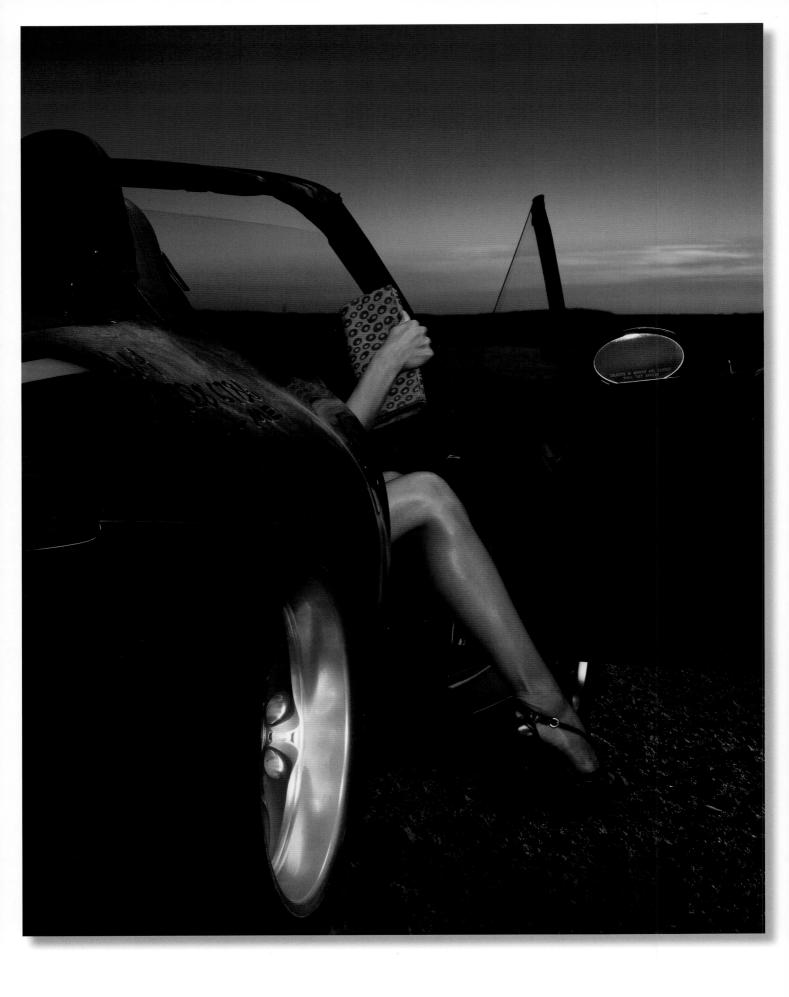

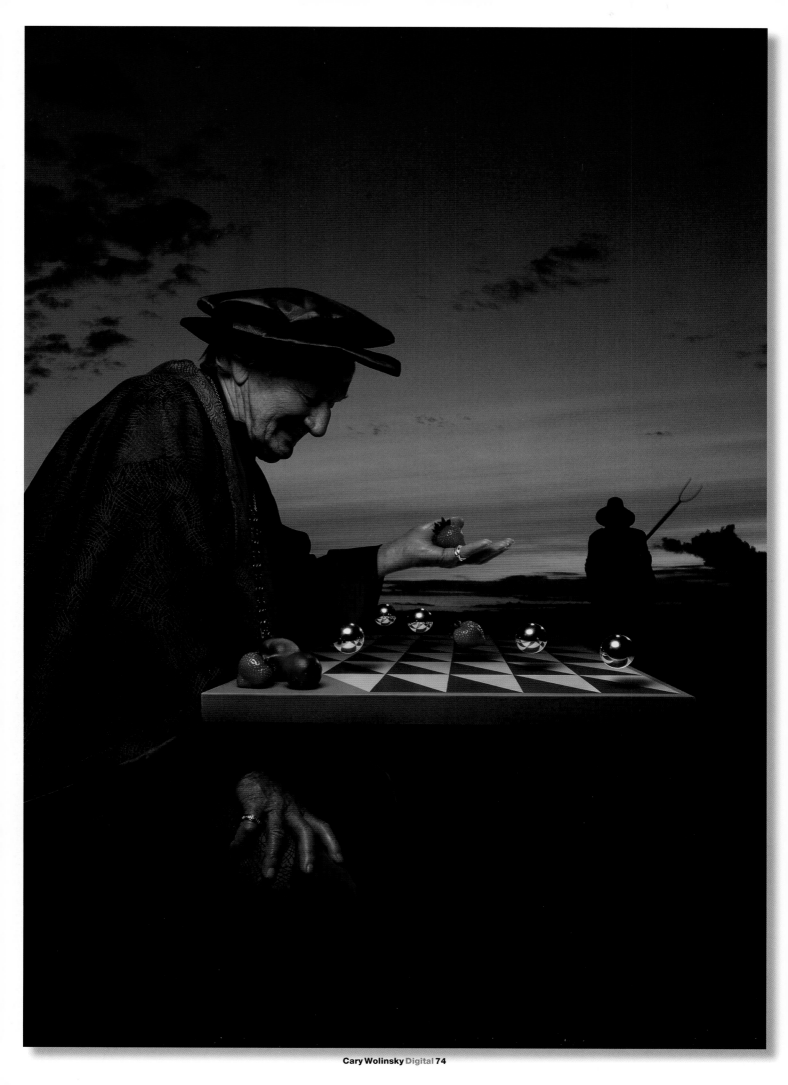

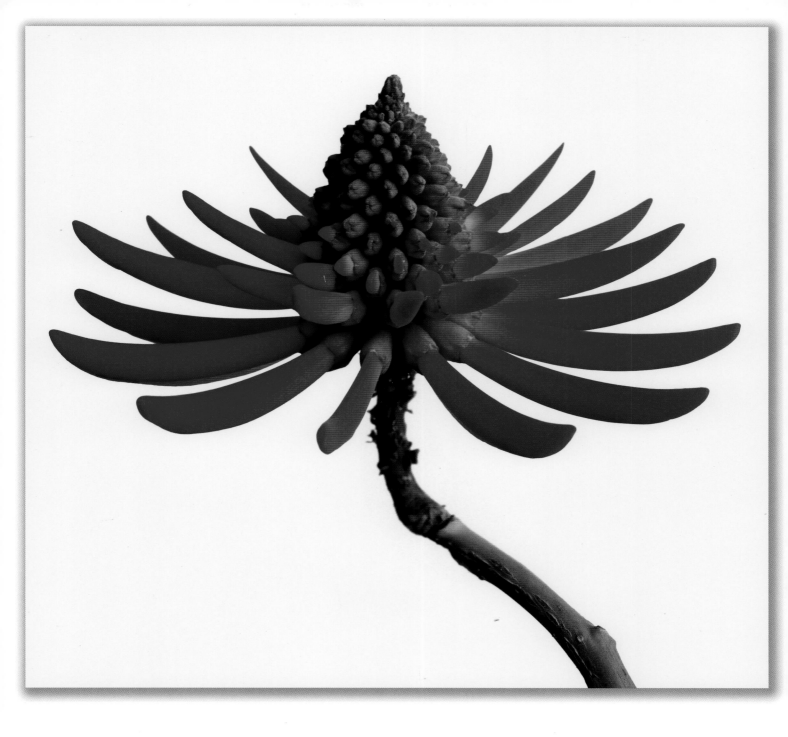

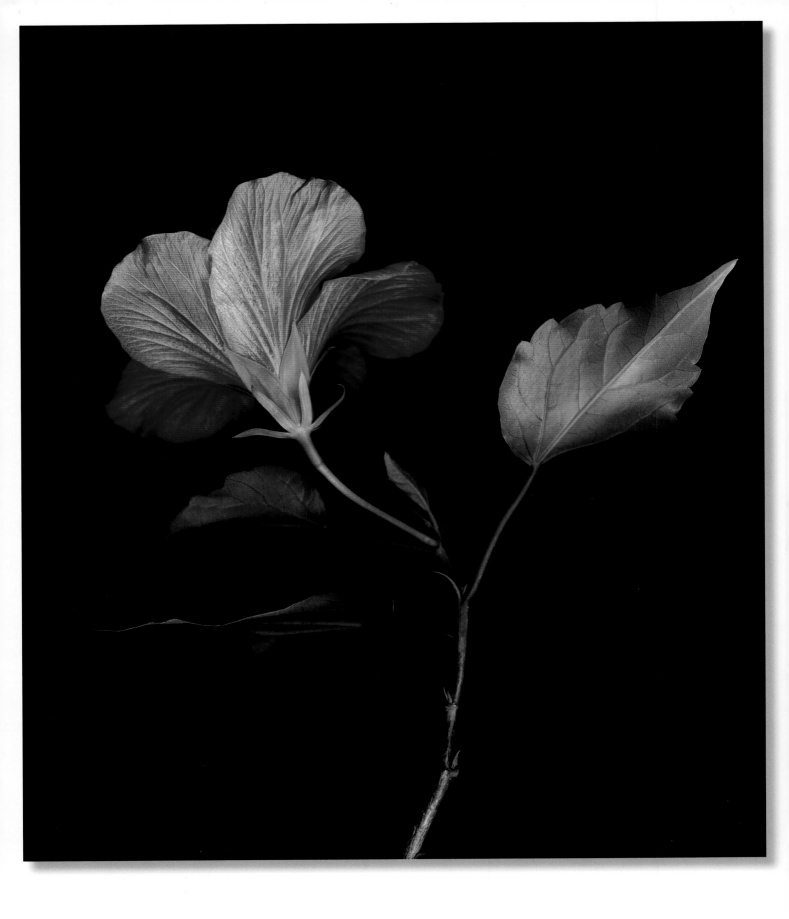

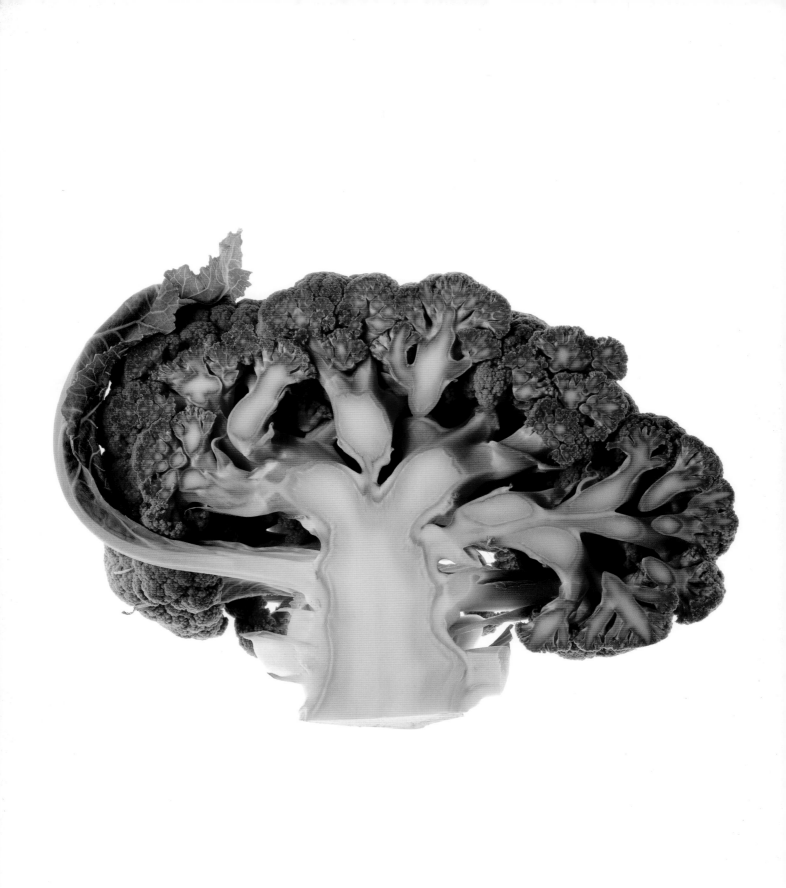

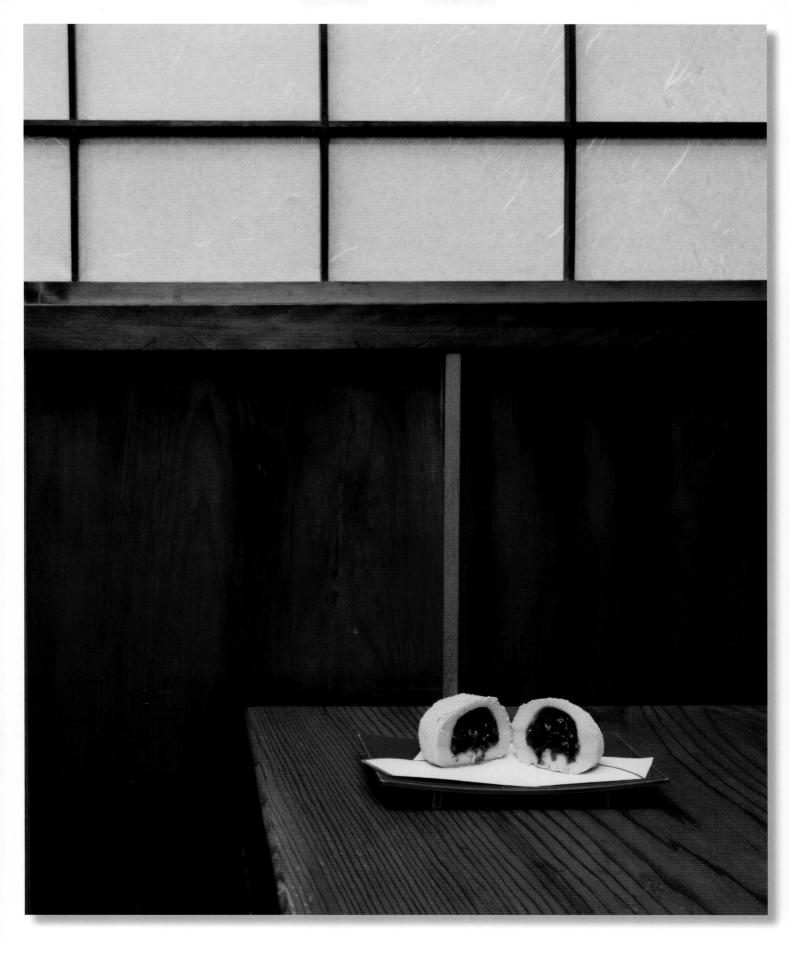

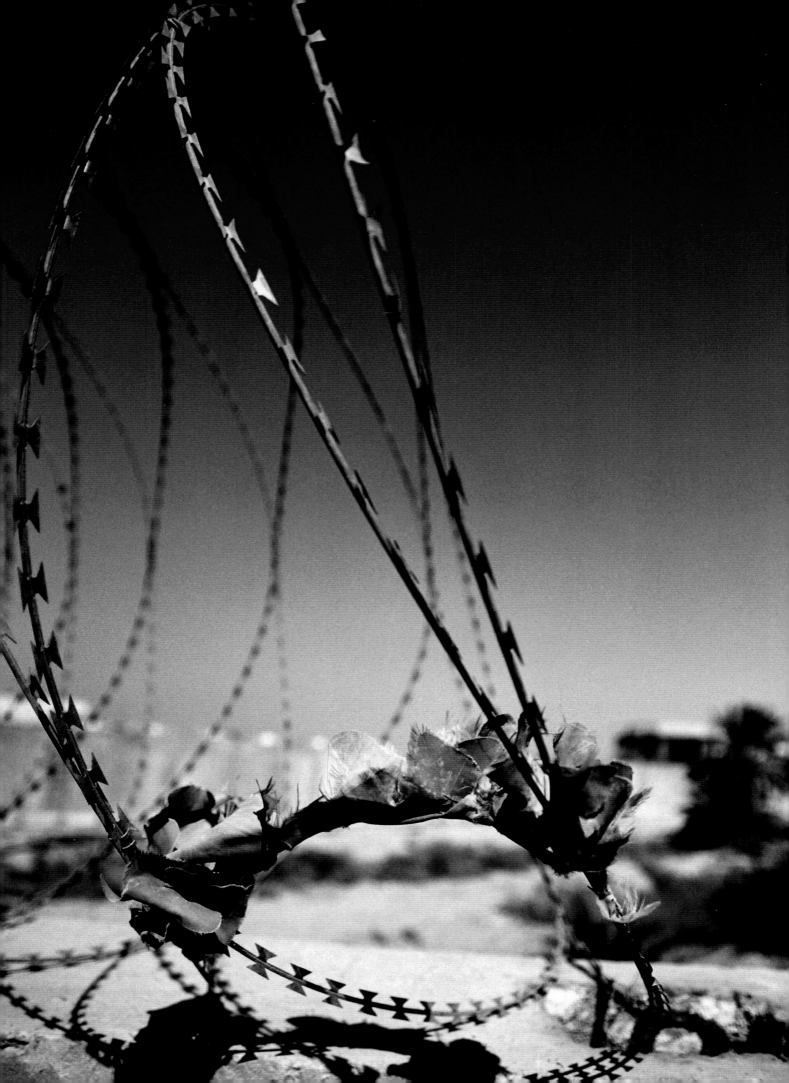

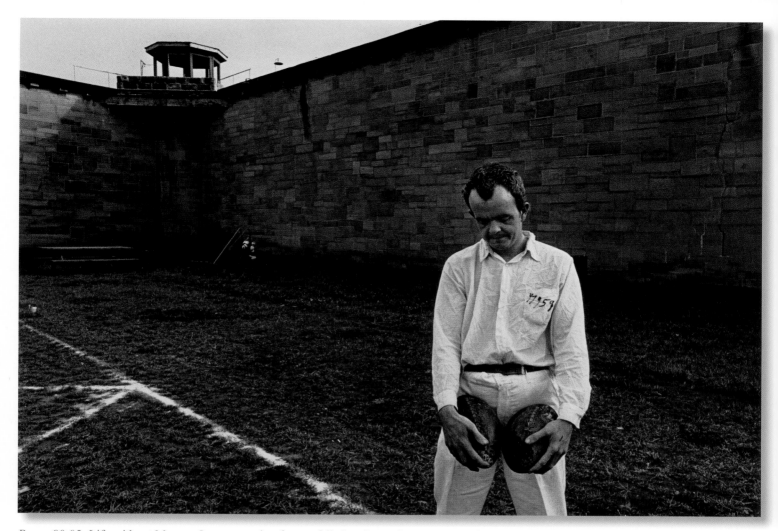

Pages 90-95: Life without Mercy - I was returning from a failed project photographing carnival workers when I drove past the state prison of one of the border states. With nothing to lose, I knocked on the door and was taken to the warden's office, where I explained that I wanted to photograph some prisoners. He stunned me by saying yes. I spent an hour in the yard doing inmate portraits. When I got home, I realized that one of these was one of the best photographs I had ever done. If there was one, perhaps there could be more. I wrote the warden, and he invited me back. Thus began my five week-long visits to two maximum-security prisons. I spent those weeks in a state of alertness and awareness such as I had never before experienced. The work had a life of its own, and I knew I was done when I felt it didn't need me to go back. Nothing has been the same since.

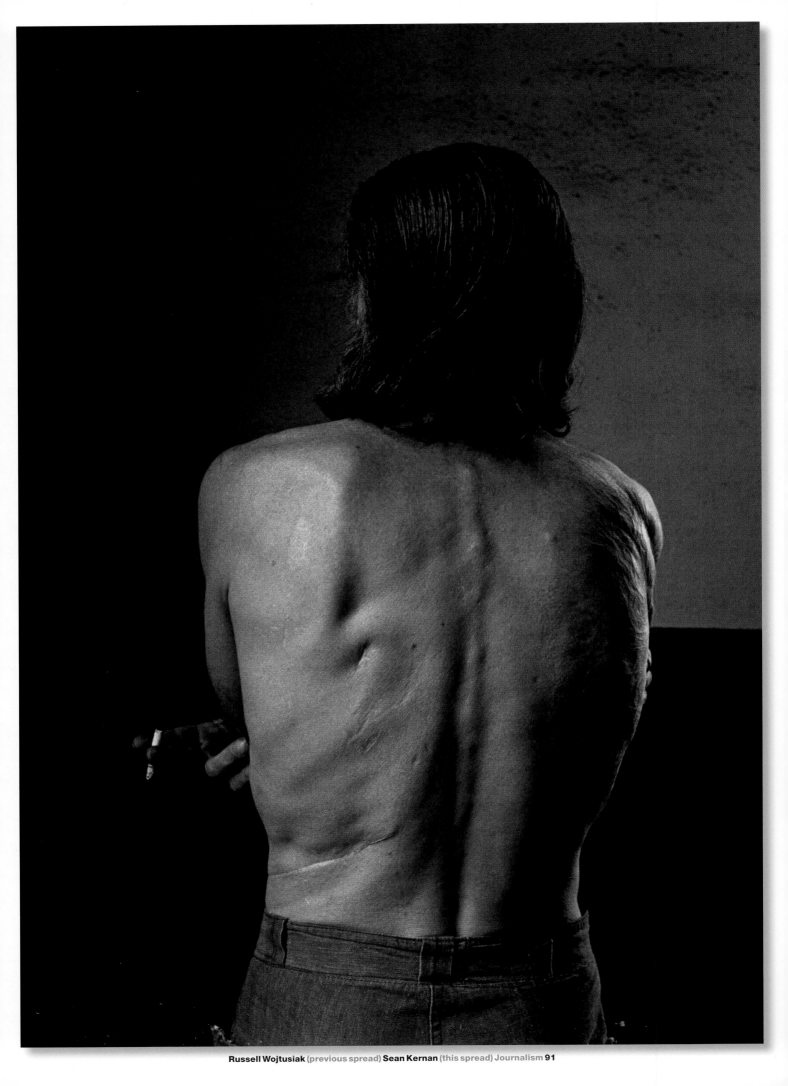

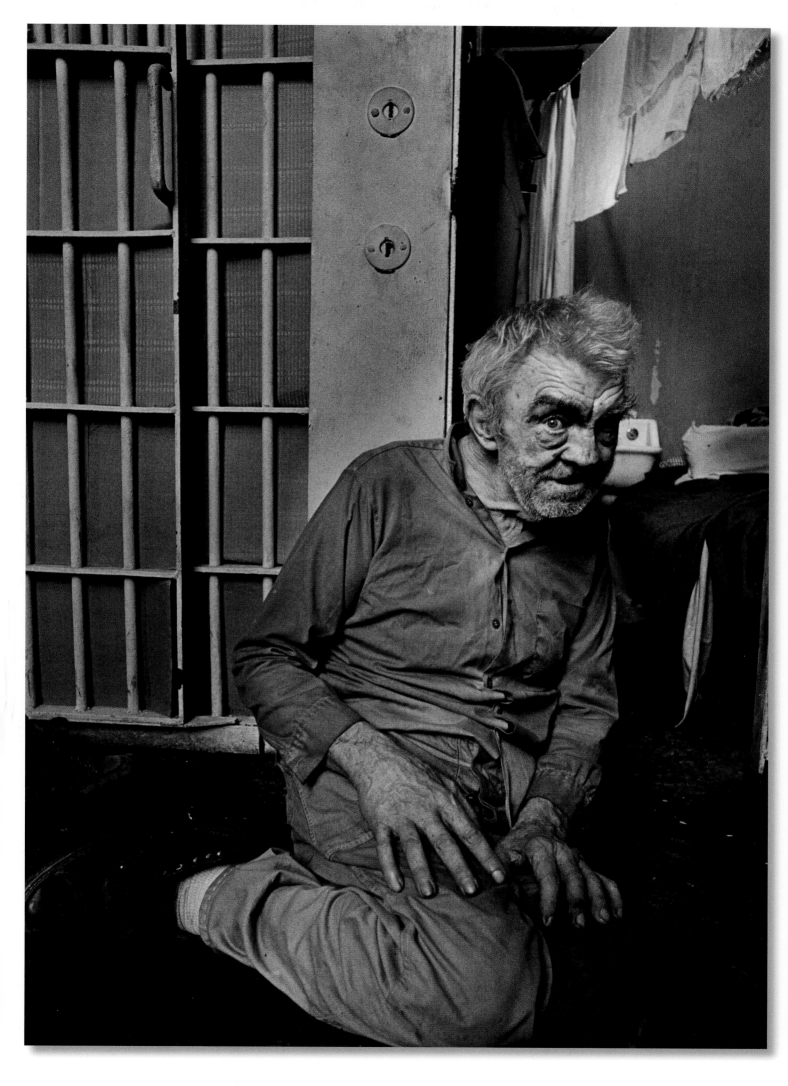

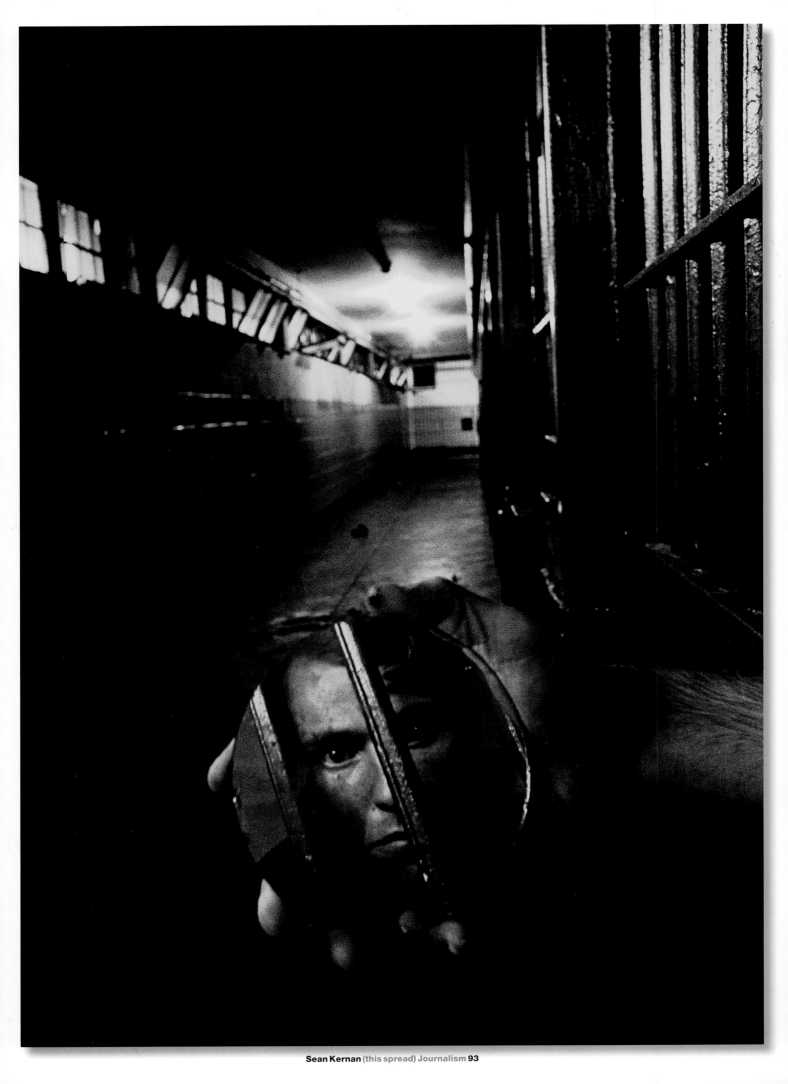

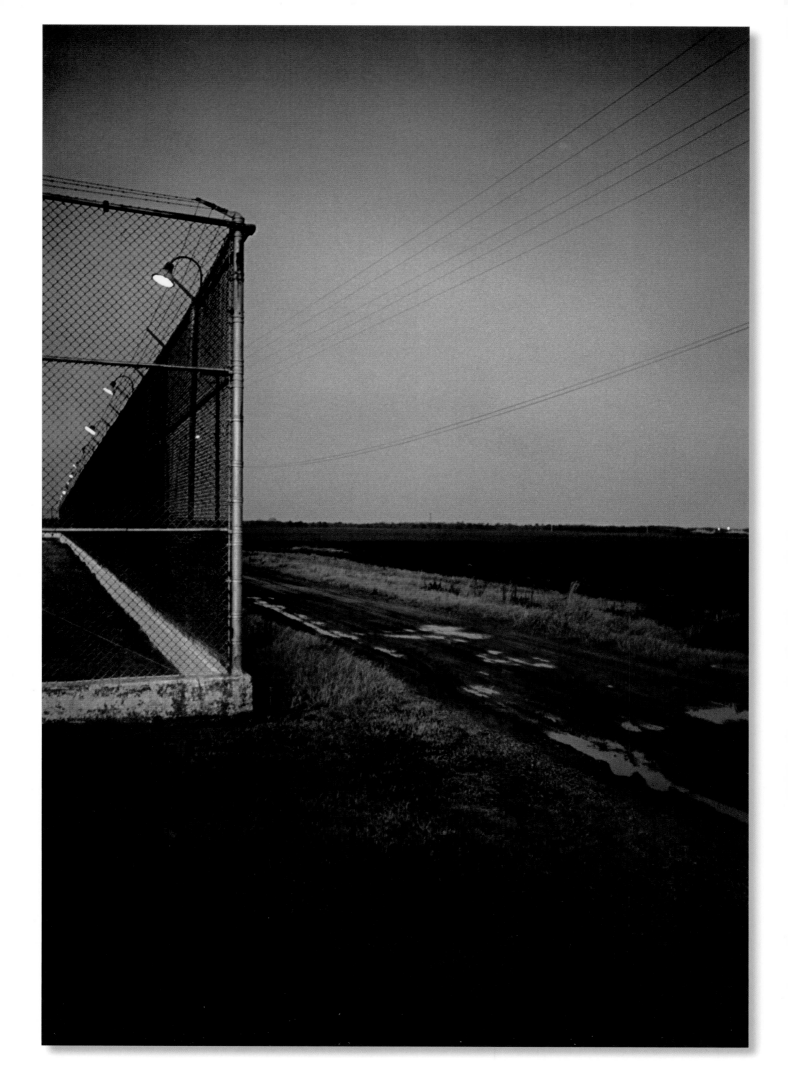

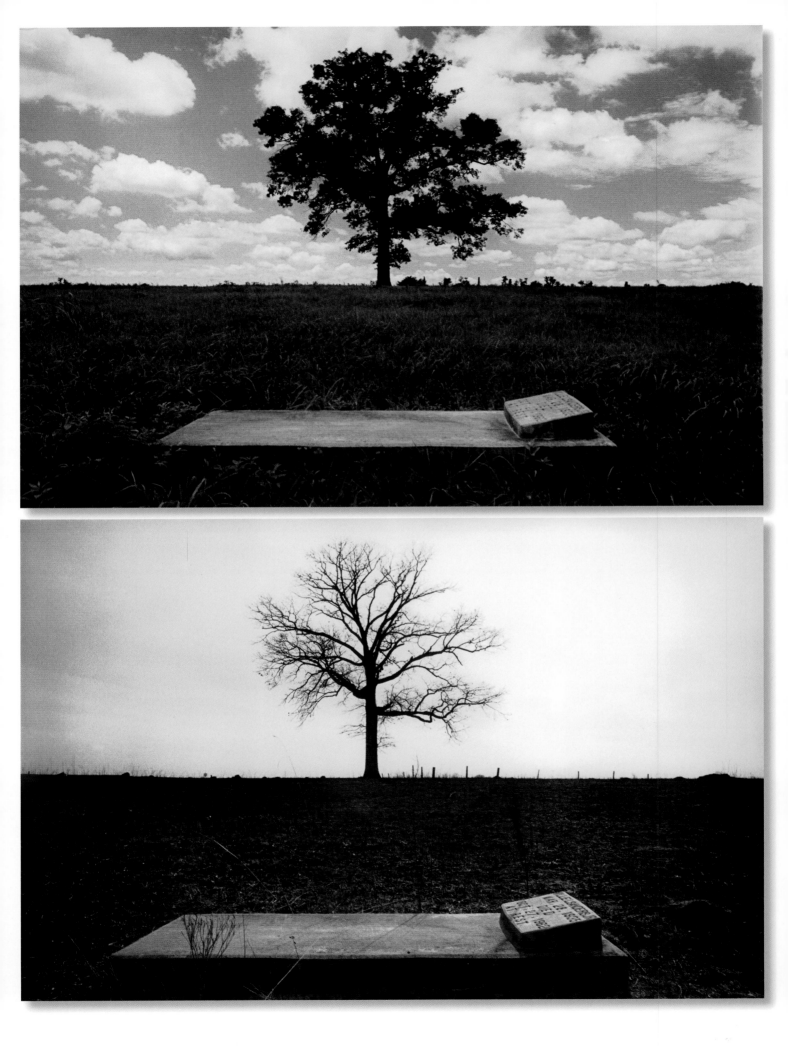

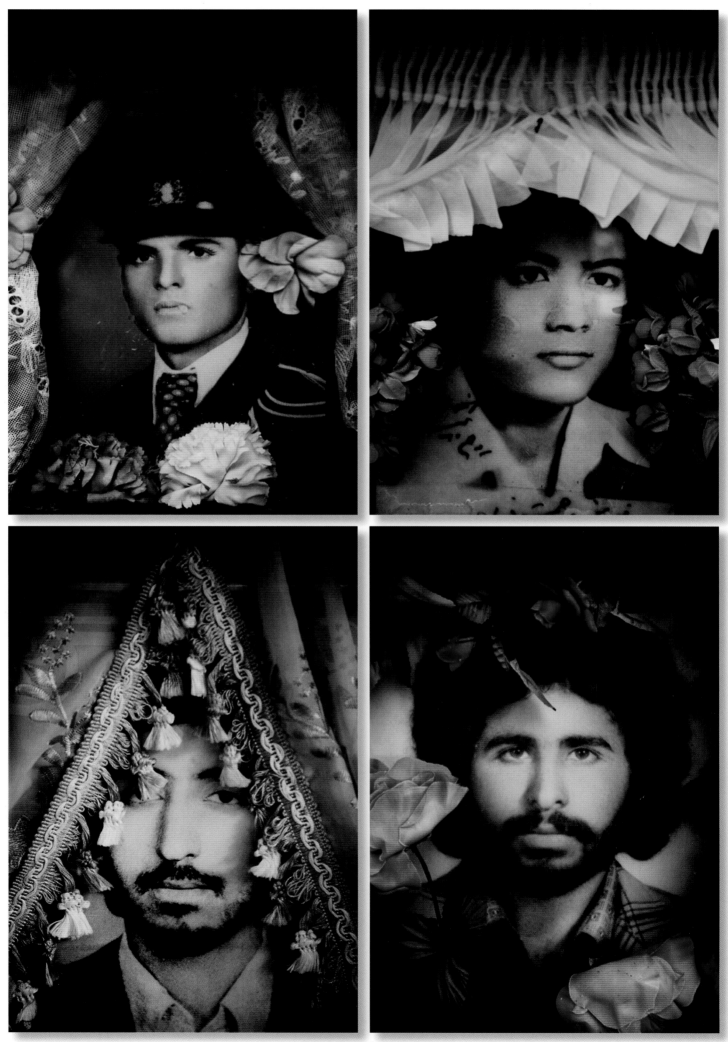

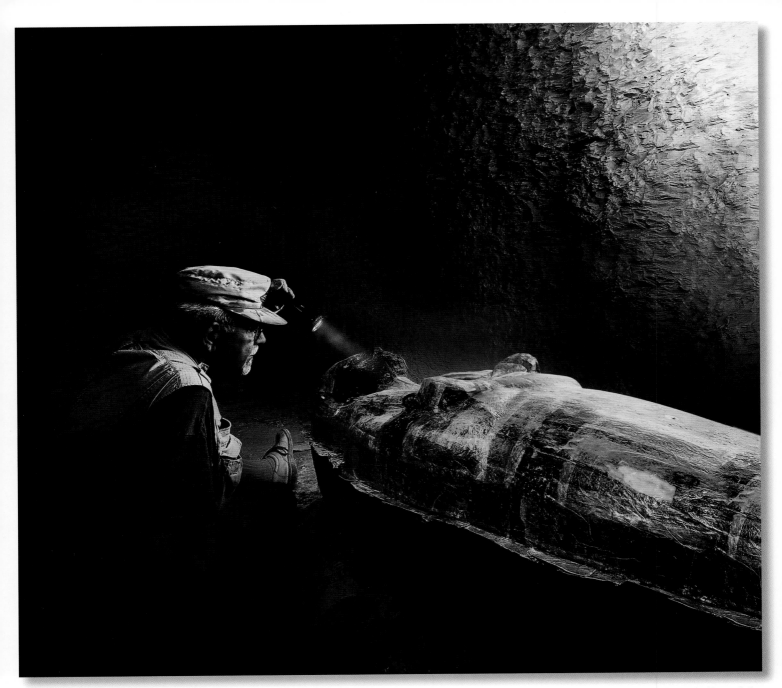

Opposite page: Behesht Zahra Martyr Cemetery - Pictures of Iranians killed during the Iran-Iraq war of 1980-1988. Teheran, Iran. Oct 2006.

This page: Photograph of archeologist Otto Schaden in Valley of the Kings, Egypt, in the newly discovered tomb, "KV63."

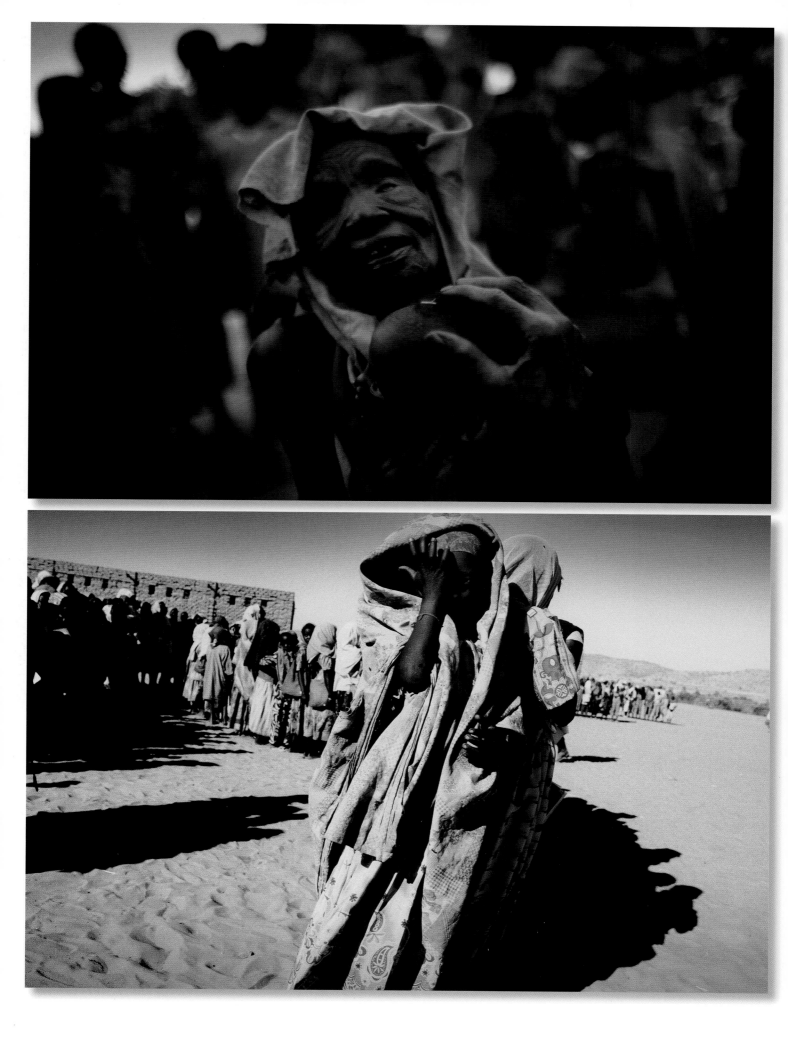

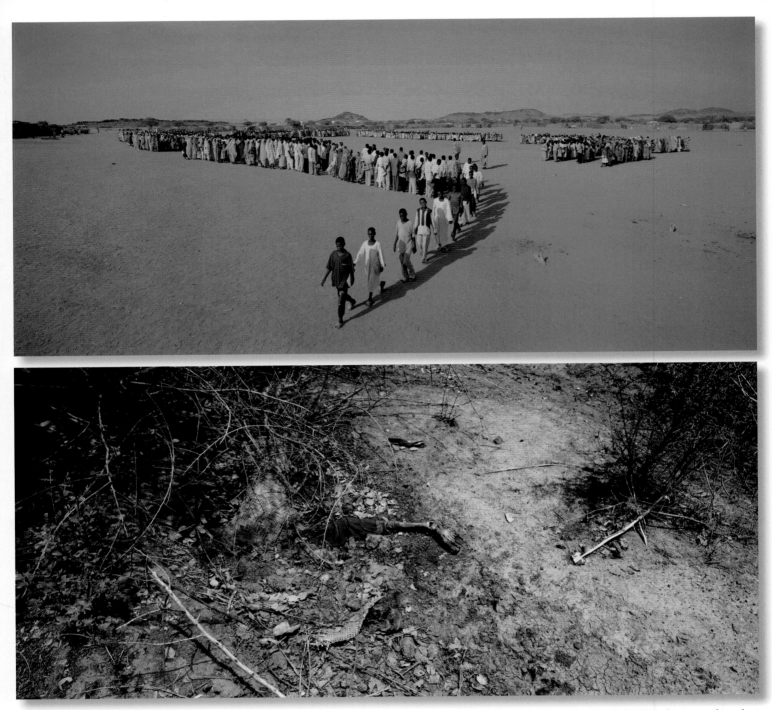

Opposite page: This year saw no end to the Janjaweed's reign of terror in western Sudan. After her village burned to the ground, a blind woman cradles her grandson while the boy's mother risks rape to seek out water for the family.

This page: The horrors in Darfur show no sign of abating, mostly because the Sudanese government of Omar al-Bashir steadfastly refuses any expansion of peacekeeping forces in the western region, where some 200,000 people have been killed, and 2 million left homeless, as a result of fighting between government troops (and pro-Khartoum militias) and rebels in the region. At the United Nations conclave last week, US President George Bush, U.N. Secretary-General Kofi Annan and other international leaders renewed calls for the deployment of a large U.N. force to halt what Washington has called a campaign of "genocide" by Khartoum. But Bashir continues to say no to an international contingent. He did agree last week to allow a small force of Africa Union peacekeepers to remain in Darfur for three months, but no one expects that small concession to save any civilian lives at a time when the government attacks in the region have been intensifying.

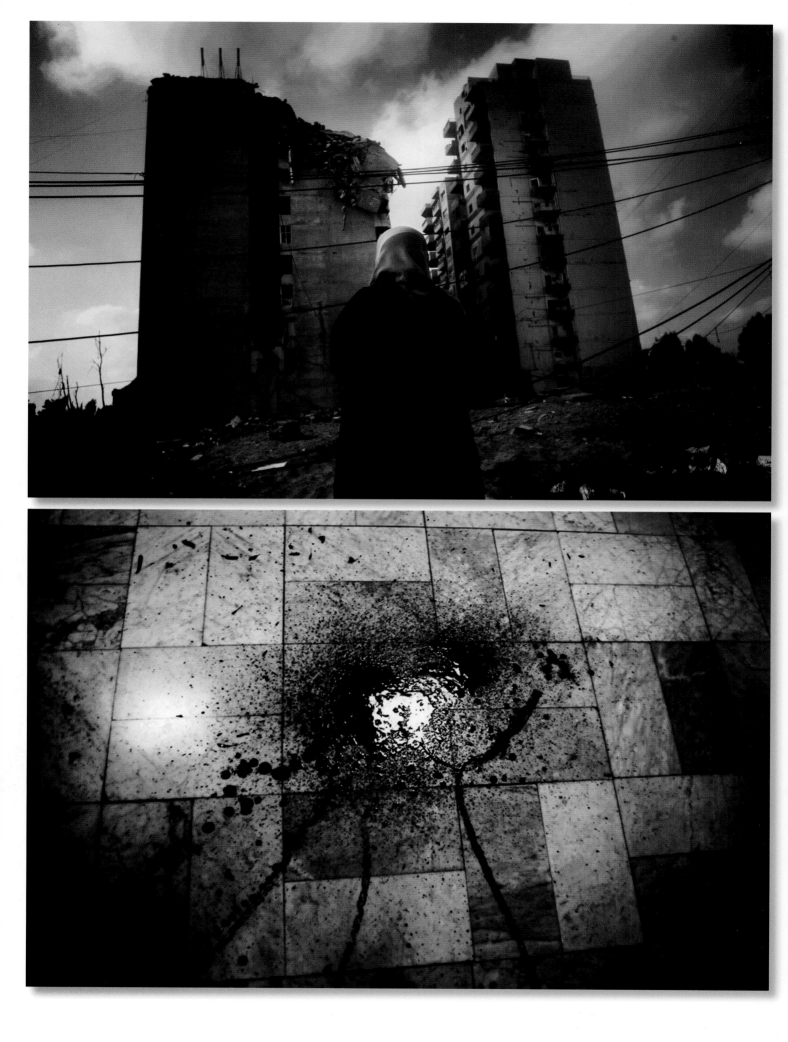

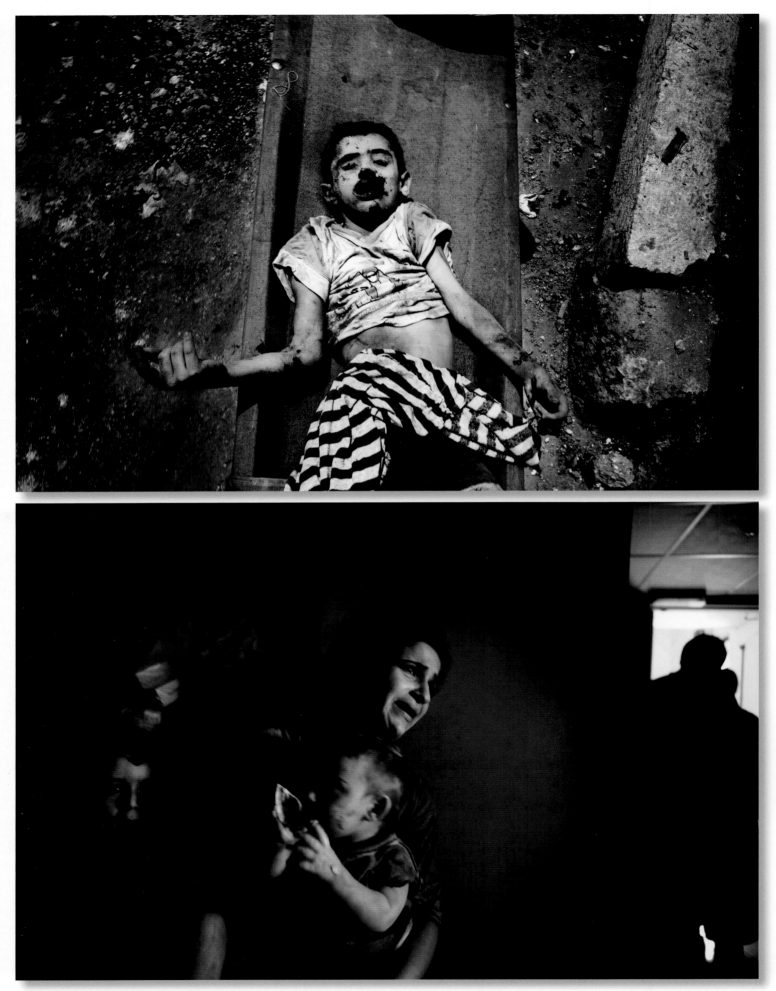

This spread: Pellegrin's powerful Photography from the July 06 war between Hizbullah and Israel is a striking vision of the brutality and desperation that gripped the region that summer. He risked life to document refugees, intense bombings, and deaths in Tyre and Qana in southern Lebanon.

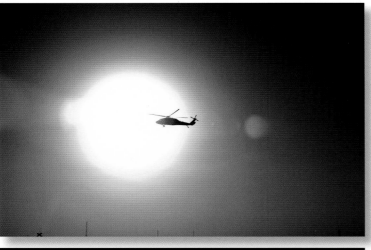

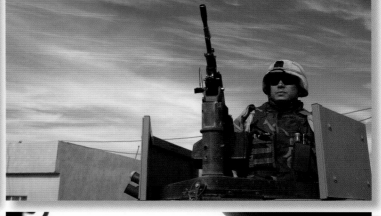

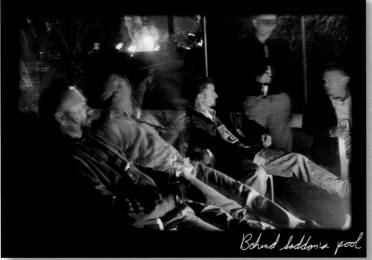

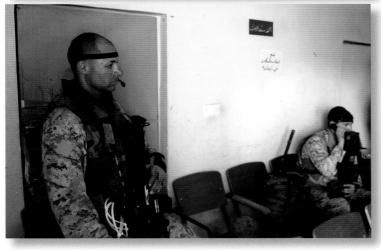

Behind Saddam's pool

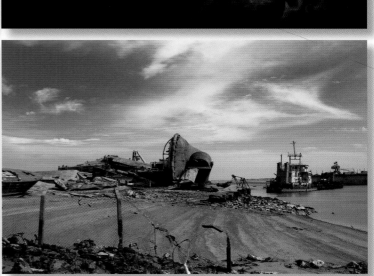

This page, clockwise from top left: (1)Helo - In Iraq, helicopters defined much of my existence. I was given the awesome and awful task of coordinating helicopter traffic requests for the Iraq Reconstruction Management Office. It was kind of like disorganized car-pooling in a war zone! (2)Untitled - While traveling through Samara to review reconstruction projects, the US Army provided transportation and convoy security for me and other members of the Iraq Reconstruction Management Office. (3) Untitled - Samara was one of the first places I traveled to in Iraq. My inexperience showed in my dress and my behavior. After I took this picture, the convoy stopped. When we went back to the HMMVES I forgot which one I was in and oddly jumped in the one next to me and said, "Mind if I hop in?" (4)Stranger Than Science Fiction - My jaw dropped and I did not move for 30 seconds when I saw these ships. Instead of being disposed of properly, wrecks from the Iran-Iraq War were piled high along the shore. I immediately asked "Doc" from our security detail to follow me. I had to get a picture of this, because no one would ever believe me. (5)Untitled - A security presence is maintained at all times at the CMOC. (6)Behind Saddam's Pool - Before the US Embassy in Iraq became very formal, I used to enjoy hanging out by the pool on Thursday nights. Drinking, bul-lets being thrown into the fire, and bicycles ridden off the high dive were all possible outcomes from the evening.

Opposite page, clockwise from top left: (1)Justice - The Iraq War will never be remembered like World War II, as a great cause. For those of us who were there, it was our cause and there were victories. In all the mess of Iraq, one thing was certain: Saddam Hussein and his Republican Guard tortured, murdered, raped, and abused the Iraqi people. It is good and just that this building, as seat of his power, was bombed, destroyed and burned. (2)Untitled - Wars are different, but history does repeat itself. Here I was an American, flying over a country with palm trees in a helicopter. My Uncle Jerry, who served in Vietnam, swore that this photo could have been taken there. (3)The Bunker Bar - For a time, the Bunker Bar was a popular Friday night event in the International Zone. Once an actual bunker beneath a house, it boasted one bar, served only canned beer, and the walls were decorated with Saddam regime memorabilia and rifles. (4)The Joy of T Walls - Barbwire and concrete are part of your life in Iraq, surrounding everything. The walls of our defenses free us from our foes, and imprison us from our friends. These metal and concrete custodians were so normal in Iraq that when there were none in sight one felt scared and uneasy.

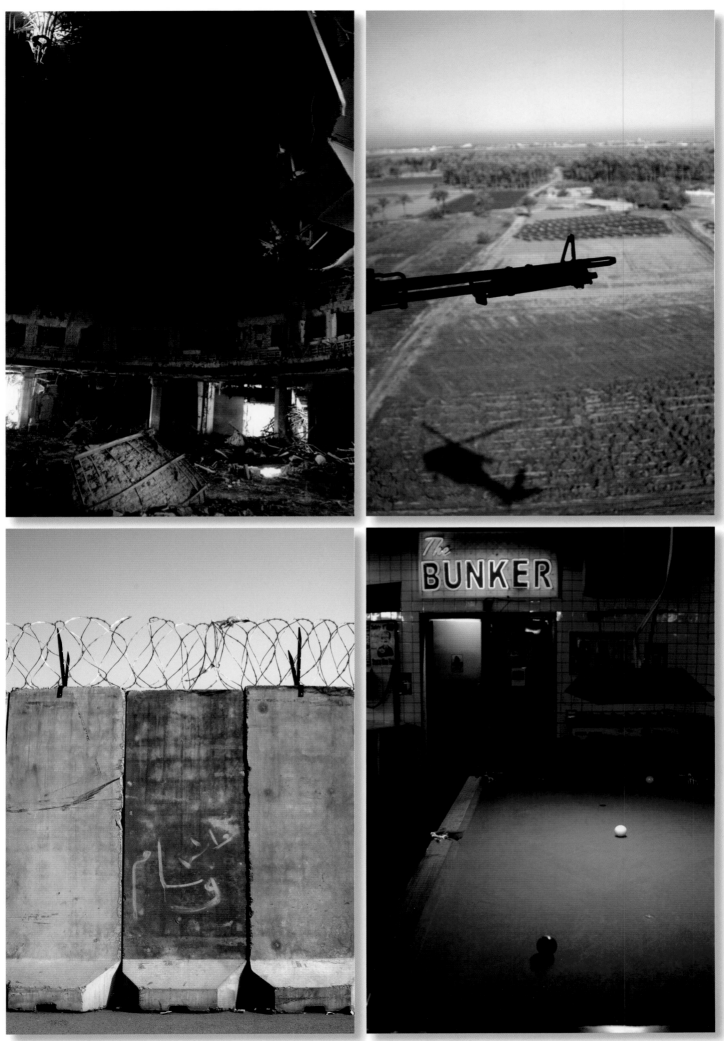

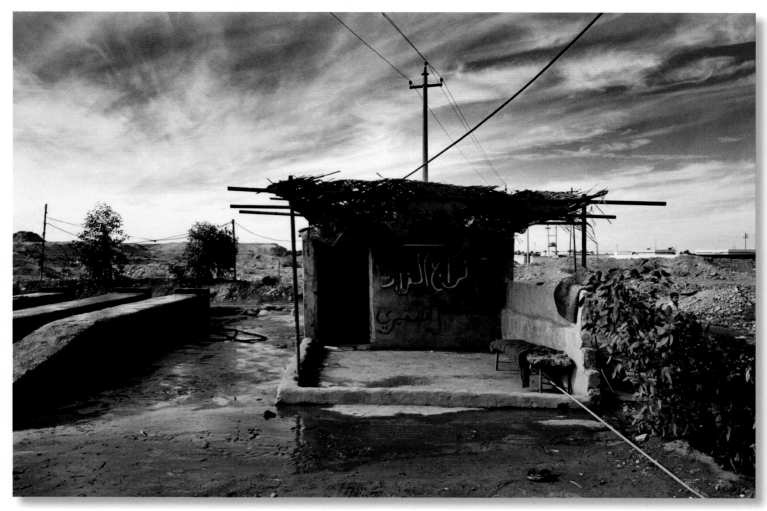

This page: Walking around Iraq is like opening up an old car that still runs. You pop the hood and stare at the engine, and you say, "How the f… can it keep running in this condition?" But that's Iraq, those are Iraqis. Not only does it run, but it can be beautiful.

Opposite page: The US Embassy in Basrah, Iraq, was surrounded by concrete walls and guard towers that were caped with barbwire. These walls kept the bad guys out and us in.

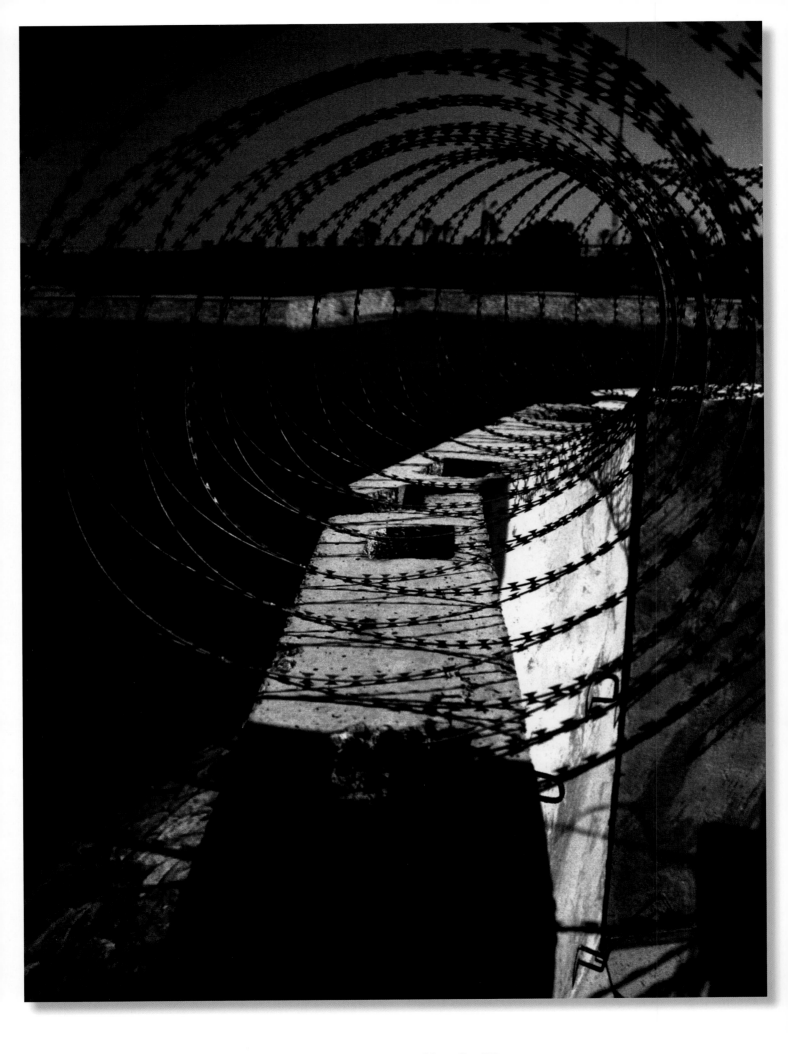

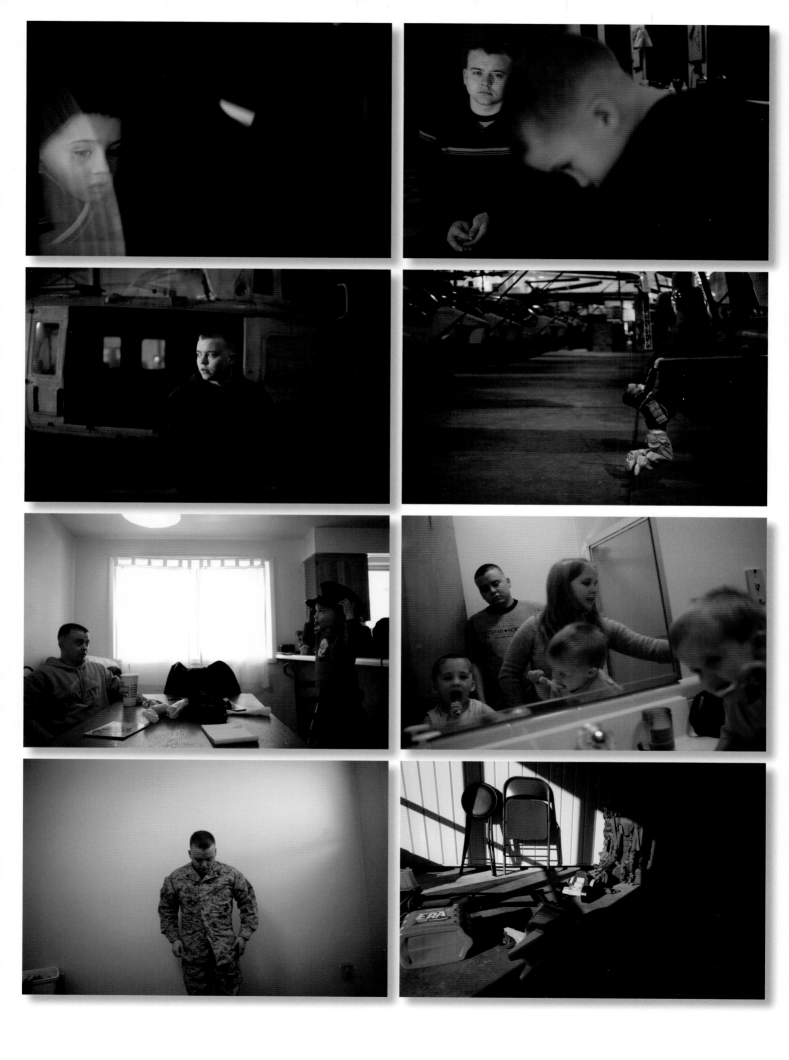

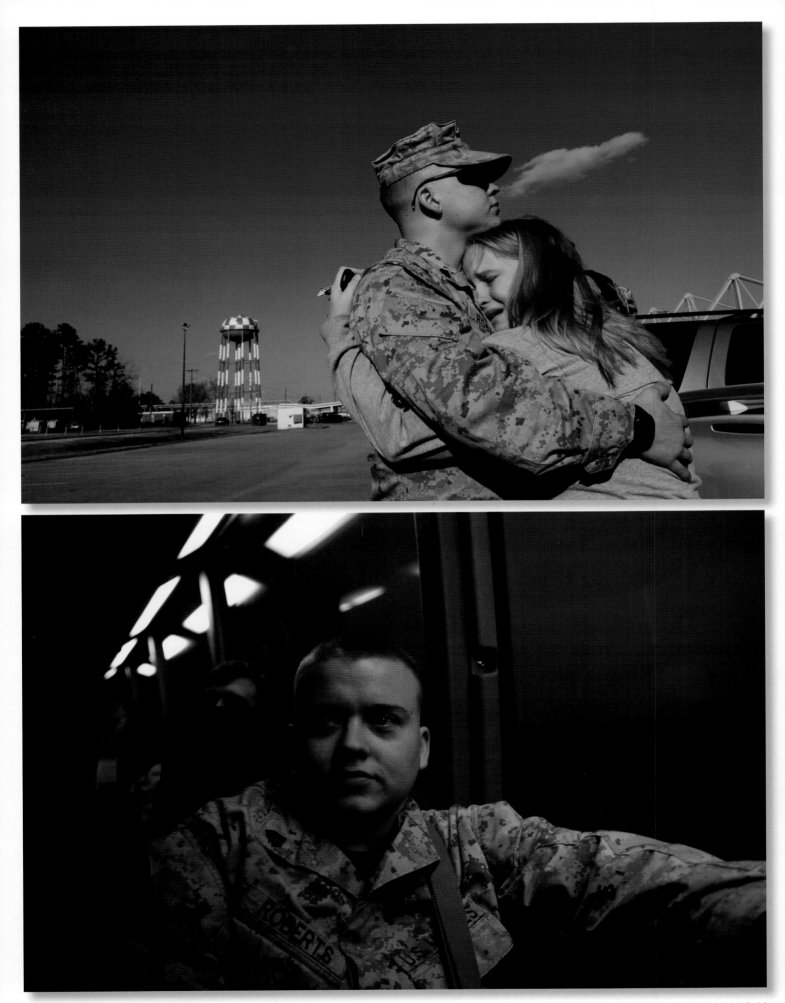

This spread: Marine Sgt. Matt Roberts, 23, deploys to Iraq for the third time in as many years, leaving behind his wife, Patricia, 22, and their sons, Isaiah, 3, and Joseph, 2. The deployment of thousands of Marine and Army personnel for multiple times is affecting morale both in the field and in the United States. These images are a look at Sgt. Roberts's last few days with his family at Marine Corps Air Station in North Carolina.

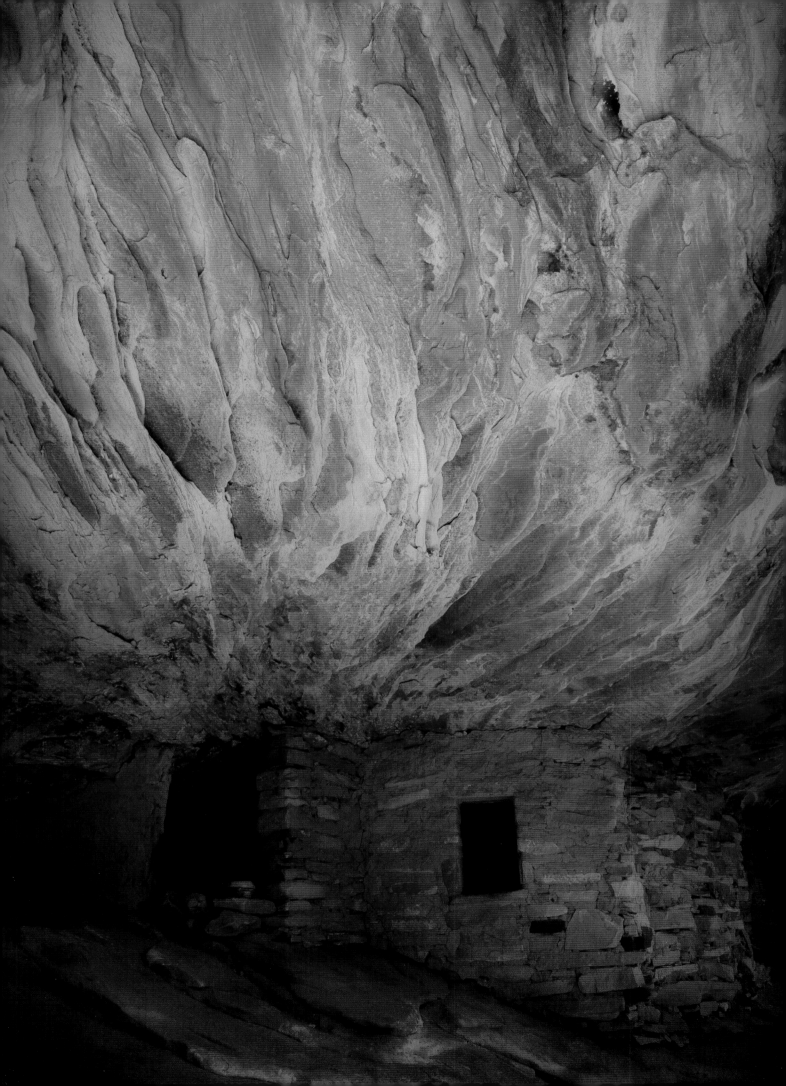

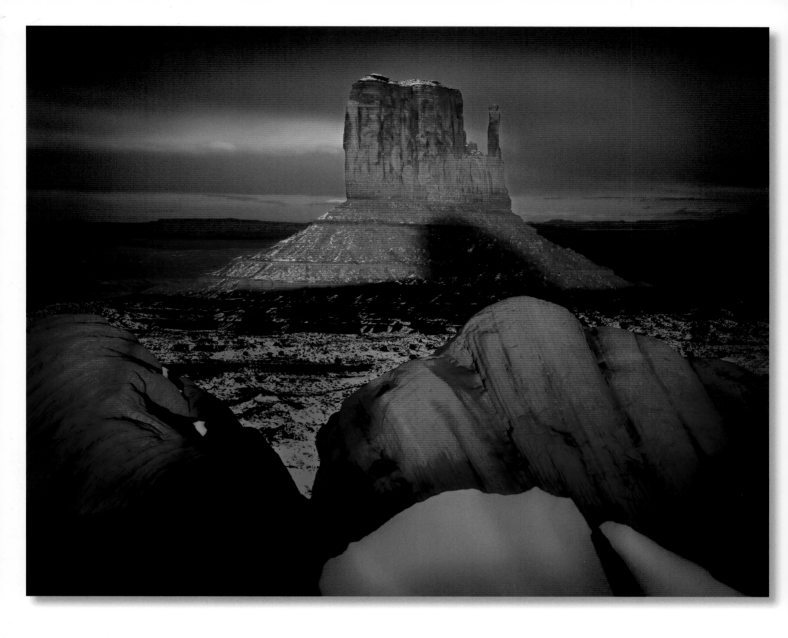

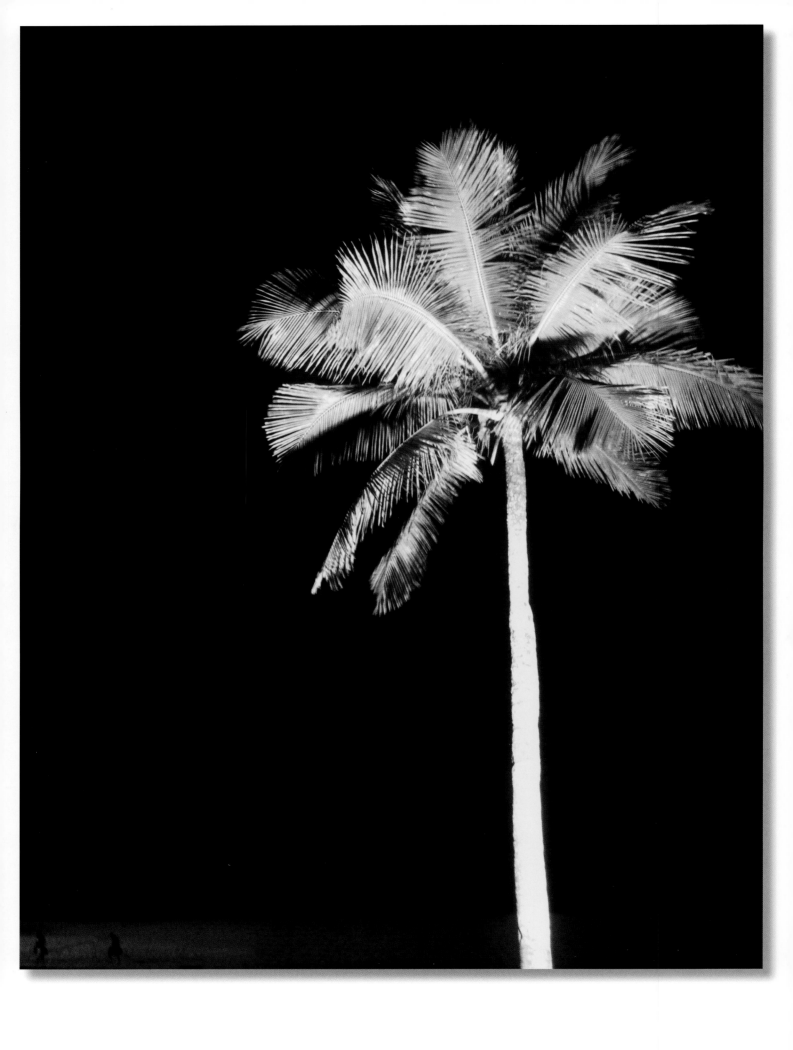

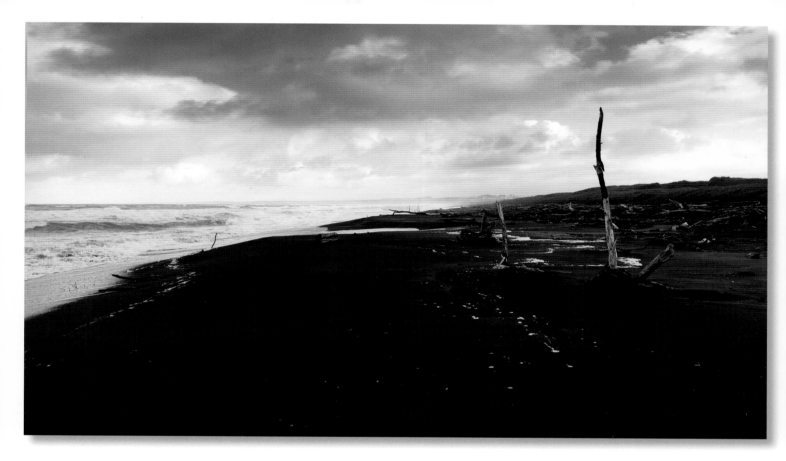

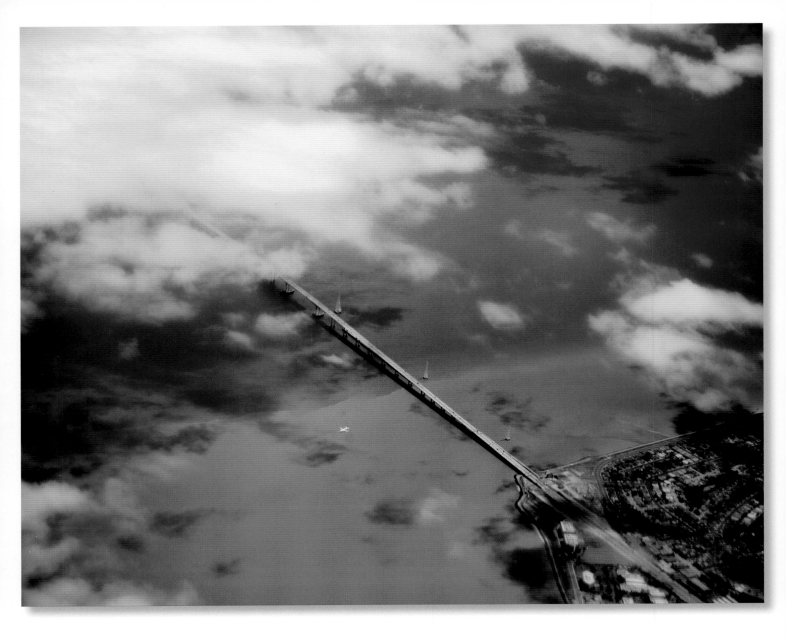

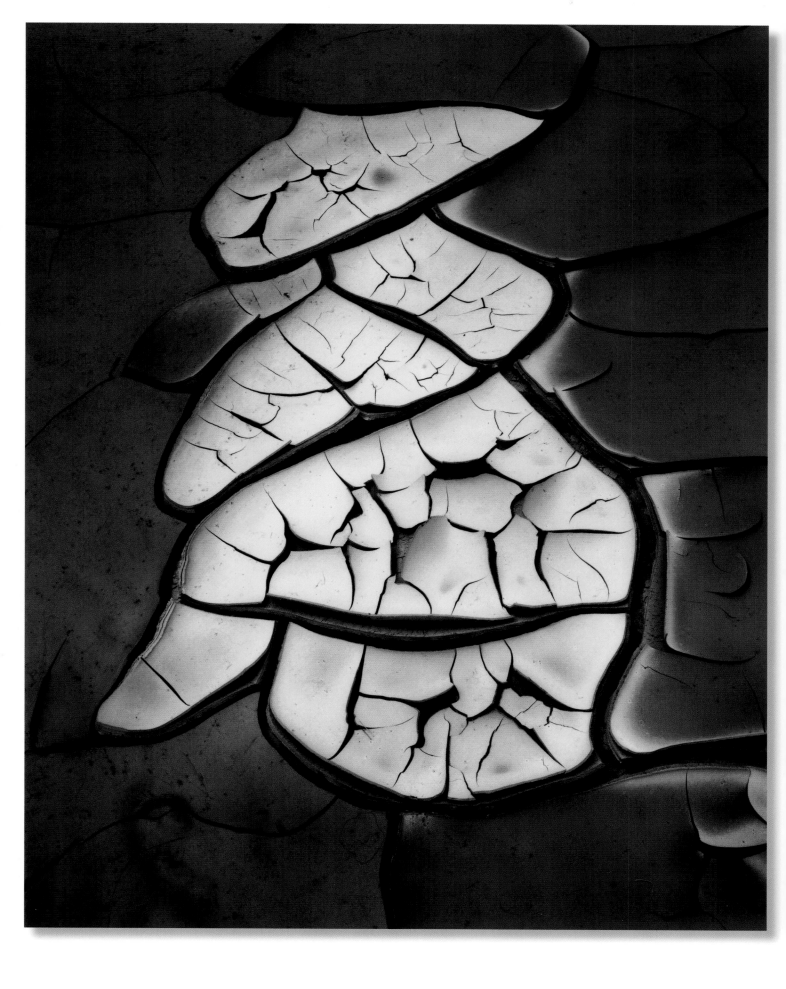

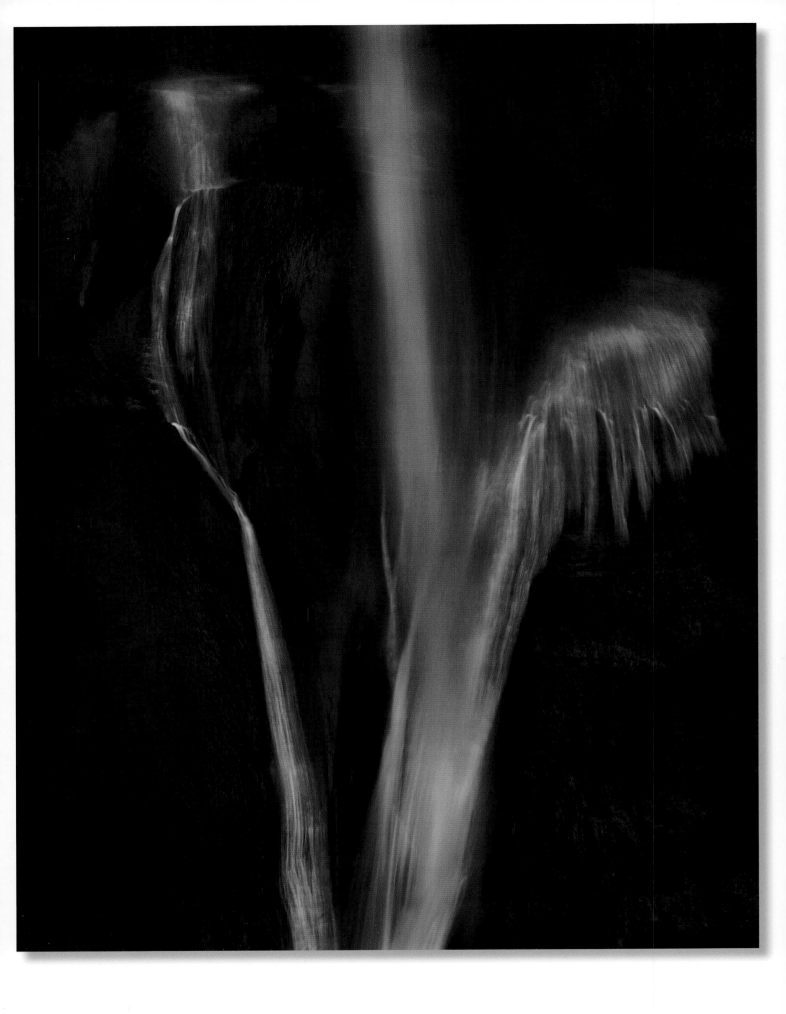

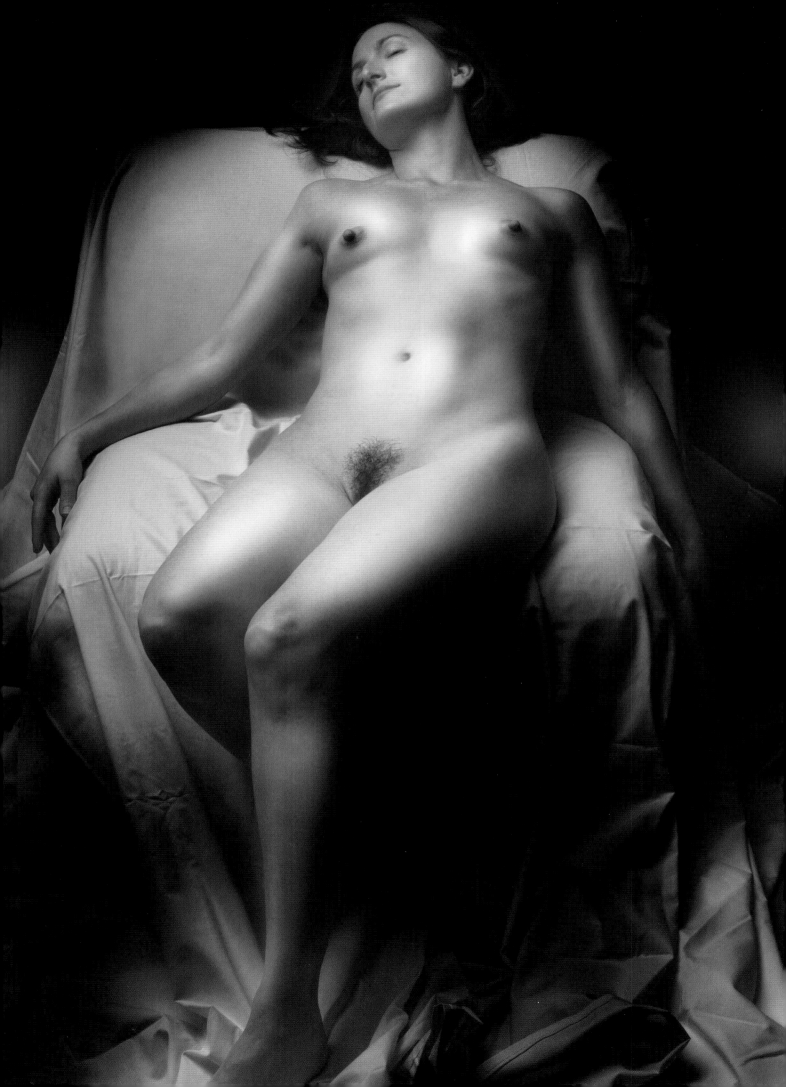

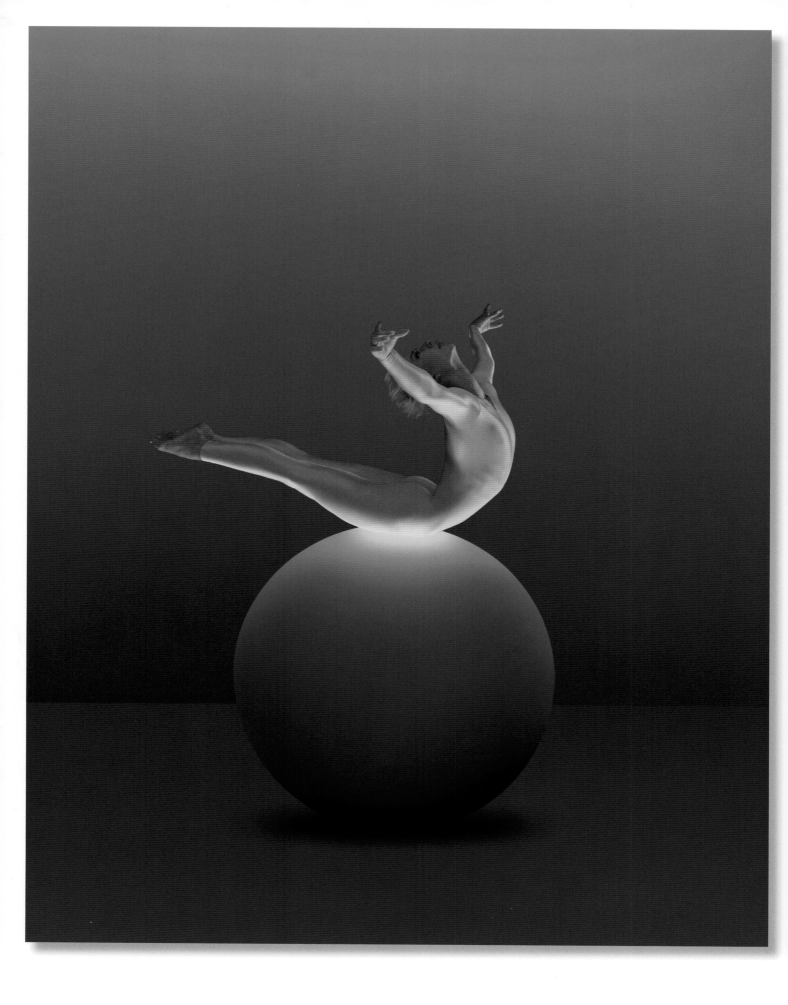

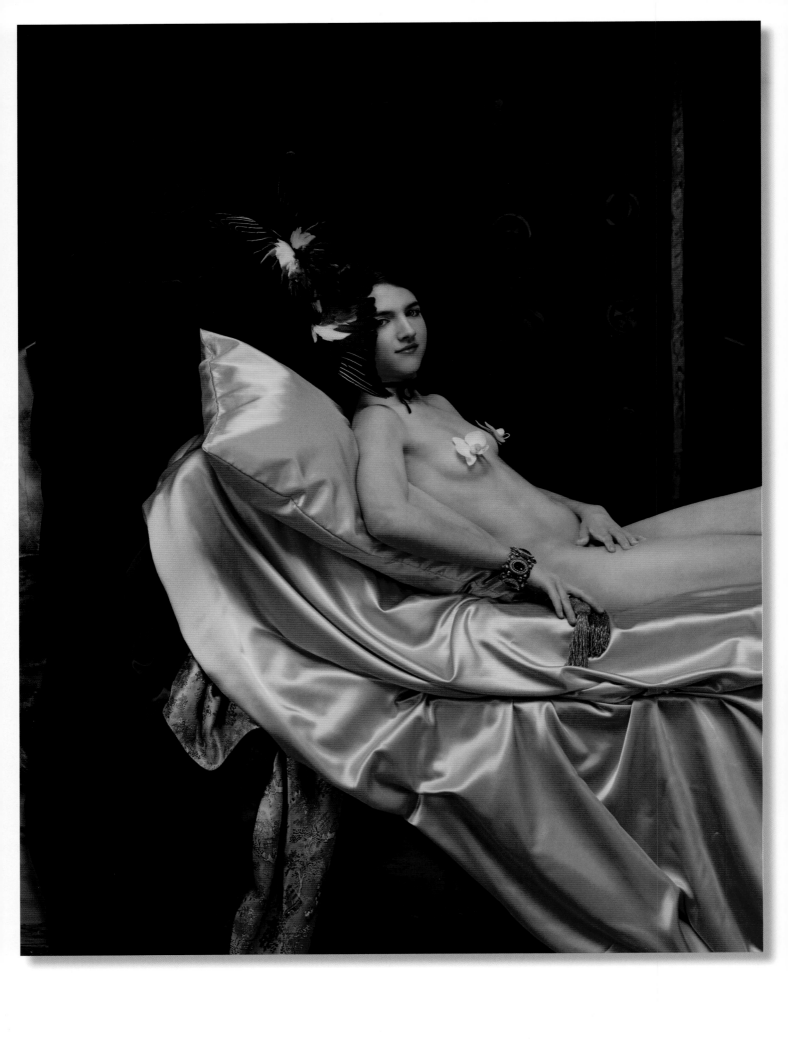

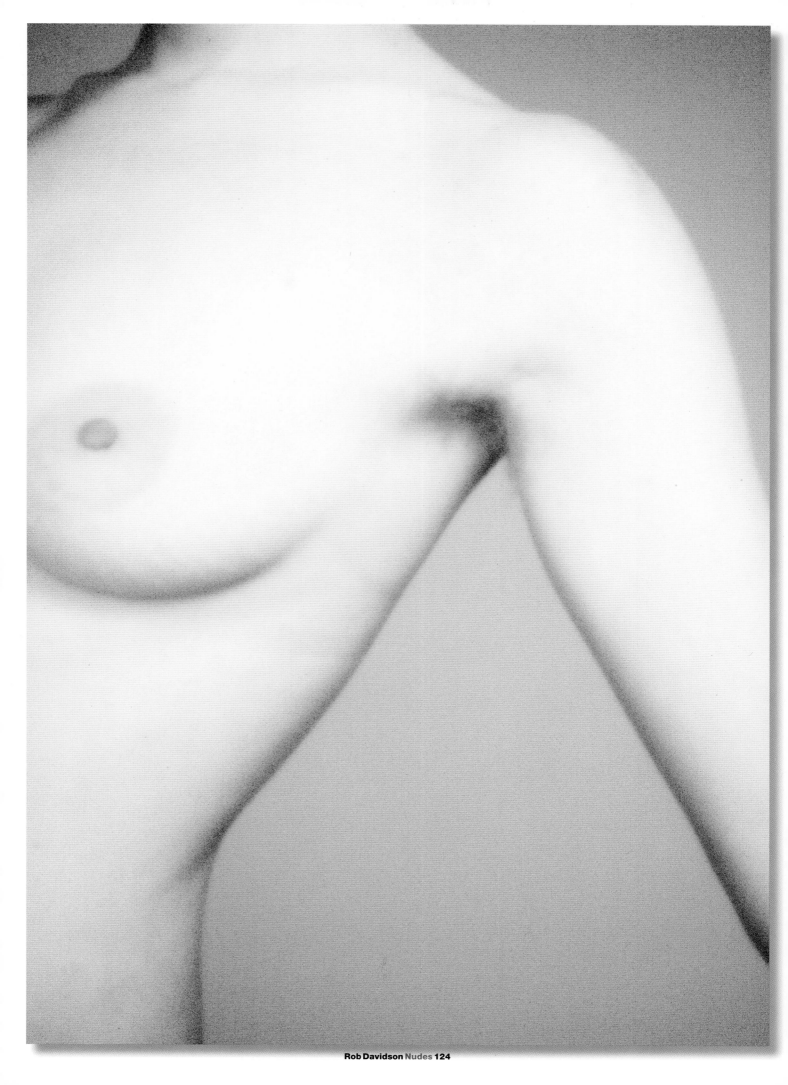

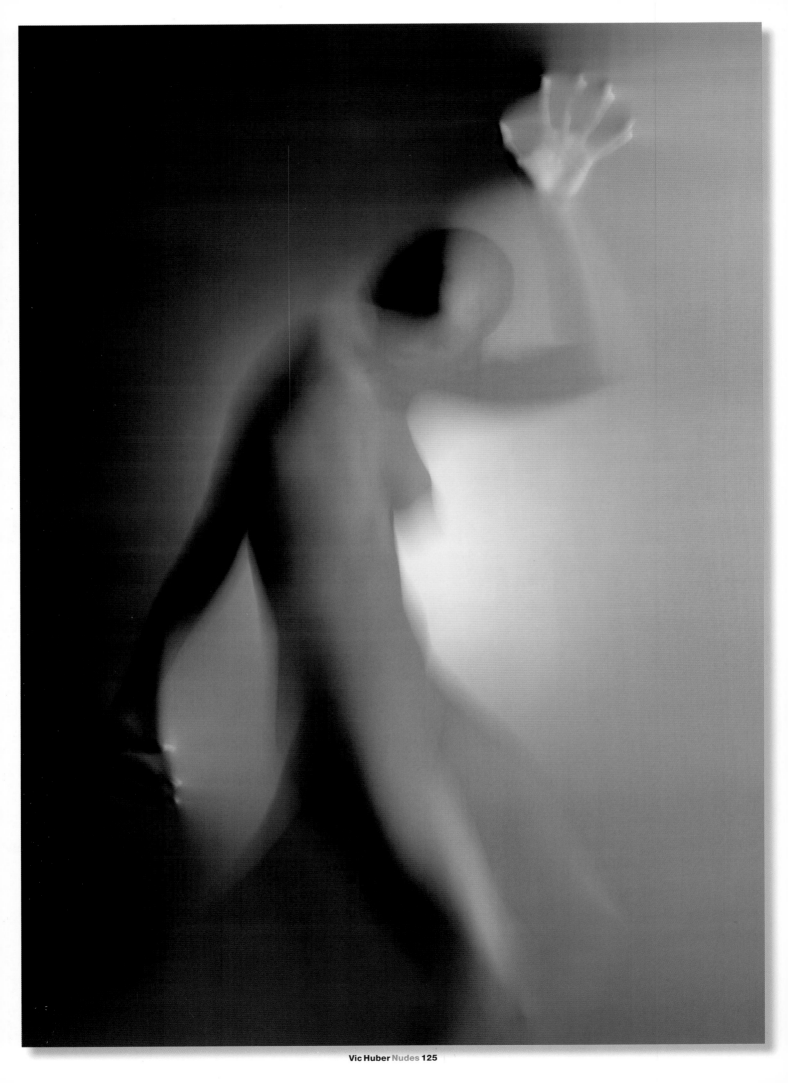

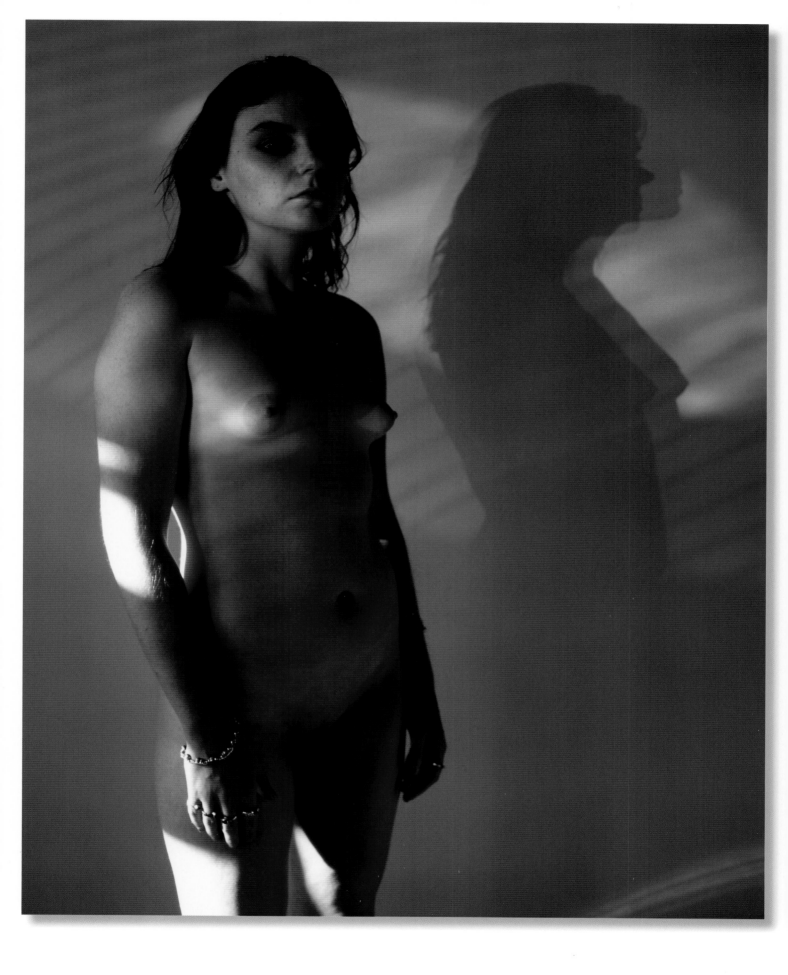

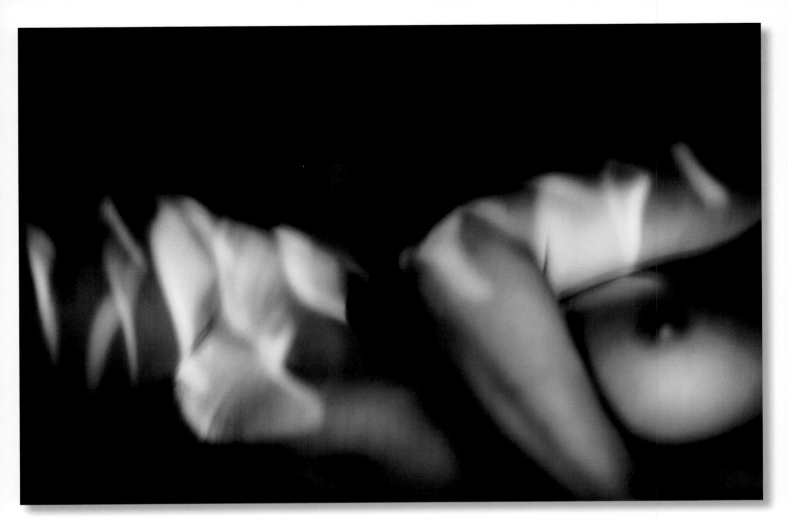

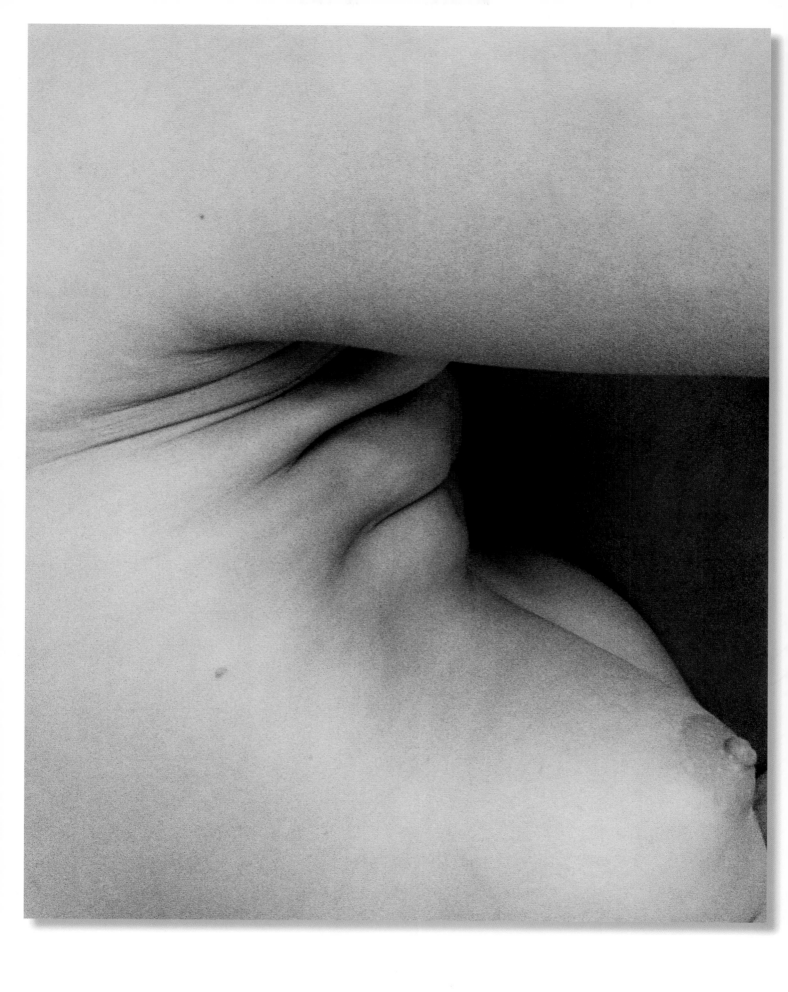

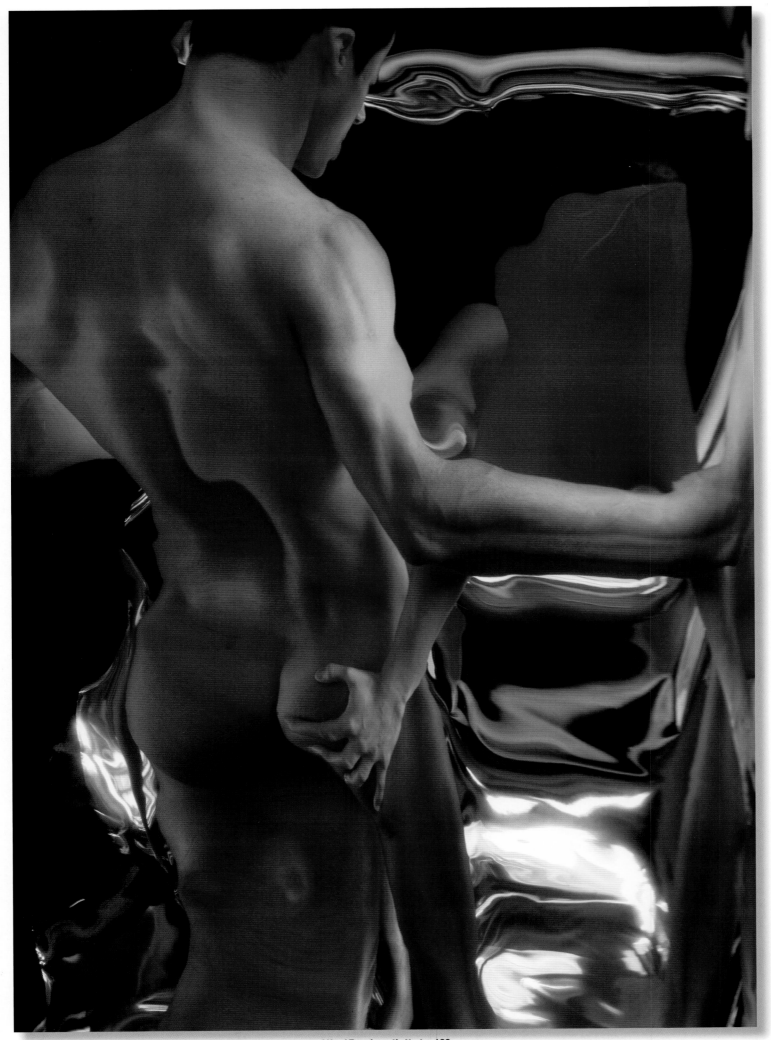

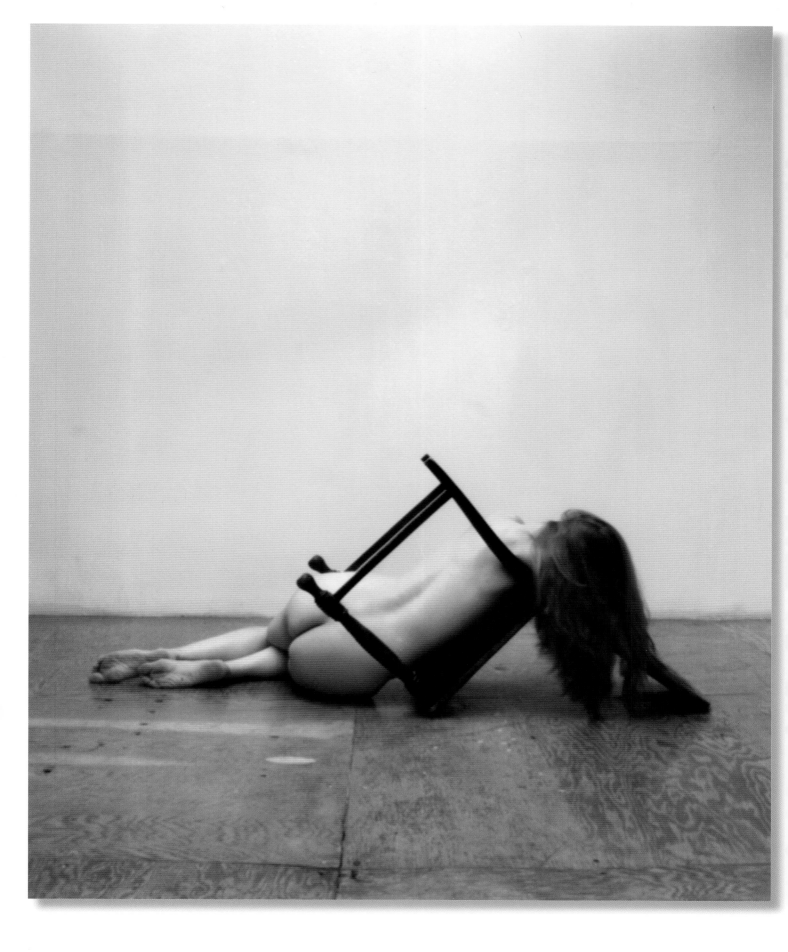

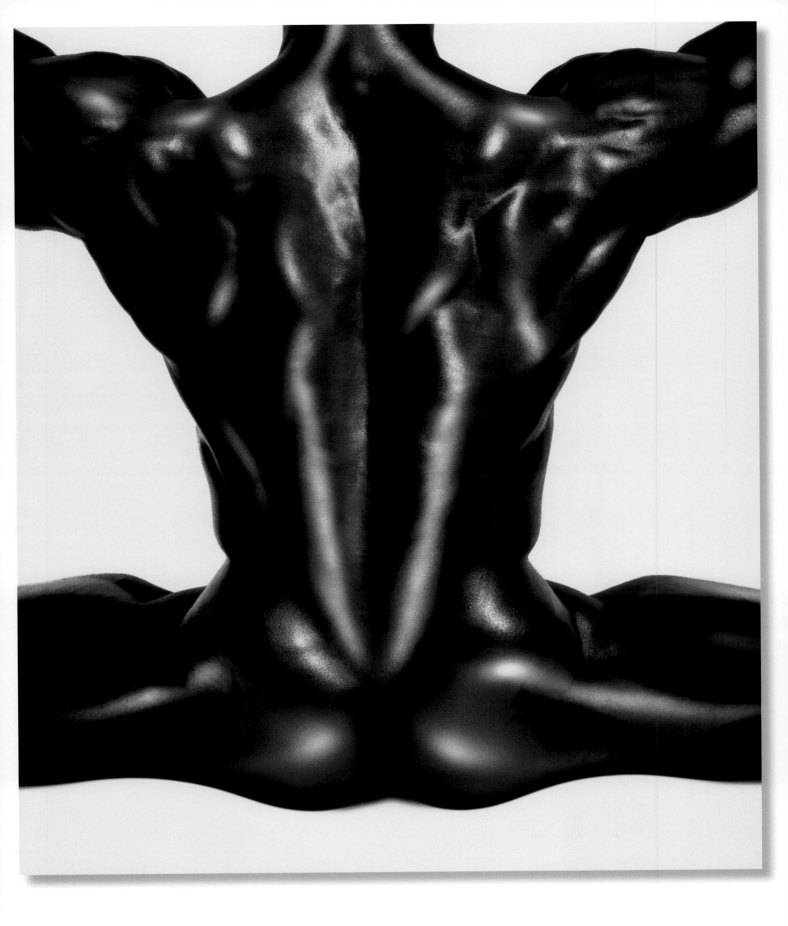

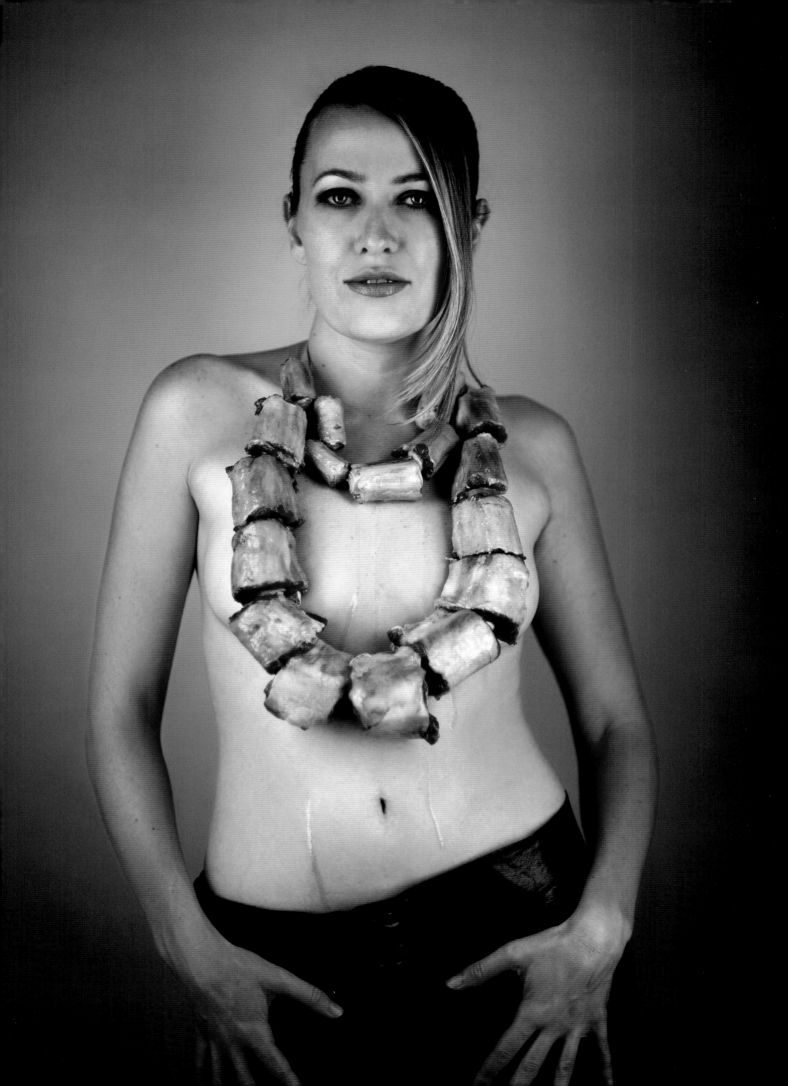

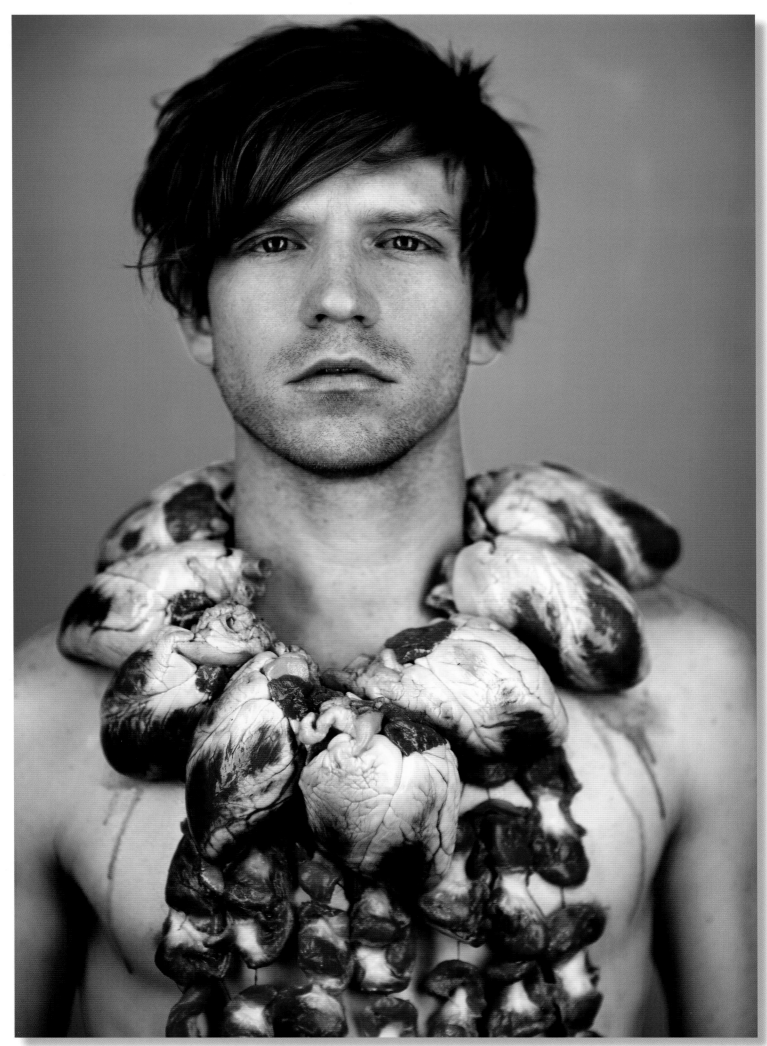

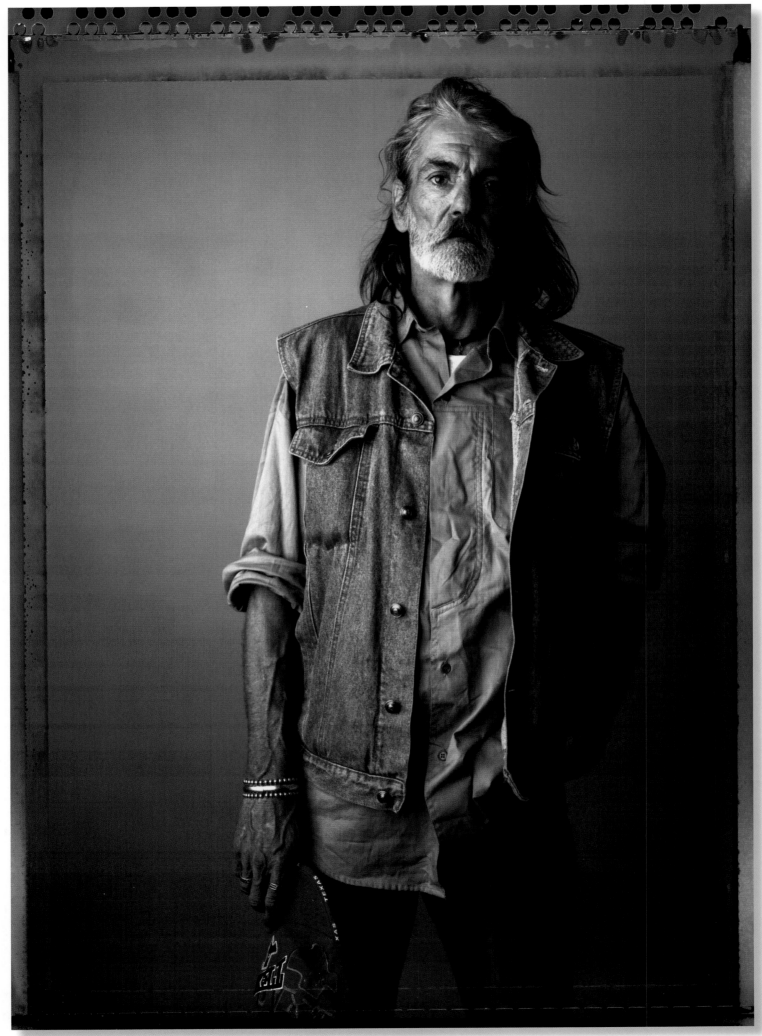

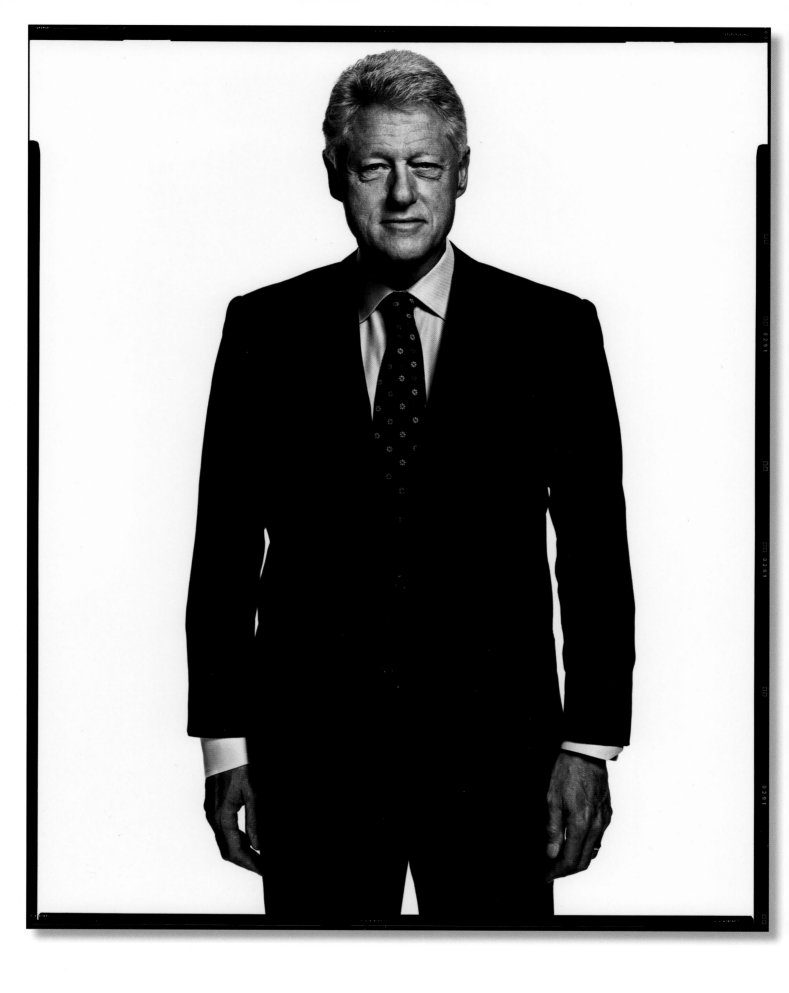

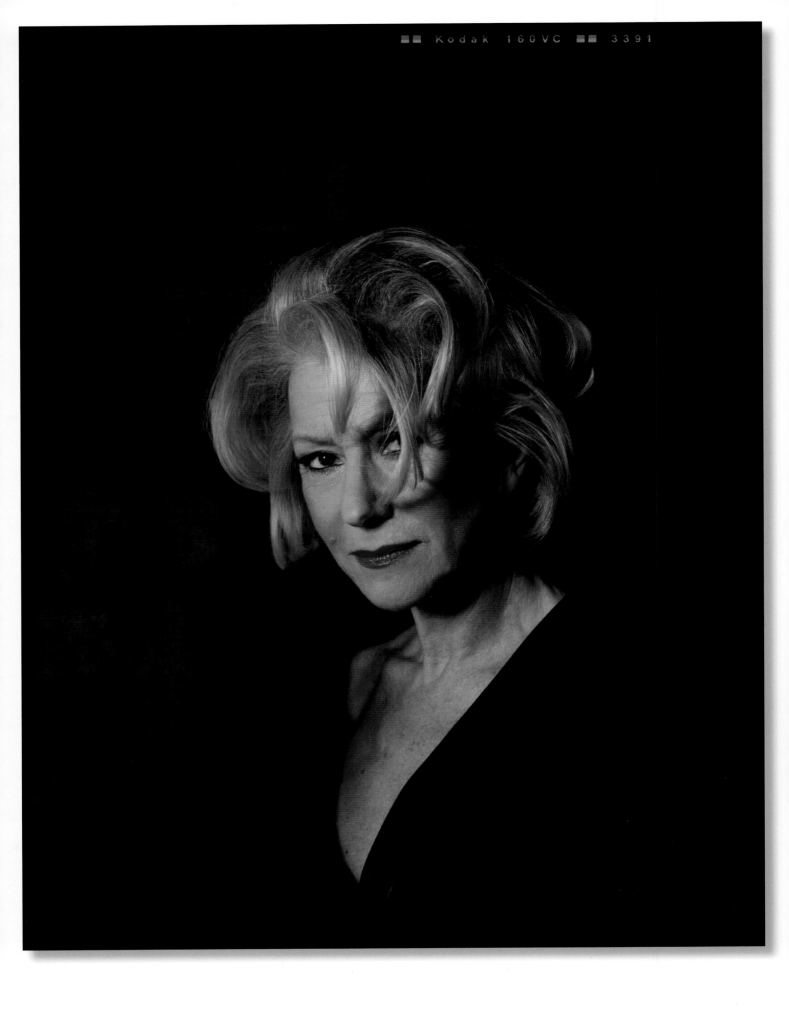

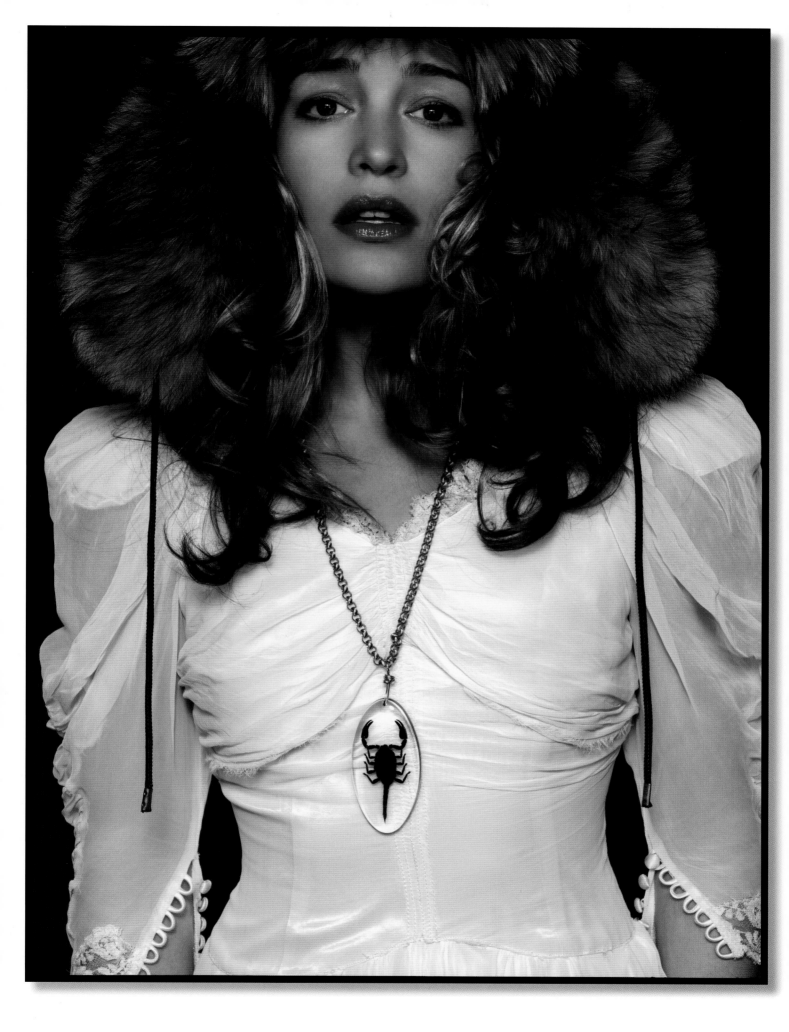

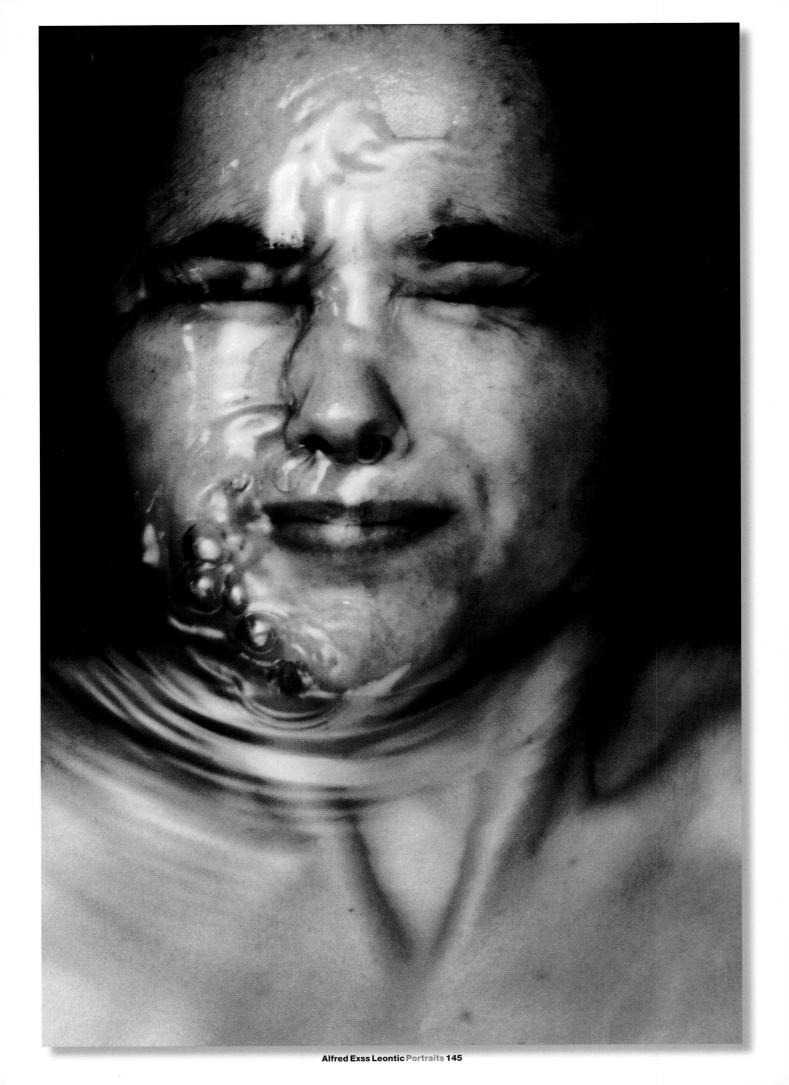

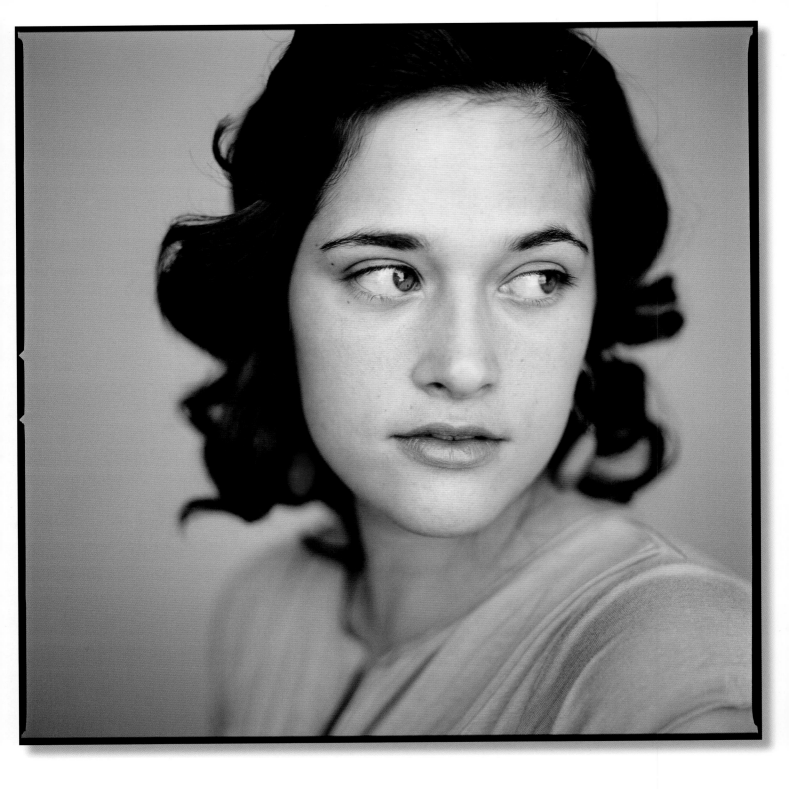

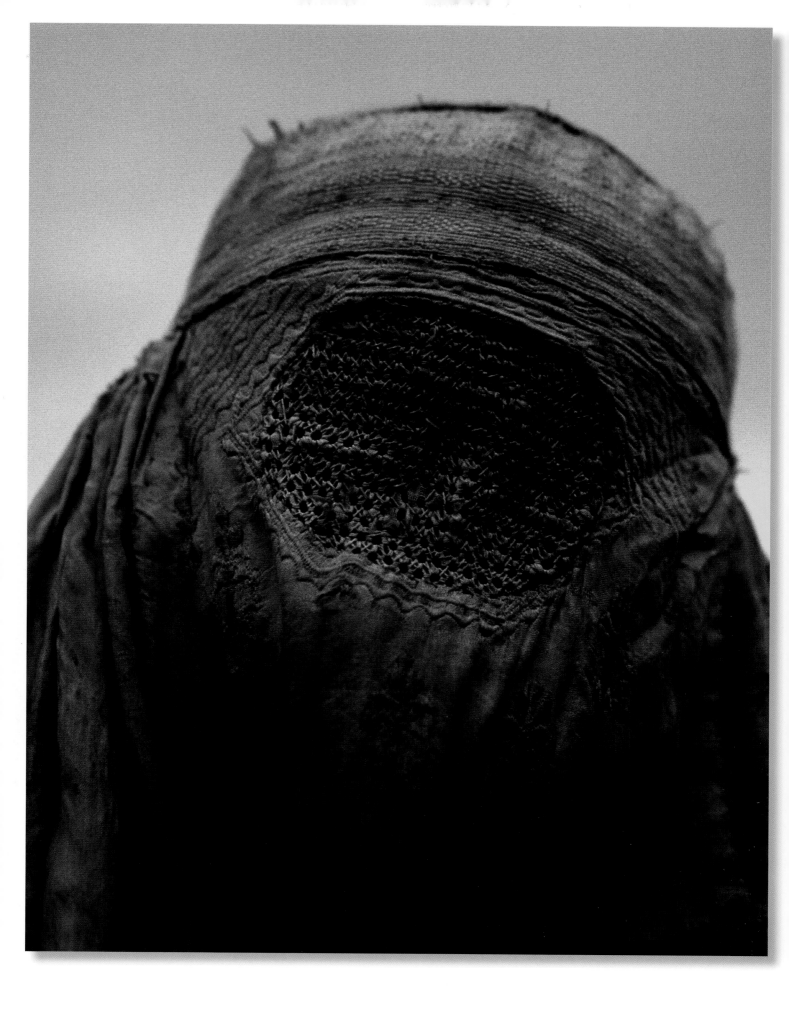

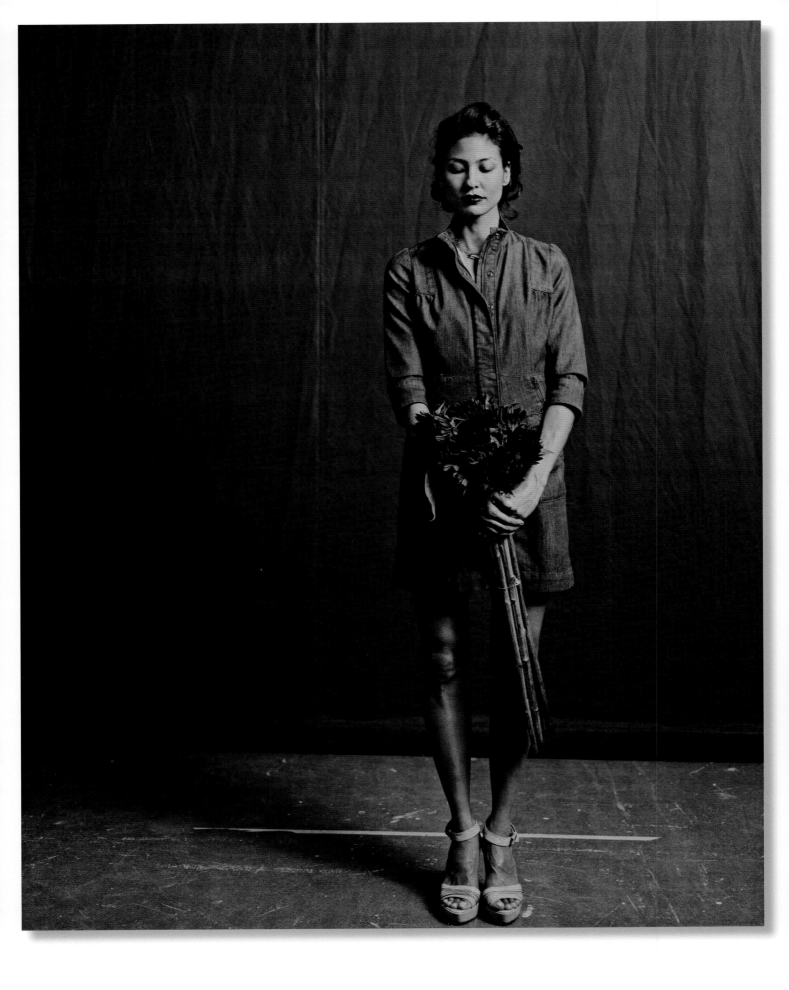

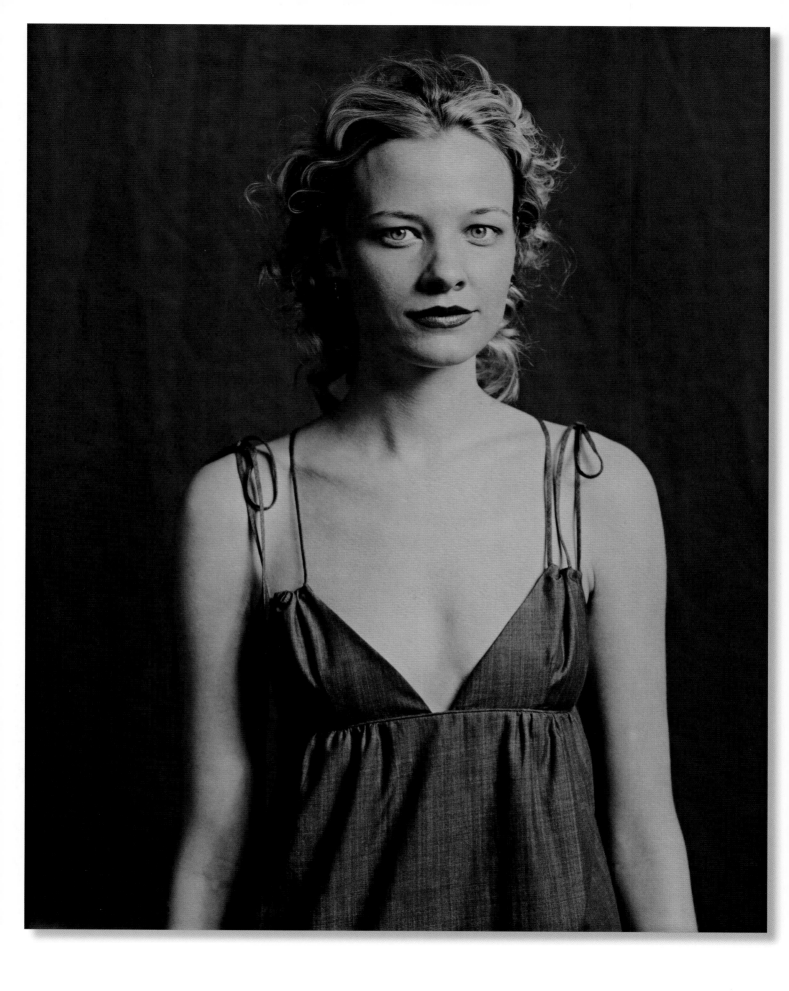

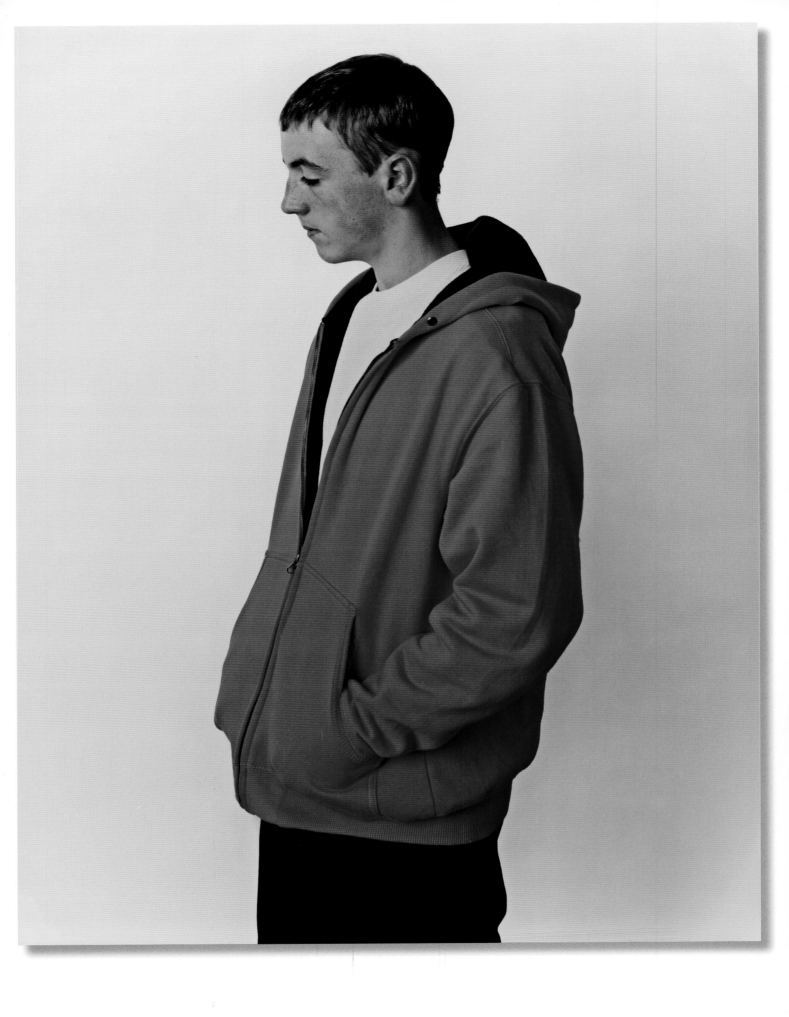

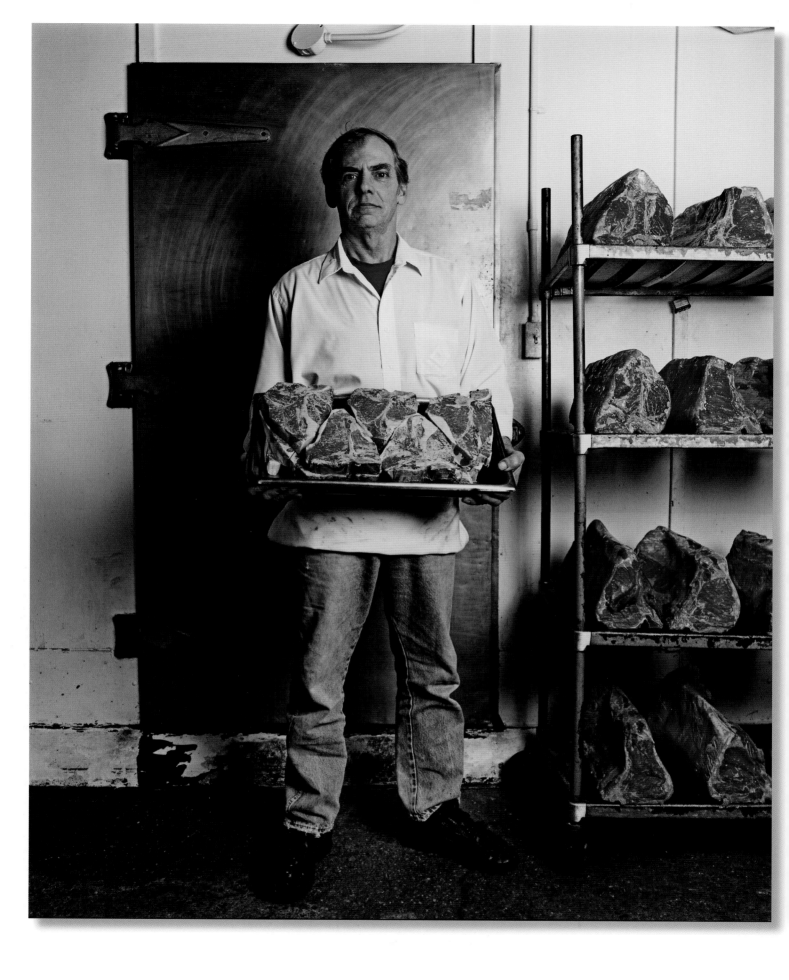

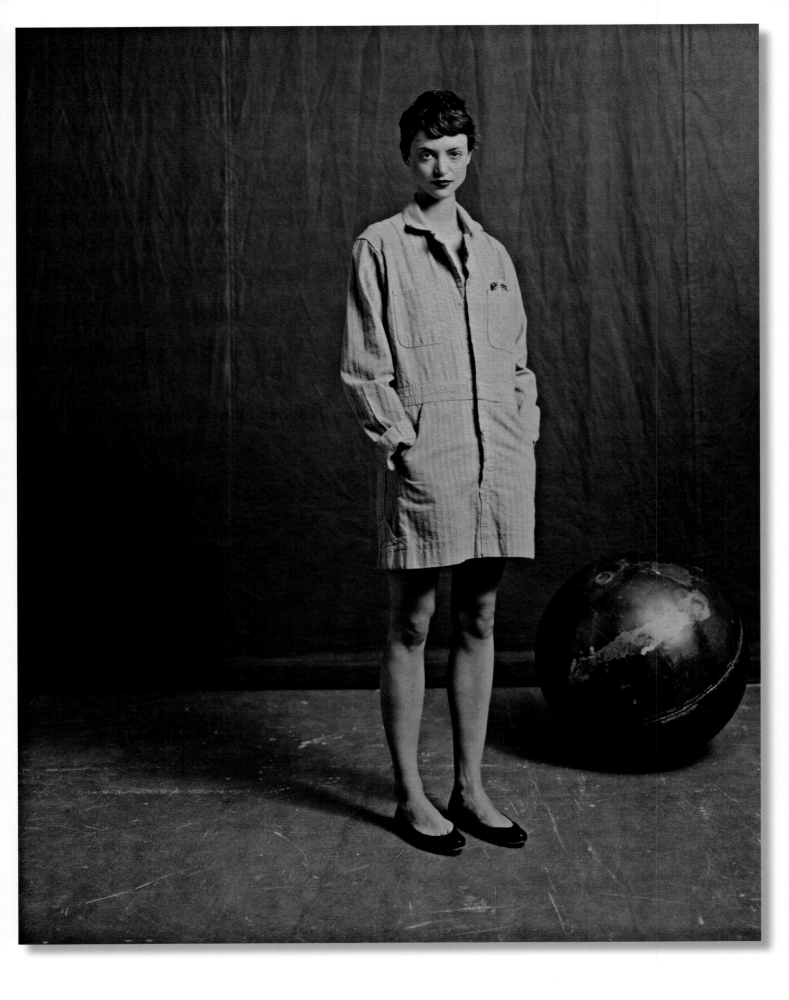

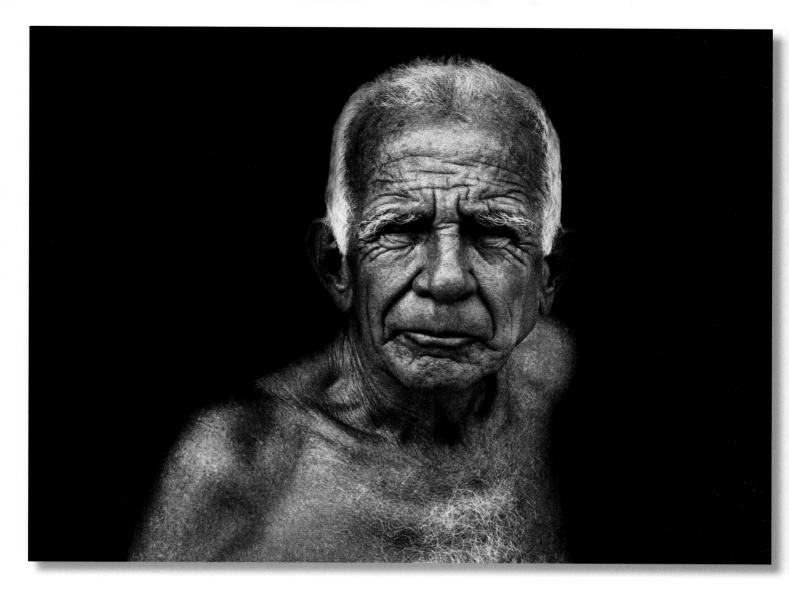

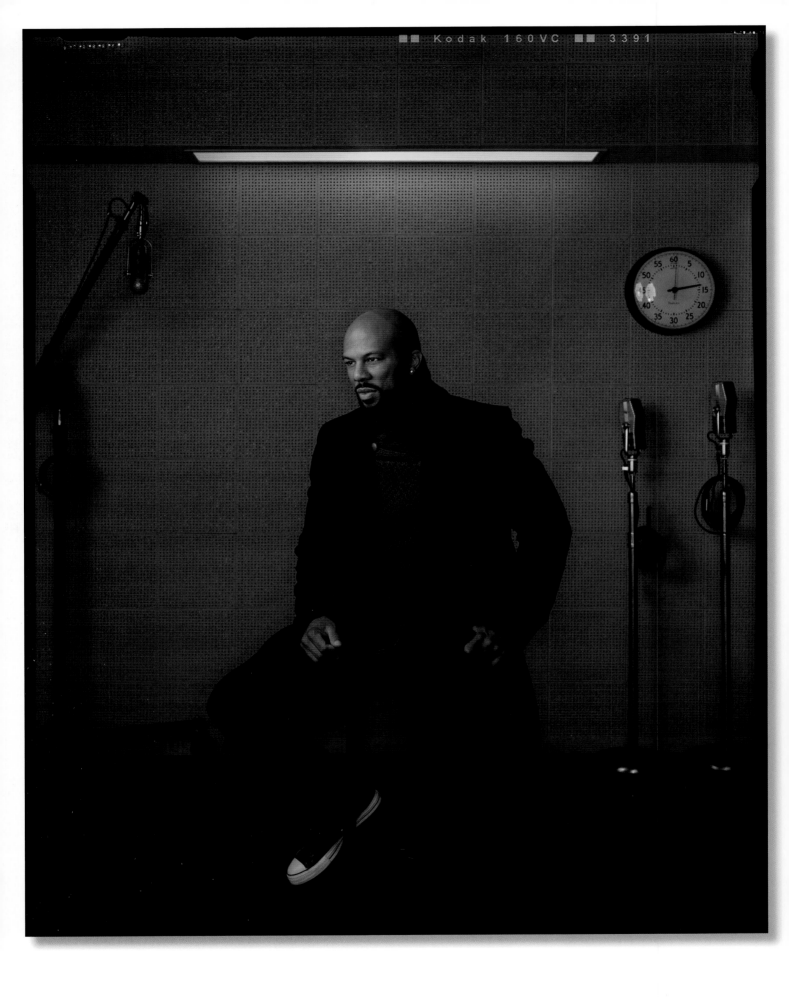

Kodak 160VC 3391

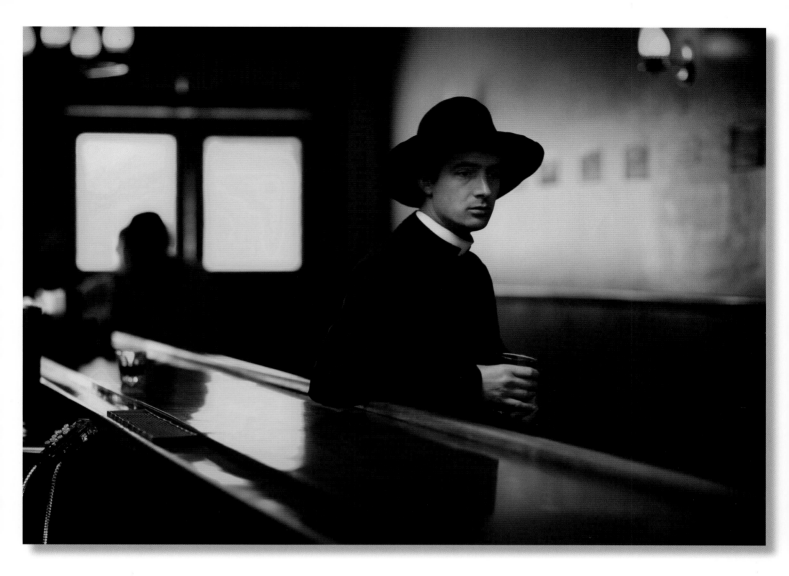

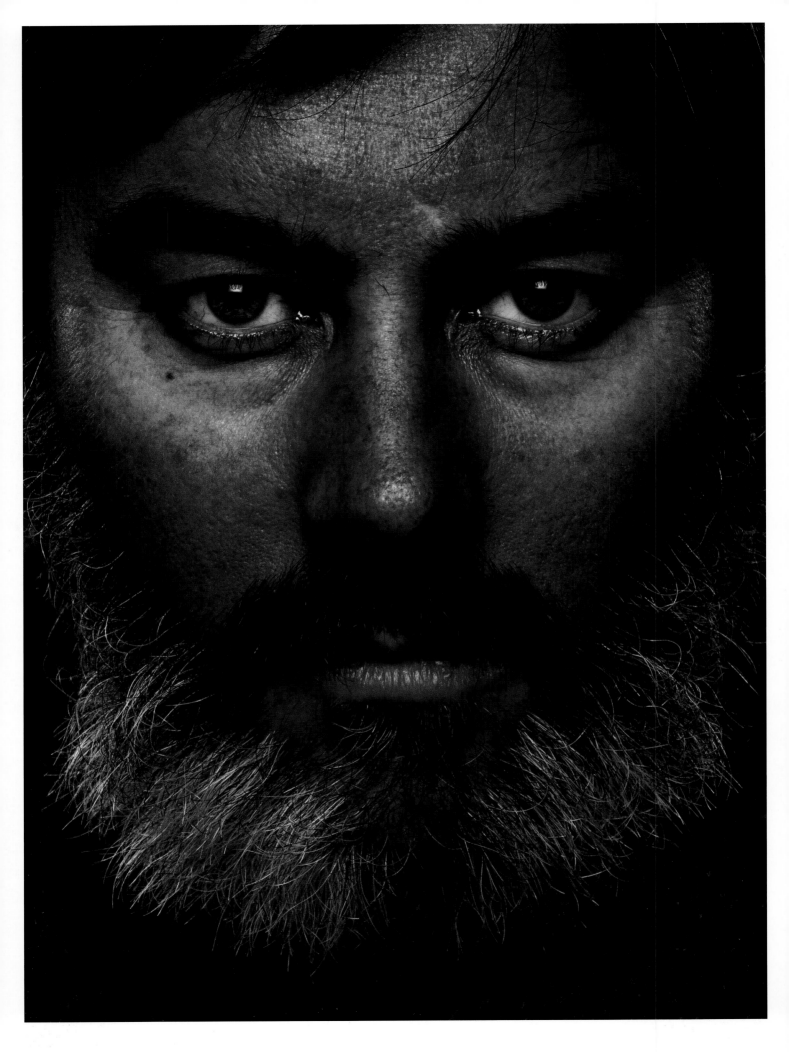

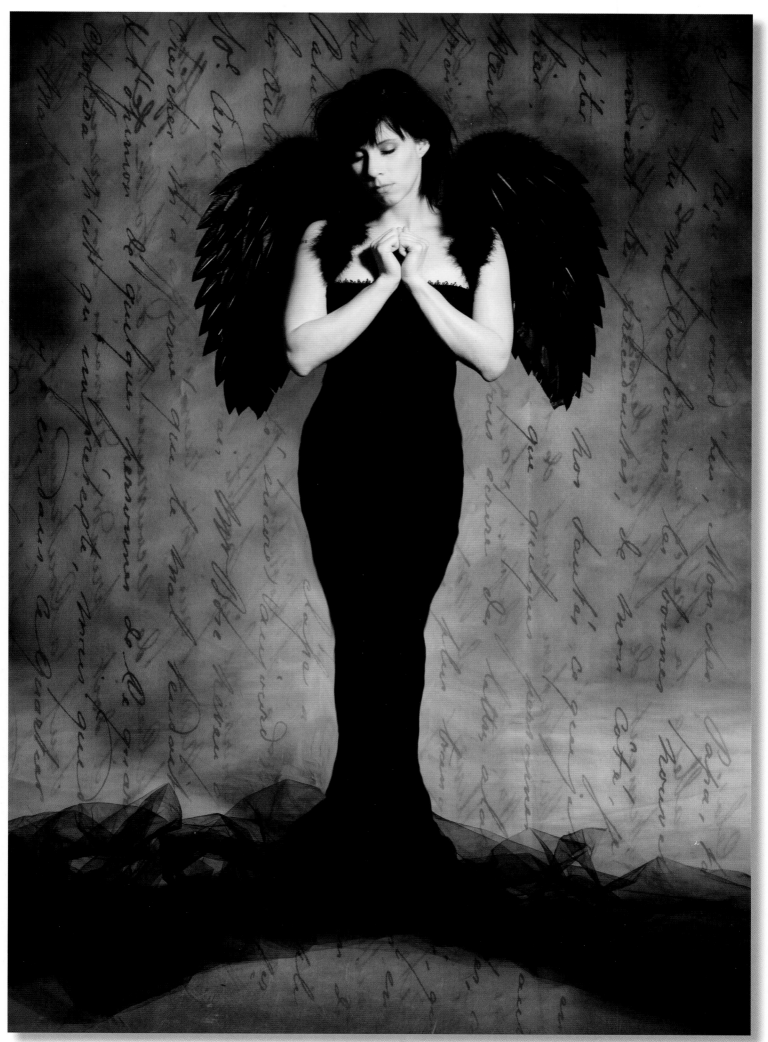

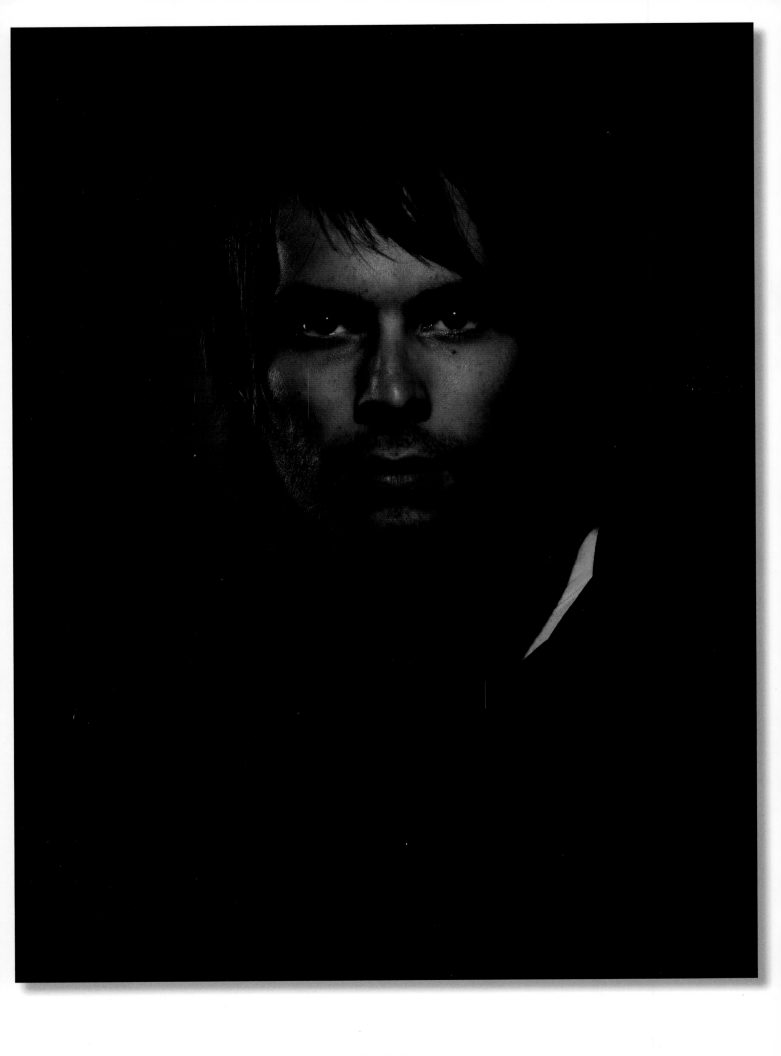

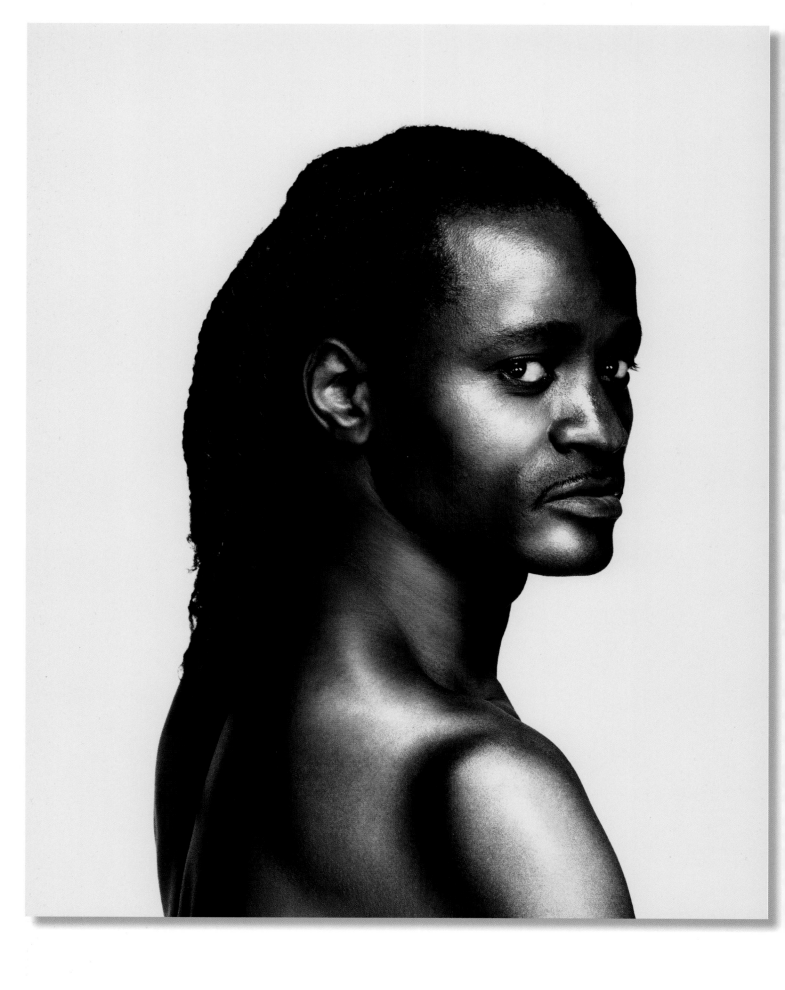

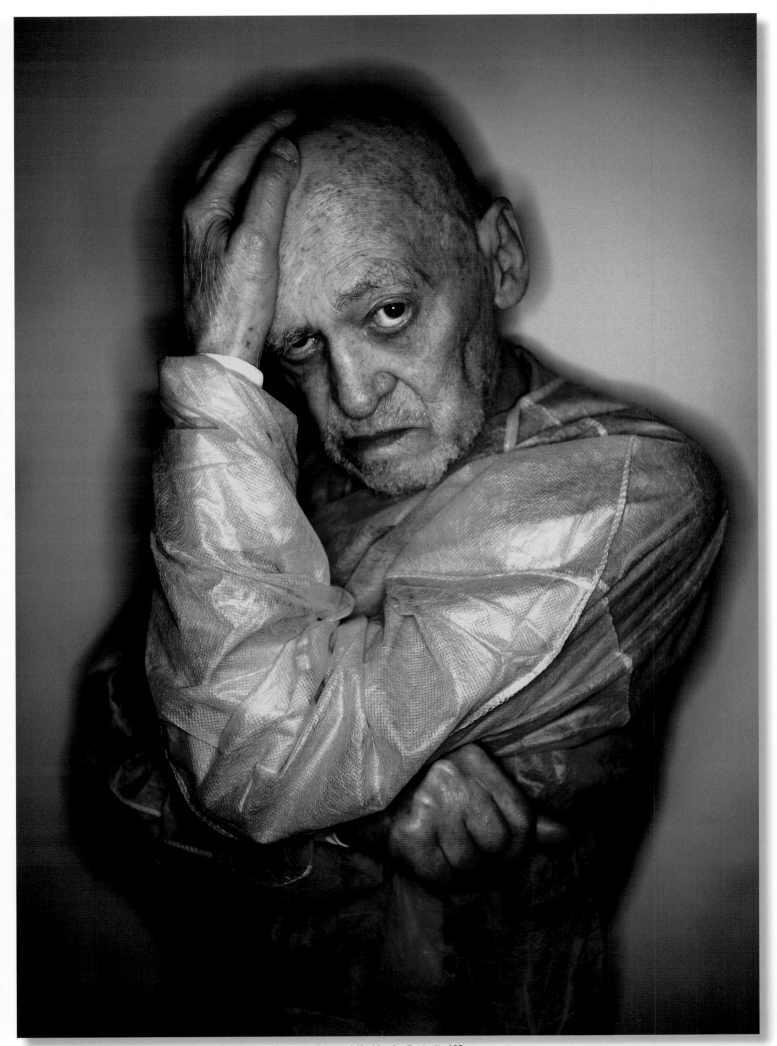

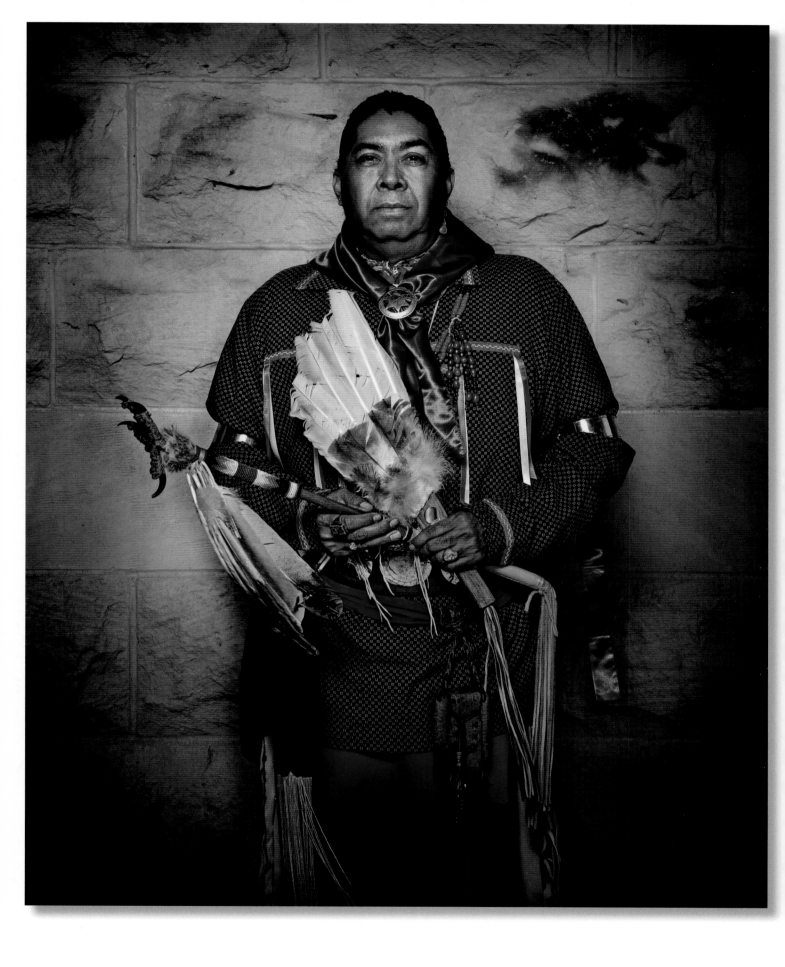

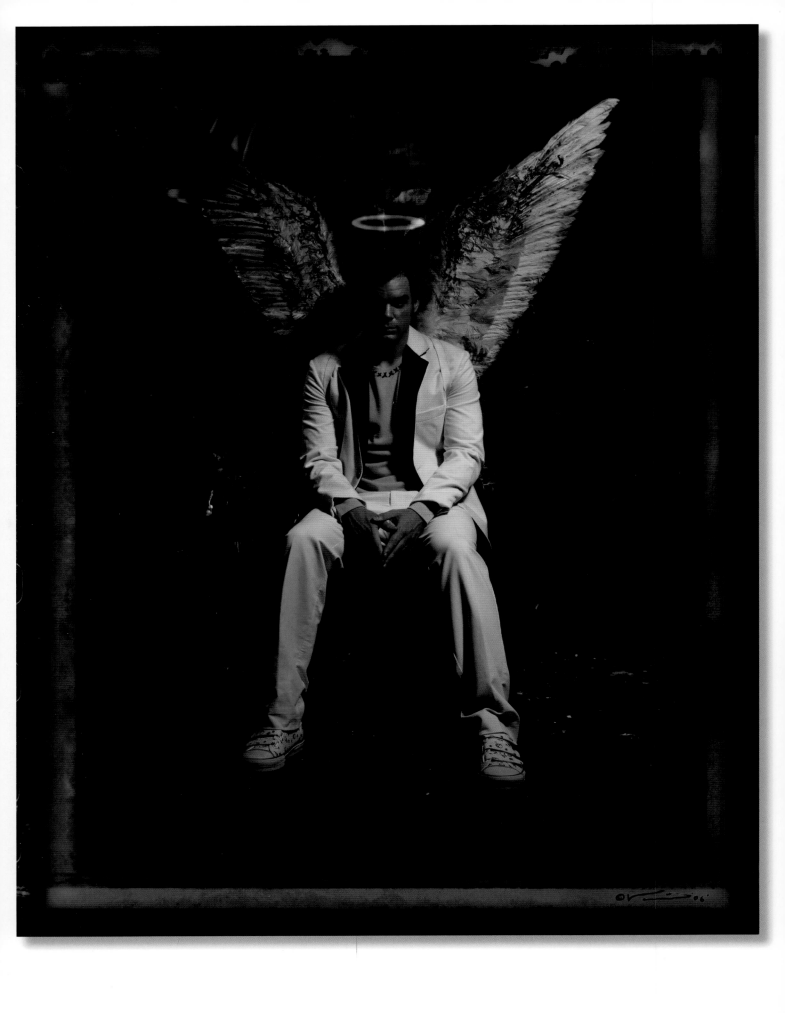

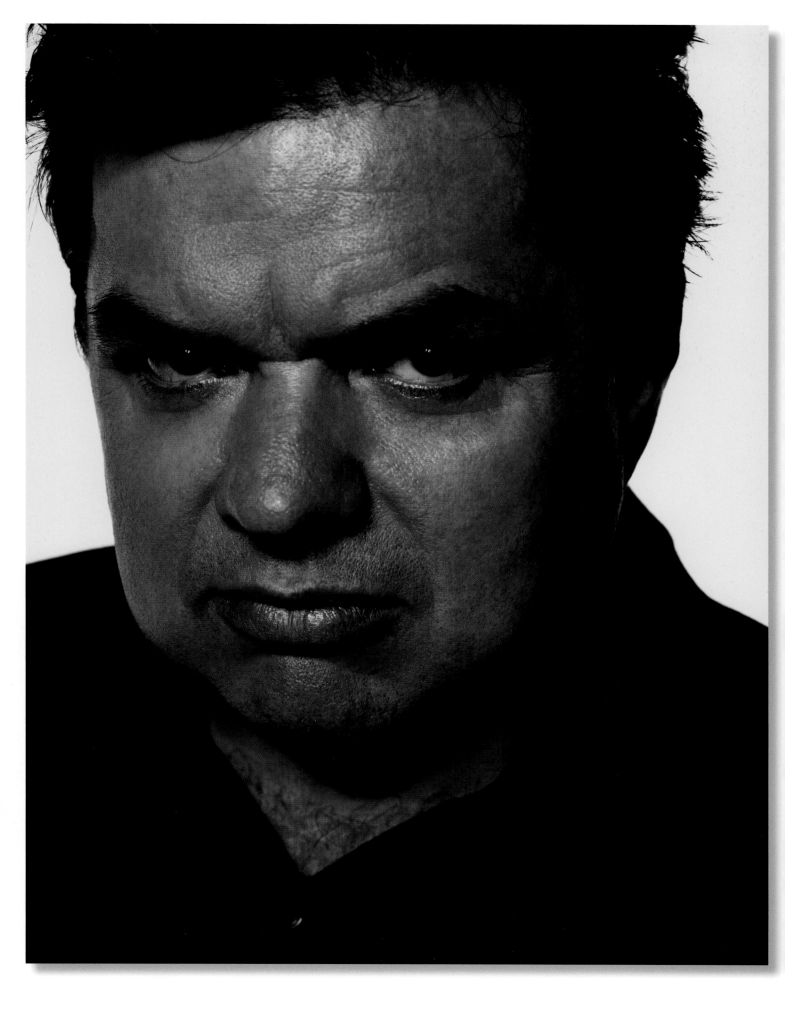

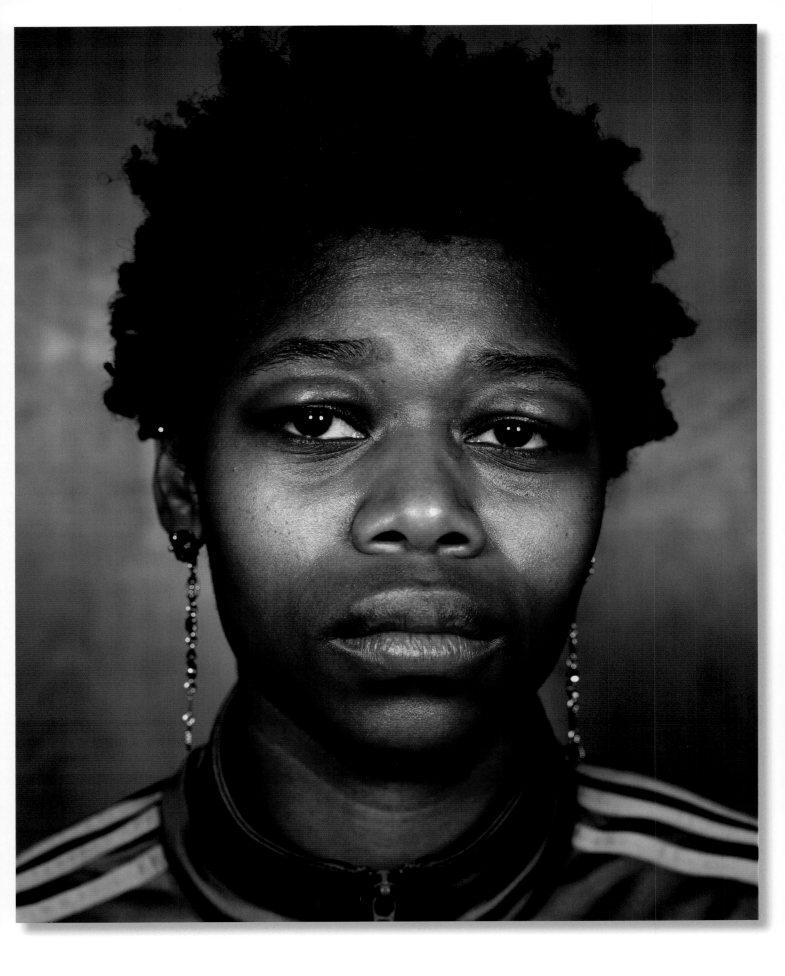

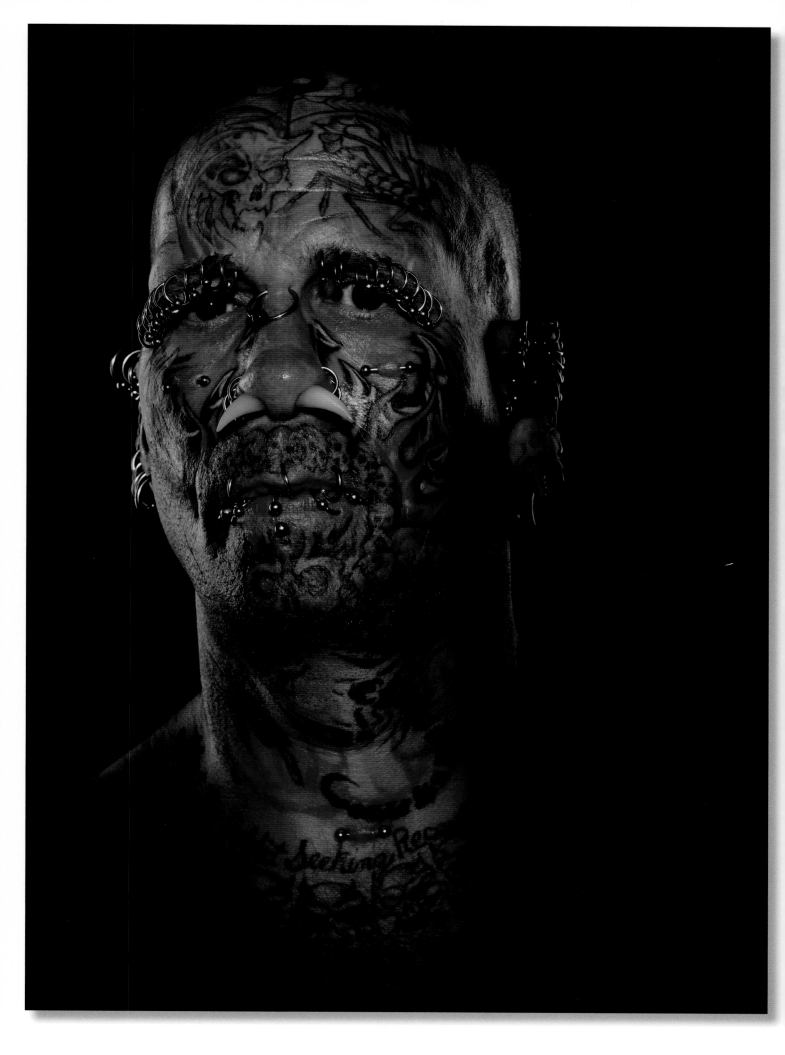

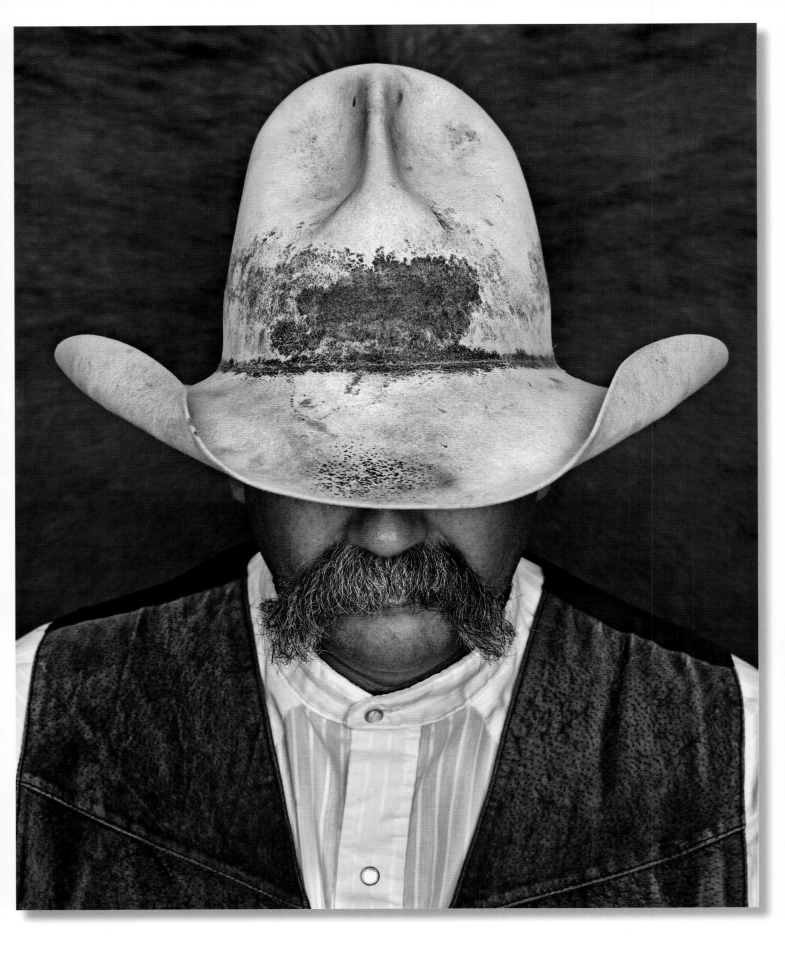

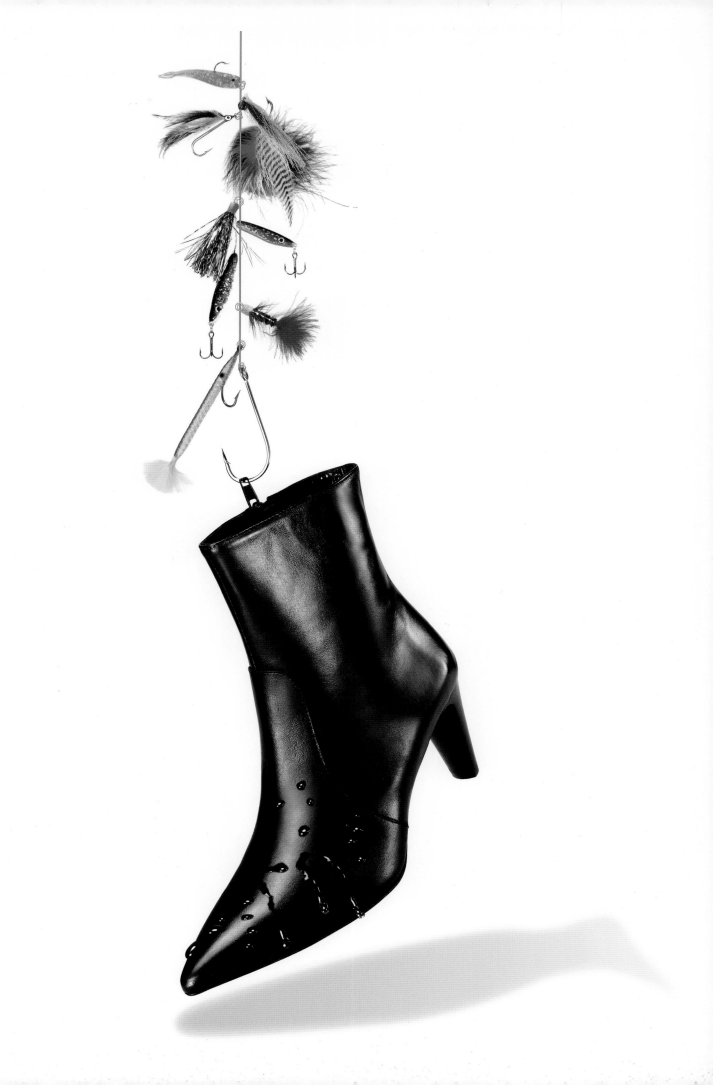

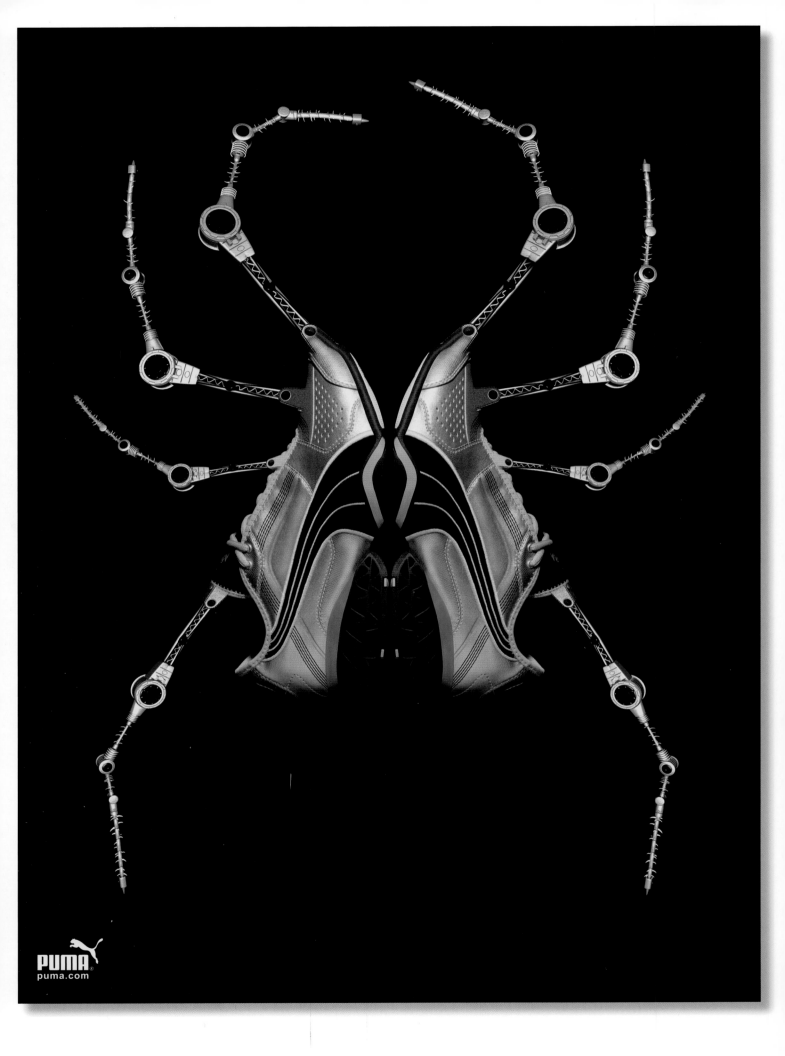

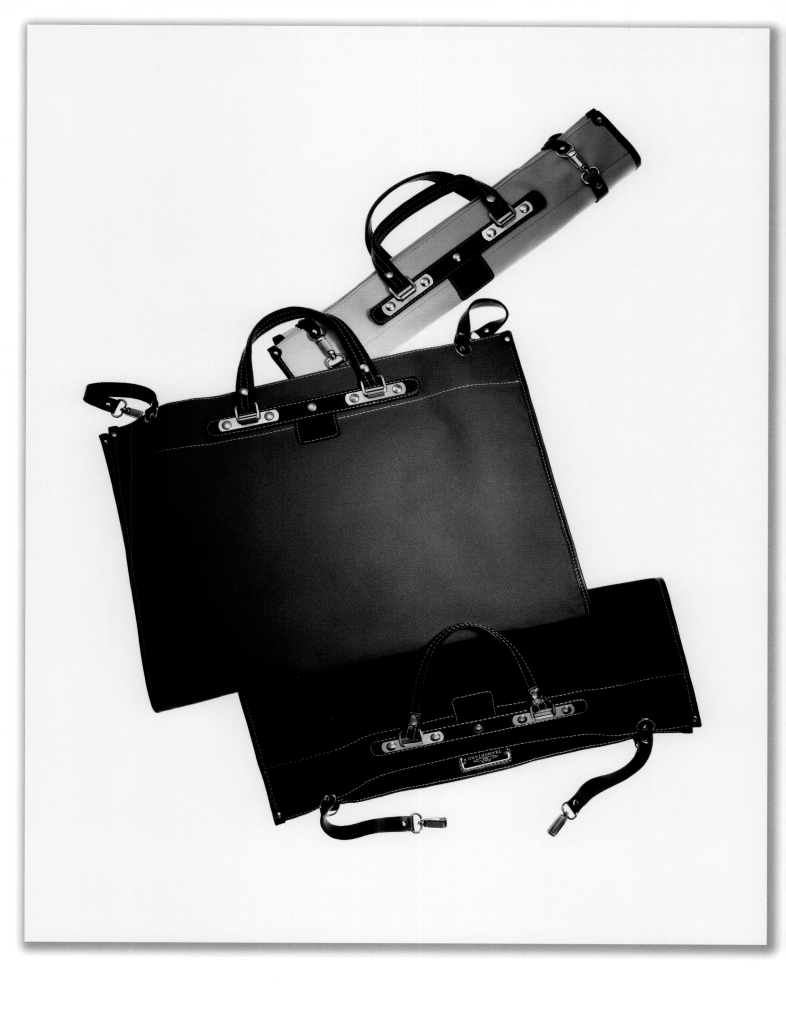

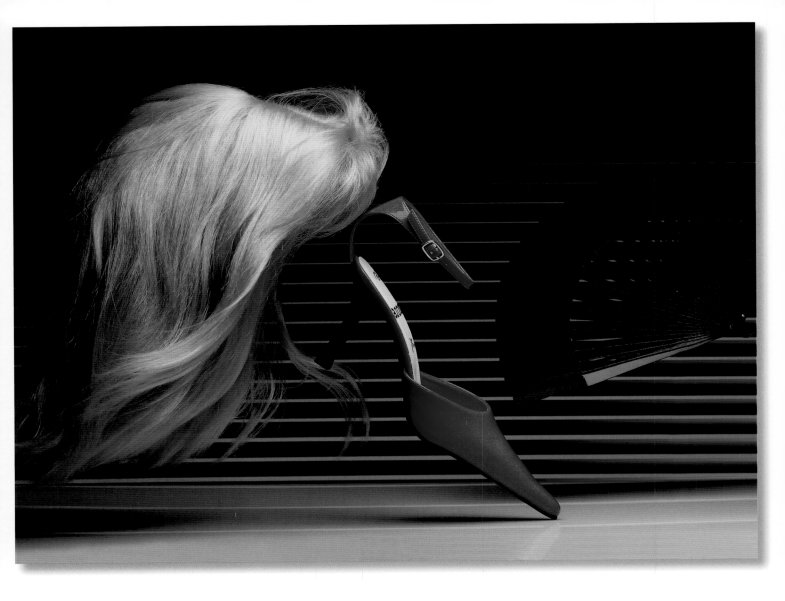

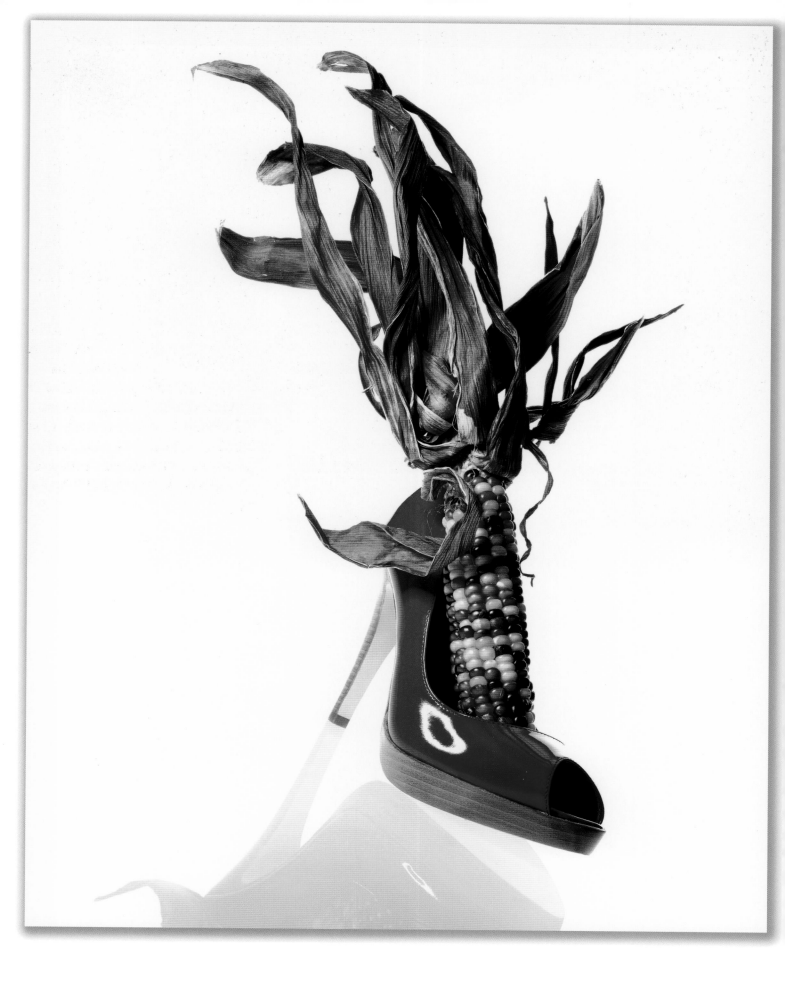

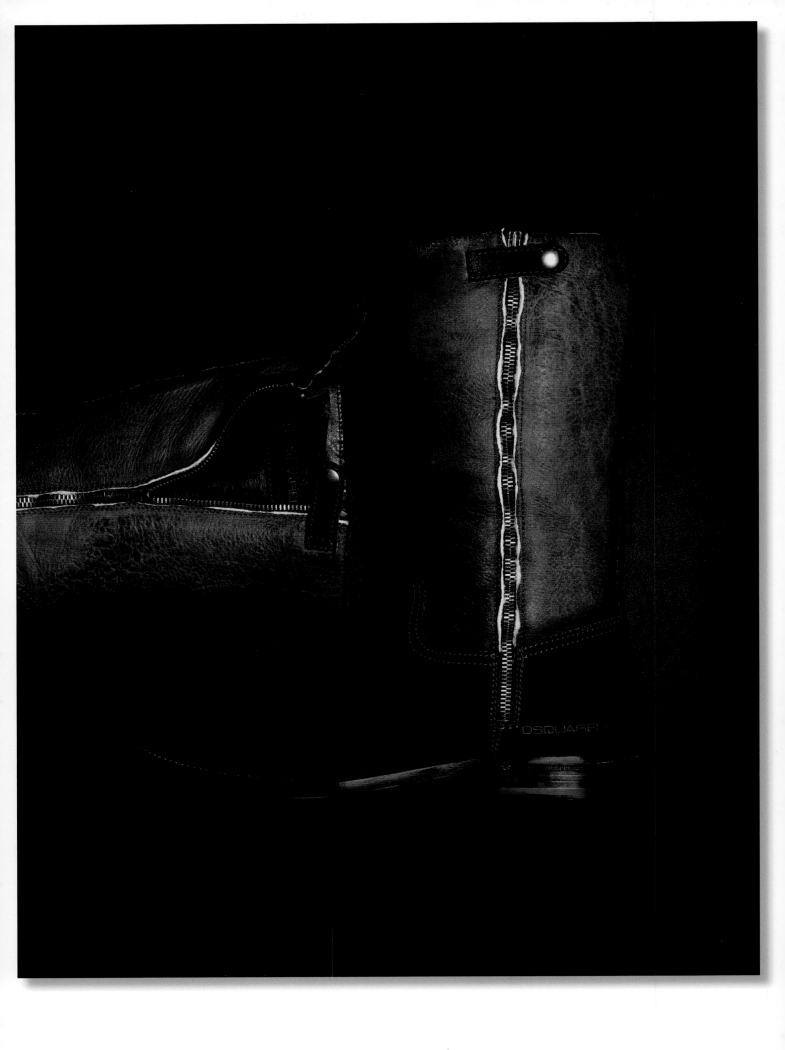

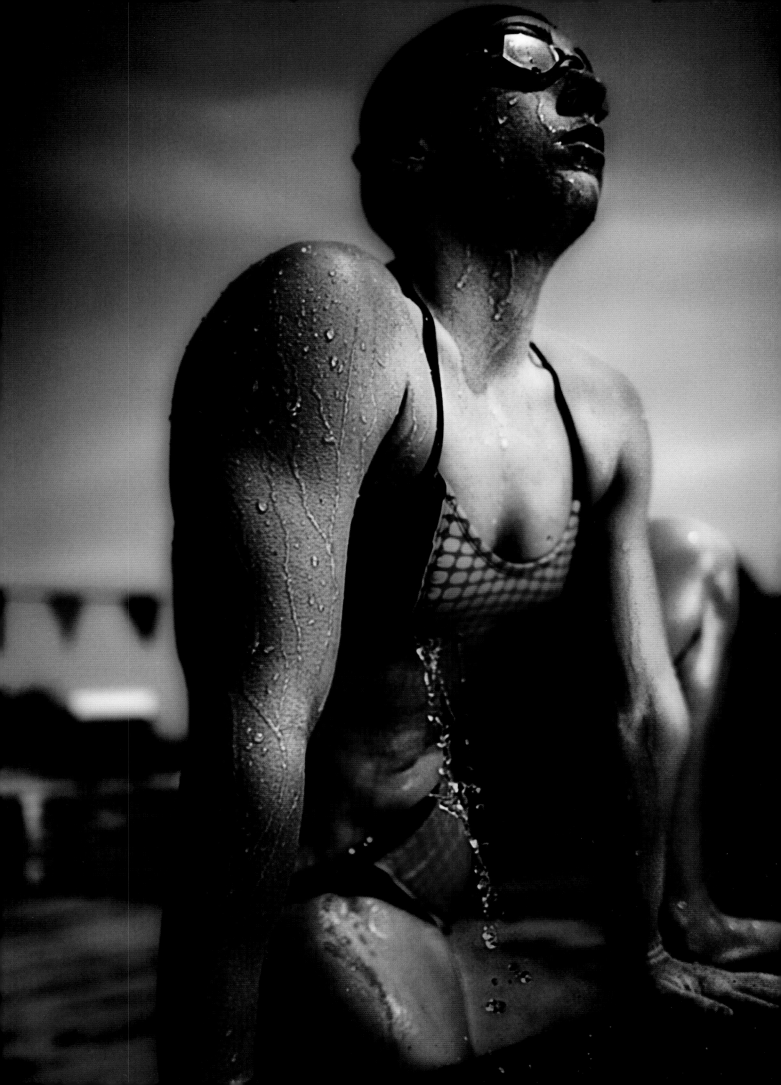

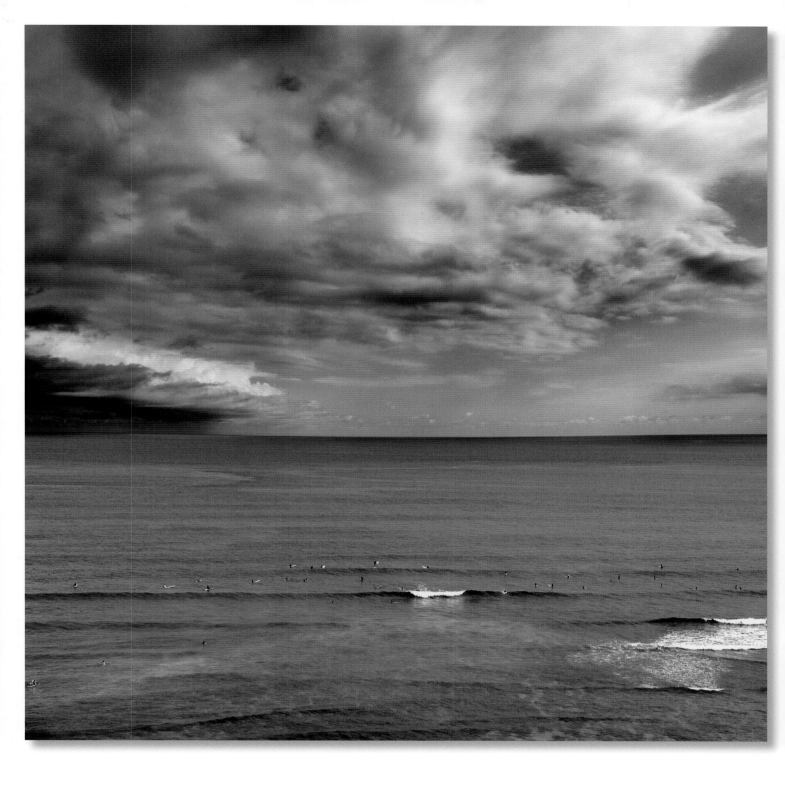

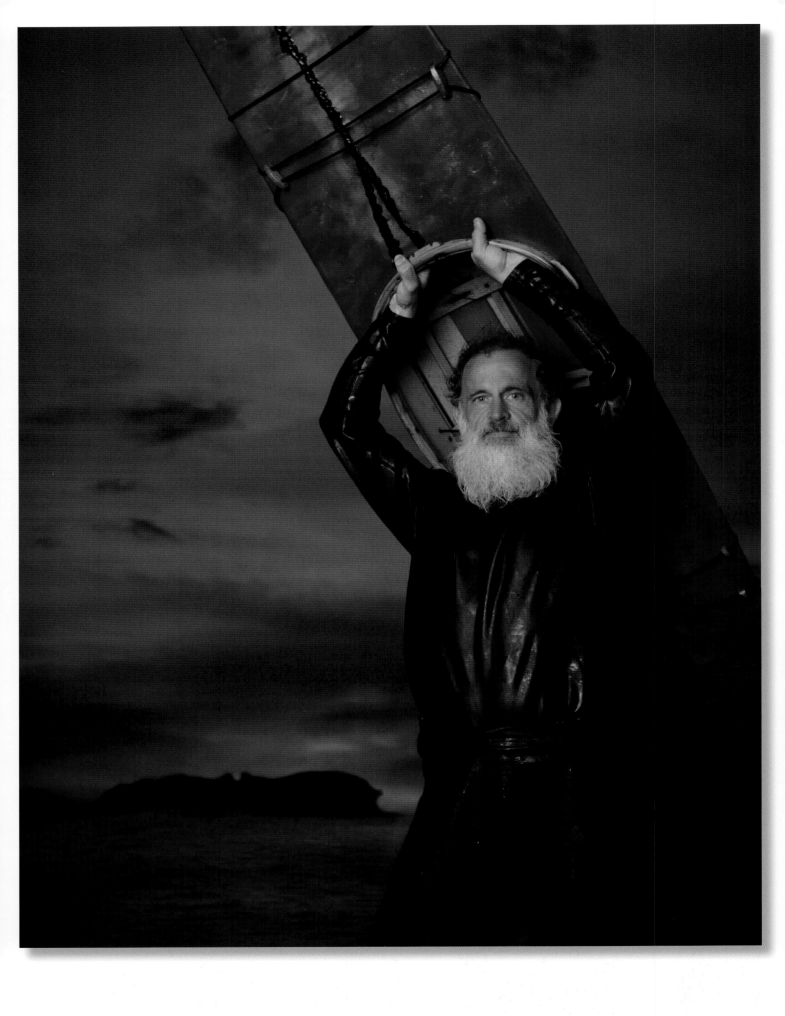

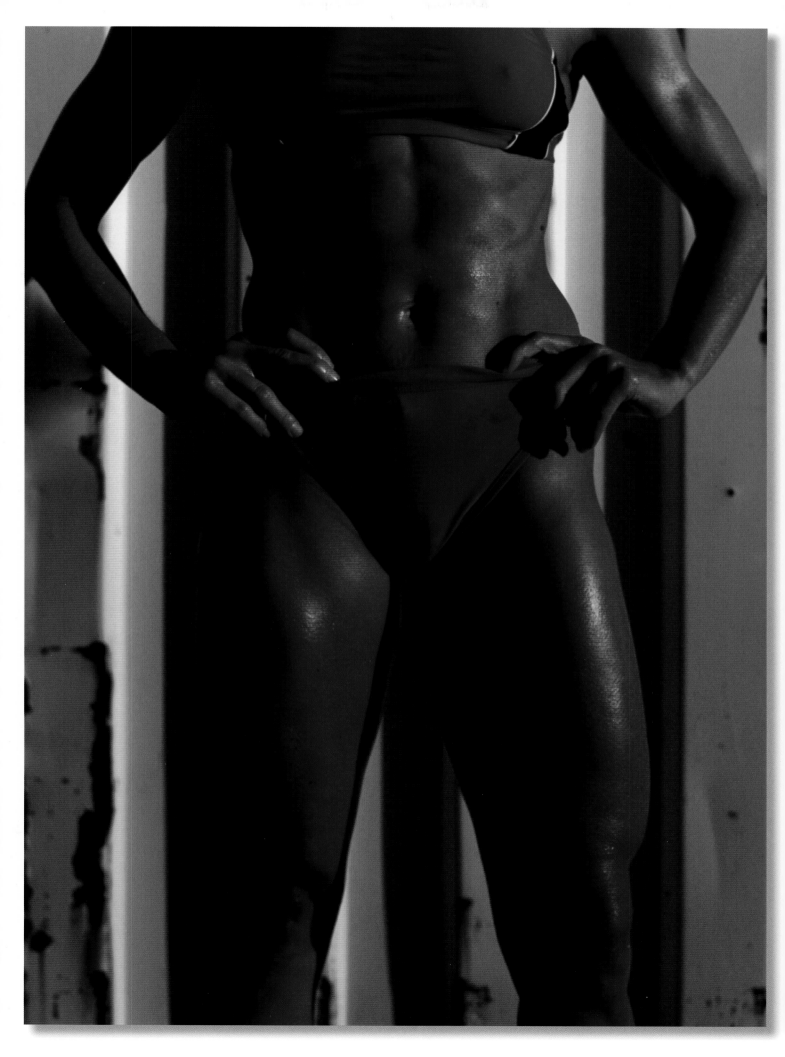

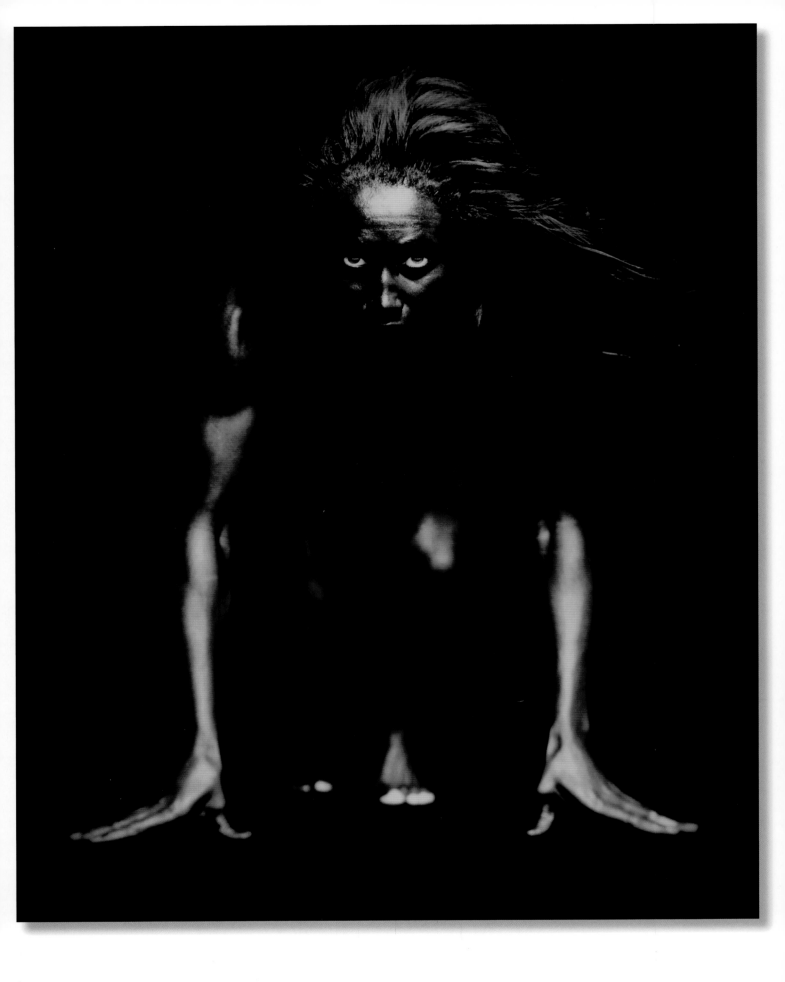

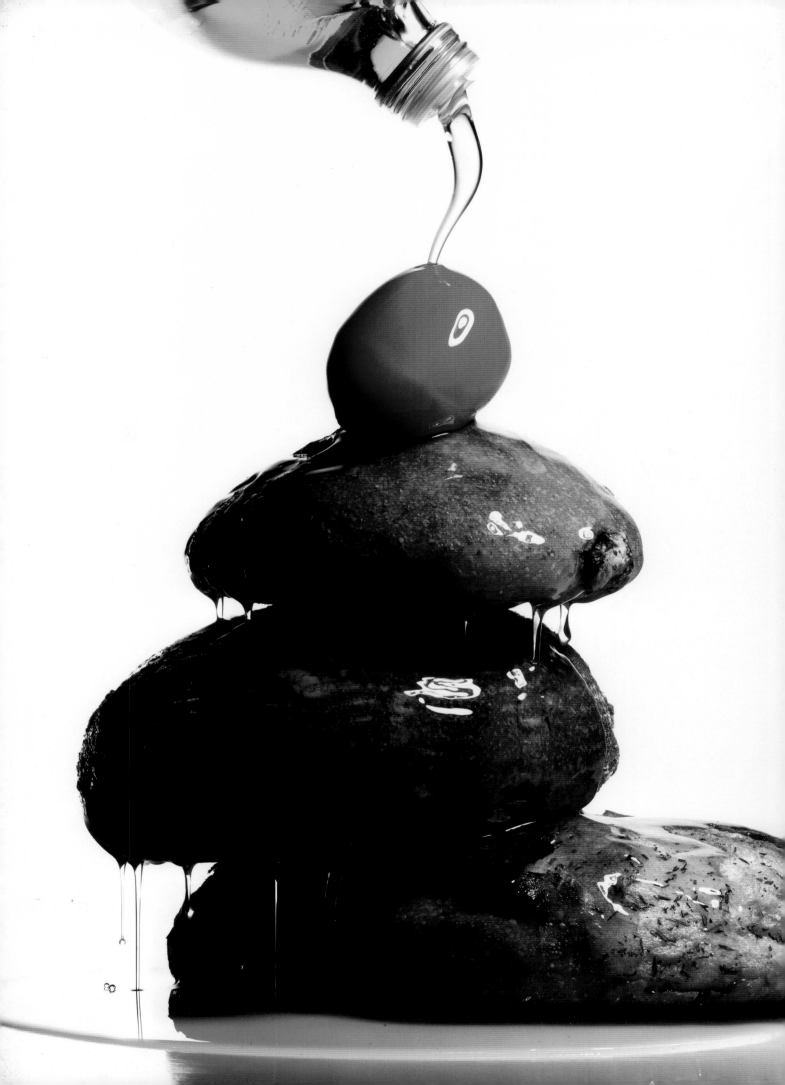

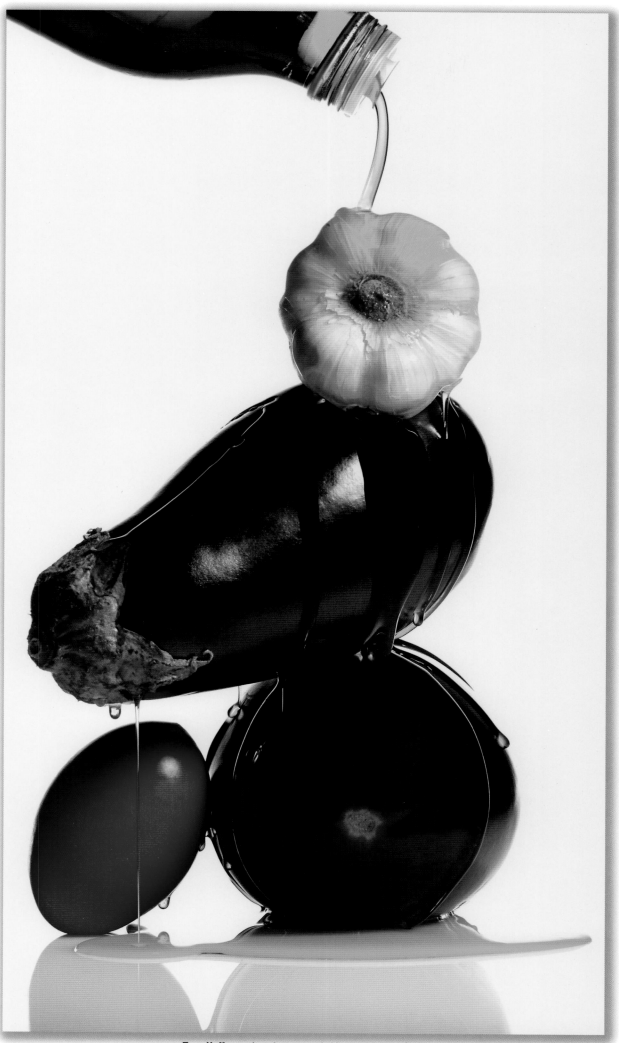

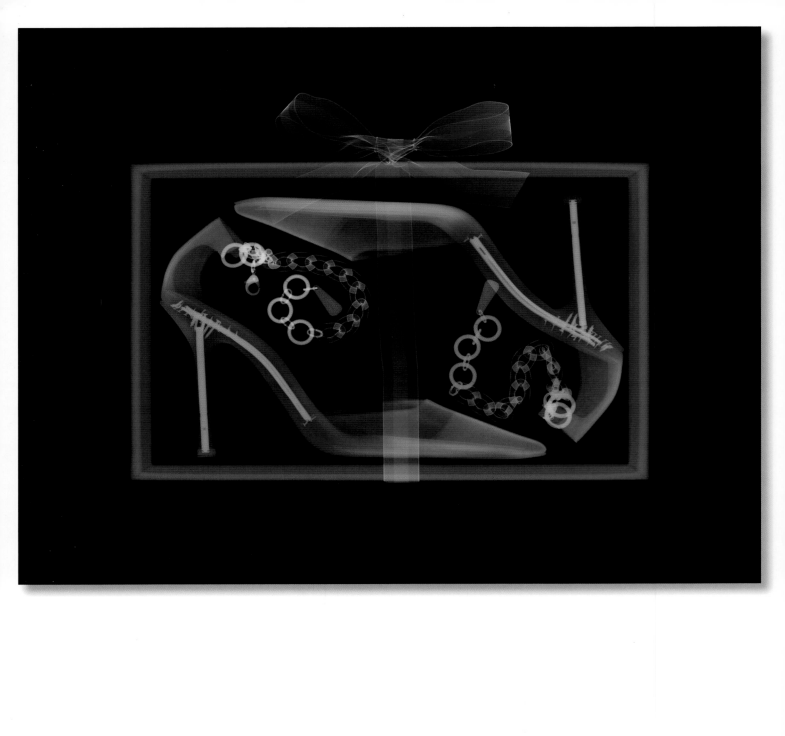

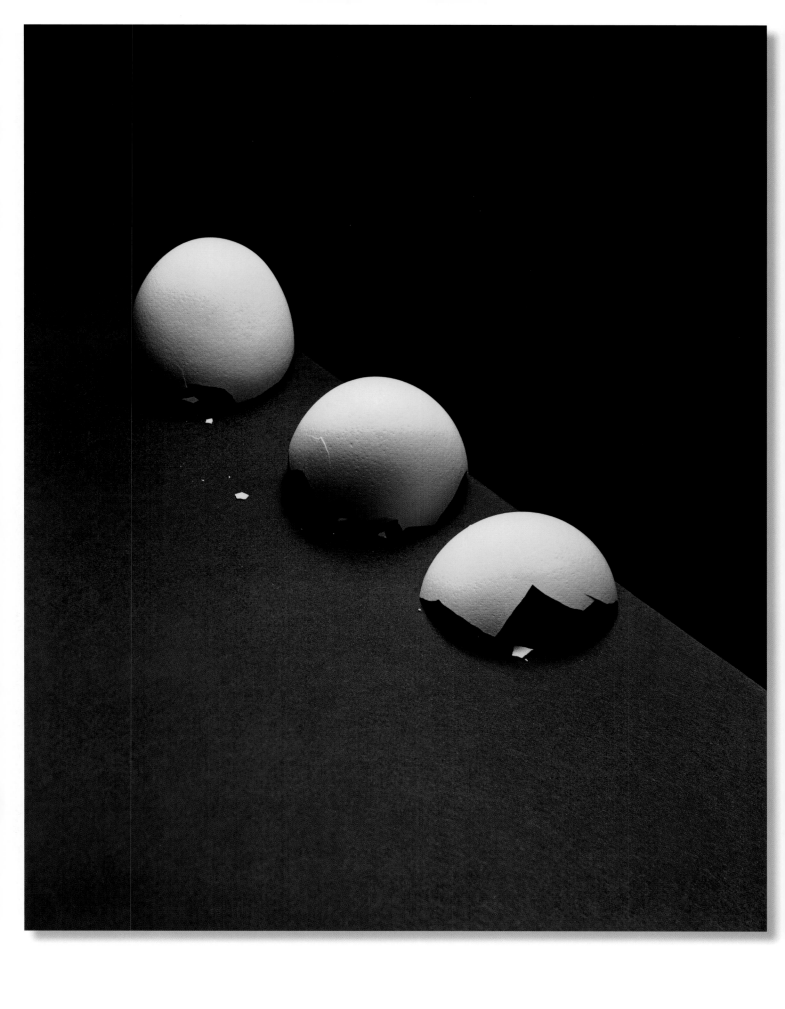

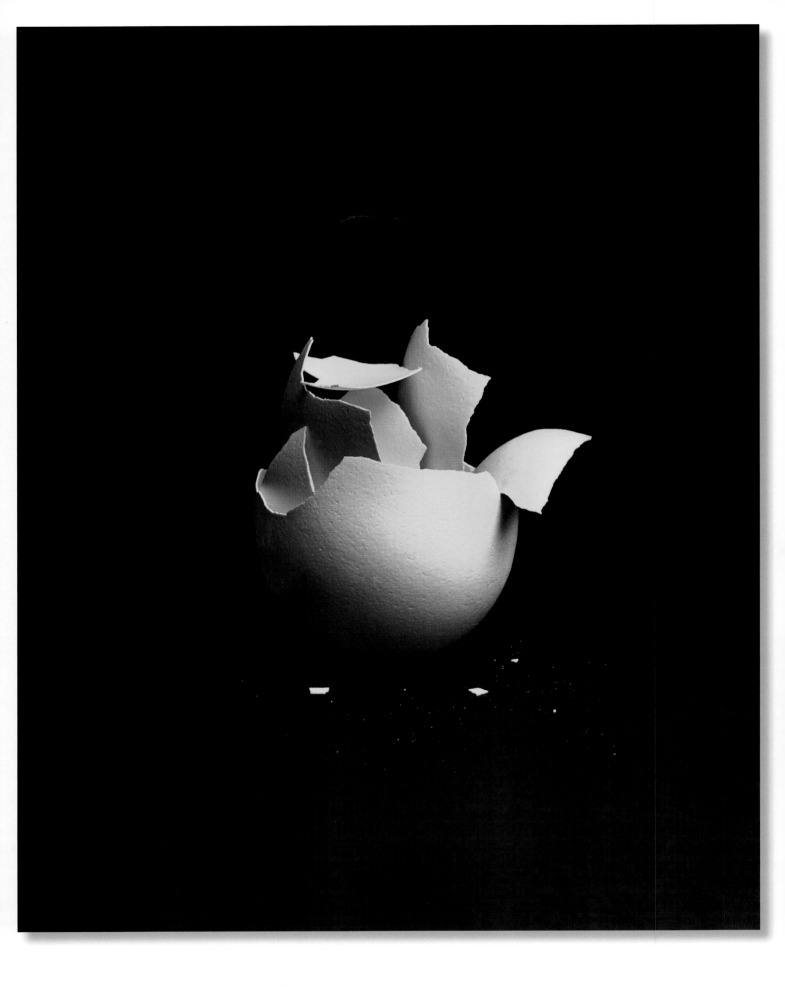

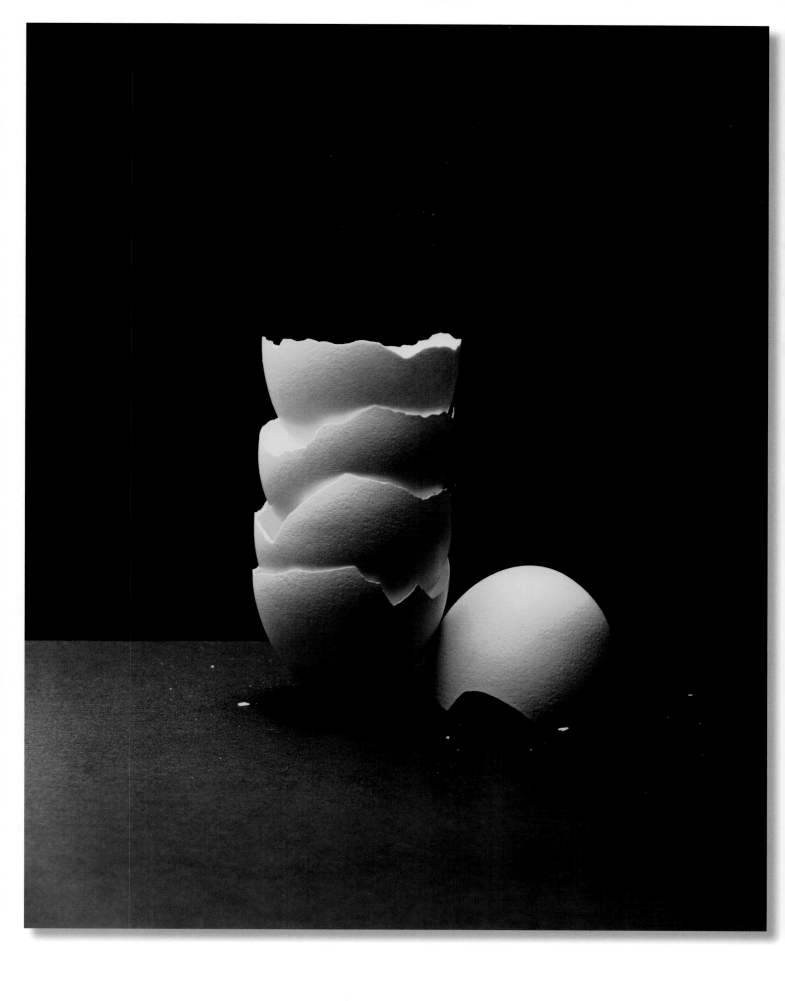

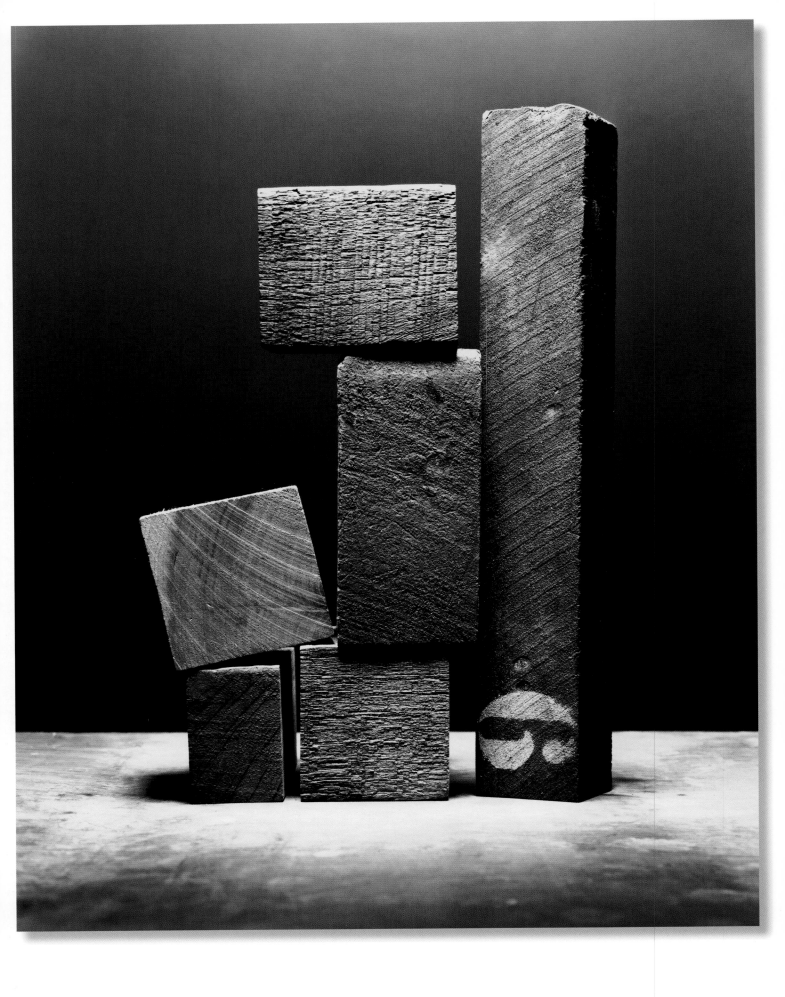

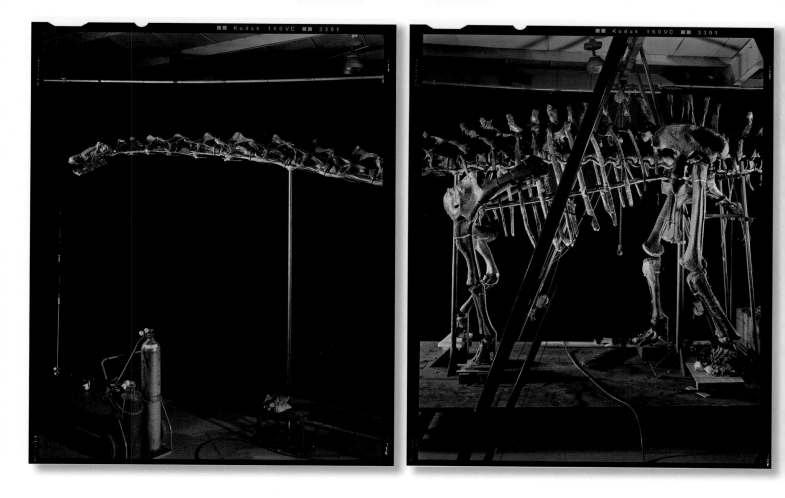

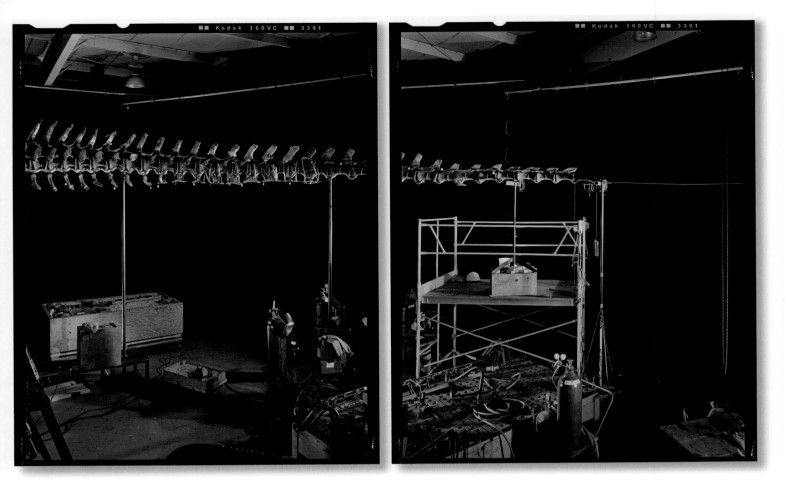

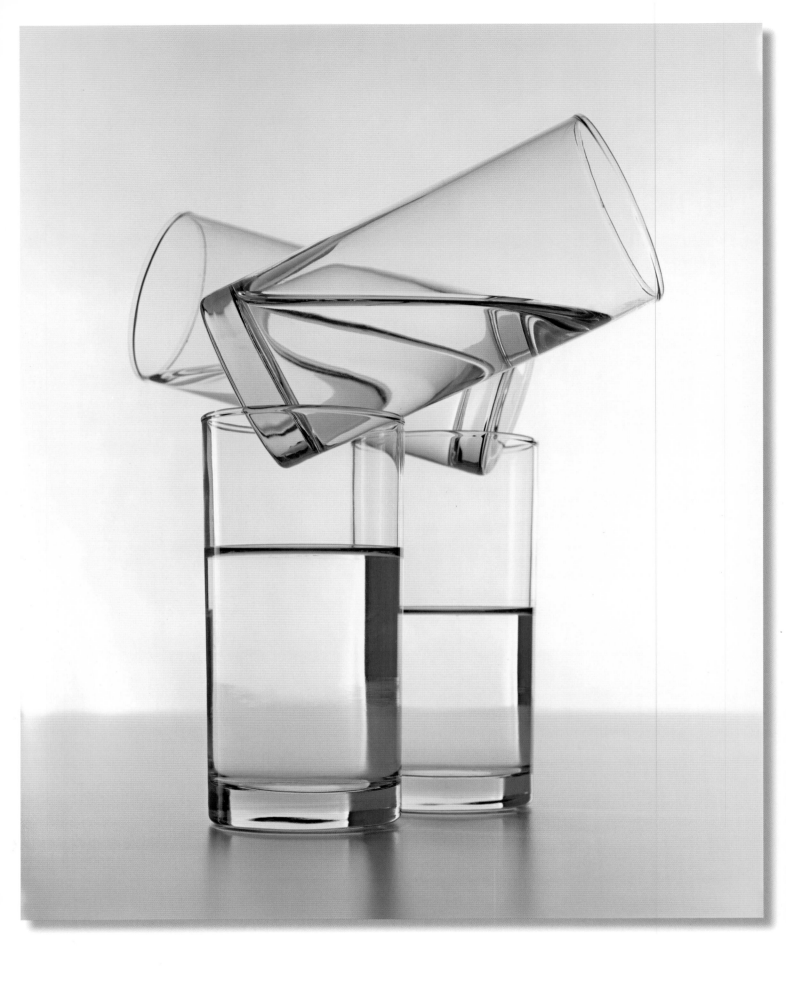

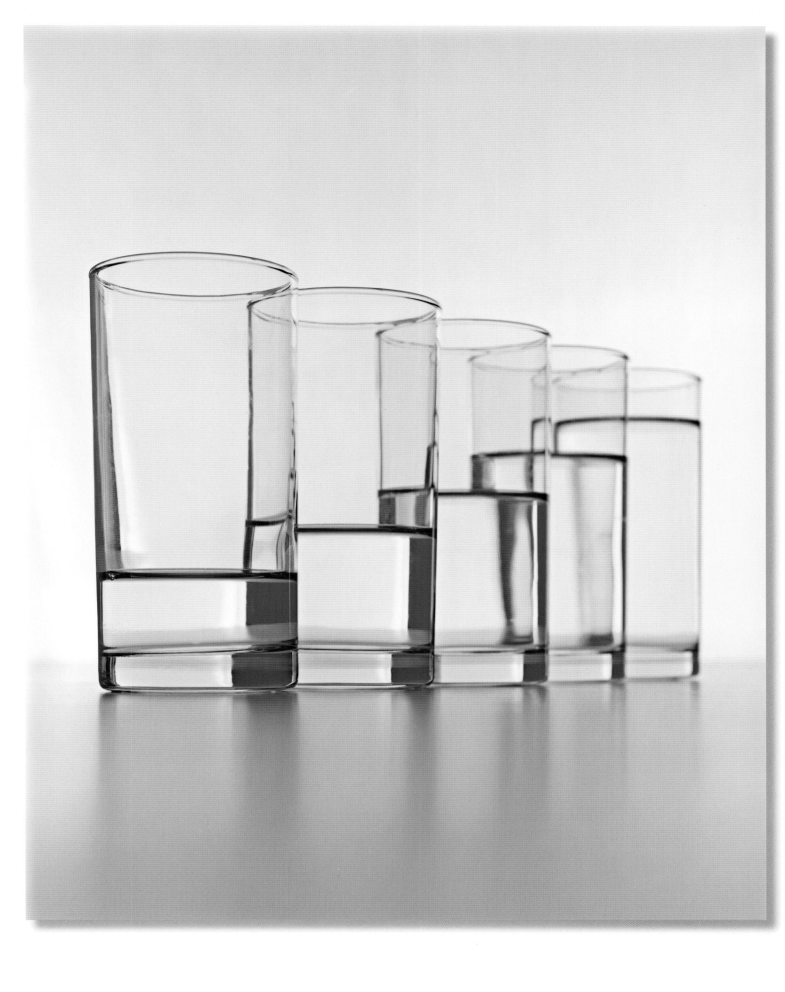

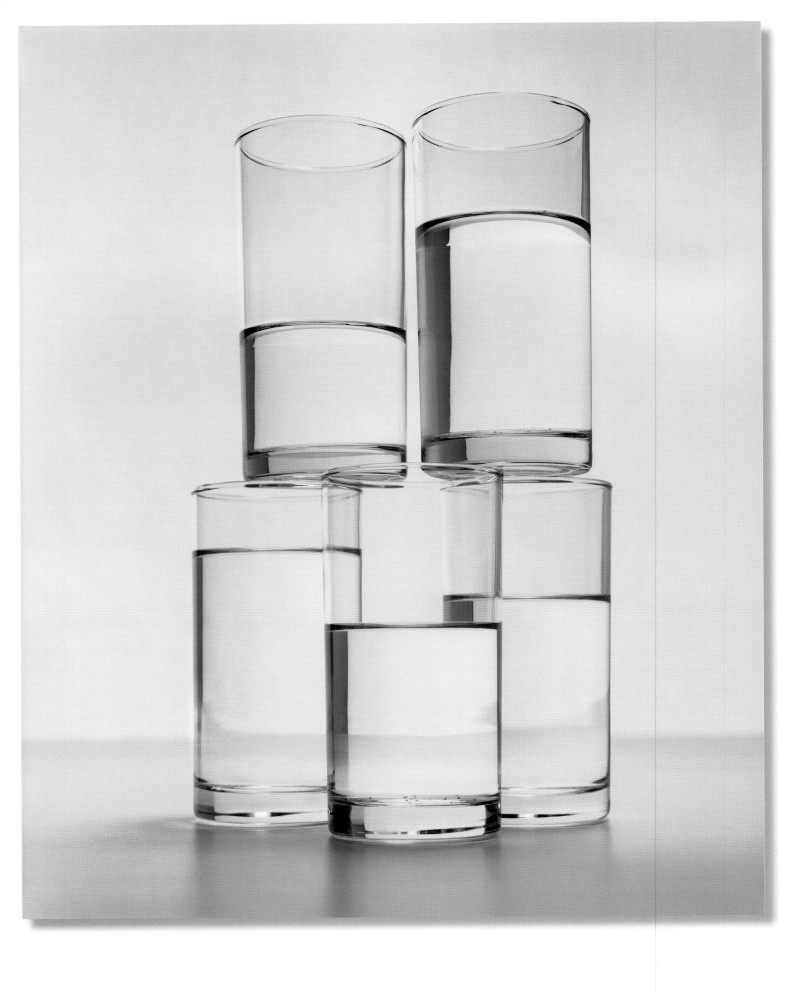

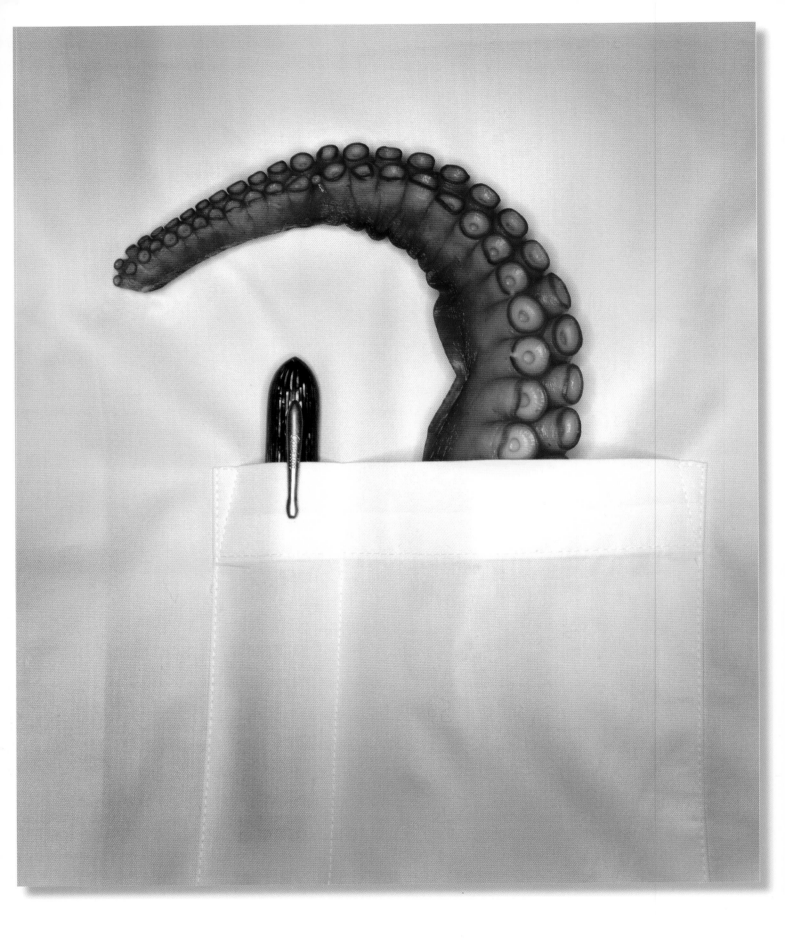

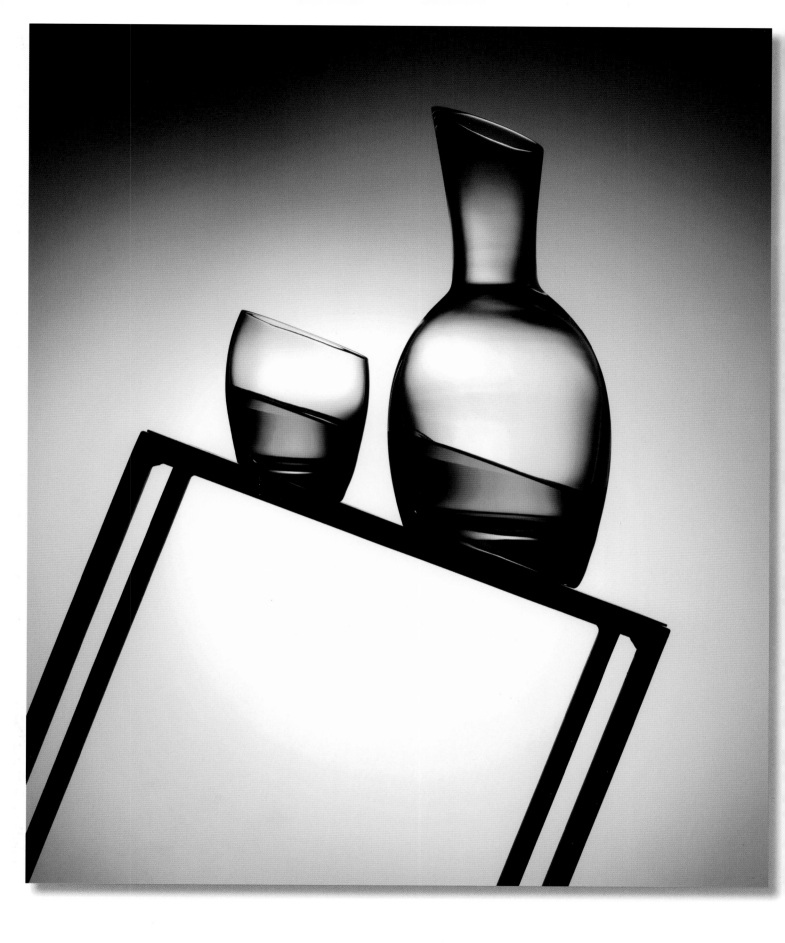

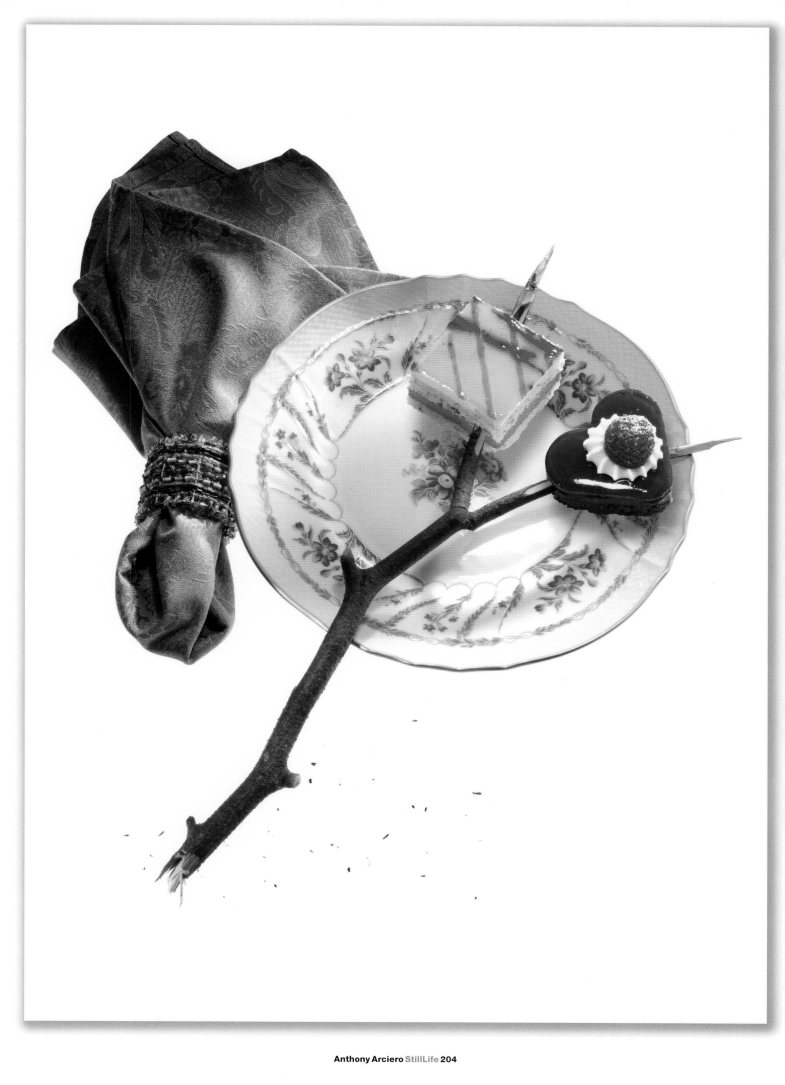

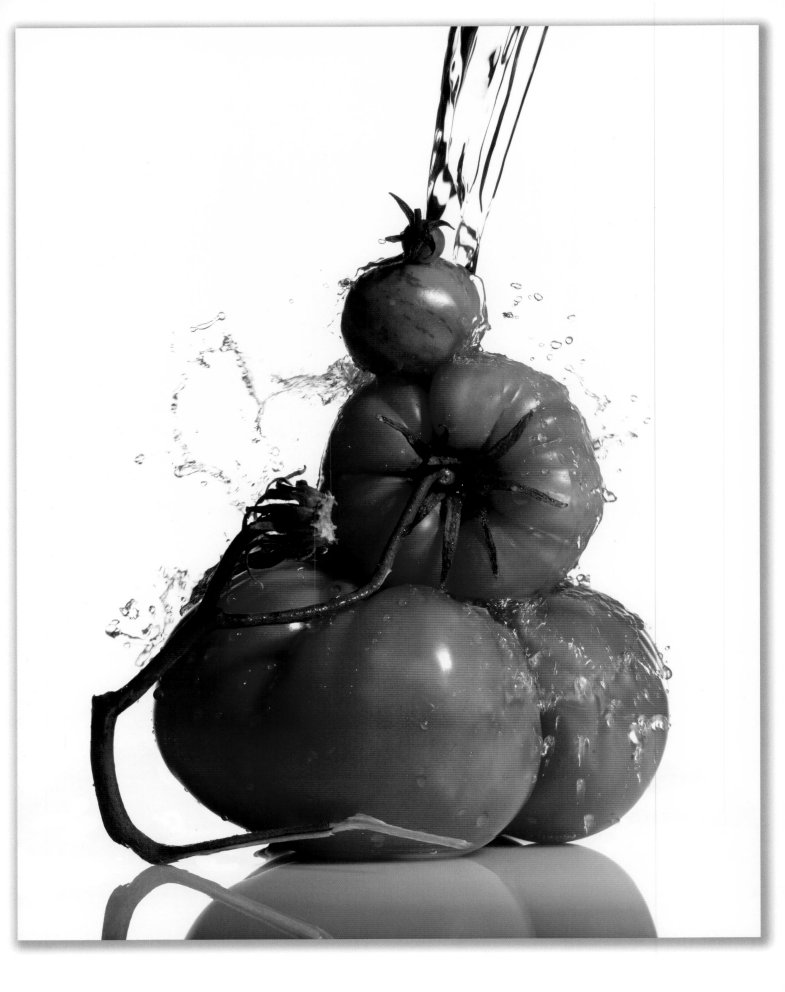

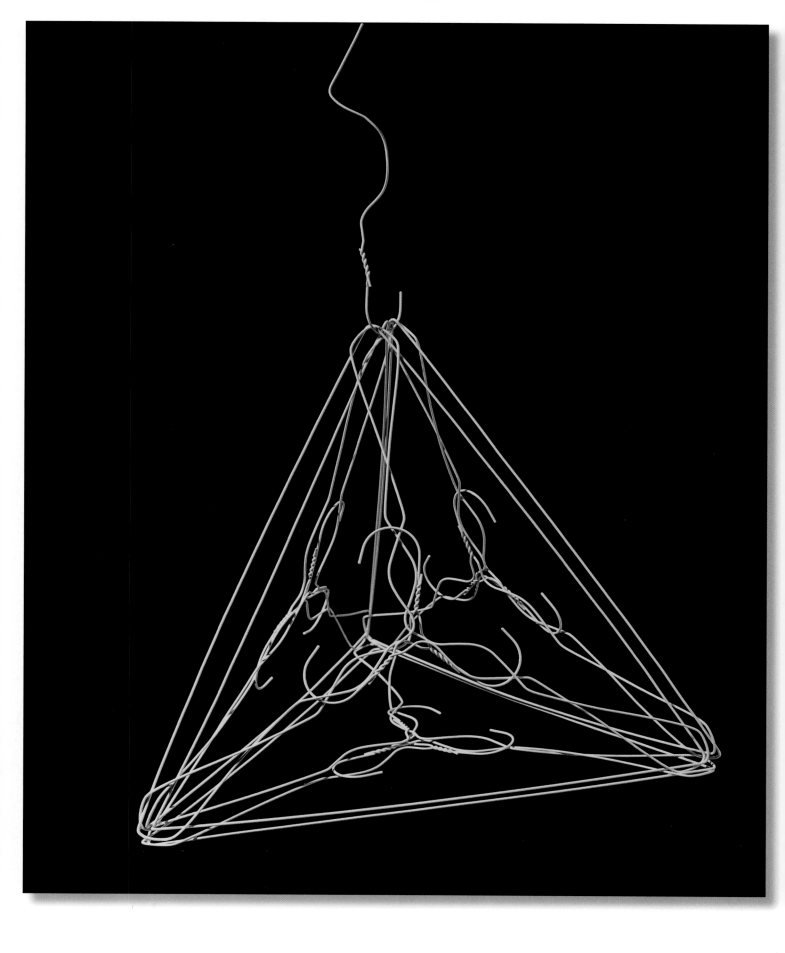

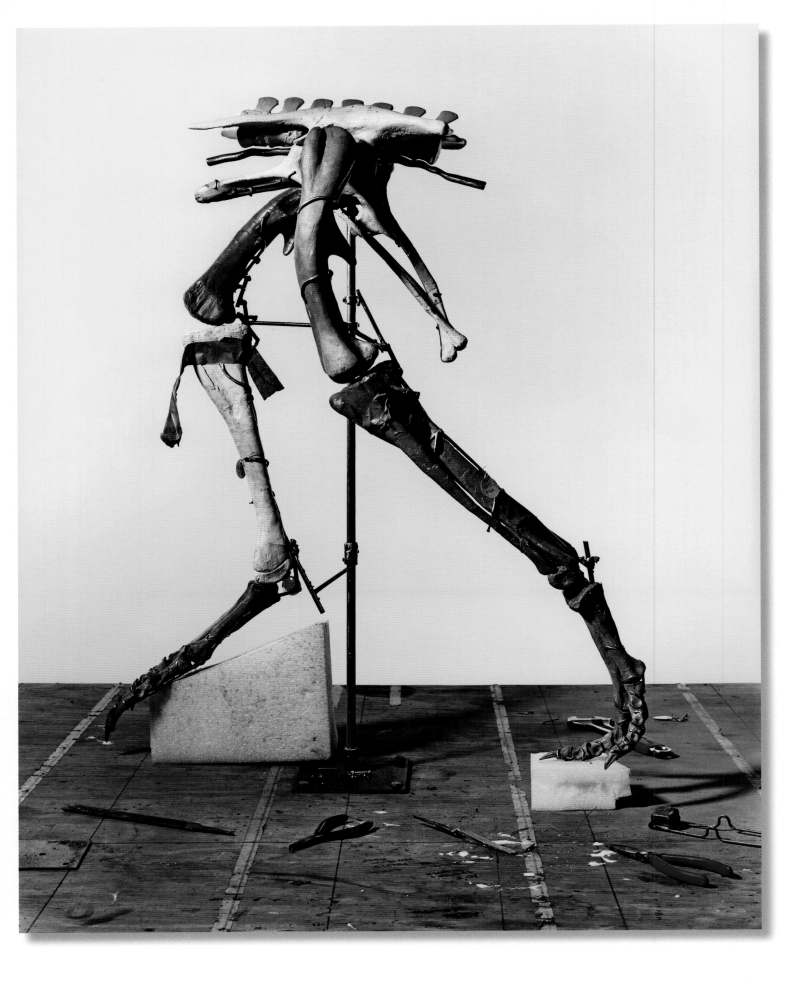

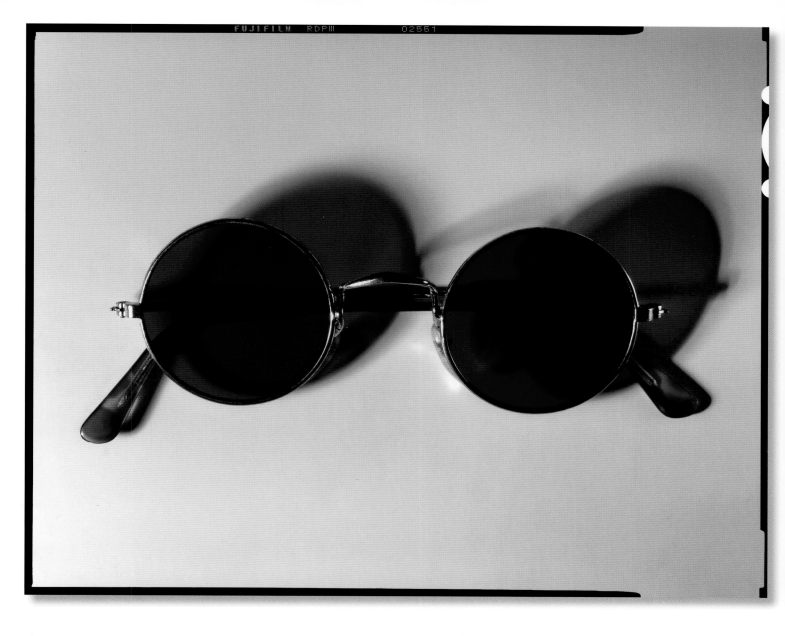

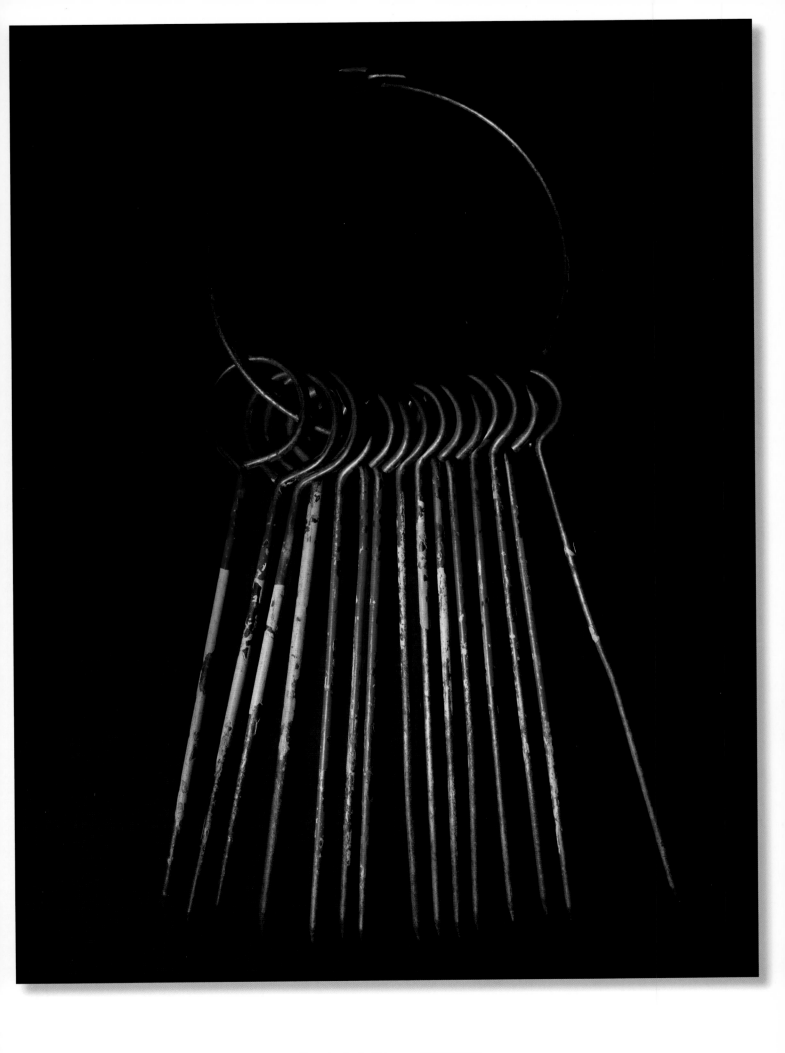

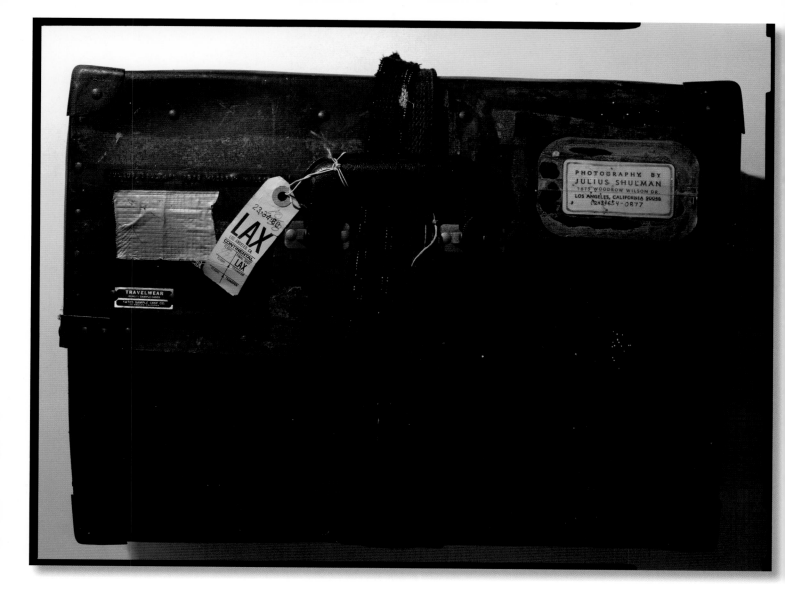

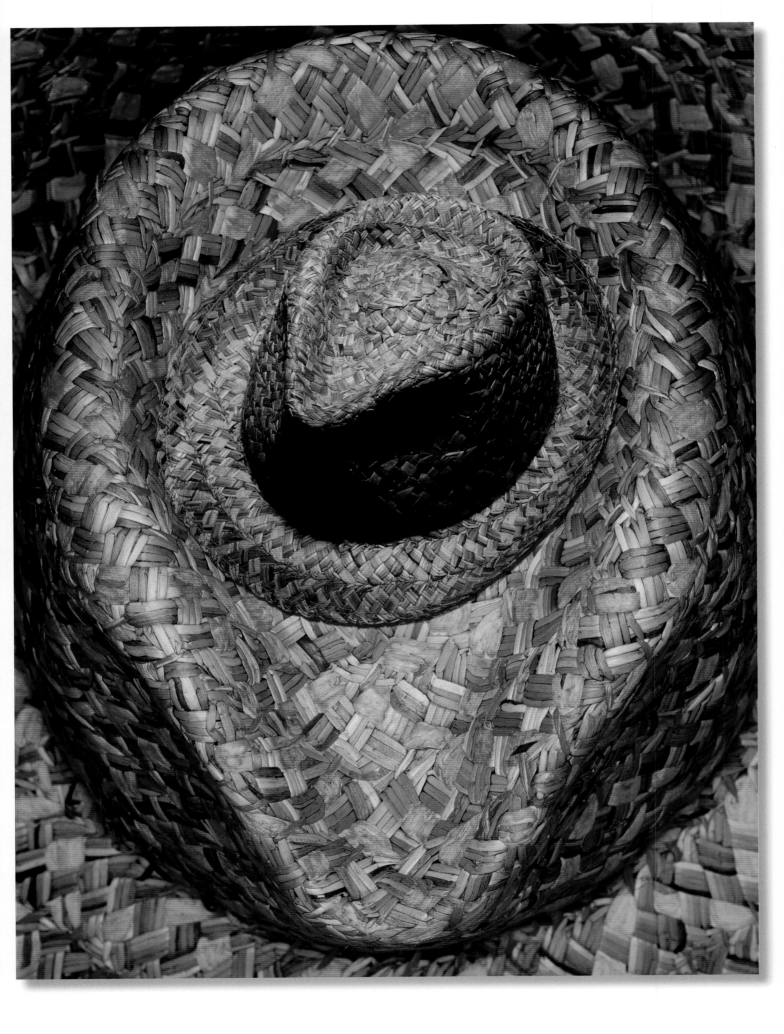

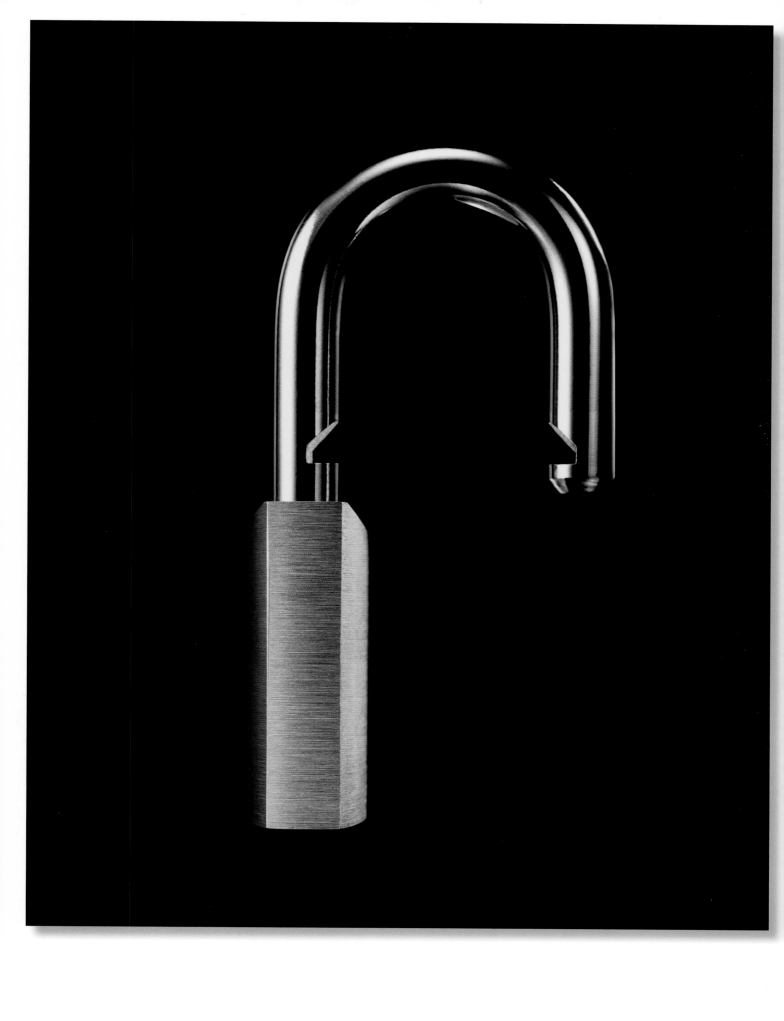

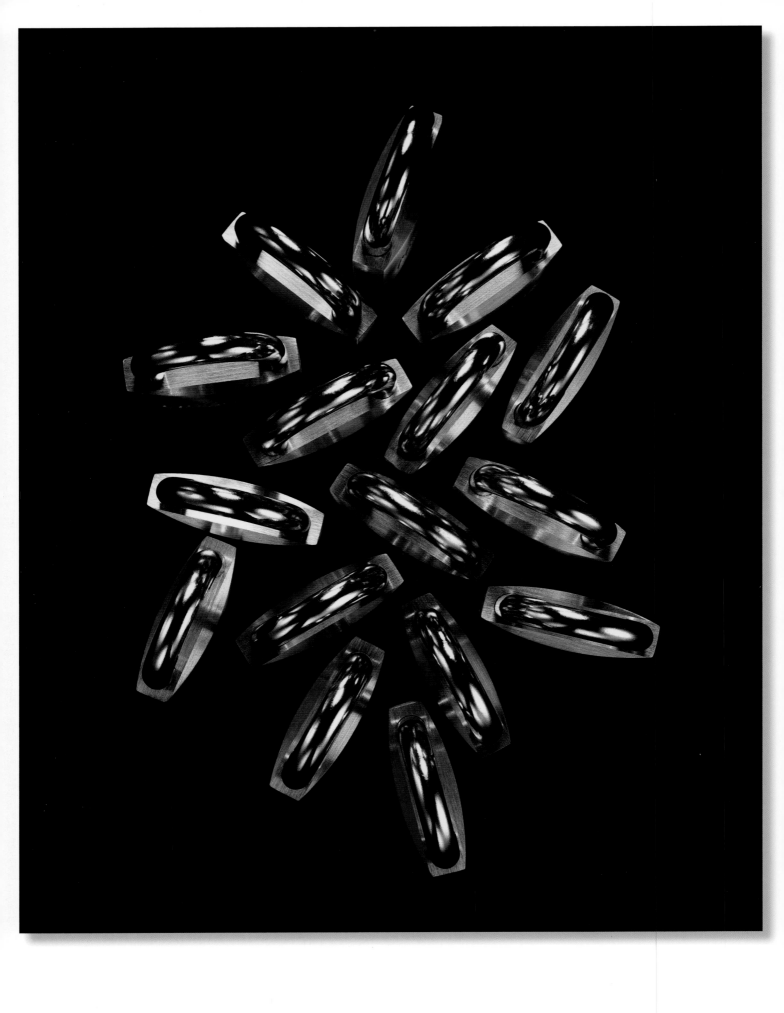

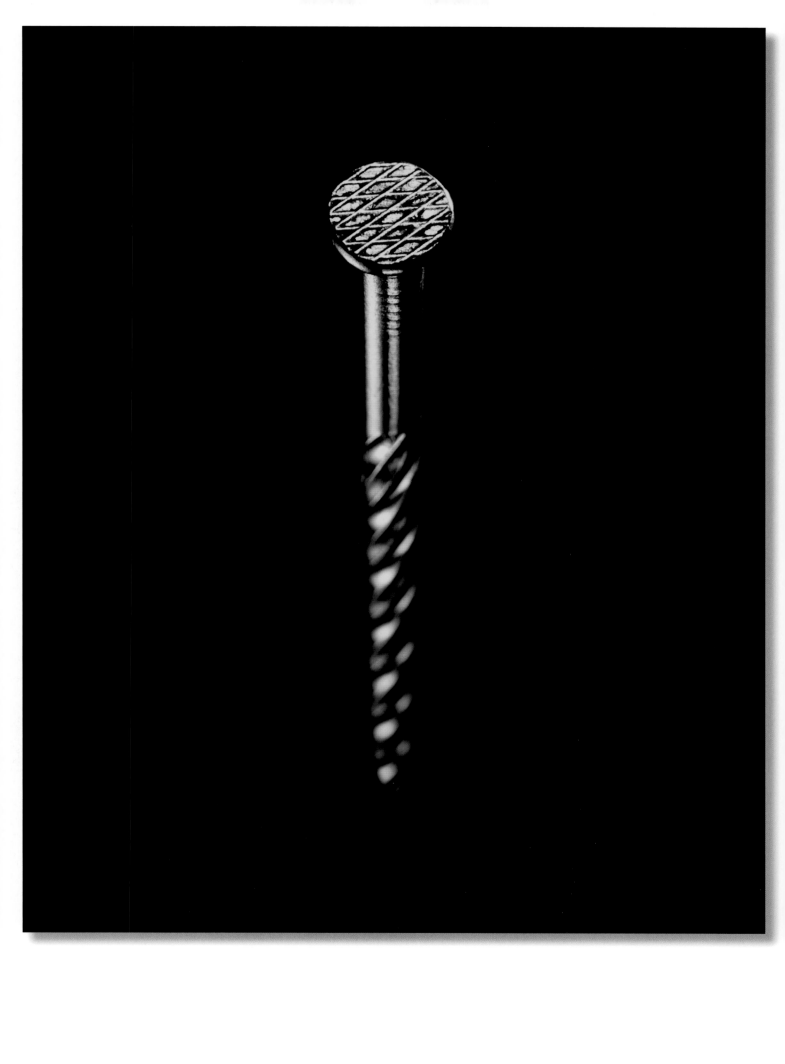

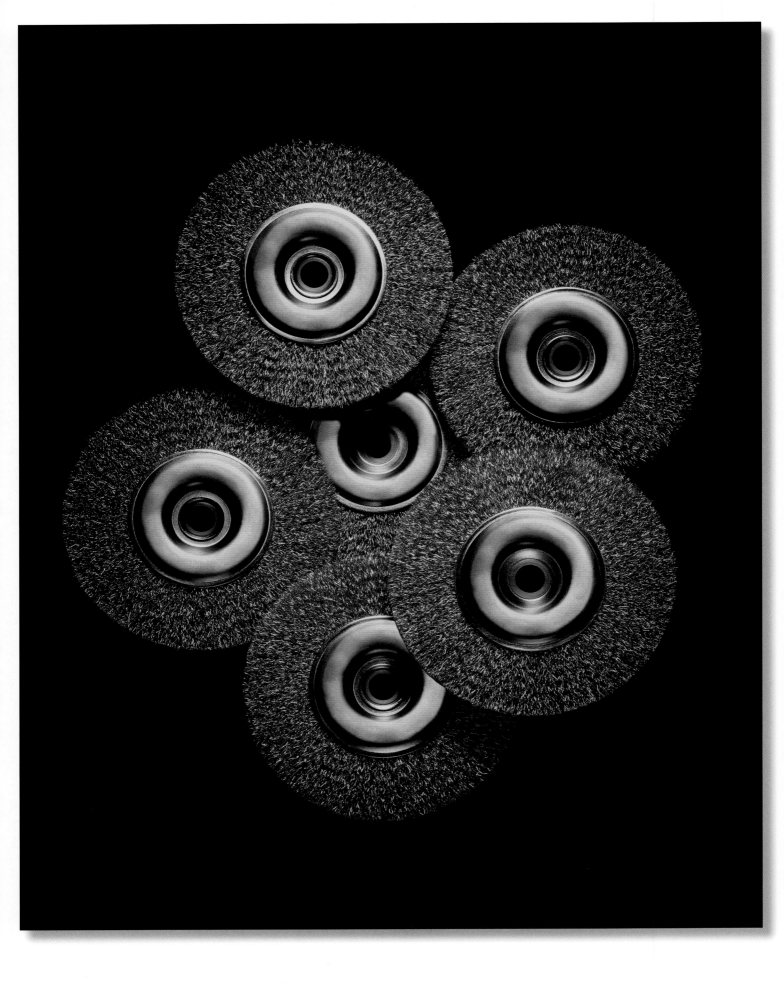

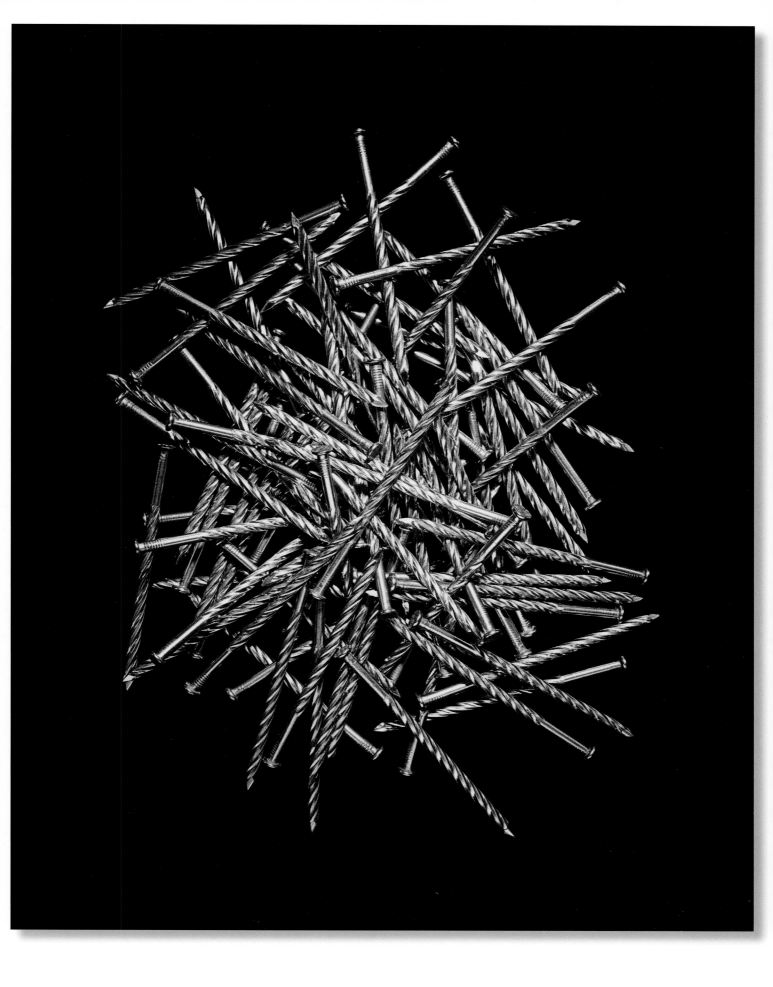

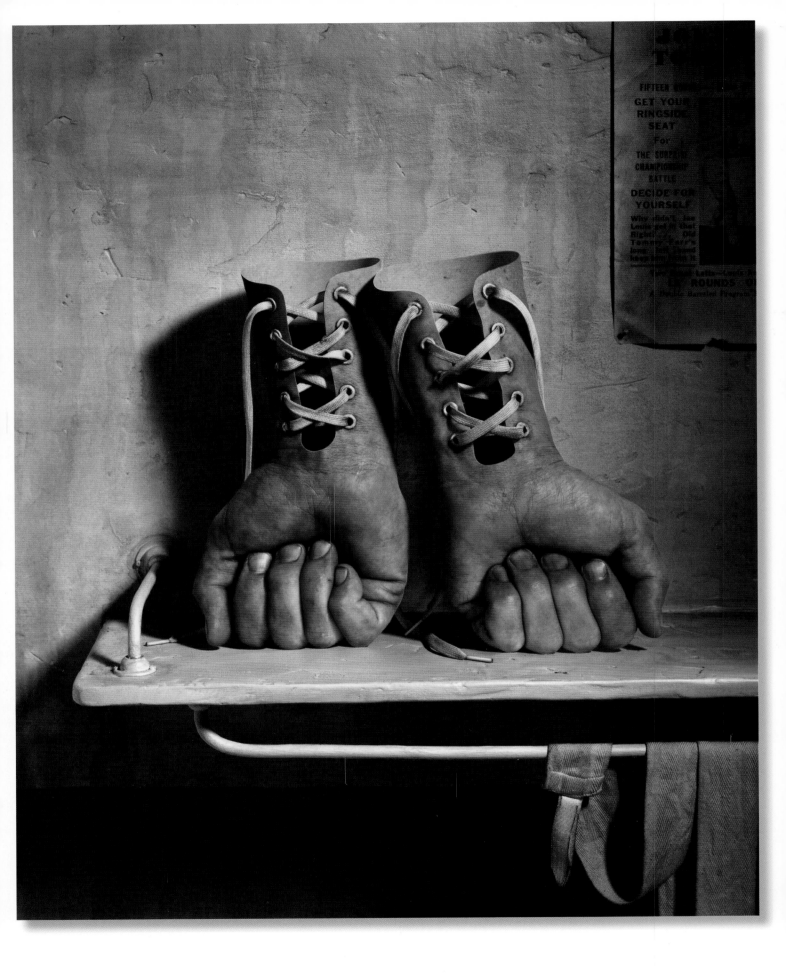

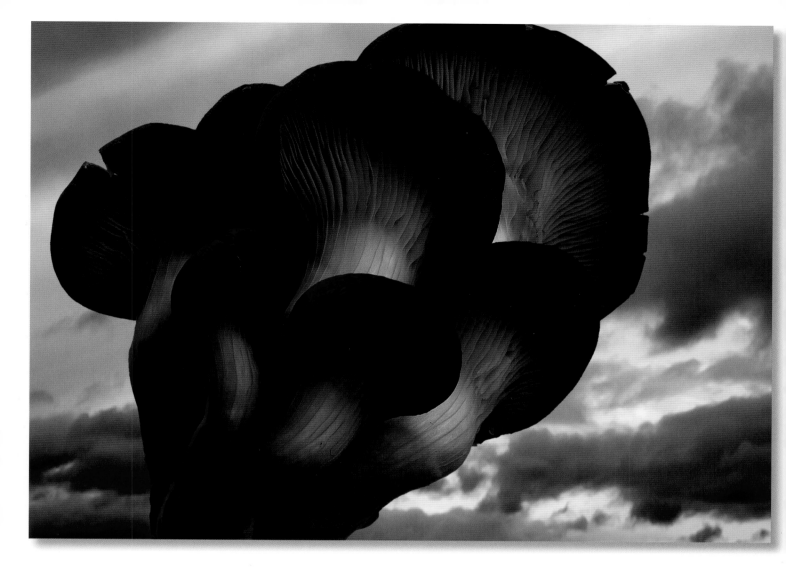

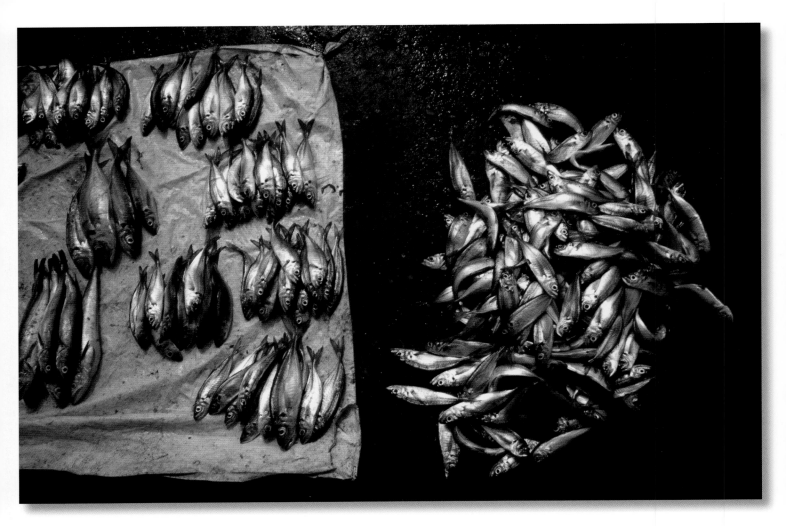

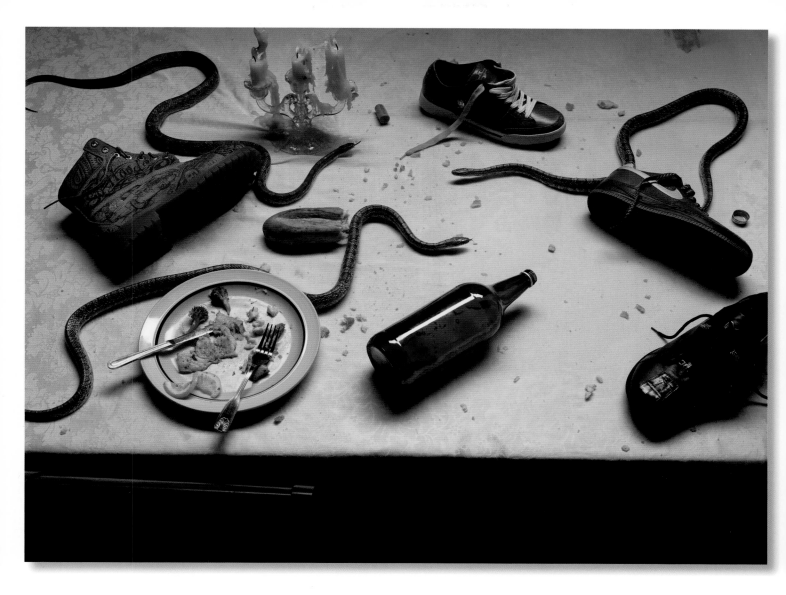

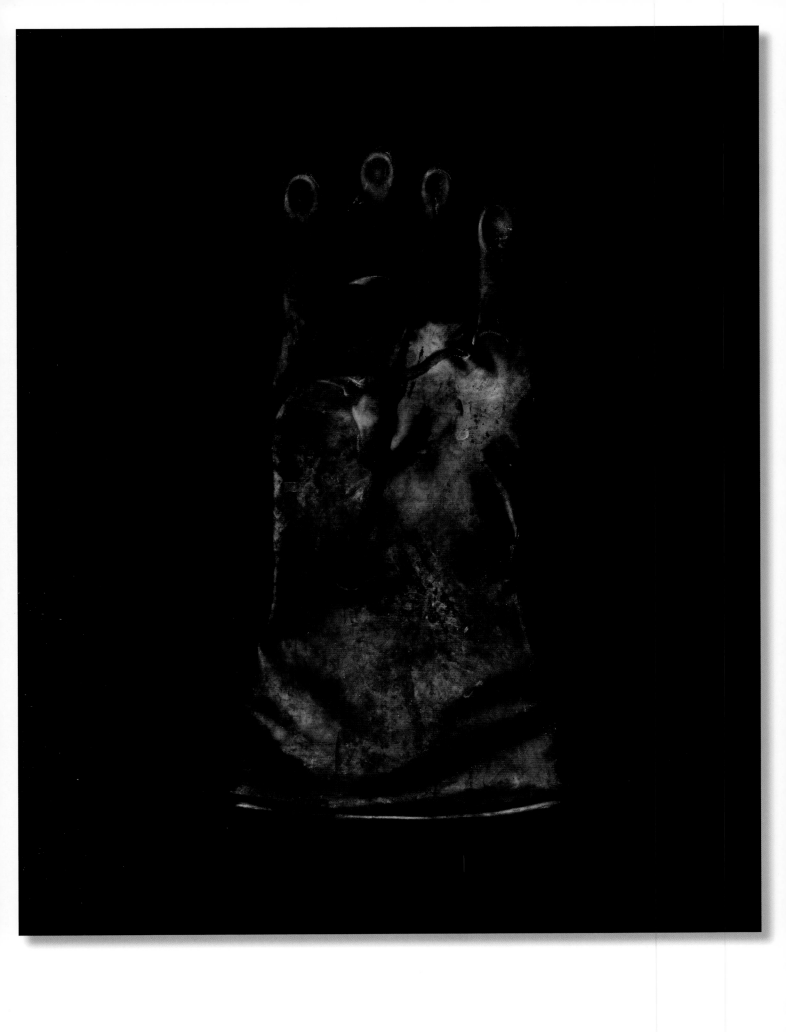

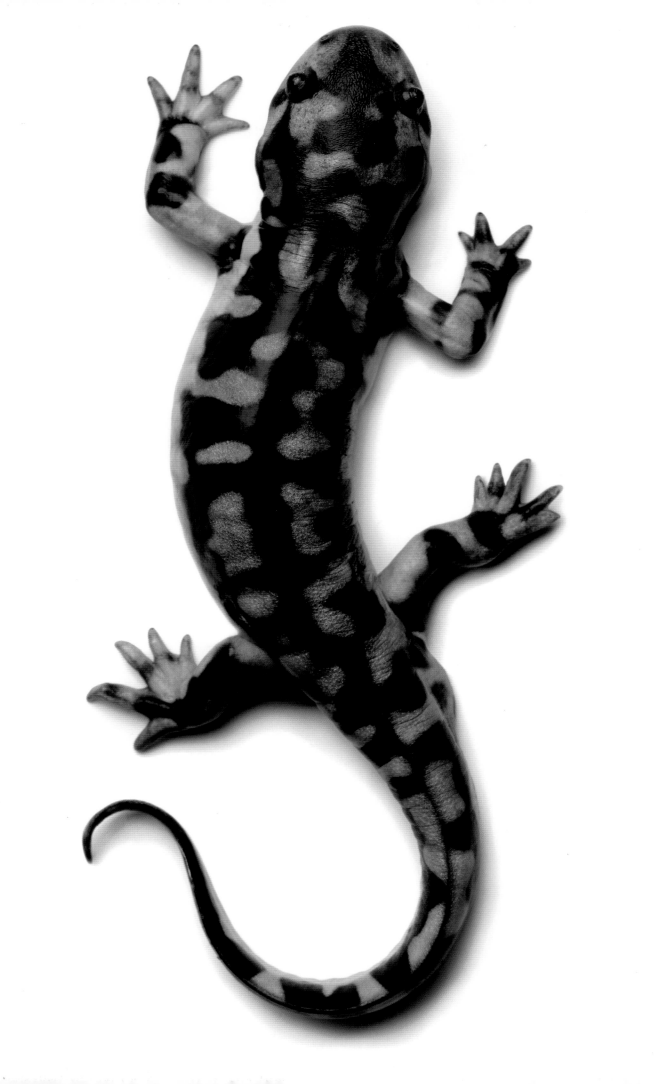

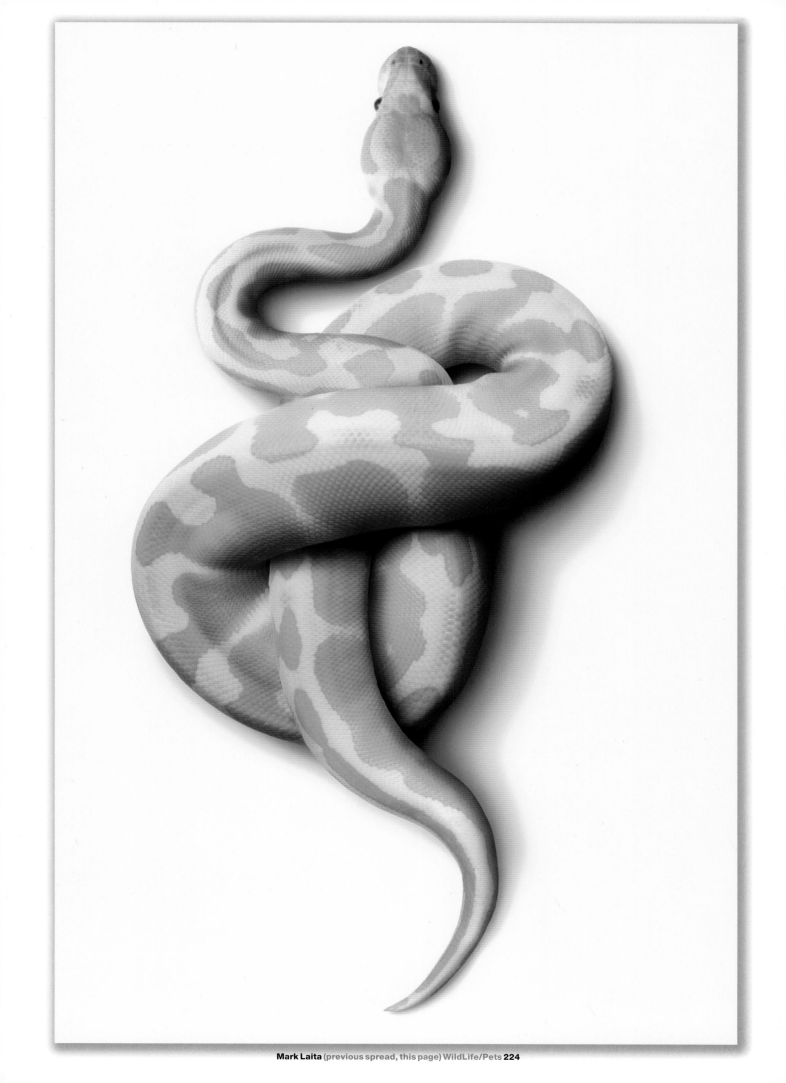

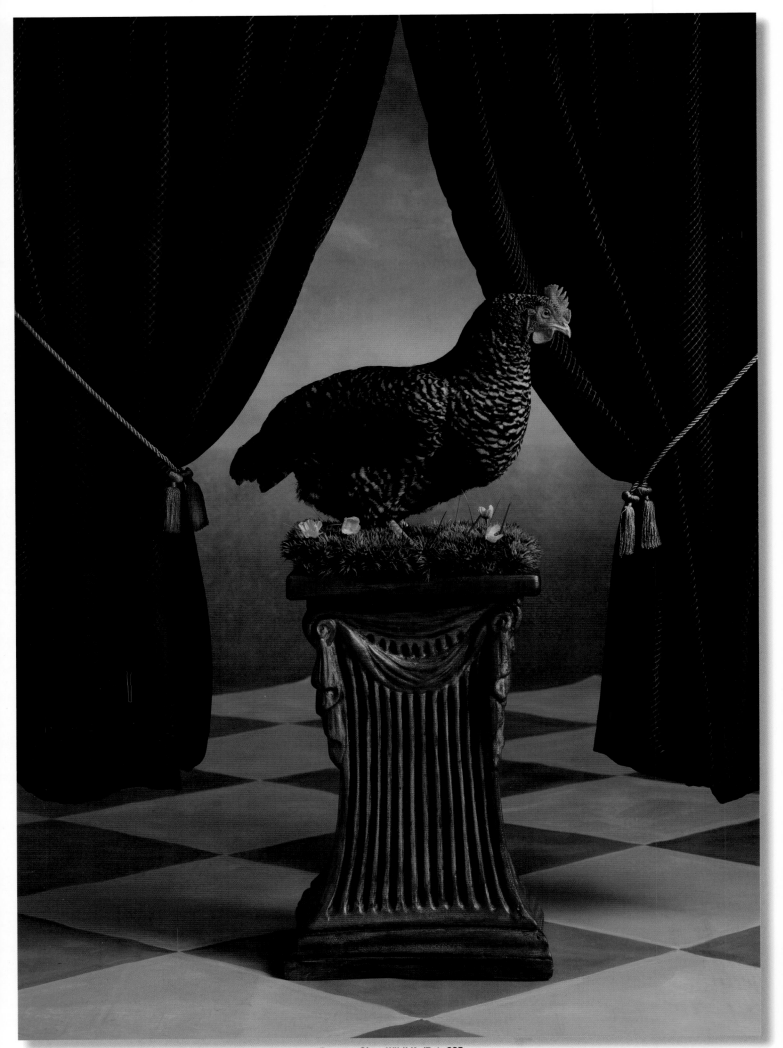

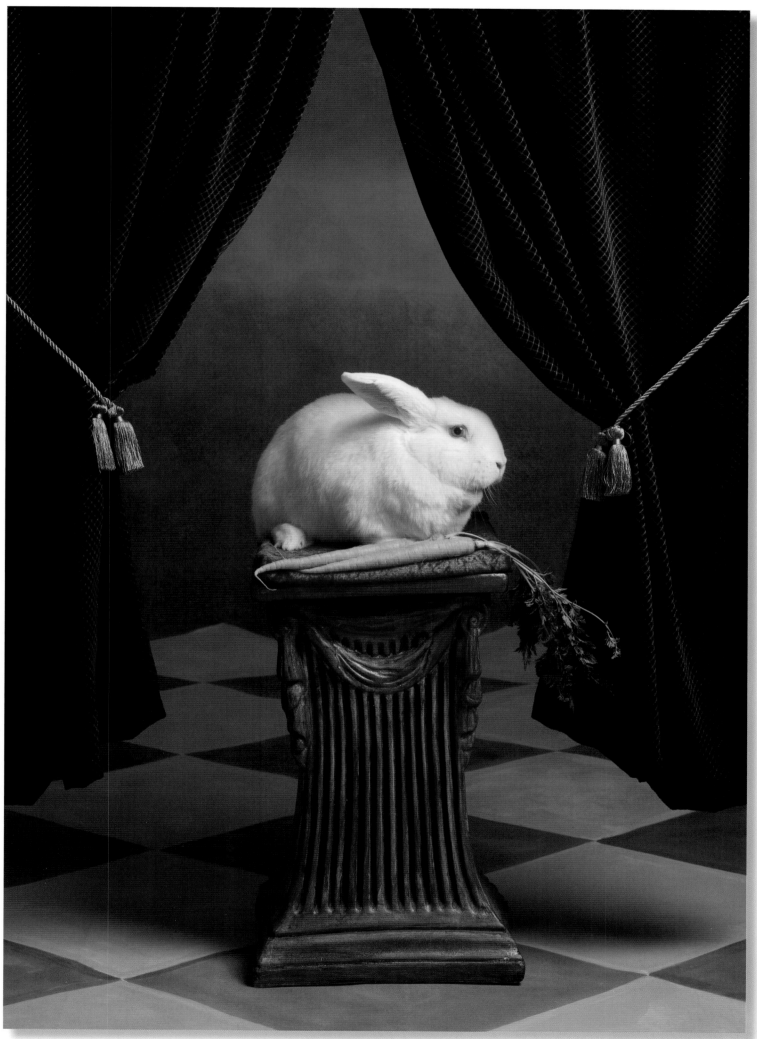

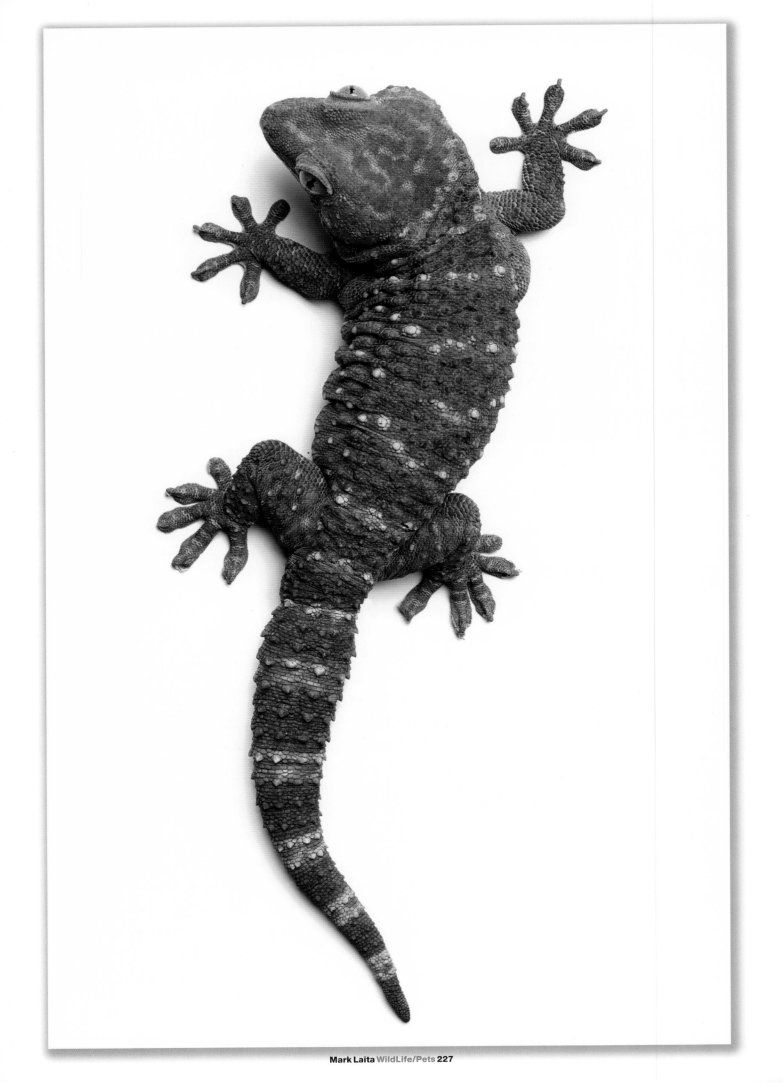

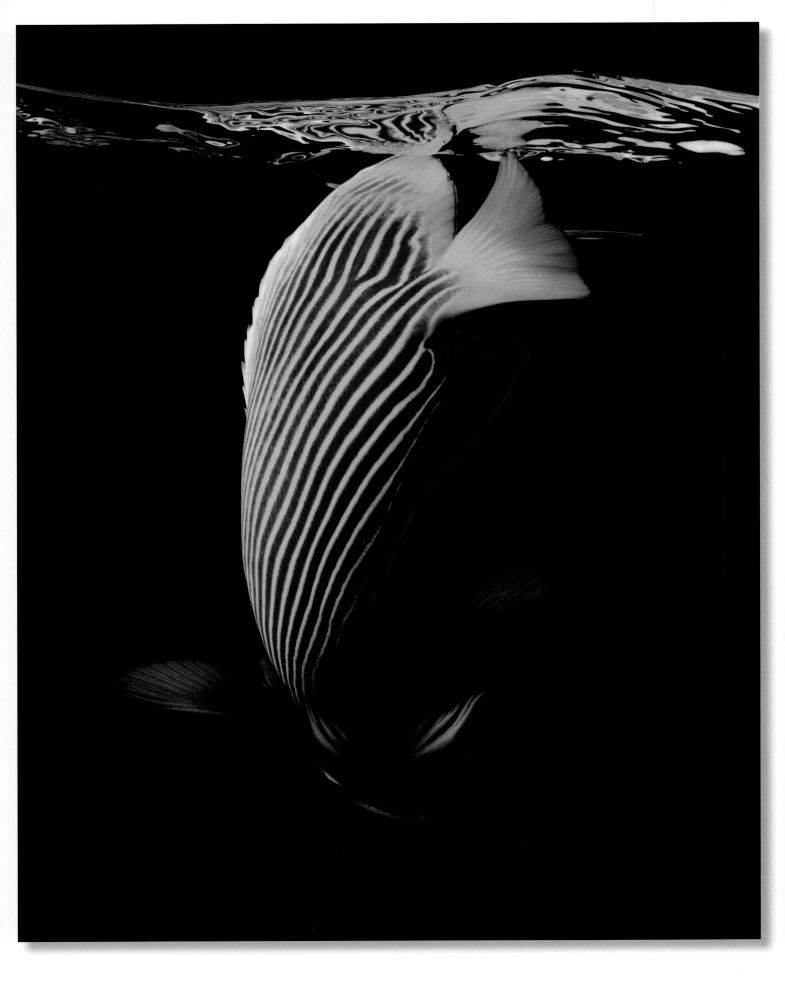

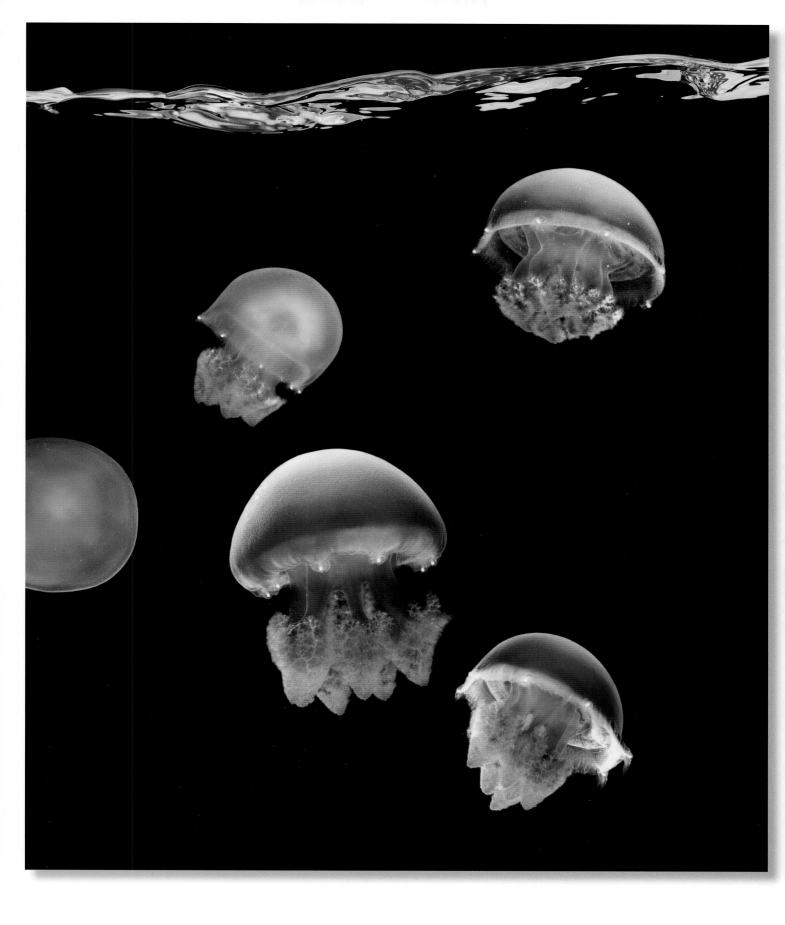

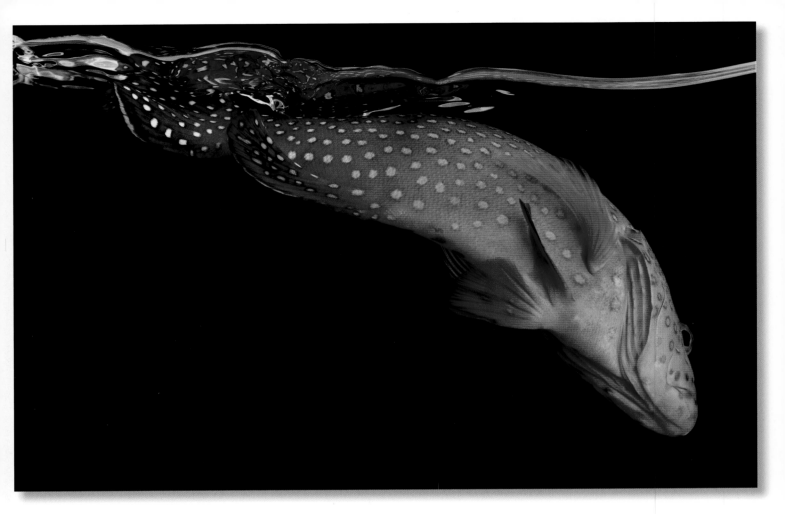

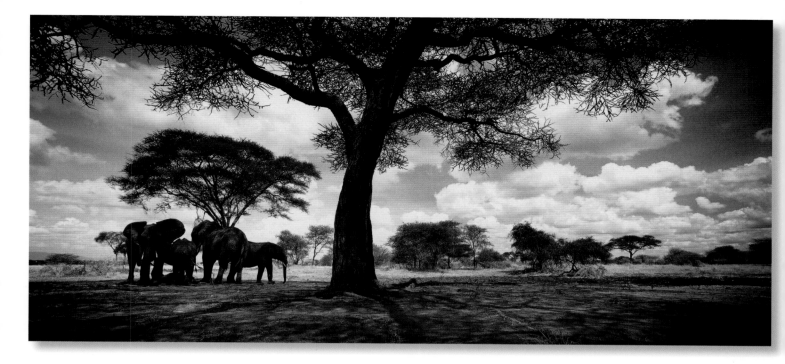

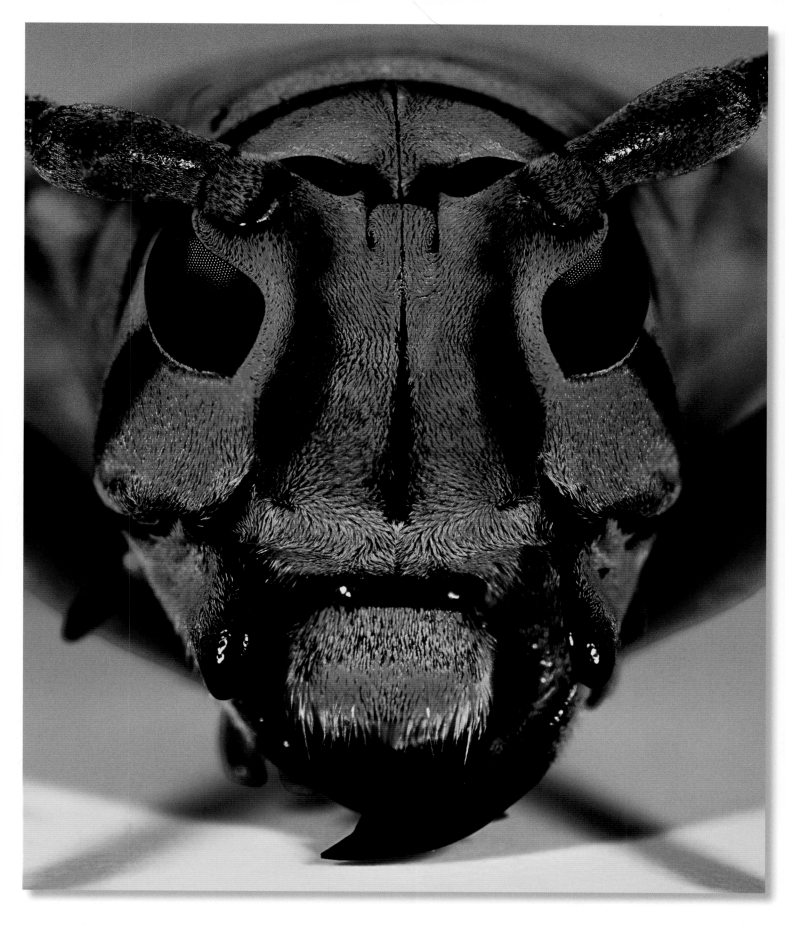

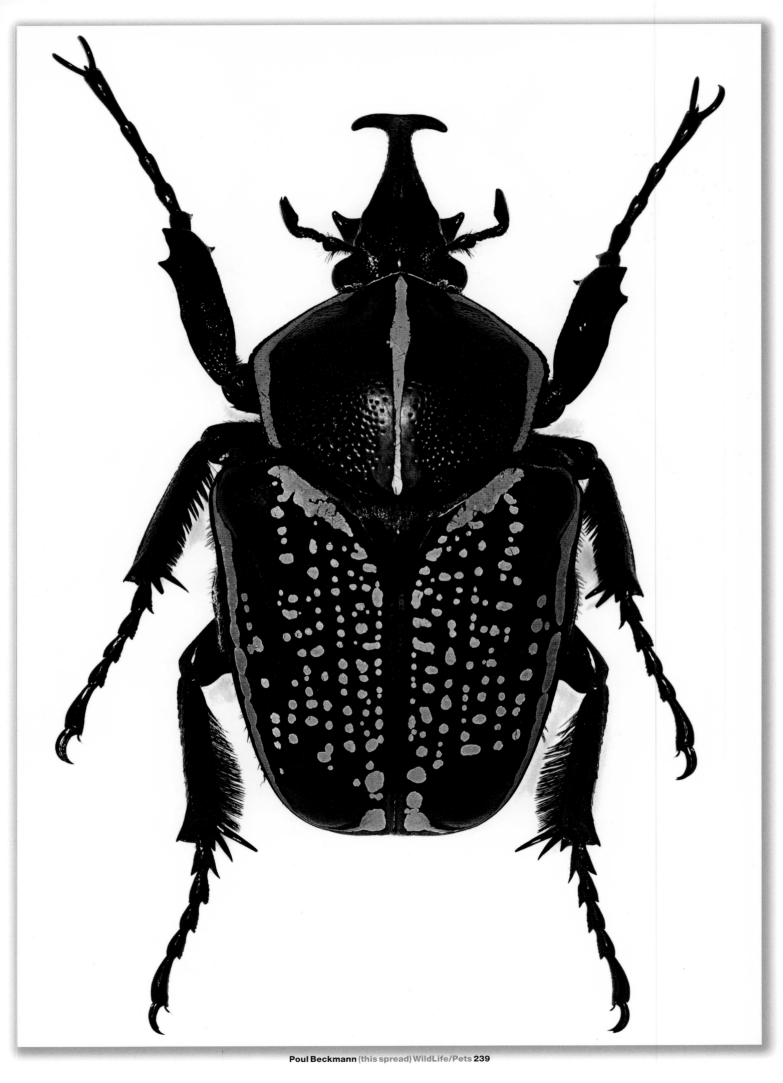

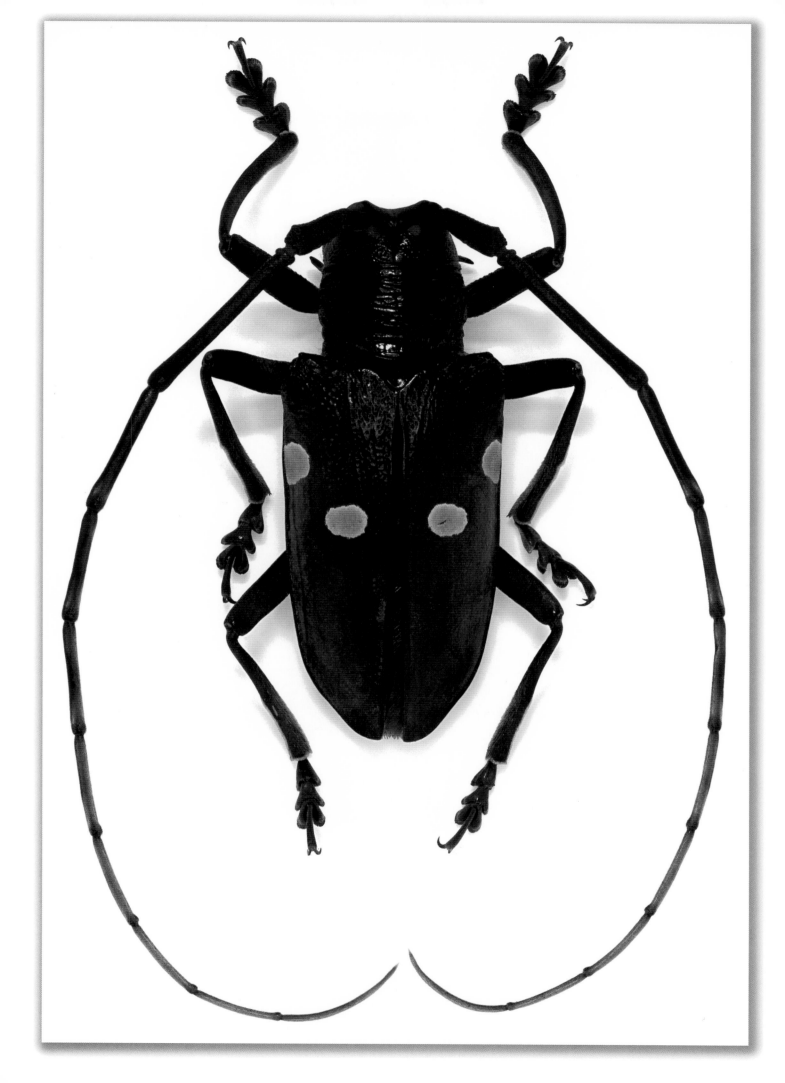

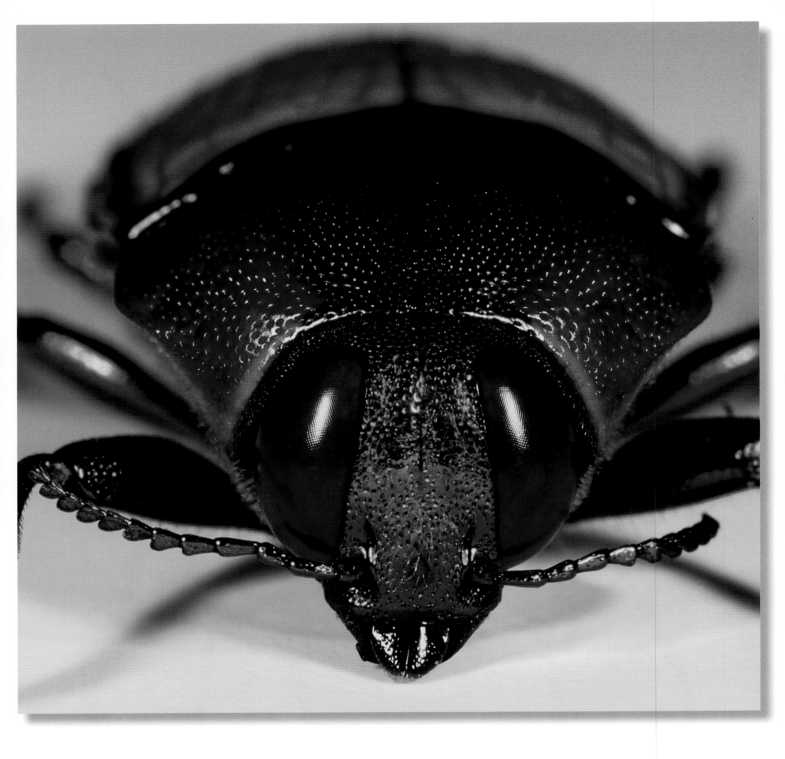

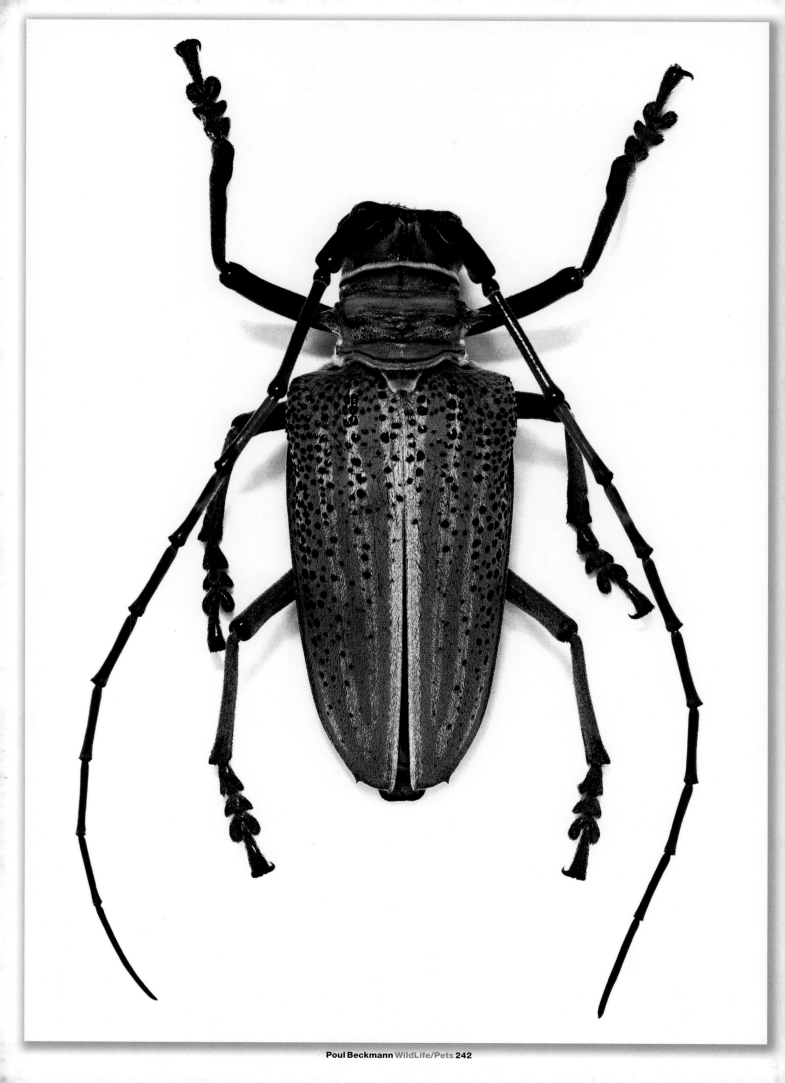

Credits

Intro

2 American Icons | Photographer: Shaun T. Fenn, Shaun Fenn Photography | Camera: Mamiya with Phase One Digital Back | Lighting: ProFoto | Client: Self-promotion series titled "American Icons"

Comments: This project was created to update some selected images from historical advertising campaigns. It was shot in studio in Bozeman, Montana. The model was cast from real people on the street.

4 No.2 Pencil | Photographer: John Schulz, Studio Schulz | Art Director: Dave Roberts | Client: S.A.F.E.

Comments: An ad appearing in annual fundraiser program for SAFE. SAFE provides financial aid in life crisis situations to members of the San Diego county advertising industry.

6, 7 Raising the flag on Iwo Jima | Photographer: Joe Rosenthal | Courtesy of AP Photo

9 Denim Story | Photographer: Craig Cutler | Art Director: Debra Bishop | Makeup: Sonia Lee | Hair: Corey Tuttle | Client: Blueprint Magazine

Comments: Editorial Series for Blueprint Magazine.

Advertising

36, 38 TLC's "American Chopper" | Ad Firm: Discovery Communications, Inc., Silver Spring | Art Director: Dan Cavey | Design/Retouching: Matt Stockenberg, Carrie Hurlburt, Jeff Humberson, Gene Bresler | Editor: Susan Wetherby | Photographer: F. Scott Schafer | Set Designer & Props: Sebastian Sergeant, Luis Suarez, Peter Klein, Jonathan Schipper | Camera: digital Hasselblad H1 with the Phase One P30 back | Client: TLC

Comments: Photographs of Paul Teutul Sr., Paul Teutul Jr. and Mikey Teutul (shot individually and as a group) used to promote Season 4 of the TLC program "American Chopper."

39 World Stage | Photographer: Jason Bell, Jason Bell Photography, NY | Account Director: Kirsty Doubleday | Art Director: Larry Osborne | Artists: Liping Zhang, Federico Bonelli, Leanne Benjamin | Photographer's Assistants: Robert Harper, Ben Gold, Gabriel Hanway | Client: Royal Opera House

Comments: A series of 3 images that were completed last year to mark the international diversity of the performers at the Royal Opera House, photographing them all in their own countries.

40 Clutter | Photographer: Hugh Kretschmer, Los Angeles | Art Director: Andrzej Janerka | Set Designer & Props: Andy Henbset | Makeup: Teri Jenson | Wardrobe: Andrew Salazer | Camera: Hasselblad H2 | Client: AARP Magazine

Comments: The opening image for an article for *AARP Magazine* on clutter and the psychological effects it has on our lives.

41 Train Any Body (Hot Granny) | Photographer: Roger Hagadone, Hagadone Photography, New York | Creative Director: Fritz Westenberger | Stylist: Shelley Rosario | Camera: Canon 1ds MK 2 | Client: Sugartown Creative

Comments: Ads for a gym chain. A humorous campaign illustrating the idea that anyone can get in shape, Train Any-Body.

42 Discovery Channel's "Deadliest Catch" | Ad Firm: Discovery Communications, Inc., Silver Spring | Art Director: Christian Williams | Creative Director: Stefan Poulos | Editor: Susan Wetherby | Makeup: Jane Choi | Model: Joe Noia | Photographer: Richard Schultz | Photographer's Assistants: Joel Laino, Hesh Johnson | Project Manager: Lisa Maria Cabrera | Stylist: Margie Eis Aghion | Camera: digital Hasselblad H2D-39 with 50-110mm lens | Client: Discovery Communications, Inc.

Comments: Photograph taken to promote Discovery Channel's program "Deadliest Catch."

43 Discovery Health Channel's "National Body Challenge" | Ad Firm: Discovery Communications, Inc., Silver Spring | Art Director: Mike Ring | Editor: Kerry Faulkner | Photographer: Henry Blackham | Client: Discovery Communications

Comments: Image shot for an advertisement to promote the annual "National Body Challenge," sponsored by Discovery Health Channel.

44 CAT | Photographer: Jonathan Knowles, staudinger+franke gmbH, Vienna | Art Director: Bernhard Grafl | Photographer: Andreas Franke | Photographer's Assistant: Christoph Meissner | Client: CAT City Airport Train

45 Festival Of Air | Firm: Jonathan Knowles Photography, London | Art Director: Guy Featherstone | Client: Nike - Wieden & Kennedy

Architecture

46 Sundae with cherry | Photographer: Warren Eakins | Firm: Ace Art, New York | Art Director: Warren Eakins | Creative Director: Warren Eakins | Client: Ace Art, Inc.

Comments: This is a shot of the original AIG building in the Financial District of New York. It is near where I live along the East River, and on a walk one winter's night I found the building shrouded in fog. It is one of my favorite buildings; I always thought it looked like an ice cream sundae with a cherry on top. At the same time I find it stately and somehow formidable.

48 Garden Bench | Ad Firm: Herve Grison Photography, Los Angeles | Author: Herve Grison | Photographer: Herve Grison | Client: Stock

Comments: Sometimes, the story is all about what is not there. This image is designed to incite the viewer to imagine his/her own story.

49 Las Vegas Series | Firm: Stephanie Knopp Designs, Philadelphia | Art Director: Stephanie Knopp | Artist: Stephanie Knopp | Camera/Film: Diana, Kodak 120 (color pictures), Kodak T-max (b&w) | Client: Self-Promotion

Comments: This is a series of personal photographs of Las Vegas that I created for a self-promotional piece.

50, 51 The Amazing Faith of Texas | Photographer: Randal Ford | Art Director: Craig Denham | Chief Creative Officer: Roy Spence | Creative Director: David Crawford | Designer: Craig Denham | Print Producer: Diane Patrick | Writer: Roy Spence

Comments: Communicate the often unseen unity among Texans amid their varied religions and denominations.

Automotive

52 Self-promotion | Photographer: Andreas Franke, staudinger+franke gmbH, Vienna | Photographer's Assistant: Christoph Meissner | Client: Self-Promotion

Beauty&Fashion

54, 64 Qua | Firm: Addis Creson, Berkeley | Creative Director: John Creson | Designer: Magdalena Hladka | Location: Penngrove, California | Models: Elizebeth Sutton and Jarrett Winfield | Photographer: Lisa Kimmell | Photographer's Assistants: John Kimmell, Mark Adams, Jarred Herman, David Harris | Project Manager: Kristen Zalinsky-Pembroke | Client: Harrah's

56 Untitled (Shoe Shot) | Photographer: Jamie Nelson | Photographer's Assistant: Luke Lanter | Art Director: Danielle Brown | Makeup Aritst: Lottie Stannard | Hair Stylist: Gillian Kuhlmann | Model: Alexis @ Elite Models, NY | Camera: Canon 1DS Mark II | Client: UnChin Magazine

57, 58 Untitled | Photographer: Norbert Schoerner | Camera: hasselblad, film kodak 400 | Client: NY Times Magazine

59, 60, 61 Christina's World | Photographer: Caroline Knopf | Stylist: Sylvia Griesser | Hair: Tuan @ L..Atelier NYC | Model: Enzel @ Next NY | Retouching: SKIP DIGITAL NYC | Makeup: Shawnelle Prestidge @ Walter

62 Sleek | Photographer: Frank Wartenberg | Client: Self-Promotion

63 Enchanted | Photographer: Caroline Knopf | Art Buyer: Sandra Stupka | Art Director: Catherine Knaeble | Client: Oval Room Book Macy's North

65 Breeze | Photographer: August Bradley, August Bradley Images, Los Angeles | Hair: Marc Mapile, Norma Blaque | Location: August Bradley Images Studio, Los Angeles, CA | Makeup: Kelsey Deenihan | Model: Teresa @ Vision Models L.A. | Camera: Canon 1Ds Mark II | Client: Work for Artistic Exhibition, No Client

Comments: This image is designed to create a sense of inspiration through lighting, motion, and artistic makeup and hair styling.

66 Luminosa | Photographer: Parish Kohanim, Perish Kohanim Fine Art Gallery, Atlanta | Makeup: Mary Jane Starke | Model: Colleen Koltick | Photographer's Assistant: Jessica Mahady | Stylist: Janan Armel, Marta Dobrezeniecka | Camera: Canon IDS Mark III | Client: Mooncake Boutique

67 Bold and Colorful | Photographer: Julie Brothers, Julie Brothers Photography, Los Angeles | Hair: Marco Berardini | Makeup: Marco Berardini | Camera: Canon Mark II digital camera | Client: Quingdao Wigs

Digital

68 Faces | Photographer: Danielle Hall, Danielle Hall Photography, San Francisco | Hair: Cheryl Dailey | Makeup: Cheryl Dailey | Client: My Artist's Place

70 The Addicted Brain | Photographer: James Worrell, James & Daughters, Inc., Maplewood | Art Directors: Alex Knowlton, Bess Hauser | Artist: James Worrell | Photographer's Assistant: Kristi Workman | Stylist: James Worrell | Model: Giselle Awad | Camera/film: Phase One H25/Mamiya RZ 67 | Client: Massachusetts General Hospital - Proto Magazine

Comments: This is an article about addiction and dopamine, its effects and causes. It is a medical article in their own new magazine.

71 Le Book Cover | Photographer: Jean-Paul Goude | Agency: in house | Client: LE BOOK New York 2007 | Art Director: Claudio Dell'Olio

72 Magnetist | Photographer: Andrew Zuckerman, Andrew Zuckerman Studio, Inc., NY | Art Director: Andrew Zuckerman | Creative Director: Antonio Bertone | Design Director: Adam Petrick | Designer: Allison McCarthy | Retoucher: Justin Cohen | Illustrator: Wendy Klein | Photographer's Assistant: Nick Lee | Print Producer: Veronica Madrigal | Client: PUMA AG Worldwide

73 Call Me | Art Director/Photographers: Paal Anand, Kelly Holland | Stylist: Joanne Cooke | Model: Nazli Shaw | Client: Wabags | Camera: Hasselblad 553 ELX / Toyo 45 A2 | Film: Phaseone Digital / Fuji Velvia 4x5

Comments: In order to allow the harsh landscape of the Coorong in South Australia to be more accessible to the shoot, the photo was shot in two passes. First we took a large-format film camera out to Australia to set the environment, angle of view, and depth. The foreground was then shot on Green Screen at Quixote Studios back in Hollywood. Both images were finally composited back together. Details were painted back in to help create a more seamless interaction between the two locations.

74 The Time is Always Now | Firm: Trillium Studios, Norwell | Art Director: Barbara Wolinsky | Creative Director: Tom Robotham | Hair: Rae Bertellotti | Makeup: Rae Bertellotti | Photographer: Cary Wolinsky | Stylist: Marie Brown | Camera: Canon

Comments: The photographs were created to demonstrate the printing capabilities. The photographs are part of a series created to demonstrate the wide range of capabilities of a new digital printer that Canon developed for the commercial printing industry. The images were printed in a brochure and as posters and postcards.

75 Discovery Channel's "Dirty Jobs" | Photographers: Michael Pohuski and Doug Adesko | Firm: Discovery Communications, Inc., Silver Spring | Art Director: Stefan Poulos | Designer: David Memmot | Art Buyer: Kerry Faulkner | Client: Discovery Channel

Comments: Image used to promote Discovery Channel's program "Dirty Jobs" featuring host, Mike Rowe.

Flora

76, 78 Flowers | Photographer: Mark Laita, Mark Laita, Culver City | Camera/Film: Fatif 8x10 camera, Kodak EPP film | Client: Personal

Comments: A series of flower still life.

79 Fotanical by joSon | Photographer: joSon Photography, Emeryville | Art Director: joSon | Client: Getty Images

Comments: Images created for art poster, card, stock.

80 Dutch Masters | Photographer: Stephan Abry, Stephan Abry, Hamburg | Art Director: Kate Francis | Artist: Livia Cetti | Stylist: Theresa Canning Zast | Client: Martha Stewart's Wedding

81, 82 Tulipa "Clara Butt", Begonia "Double Picotee" | Photographer: Peter Arnold | Camera: Hasselblad camera

Comments: Image for book *Tulips* published by TeNeues and book *Bulbs in Bloom* published by Laurel Glen.

83 Fotanical by joSon | Photographer: joSon, joson Photography, Emeryville | Art Director: joSon | Client: Getty Images

Comments: Images created for art poster, card, stock.

Food&Beverage

84 Vegetables | Photographer: Rob Davidson, Rob Davidson & Associates, Toronto | Creative Director: Peter Scott | Designer: Darrell Corriveau | Client: Q30 Design Inc.

Comments: Photographed for the Fresh Vegetable Growers of Ontario. The original inspiration was botanical drawings; however, the style evolved into a cleaner, more modern approach.

86 A Soba-gaki Dessert, 2007 | Photographer: Takashi Yasumura | Courtesy of Yossi Milo Gallery | Client: The New York Times Style Magazine | Camera: Horseman FA45 with a 6 x 7 roll film holder, with a lens, schneider Apo-Symmar 120mm f/5.6 | Film: Fujicolor Professional NL160 Photographic Paper: Kodak Supra Endura

Comments: Travel Summer 2007 issue. The photo was taken at a soba restaurant in Tokyo, Shimahei.

87 Mushrooms | Photographer: Rob Fiocca, Rob Fiocca Photography, Toronto | Art Director: Karen Lim | Client: Food & Drink Magazine

Journalism

88 Wire and Cloth | Photographer: Russell C. Wojtusiak | Date: Winter 2005 | Location: US Department of State Regional Embassy Office, Basrah, Iraq.

Comments: The US Embassy in Basrah, Iraq was like a small fortress. Formerly one of Saddam Hussein's many palaces, it was surrounded by concrete walls and guard towers that were caped with barbwire.

90, 91, 92, 93, 94, 95 "Life without Mercy" | Photographer: Sean Kernan | Represented by: Molly Birenbaum (Connecticut) | Client: Self-Promotion | Camera/Film: Nikon, Triax 35mm

Comments: I was returning from a failed project photographing carnival workers when I drove past the state prison of one of the border states. With nothing to lose, I knocked on the door, and was taken to the warden's office, where I explained that I wanted to photograph some prisoners. He stunned me by saying yes. I spent an hour in the yard stopping inmates and doing portraits. When I got home, I realized that one of them was one of the best things I had ever done. If there was one, perhaps there were more. I wrote the warden, and he invited me back. Thus began 5-week-long visits to two maximum-security prisons. I spent those weeks in a state of alertness and awareness such as I had never before experienced. I had few assumptions, and those were challenged to the point where I could only drop them and just try to be where I was as fully as I could. The work had a life of its own, and I knew I was done when I felt it didn't need me to go back. Nothing has been the same since.

96 Portraits of Iranian Martyrs | Firm: Newsweek, New York | Director of Photography: Simon Barnett | Senior Photo Editor: Jamie Wellford | Photographer: Paolo Pellegrin-Magnum for Newsweek | Client: Newsweek

Comments: Behesht Zahra Martyr Cemetery - Pictures of Iranians killed during the Iran-Iraq war of 1980-1988. Tehran, Iran. October 2006.

97 Discovery Channel's "King Tut's Mystery Tomb Opened" | Ad Firm: Discovery Communications, Inc., Silver Spring | Art Director: Stefan Poulos | Designer: Kerry Faulkner | Location: Valley of the Kings, Luxor, Egypt | Photographer: Sam Peach | Client: Discovery Communications

Comments: Photograph of archeologist Otto Schaden in Valley of the Kings, Egypt in the newly discovered tomb, "KV63."

98 Chad/Darfur: What happened to 'never again'? | Photographer: Jan Grarup | Firm: Newsweek, New York | Director of Photography: Simon Barnett | Senior Photo Editor: Jamie Wellford | Client: Newsweek

Comments: This year saw no end to the Janjaweed's reign of terror in western Sudan. After her village burned to the ground, a blind woman cradles her grandson while the boy's mother risks rape to seek out water for the family.

99 Darfur Refugees in Chad | Photographer: Luc Delahaye | Firm: Newsweek, New York | Director of Photography: Simon Barnett | Senior Photo Editors: Amy Periera, Jamie Wellford | Client: Newsweek

Comments: The horrors in Darfur show no sign of abating, mostly because the Sudanese government of Omar al-Bashir steadfastly refuses any expansion of peacekeeping forces in the western region where some 200,000 people have been killed and 2 million left homeless, as a result of fighting between government troops (and pro-Khartoum militias) and rebels in the region. At the United Nations conclave last week, US President George Bush, U.N. Secretary-General Kofi Annan and other international leaders renewed calls for the deployment of a large U.N. force to halt what Washington has called a campaign of genocide by Khartoum. But Bashir continues to say no to an international contingent. He did agree last week to allow a small force of Africa Union peacekeepers to remain in Darfur for three months, but no one expects that small concession to save any civilian lives at a time when the government attacks in the region have been intensifying.

100, 101 True Pain: Israeli and Hizbullah | Photographer: Paolo Pellegrin-Magnum for Newsweek | Firm: Newsweek, New York | Director of Photography: Simon Barnett | Senior Photo Editor: Jamie Wellford | Client: Newsweek

Comments: Paolo Pellegrin's powerful photography from the July 2006 war between Hizbullah and Israel is a striking vision of the brutality and desperation that gripped the region this summer. He risked his life to document refugees, intense bombings, and deaths in Tyre and Qana in southern Lebanon.

102 (top left) Title: Helo | Photographer: Russell C. Wojtusiak | Date: Spring 2005 | Location: International Zone (IZ), Baghdad, Iraq. | Equipment: Nikon D-70 Digital SLR Camera | Settings: Quality – Normal, Speed – 200

Comments: In Iraq, helicopters defined much of my existence. I was given the awesome and awful task of coordinating helicopter traffic requests for the Iraq Reconstruction Management Office. It was kind of like disorganized car pooling in a war zone!

(top right) Title: Untitled | Photographer: Russell C. Wojtusiak | Date: Dec 2004 | Location: Samara, Iraq | Equipment: Nikon D-70 Digital SLR Camera. | Settings: Quality – Normal, Speed – 200

Comments: While traveling through Samara to review reconstruction projects, the US Army provided transportation and convoy security for me and other members of the Iraq Reconstruction Management Office.

(middle right) Title: Untitled | Photographer: Russell C. Wojtusiak | Date: Dec 2004 | Location: Samara, Iraq | Equipment: Nikon D-70 Digital SLR Camera | Settings: Quality – Normal, Speed – 200

Comments: Samara was one of the first places I traveled to in Iraq. My inexperience showed in my dress and my behavior. After I took this picture the convoy stopped. When we went back to the HMMVES I forgot which one I was in and oddly jumped in the one next to me and said, "Mind if I hop in?"

(bottom right) Title: Stranger Than Science Fiction | Photographer: Russell C. Wojtusiak | Date: February 2005 | Location: The Port of Qumqusar, Bsarah, Iraq. | Equipment: Nikon D-70 Digital SLR Camera | Settings: Quality – Normal, Speed – 200

Comments: My jaw dropped and I did not move for 30 seconds when I saw these ships. Instead of being disposed of properly, wrecks from the Iran-Iraq war were piled high along the shore. I immediately asked "Doc" from our security detail to follow me. I had to get a picture of this, because no one would ever believe me.

(bottom left) Title: Untitled | Photographer: Russell C. Wojtusiak | Date: May 2005 | Location: Marine Corps Fallujah Help Center, Civil Military Operation Center (CMOC), Fallujah, Iraq | Equipment: Nikon D-70 Digital SLR Camera | Settings: Quality – Normal, Speed – 200

Comments: A security presence is maintained at all times at the CMOC.

(middle left) Title: Behind Saddam's Pool | Photographer: Russell C. Wojtusiak | Date: Winter 2005 | Location: US Embassy Baghdad, International Zone (IZ), Baghdad, Iraq | Equipment: Nikon F-5 35mm | Settings: 400 Speed Film Pushed to 800 Speed

Comments: Before the US Embassy in Iraq became very formal, I used to enjoy hanging out by the pool on Thursday nights. Drinking, bullets being thrown into the fire, and bicycles ridden off the high dive were all possible outcomes from the evening.

103 (top left) Title: Justice | Photographer: Russell C. Wojtusiak | Date: April 2005 | Location: The International Zone Baghdad, Iraq | Equipment: Nikon D-70 Digital SLR Camera | Settings: Quality – Normal, Speed – 200

Comments: The Iraq war will never be remembered, like World War II, as a great cause. But for those of who were there, it was our cause and there were victories. In all the mess of Iraq, one thing was certain: Saddam Hussein and his Republican Guard tortured, murdered, raped, and abused the Iraqi people. It is good and just that this building, as seat of his power, was bombed, destroyed and burned.

(top right) Title: Untitled | Photographer: Russell C. Wojtusiak | Date of Photo: Nov 2004 | Date of Journal Page: May 4th 2005 11:00 AM Amman Jordan | Location of Photograph: Blackhawk Helicopter, Baghdad provinces, Iraq | Equipment: Nikon D-70 Digital SLR Camera | Settings: Quality – Normal, Speed – 200

Comments: Wars are different, but history does repeat itself. Here I was an American, flying over a country with palm trees in a helicopter. My Uncle Jerry, who served in Vietnam, swore that this photo could have been taken there.

(bottom right) Title: The Bunker Bar | Photographer: Russell C. Wojtusiak | Date: Feb 11th 2005 | Location: The Bunker Bar, The International Zone, Baghdad, Iraq | Equipment: Nikon D-70 Digital SLR Camera | Settings: (Quality – Normal) (Speed – 400) with a flash

Comments: For a time, the Bunker Bar was a popular Friday night event in the International Zone. Once an actual bunker beneath a house, it boasted one bar, served only canned beer, and the walls were decorated with Saddam regime memorabilia and rifles.

(bottom left) Title: The Joy of T Walls | Photographer: Russell C. Wojtusiak | Date: Jan 2005 | Location: International Zone, Baghdad, Iraq | Equipment: Nikon D-70 Digital SLR Camera | Settings: Quality – Normal, Speed – 400

Comments: Barbwire and concrete are part of your life in Iraq, surrounding everything. The walls of our defenses free us from our foes, and imprison us from our friends. These metal and concrete custodians were so normal in Iraq that when there were none in sight, one felt scared and uneasy. Whenever I ventured far from them, my mind would drift to thoughts of protection: Was I wearing my body armor? Did I need to? Was I supposed to? Life there was all a series of calculated risks and reasons. The walls and wire could bring some moments of security, but it was quickly interrupted by the fact that our chosen form of protection not only kept us safe from danger, but from the hearts and minds of the Iraqi people. It is not easy to understand their life when you live in a cage, like a bird fearing the cats. We had no choice but to live behind those walls, even though they created a great battle to find the truth amongst the Iraqis. It was as if America existed on one side and Iraq on the other.

104 Untitled | Photographer: Russell C. Wojtusiak | Date: December 2004 | Location: Samara, Iraq | Equipment: Nikon F5 35mm SLR Camera | Settings: 100 Speed Film

Comments: Walking around Iraq is like opening up an old car that still runs. You pop the hood and stare at the engine, and you say, "How the f… can it keep running in this condition?" But that's Iraq, that's Iraqis. Not only does it run, but it can be beautiful.

105 Untitled | Photographer: Russell C. Wojtusiak | Date: Winter 2005 | Location: US Department of State Regional Embassy Office, Basrah, Iraq | Equipment: Nikon F-5 35mm | Settings: Kodak T-Max (Speed 400 film)

Comments: The US Embassy in Basrah, Iraq, was surrounded by concrete walls and guard towers that were caped with barbwire. These walls kept the bad guys out and us in.

106, 107 Story for People Magazine | Photographer: Ron Haviv | Photo Editor: Debbe Edelstein | Director of Photography: Chis Dougherty | Creative Director: Rina Migliaccio | Agency: VII Photo

Credits

Comments: Marine Sgt. Matt Roberts, 23, deploys to Iraq for the third time in as many years, leaving behind his wife Patricia, 22, and their sons Isaiah, 3, and Joseph, 2. The deployment of thousands of Marine and Army personnel multiple times is affecting morale both in the field and in the United States. These images are a look at Sgt. Roberts's last few days with his family at Marine Corps Air Station in North Carolina.

Landscape

108 Flame House Ruin | Photographer: Rodger Newbold, Salt Lake City | Client: Rodger Newbold Photography

Comments: Color image of an abandoned Anazazi Indian ruin. The overhanging, protective rock ceiling appears to look like flames.

110 Winter Sunset Monument Valley | Photographer: Rodger Newbold, Salt Lake City | Artist: Rodger Newbold | Photographer: Rodger Newbold | Client: Personal

Comments: Color image of two large rocks in the foreground with snow on them and one of the mitten rock formations at Monument Valley in midground at sunset.

111 Sundae with cherry, Ipanema Beach Palm | Photographer: Warren Eakins | Agency: Ace Art | Client: Ace Art, Inc. | Camera: Canon SD600 digital

112 Anza Borrego | Photographer: Paolo Marchesi Photography, Bozeman | Art Director: Heidi Volpe | Client: Los Angeles Times

Comments: Image taken for a feature on the Salton Sea in California. The image ran for the cover of the *Los Angeles Times West Magazine*.

113 UNTITLED | Photographer: Craig Cutler, New York | Camera/film: Hasselblad/Kodak 160VC | Client: Personal

Comments: Untitled-2007, Colorado

114 Christain Island | Photographer: Rob Davidson & Associates, Toronto | Photographer: Rob Davidson | Camera: Canon 5D | Client: Personal

115 Patchwork | Photographer: Barbara Bowles Fine Art, Santa Fe | Artist: Barbara Bowles | Photographer: Barbara Bowles | Client: Personal

Comments: This is a fine art photograph that was shot in 35mm film and printed digitally. The shot was taken in northern New Mexico. The colors and reflections are all natural. Nothing has been added or manipulated.

116 Black Sand Driftwood-NZ | Firm: Westside Studio, Toronto | Photographer: George Simhoni | Client: Personal

117 Bridge | Photographer: Paolo Marchesi Photography, Bozeman | Client: Personal

Comments: Image from a personal project called "Bird eye view."

118 Cracked Mud, Oljeto Wash, San Juan River, Utah | From the book "Recollections: Three Decades of Photographs" | Photographer: John Sexton | Camera: 4x5" Linhof Master Technika | Film: Kodak Professional T-Max 100

Comments: This image was a self-assignment made during a ten-day photography expedition floating the San Juan River in southeastern Utah. A few days before this image at the mouth of Olijeto Wash, which is a primary drainage of Monument Valley, a massive flash flood had gone through the area depositing many feet of mud and silt. Some areas of the mud had begun to dry, forming light areas, as seen in this image. The dark areas of the mud are still wet. I scoured the area looking for interesting patterns and was drawn to this particular mosaic detail.

119 Lower Calf Creek Falls Detail, Utah | Photographer: John Sexton | Camera: 4x5" Linhof Master Technika 2000 | Film: Kodak Professional T-Max 400

Comments: This was a self-assignment made when my wife, Anne, and I hiked six miles roundtrip into the falls. Though it was a blazingly hot day in the Utah desert, Lower Calf Creek Falls forms a verdant paradise. A number of images were made, with each one being different as the water flows, combined with shifting winds, revealing the different pattern in each exposure. The negative I finally printed was the only negative where the water pattern formed a design that was exactly what I had hoped for.

Nudes

120 CLUB CHAIR MADONNA | Photographer: Phil Marco | Client: Personal work

Comments: One of an ongoing series of fine art classical nudes.

122 Mary Jane Starke | Model: Elena | Photographer: Parish Kohanim, Parish Kohanim Fine Art Gallery | Camera: Caanon IDA Mark III | Client: Parish Kohanim Fine Art Gallery

123 "Head trip" story for the annual artist's statement | Photographer: Joel-Peter Witkin | Lighting: Robert C.Reck | Makeup: Myra Shoults | Model: Laila Weeks | Client: The New York Times | Courtesy: Silverstein Photography, N.Y.C., Catherine Edelman Gallery, Chicago and Valerie Baudoin Lebon, Paris

Comments: The concept was to create a tableaux of famous works of art and to make these masterworks current by using a contemporary designer's hat in each historical image.

124 Yellow Nude | Photographer: Rob Davidson, Rob Davidson & Associates, Toronto | Camera: Cannon 5D(Digital) *pinhole lens | Client: Personal

Comments: Photographed with a pinhole lens on a digital camera.

125 Un Tango Velado | Photographer: Vic Huber, Irvine | Art Director: Vic Huber | Model: Tatiana Polo | Creative Director: Vic Huber | Camera: Nikon D2XS Digital with a 17mm-55mm zoom lens | Client: Personal

Comments: From an ongoing series of veiled nudes.

126 Valerie, Milwaukee | Photographer: Raoul Benavides, Raoul Benavides Photographs, Minneapolis | Camera/Film: Mamiya, RZ, Kodak | Client: Personal portrait

127 Elledge_Mexico_Nudes | Photographer: Paul Elledge, Paul Elledge Photography, Chicago | Camera/Film: Canon 5D, Digital | Client: Self-Promotion

Comments: Nude study exploring juxtaposition of fragility and the power of the human body; inspired by the light in San Miguel, Mexico.

128 30 | Photographer: Thomas Hammel, Thomas Hammel, San Francisco | Camera/Film: rolleiflex twin-lens reflex, triax 320 | Client: Self Promotion

129 Merged Bodies | Photographer: Alfred Exss Leontic, Alfred Exss, Santiago | Author: Alfred Exss Leontic | Client: Self-Promotion

Comments: A couple making love is distorted by flexible mirrors, generating a surreal set of images. Bodies seem to merge in a semi liquid form.

130 Amelia | Photographer: Joseph E. Reid, Joseph E. Reid, Yonkers | Model: Amelia McCarthy | Camera: Kodak Portra 400NC with a Santa Barbara 8X10 pinhole camera | Client: Personal

Comments: 8X10 pinhole nude series in Matthew Brady's studio.

131 Men Exposed | Photographer: Peter Arnold | Model: Don

Comments: Cover shot for book *Men Exposed*, published by TeNeues.

Portraits

132, 134 Offal Taste | Photographer: Stephanie Diani, Los Angeles | Art Director: Stephanie Diani | Stylist: Stephanie Diani | Photographer's Assistants: Casey Cunneen, Ben Duggan | Camera: Cannon Mark 2 1DS, 8x10 film camera | Client: Self-Promotion

Comments: A series of portraits using raw meat offal as an accessory or prop.

135, 136 Homeless | Photographer: Michael O'Brien, Austin | Designer: Mike Hicks | Writer: Elizabeth O'Brien | Project Manager: Alan Graham | Client: Mobile Loaves and Fishes

Comments: The pro bono project was to make portraits of the people that Mobile Loaves and Fishes serves. Mobile Loaves & Fishes, Inc. (MLF) is a social outreach ministry to the homeless and indigent working poor. Their mission is to provide food, clothing and dignity to people in need. Pictures will be used in a small printed piece to raise money to fund the MLF.

137 Offal Taste | Photographer: Stephanie Diani, Los Angeles | Art Director: Stephanie Diani | Stylist: Stephanie Diani | Photographer's Assistants: Casey Cunneen, Ben Duggan | Camera: Cannon Mark 2 1DS, 8x10 film camera | Client: Self-Promotion

Comments: A series of portraits using raw meat offal as an accessory or prop.

138 My Quest to Improve Care | Firm: Newsweek, New York | Director of Photography: Simon Barnett | Photographer: Norman Jean Roy | Client: Newsweek

Comments: Former President Bill Clinton.

139 Helen Mirren, "The Queen" | Photographer: Dan Winters | Set Design: Dan Winters | Set Builder: Ed Murphy | Makeup: Mary Klimek | Stylist: Denise Tohme | Client: NY Times Magazine

140, 142 Tom Waits | Photographer: Michael OBrien, Austin | Art Directors: D.J. Stout, Kevin de Miranda | Photographer: Michael O'Brien | Creative Director: Tom Waits | Client: Spirit Magazine

Comments: Portraits of the musician Waits were made in northern California for the release of his new album, "Orphans: Brawlers, Bawlers and Bastards." Tom is a demanding subject. He's like photographing a wild turkey. I tracked him for days and waited in the underbrush with a telephoto and a stun gun.

143, 144 Piper Perabo | Photographer: Henry Leutwyler Studio, New York City | Client: Personal

145 Drowning | Photographer: Alfred Exss Leontic, Alfred Exss, Santiago | Author: Alfred Exss Leontic | Client: Self-Promotion

Comments: The model was depressed, and I tried to capture her state of mind.

146 Elledge_Daniel_Libeskind | Photographer: Paul Elledge Photography, Chicago | Camera: Hasselblad 500 CM, Film: Kodak Portra 100 UC | Client: American Express 360 Magazine

Comments: Portrait of Daniel Libeskind for *American Express 360 Magazine*.

147 Elledge_Michelle | Ad Firm: Paul Elledge Photography, Chicago | Photographer: Paul Elledge | Camera: Hasselblad 500 CM, Film: Kodak Portra 400 UC | Client: Self-Promotion

148 Burka portrait | Photographer: Steven Wohlwender, San Mateo | Project Manager: Humaira Ghilzi | Camera/Film: Canon EOS 1V, fugi velvia | Client: Afghan Friends Network

Comments: Image used in many ways and materials to promote and raise awareness for a non-profit organization.

149 Weapon | Photographer: Steven Wohlwender | Project Manager: Humaira Ghilzi | Camera/film: Contax G2, (B&W)triax (Kodak) | Client: Afghan friends network

Comments: Used to promote the non-profit organization

150 UNTITLED | Photographer: Craig Cutler, New York | Camera/film: 4x5 Linhoff/Kodak 160VC | Client: Personal

Comments: Teenagers Portrait Study 2006-2007.

151, 152 DENIM STORY | Photographer: Craig Cutler, New York | Art Director: Debra Bishop | Hair: Corey Tuttle | Makeup: Sonia Lee | Client: Personal

Comments: Editorial series for *Blunprint Magazine*, story title: "Denim Story."

153 UNTITLED | Photographer: Craig Cutler, New York | Camera/film: 4x5 Linhoff/Kodak 160VC | Client: Personal

154 Untitled | Ad Firm: Craig Cutler, New York | Photographer: Craig Cutler | Camera/film: Hasselblad/Kodak 160VC | Client: Personal

Comments: Steak House-Ohama, Nebraska, *Portfolio Magazine*, 2007.

155 DENIM STORY | Photographer: Craig Cutler, New York | Art Director: Debra Bishop | Hair: Corey Tuttle | Makeup: Sonia Lee | Client: Personal

156 Abuelo, Trinidad Cuba | Photographer: Ryan Heffernan Photography, Santa Fe | Camera/film: Leica M6/ Tri X | Client: Personal Project

157 Common | Photographer: Dan Winters for Newsweek | Firm: Newsweek, New York | Director of Photography: Simon Barnett | Deputy Director of Photography: Sue Miklas | Client: Newsweek

158 Priest | Photographer: Jim Erickson, Erickson Productions Inc., Petaluma | Art Director: Kevin Houlihan | Photographer's Assistant: Tyler Jacobsen | Stylist: Shannon Ray | Client: Erickson Productions, Inc.

Comments: On a break from a photo shoot involving a rabbi and priest.

159 Andy | Photographer: Simon Harsent, New York | Client: Personal

Comments: Andy is a portrait from a series of portraits of immigrants from Australia living in NY; the series focuses on normal people who have come from Australia to experience life in NY.

160 Reverie | Photographer: Rosanne Olson Photography, Seattle | Art Director: Rosanne Olson | Model: Sarah Skinner | Camera: Canon EOS 5D digital camera | Client: Personal

Comments: Part of an ongoing series called 4 + 20 Blackbirds.

161 Rowan Fee | Photographer: Jonathan Knowles Photography, London | Model: Rowan Fee | Client: Personal Work

162 Essence of Africa | Photographer: Peter Arnold | Model: Mike

Comments: Image for book *Black Adonis*; looking for publisher. www.blackadonis.co.uk

163 Portrait before the death | Photographer: Przemek Krzakiewicz "el Emo" | Firm: visavis.pl, Krakow | Author: Przemek Krzakiewicz "el Emo" | Client: Newsweek Polska Magazine

Comments: Jan Nowak's portrait: Incurably ill actor Jan Nowak made a decision to act in a documentary movie about his life and death.

164 The Amazing Faith of Texas | Photographer: Randal Ford | Art Director: Craig Denham | Chief Creative Officer: Roy Spence | Creative Director: David Crawford | Designer: Craig Denham | Print Producer: Diane Patrick | Writer: Roy Spence

Comments: Communicates the often unseen unity among Texans amid their varied religions and denominations.

165 Michael C. Hall | Photographer: Steve Vaccariello, Vaccariello Creative Services, New York | Art Director: Paul Innis | Designer: Paul Innis | Location: Vaccariello Studios | Makeup: Paul Innis | Model: Michael C. Hall | Photographer's Assistant: Zachary Bako | Set Designer & Props: Zachary Bako | Stylist: Mario Wilson | Client: Aventura Magazine

Comments: The *Six Feet Under* and *Dexter* actor was willing to do anything for this editorial shoot for *Aventura Magazine*. An elaborate set and incredible post-production adds to this dark, dynamic tale. Makeup and post-production by Paul Innis.

166 Oliver Platt for Manhattan Theatre Club | Photographer: Henry Leutwyler Studio, New York City | Account Director: Mark Rheault | Art Director: Gail Anderson | Creative Director: Drew Hodges | Client: Spotco

Comments: Oliver Platt for Manhattan Theatre Club 2006-2007 Brochure.

167 8x10 Portrait_03 | Photographer: Sandro Miller, Sandro, Chicago | Client: Personal

168 Tatoo Man | Photographer: Bill Diodato, New York | Client: Personal

169 The Amazing Faith of Texas | Photographer: Randal Ford | Art Director: Craig Denham | Chief Creative Officer: Roy Spence | Creative Director: David Crawford | Designer: Craig Denham | Print Producer: Diane Patrick | Writer: Roy Spence

Comments: Communicates the often unseen unity among Texans amid their varied religions and denominations.

170 Self-Promotion Series | Photographer: Arciero Photography, Chicago | Camera: Hasselblad H2 with Imacon back digital capture | Client: Personal

Comments: After creating an image of a roasted marshmallow on a jeweled fork, I decided to try doing the flip side of that idea.

172 Lost Shoes | Photographer: Heinz Baumann | Client: Imagepoint AG

173 Cell Katipo | Photographer: Andrew Zuckerman Studio, Inc., New York | Art Director: Andrew Zuckerman | Creative Director: Antonio Bertone | Design Director: Adam Petrick | Retoucher: Justin Cohen | Executive Creative Strategist: Adam Petrick | Illustrator: Wendy Klein | Photographer's Assistant: Nick Lee | Writer: Rory Hanrahan | Camera: H2 with leaf aptus 75s digital back | Client: PUMA AG Worldwide

174 Lost Shoes | Photographer: Heinz Baumann | Client: Imagepoint AG

175 Cosmetics | Ad Firm: Rob Fiocca Photography, Toronto | Art Director: John Gerhardt | Photographer: Rob Fiocca | Creative Director: John Gerhardt | Stylist: Jenn Cranston | Client: Holt Renfrew

176 Just in case | Photographer: Ilan Rubin | Represented by: Jordan Shipenberg at Art Department | Soft Goods Stylist: Brenda Barr @ Mark Edward Inc. | Photo Editors: Karla Martinez and Bruce Pask | Client: T Magazines' Travel Must Haves section in Spring 07 issue

Comments: The Bags are all Taramantano Roll-up bags. Same bag, different colors. Camera: Mamiya RZ digital with P45 Phase One digital back.

177 Lost Shoes | Photographer: Heinz Baumann | Client: Imagepoint AG

178 Self-Promotion Series | Photographer: Arciero Photography, Chicago | Camera: Hasselblad H2 with Imacon back digital capture | Client: Personal

Comments: After creating an image of a roasted marshmallow on a jeweled fork, I decided to try doing the flip side of that idea.

179 D Squared Boots | Photographer: Rob Fiocca Photography, Toronto | Creative Director: John Gerhardt | Art Director: Diti Katona | Stylist: Jay Barnett | Client: Holt Renfrew

Sports

180 Nike Swim 3 | Photographer: Marcus Swanson, Swanson Studio, Portland | Art Director: Valerie Taylor Smith | Client: Nike Inc.

182 Hawaii | Firm: joSon Photography, Emeryville | Art Director: joSon | Client: Personal

183 Photographer | Ad Firm: John Madere, Old Lyme | Photographer: John Madere | Client: Personal

Comments: Portrait of Greenland Kayaker Turner Wilson for a self-assigned series of kayakers.

184 tri 2 | Photographer: Steven Wohlwender, San Mateo

185 Aja Frary-Start | Photographer: Marcus Swanson, Swanson Studio, Portland | Stylist: Katherine Ross | Camera: 8x10 Sinar View Camera Cross Processed Polaroid | Client: Swanson Studio Inc.

Still Life

186, 188 New Food Work | Photographer: Terry Heffernan Films, San Francisco | Artist: Terry Heffernan | Stylist: Ann Beldon | Camera/film:Sinar 4x5 digital back | Client: Personal

Comments: New portfolio work.

189 Jimmy Choo Shoes in Gift Box X-Ray | Photographer: Nick Veasey, Maidstone | Art Director: Richard Hales | Client: Michael Nash Associates

190, 191, 192 Still Life Series | Photographer: Craig Cutler, New York | Camera/film: 4x5/Kodak Tri-X | Client: Personal

Comments: B&W Study composed with egg shells/still life series.

193 Six Blocks | Photographer: Craig Cutler, New York | Client: Personal

Comments: Still Life study.

194, 195 Untitled | Ad Firm: Craig Cutler, New York | Photographer: Craig Cutler | Client: Personal

Comments: Dinosaur Restoration Study 2007.

196 Untitled | Photographer: Craig Cutler, New York | Client: Personal

197, 198, 199 Water Glasses | Photographer: Craig Cutler, New York | Camera/film: 8x10/Kodak 160VC | Client: Personal

Comments: A study of color patterns reflected inside water glasses, 2007.

200 Image Series "Precision Investments" | Photographer: Reimers + Hollar, Santa Ana | Client: State Street Global Advisors | Art Director: Kat McCord | Camera: Canon EOS-1 DS Mark 2

Comments: A selection of images from a series defining precision investments in an imprecise world.

201 Pen & Ink | Photographer: Reimers + Hollar, Santa Ana | Art Director: Reimers + Hollar | Camera: Canon EOS-1 DS Mark 2 | Client: Personal

202 Tipsy | Photographer: Reimers + Hollar, Santa Ana | Art Director: Reimers + Hollar | Client: Personal

203 Image Series "Precision Investments" | Photographer: Reimers + Hollar, Santa Ana | Client: State Street Global Advisors | Art Director: Kat McCord | Camera: Canon EOS-1 DS Mark 2

Comments: A selection of images from a series defining precision investments in an imprecise world.

204 Self-Promotion Series | Photographer: Anthony Arciero, Chicago | Art Director: Anthony Arciero | Camera: Hasselblad H2 with Imacon back Digital capture | Client: Arciero Photography

Comments: After creating an image of a roasted marshmallow on a jeweled fork, I decided to try doing the flip side of that idea.

205 New Food Work | Photographer: Terry Heffernan Films, San Francisco | Artist: Terry Heffernan | Stylist: Ann Beldon | Camera/film:Sinar 4x5 digital back | Client: Personal

Comments: New portfolio work.

206 White Coat Hangers | Photographer: Craig Cutler, New York | Camera/film: Mamiya RZ/Kodak 160VC | Client: Personal

Comments: Still life study composed with white coat hangers.

207 Untitled | Photographer: Craig Cutler, New York | Client: Personal

Comments: Dinosaur Restoration study.

208, 209, 210 Julius Shulman's Light Case | Photographer: Henry Leutwyler Studio, New York | Client: Personal

211 Mr Smith's Hat | Photographer: Jonathan Knowles Photography, London | Client: Personal

212, 213, 214, 215, 216 Hardware Series | Photographer: Robert Tardio Photography, New York | Camera: Sinar P2 | Client: Personal Work

217 Boxing Gloves | Photographer: Hugh Kretschmer, Los Angeles | Set Designer & Props: Hugh Kretschmer | Client: Personal

218 Empor | Photographer: Angelika von Prondczynsky fotografie, Frankfurt | Client: Personal

219 Fish Market, Morocco | Photographer: Ryan Heffernan, Ryan Heffernan Photograhy, Santa Fe | Client: Personal

220 Sneaker Creature | Photographer: Bill Diodato, New York | Art Director: Sally Berman | Client: Bill Diodato/XXL Magazine

221 Rubber Glove-Front | Photographer: Colin Faulkner, Toronto | Creative Director: Colin Faulkner | Client: Personal Work

Wild Life/Pets

222, 224 Reptiles and Amphibians | Photographer: Mark Laita, Culver City | Camera/film: Fatif 8x10 camera, Kodak EPP film | Client: Personal

225, 226 Chicken, Rabbit | Photographer: Rosanne Olson, Rosanne Olson Photography, Seattle | Art Director: Jane Perovich | Camera: Canon EOS 5D digital camera | Client: Getty Images

227 Reptiles and Amphibians | Photographer: Mark Laita, Culver City | Camera/film: Fatif 8x10 camera, Kodak EPP film | Client: Personal

228 Photographer: Chris Gordaneer, Westside Studio, Toronto | Camera: Canon 1ds mark 2 | Client: Personal

229, 230 Where Reptiles Rule | Photographer: George Simhoni | Agency: Personal Westside Studio, Toronto | Art Director: Joy Ivy | Creative Director: Billy Barnes | Writer: Billy Barnes | Client: Zilla

231, 232, 233 Sea Life | Photographer: Mark Laita, Culver City | Client: Personal

234 Elephants under tree | Photographer: Chris Gordaneer | Agency: Westside Studio, Toronto | Camera: Canon 1ds mark 2 | Client: Personal

235 Nature Series | Photographer: Mark Laita, Culver City | Camera/film: Fatif 8x10 camera, Kodak T-Max 100 film | Client: Personal

236, 237 Creature | Photographer: Andrew Zuckerman Studio, Inc., New York | Art Director: Andrew Zuckerman | Retoucher: Justin Cohen | Photographer's Assistant: Nick Lee | Camera: H2 with leaf aptus 75s digital back | Client: Personal work

238, 239, 240, 241, 242 Living Jewels 2 | Photographer: Poul Beckmann | From his latest book, *Living Jewels 2*, published by Prestel Publishing | Collaborator/Painter: Ruth Kaspin

Comments: Beckmann has complied an entirely new collection of gorgeous beetles. Magnified multiple times their normal size and photographed in opulent color, Beckmann manages to reveal their true magnificence.

Directory

Ace Art
85 South St., #7F, New York, NY 10038, United States | Tel 347 831 1812 | Fax 212 598 2938

Addis Creson www.addiscreson.com
2515 Ninth St., Berkeley, CA 94710, United States | Tel 510 704 7500 | Fax 510 649 7173

Alfred Exss www.alfred.exss.cl
San Jose de La Sierra 925, Santiago Metropolitana, Chile 6772989 | Tel 562 3388215

Andrew Zuckerman Studio, Inc. www.andrewzuckerman.com
508 W. 26th St., Studio 4A, New York, NY 10001, United States | Tel 212 727 3988

Angelika von Prondczynsky fotografie www.prondczynsky.de
Cassellastr. 30-32, 60386 Frankfurt, Germany | Tel +49 69 553866 | Fax +49 69 591096

Arciero Photography www.arciero.com
1643 N. Milwaukee Ave., Suite 2, Chicago, IL 60647, United States | Tel 773 772 7297

AP Photo www.ap.org
450 W. 33rd St., New York, NY 10001, United States | Tel 212 621 1958 | Fax 212 621 1955

August Bradley Images www.AugustBradley.com
409 W. Olympic Blvd., #203, Los Angeles, CA 90015, United States | Tel 323 898 1522

Barbara Bowles Fine Art www.barbarabowles.com
125 East Palace #135, Santa Fe, NM 87501, United States | Tel 505 983 4452

Baumann Photography www.heinzbaumann.com
Friedheimstrasse 8, Zürich, 8057, Switzerland | Tel +41 44 310 11 66

Bill Diodato www.billdiodato.com
433 West 34th St., #17B, New York, NY 10001, United States | Tel 212 563 1724 | Fax 212 594 3603

Caroline Knopf www.sarahlaird.com
134 Spring St., Suite 201, New York, NY 10012, United States | Tel 212 334 4280

Colin Faulkner www.faulknerphoto.com
1173 Dundas St. East, Suite 240, Toronto, Ontario, M4M 3P1, Canada
Tel 416 469 1557 | Fax 416 469 8235

Craig Cutler www.craigcutler.com
15 E. 32nd St., 4th Floor, New York, NY 10016, United States | Tel 212 779 9755 | Fax 212 779 9780

Dan Winters www.danwintersphoto.com
251 W. 57th St.,15th Floor, New York, NY 10019, United States | Tel 323 957 5699

Danielle Hall Photography www.daniellehall.net
660 King St., Suite 408, San Francisco, CA 94107, United States | Tel 415 793 3743 | Fax 415 863 3788

Discovery Communications, Inc. www.discovery.com
One Discovery Place, Silver Spring, MD 20910, United States | Tel 240 662 4684 | Fax 240 662 1966

Erickson Productions Inc. www.jimerickson.com
2 Liberty St., Petaluma, CA 94952, United States | Tel 707 789 0405 | Fax 707 789 0459

Frank Wartenberg www.frank-wartenberg.com
Leverkusenstr. 25, 22761 Hamburg, Germany | Tel +49 40 8508331

Gareth McConnell www.countergallery.com
44a Charlotte Rd., London EC2A 3PD, United Kingdom | Tel +44 0 20 7684 8890

GSD&M www.gsdm.com
828 West 6th St., Austin, TX 78703, United States | Tel 512 242 4622 | Fax 512 242 7622

Hagadone Photography www.rogerhagadone.com
529 W. 42nd St., #3R, New York, NY 10036, United States | Tel 212 714 9587

Henry Leutwyler Studio www.henryleutwyler.com
648 Broadway, Suite 1000, New York, NY 10012, United States | Tel 212 253 7793 | Fax 212 253 7798

Herve Grison Photography web.mac.com/hgrison
2425 McCready Ave., Los Angeles, CA 90039, United States | Tel 323 336 0294

Hugh Kretschmer www.sharpeonline.com
155 West Washington Blvd., #605, Los Angeles, CA 90015, United States | Tel 917 449 4929

James & Daughters, Inc. www.jamesworrell.net
10 Burr Rd., Maplewood, NJ 07040, United States | Tel 212 367 8389

Jamie Nelson www.jamienelson.com
101 West 23rd St., #123, New York, NY 10011, United States | Tel 805 258 9192

Jason Bell Photography www.jasonbellphoto.com
124 Thompson St., Apt 20, New York, NY 10012, United States | Tel 917 250 8650

Joel-Peter Witkin www.edelmangallery.com
1707 Five Points Rd. SW, Albuquerque, NM 87105-3017, United States | Tel 505 843 6682

John Madere Photography www.johnmadere.com
P.O. Box 376, Old Lyme, CT 06371, United States | Tel 860 434 3338 | Fax 860 434 5824

John Sexton www.johnsexton.com
P.O. Box 30, Carmel Valley, CA 93924, United States | Tel 831 659 3130

Jonathan Knowles Photography www.jknowles.co.uk
48A Chancellors Rd., London W6 9RS, United Kingdom
Tel +44 20 8741 7577 | Fax +44 20 8748 9927

Joseph E. Reid www.jerphotography.com
23 Water Grant St., 8K, Yonkers, NY 10701, United States | Tel 917 769 6327

joSon Photography www.josonphoto.com
1121 40th St., Suite 2201, Emeryville, CA 91121, United States | Tel 510 653 1194

Julie Brothers Photography www.juliebrothers.com
1202 S. LaJolla Ave., Los Angeles, CA 90035, United States | Tel 323 934 7325

Kelly Holland www.anandholland.com
7348 Jamieson Ave., Lake Balboa, CA 91335, United States | Tel 323 350 0736

LeBook www.lebook.com
552 Broadway 6th Floor, New York, NY 10012, United States | Tel 212 334 5252

Mark Laita www.marklaita.com
3815 Main St., Culver City, CA 90232, United States | Tel 310 836 1645 | Fax 310 836 1645

Michael O'Brien www.obrienphotography.com
6501 Minikahda Cove, Austin, TX 78746, United States | Tel 512 472 9205

Newsweek www.newsweek.com
251 W. 57th St., 15th Floor, New York, NY 10019, United States | Tel 212 445 4636

Nick Veasey www.nickveasey.com
Radar Studio, Coldblow Lane Thurnham, Maidstone Kent ME14 3LR, United Kingdom
Tel +44 1622 737722 | Fax +44 1622 738644

Norbert Schoerner www.dayfornight.tv
17 Little West 12th St., Suite 202, New York, NY 10014, United States | Tel 212 924 6565

Paolo Marchesi Photography www.marchesiphoto.com
1627 W. Main #187, Bozeman, MT 59715, United States | Tel 406 585 0747 | Fax 406 585 074

Parish Kohanim www.parishkohanim.com
1130 West Peachtree St., Atlanta, GA 30309, United States | Tel 404 892 0099 | Fax 404 892 0156

Paul Elledge Photography www.paulelledge.com
1808 W. Grand Ave., Chicago, IL 60622, United States | Tel 312 733 8021 | Fax 312 733 3547

Peter Arnold www.flowerimagebank.com
125 Queenstown Rd., Battersea, London SW8 3RH, United Kingdom | Tel +44 207 819 9542

Phil Marco www.philmarco.com
137 West 25th St., New York, NY 10001, United States | Tel 212 929 8082

Poul Beckmann (Prestel Publishing) www.living-jewels.com
900 Broadway, Suite 603, New York, NY 10003, United States | Tel 212 995 2720

Raoul Benavides Photographs www.raoulbenavides.com
4109 Park Ave., Minneapolis, MN 55407, United States | Tel 612 341 6585

Reimers + Hollar www.sharpeonline.com
441 E. Columbine Ave., Suite i, Santa Ana, CA 92707, United States | Tel 714 545 4022

Rob Davidson & Associates www.rdaphoto.com
19 Atlantic Ave., Toronto, ON M6K 3E7, Canada | Tel 416 504 2207

Rob Fiocca Photography www.fioccaphoto.com
69 Pelham Ave., Studio A, Toronto, ON M6N 1A5, Canada | Tel 416 516 0034 | Fax 416 516 0661

Robert Tardio Photography www.roberttardio.com
118 East 25th St., Floor 6, New York, NY 10010, United States | Tel 212 254 5413 | Fax 212 254 3735

Rodger Newbold www.slacphoto.net
P.O. Box 520021, Salt Lake City, UT 84152, United States | Tel 801 487 7041

Ron Haviv www.viiphoto.com
236 West 27th St., Suite 1300, New York, NY 10001, United States

Rosanne Olson Photography www.rosanneolson.com
5200 Latona Ave. NE, Seattle, WA 98105, United States | Tel 206 633 3775 | Fax 206 547 1986

Russell Wojtusiak
P.O. Box 2469, Montauk, NY 11954, United States | Tel 917 885 6267

Ryan Heffernan Photograhy www.ryanheffernan.com
1807 A Agua Fria, Santa Fe, NM 87505, United States | Tel 207 577 5122

Sandro Miller www.sandrofilm.com
2540 West Huron St., Chicago, IL 60612, United States | Tel 773 486 0300 | Fax 773 486 0300

Sean Kernan www.seankernan.com
28 School St., Stony Creek, CT 06405, United States | Tel 203 481 0213

Shaun Fenn Photography www.shaunfennphotography.com
5646 Maxwelton Rd., Oakland, CA 94618, United States | Tel 510 282 0660

Simon Harsent www.simonharsent.com
168 2nd Ave., #226, New York, NY 10007, United States | Tel 646 258 4719

staudinger+franke gmbH www.staudinger-franke.com
Mollardgasse 85A/1/4, Vienna 1060, Austria | Tel +43 1 5970124 | Fax +43 1 5970124 44

Stephan Abry www.stephanabry.com
Struenseestrae 31-37, Hamburg 22767, Germany | Tel +49 172 4108756 | Fax +49 40 39 90 58 27

Stephanie Diani www.stephaniediani.com
656 S. Ridgeley Dr. #301, Los Angeles, CA 90036, United States
Tel 323 936 4905 | Fax 323 936 4905

Stephanie Knopp Designs
334 West Allens Lane, Philadelphia, PA 19119, United States | Tel 215 242 2932

Steven Wohlwender www.stevenwohlwender.com
1330 Rainbow Drive, San Mateo, CA 94402, United States | Tel 415 407 1547

Studio Schulz www.studioschulz.com
6790 Top Gun St., #11, San Diego, CA 92121, United States | Tel 858 452 8862

Swanson Studio www.swansonstudio.us
1526 NW 17th Ave., Portland, OR 97209, United States | Tel 503 228 2428 | Fax 503 228 2122

Terry Heffernan Films www.heffernanfilms.com
991 Tennessee St., San Francisco, CA 94107, United States | Tel 415 896 0499

Thomas Hammel www.thomashammel.com
207 Prospect Ave., San Francisco, CA 94110, United States | Tel 415 643 9555

Trillium Studios www.carywolinsky.com
70 Green St., Norwell, MA 02061, United States | Tel 781 659 2839 | Fax 781 659 2427

Vaccariello Creative Services www.vaccariello.com
154 West 27th St., Suite 4, New York, NY 10001, United States | Tel 212 727 2596 | Fax 212 727 7920

Vic Huber www.vichuber.com
1731 Reynolds Ave., Irvine, CA 92614, United States | Tel 949 261 5844 | Fax 949 261 5973

visavis.pl www.visavis.pl
ul.Karmelicka 36/9b, 31-128 Kraków, Malopolska 31-128, Poland | Tel +48 12 634 26 22

Westside Studio www.westsidestudio.com
70 Ward St., Toronto, ON M6H 4A6, Canada | Tel 416 535 1955 | Fax 416 535 0118

Clients

Hair/Makeup/Stylists

Models

Writers

AdditionalCreativeContributors

Graphis Standing Orders (50% off):

Save 50% off the price on new Graphis books when you sign up for a Standing Order on any of our best-selling books (annuals or bi-annuals).

A Standing Order is a subscription to Graphis books with a 2 year commitment. Secure your copy of the latest Graphis titles, with our best deal, today online at *www.graphis.com*. Click on Annuals, and add your selections to your Standing Order list, and save 50%.

Graphis Titles

Nudes1

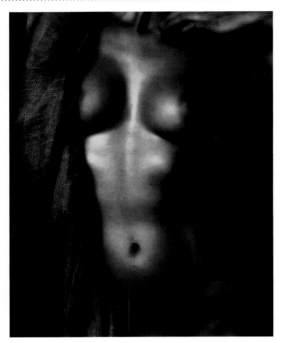

Published 1997 *200 plus color illustrations* *ISBN: 3-85709-435-4*
Hardcover: 256 pages *Trim: 10 1/2 x 14"* *US $60*

The human figure has long been one of Photography's most intriguing, challenging and controversial subjects. *Nudes 1* is the most popular title in the Graphis *Nudes* series, an elegant and exciting anthology of nude Photography from around the world. Introductions by two noted Photography editors, **Sean Callahan** and **Petra Olschewski**, set the scene for the carefully selected and superbly printed gallery of outstanding images by more than 100 respected Photographers. This stunning selection of nude Photography has proven so popular, it is now in its third printing.

Nudes2

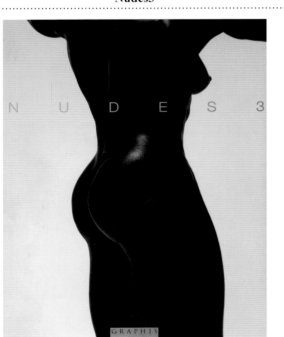

Published 1998 *115 plus color illustrations* *ISBN: 1-888001-30-5*
Hardcover: 224 pages *Trim: 10 1/2 x 14"* *US $70*

This is the second volume in the Graphis series dedicated to the human figure. Since the inception of this medium, Photographers have been fascinated by the human body—its grace, its vulnerability and the seemingly infinite ways it can be depicted. With an insightful introduction by writer and critic **Lyle Rexer** and commentary by longtime collector **Uwe Scheid**, this compilation presents more than 200 sublime and surprising images by some of the most respected Photographers of this century, including **Imogen Cunningham, Ralph Gibson, Horst**, and **Edward Weston**.

Nudes3

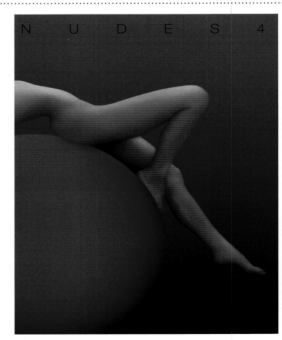

Published 1999 *200 plus color illustrations* *ISBN: 1-888001-66-6*
Hardcover: 256 pages *Trim: 10 1/2 x 14"* *US $70*

The third volume in this series, *Nudes 3* continues to present the best contemporary work in the classic, yet ever-changing arena of nude Photography. From luminous abstracted presentations of the human form to highly stylized and direct portrayals, *Nudes 3* explores the diversity and beauty of the nude figure. With over 200 intriguing photos from artists around the world, this book features exceptional work from emerging new talents as well as some of the most esteemed Photographers of this era, including **Herb Ritts, Sheila Metzner, Robert Farber, Sandi Fellman** and **Mark Seliger**.

Nudes4

Published 2006 *150 plus color illustrations* *ISBN: 1-932026-26-6*
Hardcover: 224 pages *Trim: 9 3/4 x 13 3/8"* *US $70*

Graphis Nudes 4 is a striking collection of over 100 world-class photographs celebrating the human body. These images honor the human form through the eyes of Photography masters such as **Phil Bekker, Parish Kohanim, Barry Lategan, Henry Leutwyler, Joyce Tenneson** and **Albert Watson**. Thoughtful insights from some of the featured Photographers complement these beautifully reproduced images. This international, nude art presentation is the fourth volume in Graphis' popular series, and will inspire and intrigue a sophisticated audience.

Available at www.graphis.com

Graphis Titles

PhotographyAnnual2003

Published 2002
Hardcover: 256 pages
300 plus color images

Trim: 8 1/2 x 11 3/4"
ISBN: 1-931241-16-3
US $70

Selected from an international competition, this collection represents some of the most exciting work being produced in the field of Photography. Complete indices of Photographers, representatives, creative personnel and clients make this book an essential resource for any Photography professional or fan. The *2003 Annual* includes **Lyle Rexer**'s "20 Questions on Photography" with **Hans Neleman** and **Ilan Rubin**, as well as a reprinted article in honor of the passing of **Robert Nettarp**, originally published in *Graphis Magazine #337*.

PhotographyAnnual2004

Published 2003
Hardcover: 256 pages
300 plus color images

Trim: 8 1/2 x 11 3/4"
ISBN: 1-931241-33-3
US $70

The award-winning images in *GraphisPhotographyAnnual2004* were carefully selected from an international call for entries. More than 250 photographs are reproduced in this outstanding collection of the best contemporary Photography from around the world. Each image is lavishly presented in full color and a gorgeous format that befits the high artistic quality of the work. This year's *Annual* includes dedications to **Herb Ritts** and **Sue Bennett** as well as interviews with **Sheila Metzner** and **Les Stone**.

PhotographyAnnual2005

Published 2004
Hardcover: 256 pages
300 plus color images

Trim: 8 1/2 x 11 3/4"
ISBN: 1-931241-41-4
US $70

Dedicated to **Helmut Newton**, *GraphisPhotographyAnnual2005* features an interview with the master, originally published in *Graphis Magazine, Issue #341*. At a time of war, the front matter focuses on Photojournalism with an eloquent essay by **Sheryl Mendez**, the New York Editor of Photography at *US News & World Report*. This book also includes individual Q&As with **Antonin Kratochvil, Alex Majoli** and **Alan Chin**, three award-winning Photographers commenting on their favorite images of the year.

PhotographyAnnual2006

Published 2005
Hardcover: 256 pages
300 plus color images

Trim: 8 1/2 x 11 3/4"
ISBN: 1-931241-46-5
US $70

A stylistic tour de force, this is the definitive yearbook of Photographic Art, with an emphasis placed on commercial assignments. The 300 plus award-winning images, in most instances featured one per page, represent the year's best international Photography. Full indices of Photographers and representatives, as well as camera/film information, make this book an essential resource for Art directors, Art buyers, and Photography enthusiasts. This year's collection includes conversations with **Bill Diodato, Mark Laita** and **Craig Cutler**.

PhotographyAnnual2007

Published 2006
Hardcover: 256 pages
300 plus color images

Trim: 8 1/2 x 11 3/4"
ISBN: 1-932026-39-8
US $70

GraphisPhotographyAnnual2007 is a striking collection of the year's best photographs, selected from an extensive, international pool of entries. Taken by some of the world's most respected Photographers, these images have been beautifully reproduced in classic Graphis quality. This year's book features interviews with **Joel Meyerowitz**, the only Photographer granted access to Ground Zero after September 11th, **Albert Watson,** on his upcoming book, *Shot in Vegas,* and **Paolo Ventura** on his series and book, *War Souvenir.*

PhotographyAnnual2008(New)

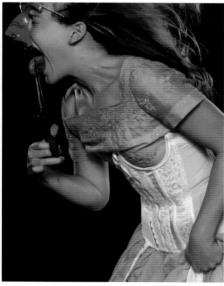

Published 2007
Hardcover: 256 pages
200 plus color illustrations

Trim: 8.5 x 11.75"
ISBN: 1-932026-45-2
US $70

GraphisPhotographyAnnual2008 celebrates the year's best Fine Art and commercial photographs, shot by some of the best Photographers in the world. Each included photograph has earned a new Graphis Gold and/or Platinum award for excellence. In addition, this year's *Annual* includes interviews with a trio of eclectic, internationally renown Photographers — **Parish Kohanim**, **Hugh Kretschmer** and **Henry Leutwyler**. This is a must-have for anyone with a passion for the art of Photography — a celebration of the year's finest.

Available at www.graphis.com

Graphis Titles

Tintypes

Published 1999
Hardcover: 240 pages
115 plus color illustrations
Trim: 7 1/2 x 10"
ISBN: 1-888001-79-8
US $60

Jayne Hinds Bidaut revives the lost art of ferrotype or tintype in studies of exotic insects and classically draped nudes. In these tintypes, insects appear as large as humans, while people are scaled down to the size of bugs. Tintypes is prefaced with an essay by art historian **Eugenia Parry**, who draws parallels between Bidaut's photographs and the sympathetic visions of A.S. Byatt and Emily Dickinson. Beautifully bound in rich red cloth with debossed lettering; an elegeant addition to anyone's library.

DanaBuckley:Fifty

Published 2004
Hardcover: 112 pages
50 plus color images
Trim: 10 1/2 x 14"
ISBN: 1-932026-16-9
US $60

Photographer **DanaBuckley**'s book presents sensual and unique floral imagery. A series of floral prints, displayed in platinum process, brings a sense of romance and depth to each striking image. Dana Buckley has been a Photographer for 17 years. Her editorial credits include *Redbook, Self, Victoria, American Baby, Brides, Family Circle, Ladies Home Journal, Parenting, Family Life,* and *Children's Business.* Her work has been displayed in galleries around the US, and she has also won numerous awards and grants.

SportingLife

Published 2002
Hardcover: 192 pages
150 plus color images
Trim: 7 x 10"
ISBN: 1-932026-00-2
US $35

Part travelogue and part memoir, *SportingLife* is an artistic diary combining photos, newspaper clippings, and handwritten thoughts into visually arresting collages. The Photographer's own words frame photographs of his most famous subjects, including Kobe Bryant, Michael Jordan, David Beckham, Anna Kournikova, Heidi Klum, Muhammad Ali, and Tiger Woods, many of which are printed here for the first time. **Walter Iooss** has been a sports Photographer since the age of 17. His work has appeared on more than 300 *Sports Illustrated* covers.

NightChicas

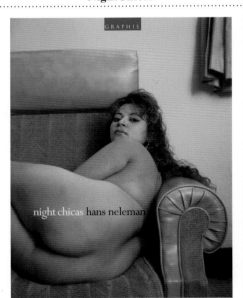

Published 2003
Paperback: 288 pages
300 plus color illustrations
Trim: 7 x 9"
ISBN: 1-932026-05-3
US $50

NightChicas is a complex, anthropological tour through a damaged landscape of Guatemalan prostitution. A product of Photographer **Hans Neleman**'s travels to Guatemala, this collection is a portrayal that deftly fills the gap between documentary and staged portraiture, to restore the human value of marginalized women. It is an approach that humanizes the issue of the sex trade — an international problem that reaches far beyond the brothels of Latin America. *NightChicas* is a dramatic collection which will educate and move audiences.

Crosses

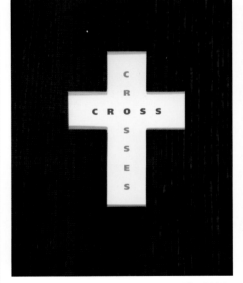

Published 2005
Hardcover: 416 pages
400 plus color images
Trim: 5 1/2 x 7 3/4"
ISBN: 1-932026-19-3
US $30

Crosses is an arresting collection of photographs on the varied applications of the cross, found in every culture around the world. The book includes a brief introduction summarizing the history of the cross, from its early inception through its recognition as a worldwide Christian symbol. *Crosses* was beautifully conceived and photographed by Fine Art Photographer **Francoise Robert**, a highly accomplished, award-winning Photographer. Mr. Robert has appeared many times in *Graphis Photo Annuals*.

Flora

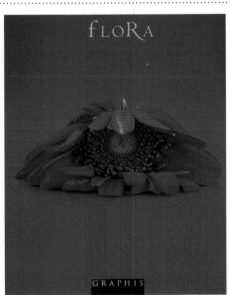

Published 2002
Hardcover: 200 pages
160 plus color images
Trim: 7 x 10"
ISBN: 1-931241-09-0
US $40

This definitive survey of contemporary floral Photography features 200 photographs. It includes a wide range of talent and a variety of genres, such as still life, landscape, abstraction and more. *Flora* features the work of **Amanda Means, John Huet, joSon,** and many others. It also includes introductory material by **Sydney Eddison**, acclaimed author and lifetime gardener. Impeccably designed and produced according to Graphis' high standards, *Flora* is an elegant addition to any Photography enthusiast's library.

Available at www.graphis.com